Harriet Hosmer
American Sculptor
1830–1908

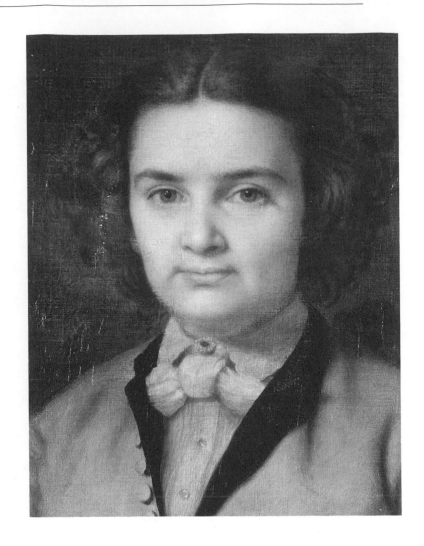

Harriet Hosmer American Sculptor 1830–1908

Dolly Sherwood

University of Missouri Press
Columbia and London

Sherwood, Dolly.
 Harriet Hosmer, American sculptor, 1830–1908 / Dolly Sherwood.
 p. cm.
 Includes bibliographical references and index.
 ISBN 0-8262-0766-9 (alk. paper)
 1. Hosmer, Harriet. 2. Sculptors—United States—Biography.
 I. Title.
 NB237.H6S53 1991
 730'.92—dc20
 [B] 91–15632
 CIP

∞™This paper meets the requirements of the American National Standard for
Permanence of Paper for Printed Library Materials, Z39.48, 1984.

Designer: Elizabeth K. Fett
Typesetter: Connell-Zeko Type & Graphics
Printer: Thomson-Shore, Inc.
Binder: Thomson-Shore, Inc.
Typeface: Sabon

Portions of material from the Hosmer letters appeared in my "My Dearest Mr.
Crow," *Washington University Magazine* 51, no. 3 (Fall 1981). Chapter 3, in
slightly different form, appeared as "Harriet Hosmer's Sojourn in St. Louis," in
Gateway Heritage 5, no. 3 (Winter 1984–1985). Chapter 12 was adapted for
"Harriet Hosmer: The Homecoming 1857," in *Sweet Auburn: The Newsletter of
the Friends of Mount Auburn* (Spring 1988). Information from Chapter 9, along
with other Browning material, provided the source for "The Brownings in Flor-
ence," *House & Garden* (May 1990).

Frontispiece: *Harriet Hosmer,* by William Page, ca. 1855, oil on canvas, painted
oval, 21.5″ x 16.75″. Courtesy Museum of Fine Arts, Boston, gift of the Estate of
Mrs. Lucien Carr.

To Ed

Contents

Acknowledgments

The writing of a biography is an intensely subjective and personal pursuit, sometimes a lonely one. But many people have contributed to what was for me a rich and vital experience. First of all, I feel a strong, retrospective kinship with Cornelia Crow Carr, editor of *Harriet Hosmer: Letters and Memories,* published in 1912. Mrs. Carr collected and edited the letters of her famous friend, testifying to the difficulty of reading words written on the thinnest of papers, with only three letters in several hundred bearing the date of the year in which they were written.

To Isabella Carr Leighton, granddaughter of Cornelia Carr, warm thanks are extended. As the donor of the Harriet Goodhue Hosmer Collection at the Arthur and Elizabeth Schlesinger Library on the History of Women in America, Radcliffe College, she has made it possible for me, as well as others, to know Harriet Hosmer through her letters and memorabilia. I am privileged to have met Mrs. Leighton and to have shared in her recollections of her grandmother and other members of the Crow family.

The Hosmer Collection at the Schlesinger Library became my principal manuscript source. During several sojourns there, I was obligingly assisted by staff members. I thank particularly the director, Patricia King, and her assistant, Elizabeth Shenton. I am grateful to the Schlesinger Library for permission to use and to quote from materials in the Hosmer Collection.

The collection of Hosmer works and memorabilia at the Watertown Free Public Library, where I have visited and worked on several occasions, is another prime resource for scholars. There I was graciously helped by Sigrid Reddy, then director, and by Helene Tuchman,

present director, and Jane Eastman. Library trustee and local historian Charles T. Burke enlightened me on several aspects of Watertown history and guided me to the work of the Reverend Joseph L. Curran, Jr. While Father Curran was a staff member at the Watertown Free Public Library, he compiled a catalogue raisonné of the Hosmer works and a comprehensive bibliography of Hosmer sources. Available on microfilm through the Archives of American Art of the Smithsonian Institution, this resource is the starting point for researchers.

In Lenox, Massachusetts, another Hosmer locale, the assistance and kindness of M. M. Kennard of the Lenox Library Association, Marcia B. Brown of the Lenox Historical Commission, and regional writer Gerard Chapman have not been forgotten.

Urging me at the outset to seek out original manuscripts was Bobbie Bristol, without whose professional advice as an editor and encouragement as a friend there may have been no book. I am grateful also to Dr. Arline Thorn of the University of West Virginia College of Graduate Studies, who helped me to prepare for the subsequent writing of this book—and I had much to learn.

Since my interest in Harriet Hosmer began after a visit to the Casa Guidi in Florence, where she was often a guest of Robert and Elizabeth Barrett Browning, it seemed providential that as the circle came round again, I should meet Philip Kelley, editor of the Browning Correspondence, who with his vast knowledge has directed me to unpublished Browning resources and opened new vistas in Browning studies.

Phoebe Dent Weil, chief conservator and fellow at Washington University Technology Associates, St. Louis, Missouri, has helped me immeasurably, reading the manuscript, commenting, correcting, and guiding me to materials that I might have missed and, in addition, sharing with me her joy in Rome and its environs.

No person has done more to stimulate interest in neoclassical sculpture and its practitioners than Dr. William H. Gerdts, professor of art history, Graduate School of the City University of New York. Dr. Gerdts has written extensively on the sculptors of the period and about Harriet Hosmer in particular. His writings in books and journals have been resources of prime importance.

I am grateful to the Missouri Historical Society, the Massachusetts Historical Society, the New-York Historical Society, and the Folger Shakespeare Library for permission to use manuscript material in their collections. I thank also Denison Burton, Chatham, New Jersey, who shared with me letters written by family members of Thomas Buchanan Read that are in her private collection.

For permission to use Browning manuscripts, I thank the Syndics of

the Fitzwilliam Museum, Cambridge, England; the Henry W. and Albert A. Berg Collection, the New York Public Library, Astor, Lenox and Tilden Foundations; the Ella Strong Denison Library, Scripps College, Claremont, California; and the Beinecke Rare Book and Manuscript Library, Yale University Library, New Haven, Connecticut. I am grateful also to John Murray, Esq., for permission to quote from the Browning letters to which he holds copyright.

The list of friends who helped in some way, great or small, has grown too long to manage. Among them are, most notably, my longtime friend Mary Perry, incredible finder of old books; H. H. Smallridge III, who has the searcher's eye for current information; Christine Jones Huber, art historian and friend, who, discovering my interest in Hosmer, shared materials from her own library with me; the late Caroline Chaney, who read an earlier draft of the manuscript with a copy editor's eye to search out typos and glitches; and Jane Curry, who has retained her interest in the work through good times and days of discouragement. There are many more whom I also thank.

I acknowledge gratefully those who assisted me at various educational and cultural institutions, either in response to my request or on their own behalf. I mention with thanks: Garnett McCoy, Archives of American Art; Jonathan Harding, Library of the Boston Athenaeum; Paul Ivory, director, and Barbara Roberts, conservator, Chesterwood, Stockbridge, Massachusetts; Michael Richman, curator of the Daniel Chester French Papers, National Trust for Historic Preservation, Washington, D.C.; Sally Bond, Peabody Museum of Archeology and Ethnology, Cambridge, Massachusetts; Patricia Holland, University of Massachusetts, Amherst; Joan A. Lemp, Corcoran Gallery of Art, Washington, D.C.; Wayne Craven, University of Delaware; Lilly Lievsay, Laetitia Yaendle, Folger Shakespeare Library, Washington, D.C.; Jane Stroup, Maria Mitchell Science Library, Nantucket, Massachusetts; Susan Menconi, Hirschl-Adler Galleries, New York; Lewis I. Sharp, formerly of the Metropolitan Museum of Art, New York, and now director of the Denver Museum of Art; Mark Weil, Washington University, St. Louis, Missouri; Elizabeth Kirchner, the Mercantile Library, St. Louis, Missouri; Betty Coley, Armstrong-Browning Library, Baylor University, Waco, Texas; Sandra Donaldson, University of North Dakota; Karen Blair, University of Washington, Seattle; Marlene Park, City University of New York; Homan Potterton, director, the National Gallery, Dublin, Ireland; and Roland Hudson, editor of the Browning Correspondence. The New York Public Library; the Library of Congress; the Ryerson Library of the Art Institute of Chicago; the Kanawha County Public Library, Charleston, West Virginia; and the libraries of the National

Gallery, Washington, D.C., and the Missouri Historical Society have all been resources for my work.

I am especially grateful to my literary agent, George F. Scheer, for his steadfast confidence in my work and for making sound suggestions for some revision of the manuscript. I am happy also to have found a home at the University of Missouri Press, where Beverly Jarrett, director and editor-in-chief, and Jane Lago, managing editor, as well as other staff members, have guided me through the publishing process, not only with expertise and efficiency, but with a kindness and consideration that is much appreciated. Joy Kasson, associate professor of American Studies, University of North Carolina, Chapel Hill, N.C., was an exceptional external reader, whose critique was most helpful. Finally, to Catherine McKenzie I owe a debt of gratitude for her sensitive and intelligent copy editing.

I cannot adequately express my appreciation to the Marquess of Northampton for receiving me at Compton Wynyates, where I was given full use of the letters of Harriet Hosmer to Louisa Lady Ashburton. During the time that I spent there, my work was greatly facilitated and made more enjoyable with the help of Sue Wyles, then administrative assistant to Lord Northampton. At Castle Ashby we were guided by Peter McKay, a knowledgeable cicerone. For her advice regarding materials at Compton Wynyates, as well as gracious hospitality, I am enduringly grateful to Virginia Surtees, biographer of Lady Ashburton. At Leighton House, the then curator, Stephen Jones, allowed me the use of materials otherwise unobtainable. I also owe debts of gratitude to Christopher Payne, Sotheby's Belgravia; archivist Gordon Phillips, The Times Newspapers, Ltd.; the British Library; the Royal Academy; and the National Portrait Gallery.

For kindnesses in Rome, I would thank Signor Luciano Grimaldi of the Caffè Greco; Father Murel Vogel, S.J. of Loyola University; Barbara Crotty; Dottoressa Alexandra Pinto Surdi, Centro di Studi Americani; Dr. Dieter Graf, Bibliotheca Hertziana; Sir Joseph Cheyne, Keats-Shelley Memorial. In Florence our friends Virginia and Giuliano Prezzolini arranged for the memorable interview in Lugano with Giuliano's father Giuseppe Prezzolini (1882–1982), one of the first twentieth-century writers on Americans in Italy and a distinguished cultural historian. More recently, I have reason to thank Caroline Burton Michahelles for receiving us so warmly at the Villa Bricchiere-Colombo.

Writing a biography is an awesome responsibility through which I gained new insights into myself as well as my subject. I could not have written this work at any other season of my life. Earlier years, filled with family concerns, were not congenial to ventures requiring quietude,

time, energy, travel, and resources—they were all spoken for. I am grateful to have been able to realize work in which I never lost interest. For whatever errors in fact, analysis, or judgment that may come to light, I am entirely accountable.

My children and their families have taken pleasure in my work on this biography, enlivening the process with humor from time to time. More than anyone else, my husband, Edward Sherwood, has loyally supported me throughout this long period of preparation and creation, willingly and enthusiastically traveling to every place that might enrich my perceptions of Harriet Hosmer, of her life and times. We have searched for the sculptor in many places, most memorably in Italy and in Britain, odysseys to be recalled with delight. It is to him that I dedicate this book.

Harriet Hosmer
American Sculptor
1830–1908

1
Beginnings

On a damp, bone-chilling afternoon in Rome in the 1850s, visitors trickle into the unprepossessing little street called the Via Fontanella. There they are admitted, through a worm-eaten door with a gaping hole, to the courtyard of a studio, a revelation of particular beauty after the shoddiness of the street. The distinguished sculptor John Gibson, whose studio it is, receives them cordially. But it is not Gibson they have come to see, but rather the young marvel Harriet Hosmer, who is his pupil.

The callers might be Americans, the men well turned out, the women in fashionable bonnets with satin ribbons, recently purchased in Paris. The visitors glance self-consciously at the nude figure of Gibson's *Tinted Venus,* which seems all the more shameless and shocking to them because of the painted lips and golden hair. Then they inquire discreetly if they may see "la signorina." Should Miss Hosmer be modeling Lady Mordaunt's nose, the answer must be no, for a client's privacy is scrupulously respected. But since she is free to receive them, they climb the garden stairway to the little room at the top, where the studio boy Pietro pulls aside a curtain that screens the studio from view. There at work is Harriet Hosmer, a girl in her twenties, at once woman and *wunderkind*—of all things, a female sculptor.

Nathaniel Hawthorne, visiting her studio with his wife, Sophia, in 1858, observed his young countrywoman and recorded his impressions.

> We found Miss Hosmer in a little up-stairs room. She is a small, brisk, wide-awake figure, of queer and funny aspect, yet not ungraceful, nor to be rejected from one's good graces without further trial; and she seems so frank, simple, straightforward, and downright, that there can be little further trial to make. She had on petticoats, I think; but I did not look so low, my attention being chiefly drawn to a sort of man's sack of purple or plum-colored broadcloth, into the side-pockets of which her hands were thrust as she came forward to greet us. She withdrew one hand, however, and presented it cordially to my wife (whom she already knew) and to myself without waiting for an introduction.

3

Had Hawthorne looked "so low," he might have seen full bloomers, cut like a Zouave's trousers, in which she could easily climb a scaffold. Hawthorne, who considered dress emblematic of the one who wore it, described her epicene costume.

> She had on a male shirt, collar, and cravat, with a brooch of Etruscan gold, and on her curly head was a picturesque little cap of black velvet; and her face was as bright and funny, and as small of feature, as a child's. It looked, in one aspect, youthful and yet there was something worn in it, too, as if it had faced a good deal of wind and weather, either morally or physically. There was never anything so jaunty as her movement and action; she was indeed very queer, but she seemed to be her actual self, and nothing affected nor made-up; so that, for my part, I give her full leave to wear what may suit her best, and to behave as her inner woman prompts.[1]

Visits to the studios of sculptors were an essential exercise on the agenda of nineteenth-century travelers. They would drop in, meet the artist, look at the magnificent marbles, then move on to the next address. All of them—aristocrats, acquisitive parvenus, literary figures, anonymous wanderers, perhaps even reigning monarchs—engaged in the ritual of studio visiting.

Autumn was the time to go to Rome, when the danger of *mal'aria,* the sickness named for the bad air thought to be its cause, had passed. The long fall, generally sunny but given to sudden thunderstorms, was followed by a short winter, damp and penetrating but mild by New England standards. While the initial response of sojourners might have been dismay at the dirt of centuries beneath their feet or the pesky fleas that gnawed at them, all hearts and minds were eventually won over. A year in Rome added a decade to the life of the mind and spirit, it was believed.

In May or June, when street vendors in the Piazza Barberini were balancing baskets of strawberries on their heads and calling, "Fragole, fragolini," it was time to leave for the Alban Hills just outside the city or for Tuscany in the north. Impecunious artists who stayed in Rome enjoyed a time to work uninterruptedly. Rome settled down to a lazier pace as peddlers in the Piazza di Spagna sold lemonade—"Limone, limone"—served from baskets lined with fresh, green leaves.

The expatriate artists clustered in the streets that ran from the Piazza del Popolo to the Spanish Steps, a section frequently called "the English ghetto." In palace or tenement, whatever they could afford, they took up residence. Many sculptors worked in studios in the Via Margutta, where the sound of hammer and chisel rang out. The marble, readily available from Carrara or Serravezza, was brought by ox cart from a

nearby landing on the Tiber right up into the studios, where skilled artisans were on hand to transfer the sculptors' clay models into marble.

Both painters and sculptors were free to work from living models, a practice almost unheard of in mid-nineteenth-century America. Whole families of models congregated on the Spanish Steps—idling, arguing, some selling violets to mitigate their poverty. Artists could engage them right on the spot to pose for four hours for about a dollar. Frequently, the artists banded together to share the expense. As lagniappe, a model might offer a lesson in Italian as the Romans spoke it. When an artist seeking a model appeared on the scene, they put aside whatever they were doing to strike the pose that best displayed their features. Since religious themes prevailed, many a fellow had portrayed God Almighty, although such a face might do as well for a classic Jove. Bearded old men, typecast as Moses or Saint Joseph, became patriarchal in demeanor. A madonna with baby might cast her eyes to heaven or fold her hands prayerfully, while a boy dressed in the skins of a shepherd would stop pitching pennies to take the stance of a young John the Baptist.[2]

A permanent presence on the Spanish Steps was the horde of beggars, each staking out his own territory, as forest birds do when they nest. One regular was Beppo, King of the Beggars. A pitiful sight as he shifted his nearly legless torso to his chosen spot, he had fastened to his deformed hands and the stumps of his legs pieces of wood, the better to scramble up and down within his special zone. His customary greeting, spoken with just the right inflection—confident but not too cocky—was "And how much is your gracious excellency going to give this morning?" The least coin was a *baiocco,* a penny; but the *paul,* about a dime, was the usual largesse, although any ambitious mendicant would press for more. Beppo enjoyed a reputation for solvency, even affluence. He supported a wife and many children. For the daughters, he could even provide a dowry. At the season of Advent, the *pifferaio* put on the shaggy coat of a shepherd to play a serenade on flute or pipe. Often accompanied by the *zampognaro* with his bagpipe, the piper stood under the open windows in the Piazza Santa Trinità or extended his lean body to nap in the sun on the Steps.[3]

In curious contrast to the vagabonds on the Steps were the young ladies of the aristocracy who attended the convent school at the top of the worn travertine stairway. A New York traveler, W. M. Gillespie, watched the cloistered French nuns of the Sacred Heart solemnly march their charges to mass in the Church of Santa Trinita dei Monti, keeping them carefully insulated from the world outside in two straight lines. Even so, a pretty young girl lifted her veil to wink at the American onlooker.[4]

Down below in the Piazza di Spagna, with its boat-shaped fountain fed by ancient aqueducts, were institutions that the foreigners had come to expect: Hooker's Bank and, beyond, on the ground floor of an old palace, Spillmann's ice cream parlor and trattoria, where hampers of food could be packed for a picnic. Americans quickly discovered the joys of eating out. From a wide choice of restaurants and taverns, Lepre's was the favorite of the artists. Servants of the Roman aristocracy, including the chefs, ran Lepre's with the blessing of their employers, who paid them so poorly that an alternate endeavor was encouraged. Lepre's offered a bill of fare of five hundred tasty dishes, of which a hundred were served on a single day. A sumptuous meal could be had for under twenty-five cents. Flasks on the tables, laced with straw to reinforce them, contained the wines of the region, Velletri, Frascati, and Orvieto. During the 1840s, in the English room, so called because it was the rendezvous for English-speaking expatriates, a favorite waiter known to all would take a pinch of snuff, lift a corner of the tablecloth, and figure the bill on the table's bare surface.[5]

Across the street in the Via Condotti was the famous Caffè Greco. Its venerable age of well over a hundred years did not give it any airs. Early in the century, Germans—among them, Goethe, Ludwig I, and the Nazarene painters Peter von Cornelius and Johann Friedrich Overbeck—frequented the place. Some said it should be called the Caffè Tedesco, the German Café. At mid-century the Germans still commanded the best seats in the house, but artists of every country were welcomed to the growing circle. Women went to the Greco, too—especially those who were emancipated as artists or actresses.

The day at the Greco began early as the regulars sipped the special coffee imported from Mocha by the proprietor. Later the wine flowed freely, and a convivial atmosphere prevailed. When Raffaello the head-waiter was not answering urgent calls for service, he could direct the inquirer to an old metal box that held important messages, even mail from home. It had once contained tobacco, but in its present function it might hold a commission to tide an artist through the winter.

In Ludwig Passini's 1852 painting of the Caffè Greco, customers wearing tall hats sit around the marble-topped tables and exchange gossip or jokes. A dog—perhaps it is the one known as Beefsteak—lies on the floor. A bartender serves a thirsty fellow in a long coat, and a clock over the bar is a subtle reminder of the hour. Handsome gas fixtures light the room, and the atmosphere is thick with the smoke of cigars.[6]

There were several rooms in which the patrons played chess or acted out comic charades, but the favorite room was the long, narrow "omnibus," with its red plush banquettes. On the walls were an ever-increas-

ing number of medallions commemorating one notable customer or another. One heretic later confessed that he would rather be honored with a plaque in the Greco than a monument in St. Peter's.[7]

For the tourist, each day brought new discovery. Antique Rome offered walks within the Forum or, in a procession of Bengal lights, to the Colosseum, ghostly in the moonlight. To satisfy the most grisly tastes, there were the Gothic horrors of the Capuchin church, where, in the burying ground of the monks, the skulls and skeletons of the departed were there for all to see. Or an expedition to the gloomy subterranean maze of the catacomb of Saint Calixtus could make the visitor shudder with exquisite terror. On certain feast days, the dome of Saint Peter's was brilliantly illuminated with gaslights, its outline sharply etched against the night sky. To hear a magnificent "Miserere" during Holy Week, even the most rigid Protestants put aside their biases.

In its niche in the Cortile del Belvedere at the Vatican was the *Apollo Belvedere,* almost an icon. To return from Rome without having seen it was unthinkable.[8] Still, the expatriates had their private joke about it that involved a certain American, a newly rich Mrs. Raggles, who stood, arms akimbo, earnestly studying the figure thought to be one of the noblest images of the human body. Closing her Baedeker, she concluded, "I've seen the Apollo Belvedere, and I've seen Raggles, and give me Raggles."

Seasonal visitors, expatriates, and even the Romans were drawn to the matinee ritual on the Pincian Hill. Although the spectacle of the setting sun provided the excuse, mingling in the formal gardens was a way to see and be seen. Descending the steep hill to the Piazza del Popolo below, dark pines stood like sentinels. In the late afternoon, a cosmopolitan gathering assembled for a *tableau vivant.* Artists taking the air after their working day wore their bohemian dress, and there were also beautifully attired women, attended by handsome men, all of whom went to be admired. Should the ladies be Romans, the men might not be their husbands, the attentions of cavaliers not discouraged in Roman society. The Americans came in families, their children starchily dressed in fancy clothes, to hear the French military band. As the sun began to go down, all eyes were riveted on the sight across the Tiber as the dome of Saint Peter's changed from its customary ochre to shimmering gold. The ceremony over, those on foot would stroll off while others departed in shining landaus.

This was Harriet Hosmer's Rome, the city that seduced her with its sweet air, soft language, and artistic milieu. During the years in which her life played against the backdrop of papal Rome and the emerging Italian state, she became the most famous woman sculptor of the era. She was buoyant and witty, and the record of her interesting friendships

with literary and artistic notables helps to illuminate the period. More-over, she was a symbol of independence and a woman's right to deter-mine her own destiny.

Harriet Goodhue Hosmer was born October 9, 1830, in Watertown, Massachusetts, a lively town already celebrating its bicentennial in the year of her birth. Founded by an English statesman, a reckless adven-turer, and courageous clerics, Watertown, situated on the Charles River, was a cusp of the fertile literary crescent that included Boston and Cambridge, with Concord and Salem only a short distance away. In this neighborhood the American cultural consciousness took root, grew, and blossomed. Its very air exuded an intellectual energy and encour-aged excellence in all its sons and daughters. Growing up in such surroundings, with many of the distinguished figures of the time as friends and familiars, Hosmer formed a strong sense of her own identity and the determination to succeed in a field difficult enough for men and almost unheard of for women.

Hatty, as she was called, was the daughter of Hiram Hosmer and his wife, Sarah Grant. Both Hosmers and Grants were descended from colonial forebears who went to New England in the seventeenth century, intelligent, well-educated, and hardworking, the very salt of the New England soil. The Hosmers claimed as progenitor one James Hosmer of Hawkhurst, a village on the plains of Kent in England, a farmer who had come to New England in 1635. Hatty Hosmer, secure about her lineage, liked to talk of her ancestors in a joking way, leaving her listeners to wonder whether to take her seriously. "Our real name is 'Osmer,'" she once said, "but our country people could never manage a name like that, so we voluntarily added the 'H.'"[9] "I tell father," she said, "the Hosmers are the most crooked sticks that God or the Devil ever concocted." And, on another occasion, "I have discovered who my grandmother was—she was a *leech* and that is the reason her grand-daughter has such a faculty for sticking here [Rome]."[10]

She sometimes insisted that she was descended from the Norse god Odin, but her father, a rational, Augustan man, could find his heroes closer to home. His father and his uncle had fought in the American Revolution, performing creditably, as all members of the family seem to have done. The fact that there was "no wrong doing in such a large family" was duly noted and recorded in the Hosmer chronicles. Sarah Grant, Hatty's mother, was from Walpole, New Hampshire, where her father, Samuel Grant, is described in the town records as "saddler, farmer, selectman, veteran of the War of 1812, and a founder of Walpole Academy," the very model of a New England forefather.[11]

Hiram Hosmer, father of Harriet Hosmer, date of photograph unknown. Photograph courtesy Watertown Free Public Library.

Ancestors on both sides, barring the commonplace incidence of infant mortality, lived to astonishingly old ages. When Hiram Hosmer married Sarah Grant in 1827, the two young people had every reason to look forward to the future with optimism. Hiram had left his cabinet making in Walpole some years before to study medicine at Harvard. He took up his practice in Watertown, where he could expect a comfortable living, and they settled in to raise a family.

The first child of their marriage, Sarah Helen, was born in 1828. Two years later a second daughter was born and christened Harriet Goodhue. Two sons followed. The first boy, Hiram Twitchell, born in December, 1832, lived scarcely two months. The cause of his death was obscured, but a form of infantile tuberculosis seems to have been the reason. Tuberculosis, or "consumption," as it was called, was one of the most prevalent and insidious diseases of the nineteenth century. In the following year, 1833, a child named George was born to the Hosmer family to fill the empty cradle.

Neither Hiram nor Sarah Hosmer believed in coddling their children. In a letter to her cousin, Sarah reported Hatty and Helen, aged

four and six, as "hearty," going to school daily, and learning well. It was just after Thanksgiving Day, 1834, when she said, "I bot them some india rubbers in town yesterday that they might spat through the mud and snow at all times."[12]

Hiram Hosmer, the hardworking family doctor, had had an "uncommon run of business" that fall, so his wife reported, a circumstance that put him in the best of health and spirits. Of her own condition, Sarah Grant made only the most perfunctory mention. "Very good," she called it, an irony in the light of what was to come. In a matter of months, the second boy, George, died, another victim of infantile tuberculosis. In less than a year and a half, when lilacs and wood violets were blooming in springtime Watertown, Sarah Hosmer died of consumption at thirty-three.

Little was recorded about this event in May, 1836. It is quite likely that a stoic suppression of grief was urged on Hatty and her sister Helen once the first tears were dried. Following a pattern that might have been set by their father, Hatty rarely mentioned her mother again, very likely suppressing a loss too painful to recall. When she referred to her deprivation, it was in an oblique manner, entirely out of tune with her customary straightforwardness.

In years to come, when she wrote to her friend Cornelia Crow to console her on the death of a little sister, Hatty awkwardly attempted to rationalize the bereavement. The death of a sister "however dear" is "but small in comparison to the loss of a parent—of a mother—the extent of which none can know except by experience." She continued staunchly, "Nothing can supply her place . . . no love can be so strong, no one with influence so great."[13]

Dr. Hosmer, putting his own feelings aside, had to face the problem of caring for his motherless daughters. Although they had never been over protected, he dedicated himself with new zeal to building their little bodies to a sturdiness sufficient to ward off any predisposition to tuberculosis that might exist. Far ahead of his time, he ignored current practices in his insistence on rigorous physical training for his small daughters. Oblivious also to social distinctions concerning the upbringing of female children, he stood his ground: "There is a lifetime for the cultivation of the mind, but the body develops in a few years, and during that period nothing should be permitted to interfere with its free and healthy growth."[14] The picture of Hiram Hosmer putting his daughters through their paces might be amusing were it not for another somber development. While Hatty flourished, Helen developed the same disease that had claimed her mother and two little brothers.

As July 4, 1842, neared, the people of Watertown were preparing to

celebrate with all of the festivity that the great occasion merited. There would be picnics, speeches, and fireworks, and the old patriots who remembered the very day itself would doubtless describe the ringing of the church bells for anyone who would listen. But for the Hosmer household, it became a day of mourning. Helen, not yet fourteen, died on Independence Day, and her grave was added to the number already in Mount Auburn Cemetery.[15] Her shadow is nearly imperceptible. Helen is never mentioned again by name, but Hatty's passionate attachment years later to Cornelia Crow, "sister mine," expresses the lonely child's need and internal longing for a sibling.

A housekeeper, Miss Coolidge, saw to the running of the Hosmer household. This admirable woman mothered Hatty and made Dr. Hosmer comfortable in the Hosmer homeplace, which sat high above the Charles River on an embankment and in full view of Watertown Square, already a bustling spot in the 1840s. The well-proportioned exterior of the house was painted white with green shutters. In its heyday, it boasted an outside balcony, art glass in several of the windows, and mantels hand carved with decorative motifs. The kitchen was large and well equipped with a huge ice chest and food storage bins—a model of efficiency and comfort for its time—and the cistern in the basement was an effective means of gathering rainwater. An arched lavatory was provided for each bedroom, bellpulls to call the servants were a mark of affluence, and the copper bathtub was a distinct luxury.[16]

Next door on the corner lived the Francis family. Convers Francis, Unitarian minister and theologian, was one of the original transcendentalists, a group that included Ralph Waldo Emerson, Margaret Fuller, and Henry David Thoreau. While his library was not as remarkable as that of his friend Emerson, he did have a fine collection of books, whose resources he generously offered to Hatty in later years. He was looked upon as an eloquent preacher, one who gathered inspiration from the phenomena of the natural world to illuminate his sermons. But he was not without whimsy, and even after he had left the Watertown church to teach theology at Harvard, no one had forgotten his prayer, "May the intemperate become temperate and the industrious dustrious," his little joke perhaps to see who was listening.[17]

During the pastorate of Convers Francis, the Congregationalist church in Watertown slipped effortlessly into the Unitarian fold, as many other churches of the denomination had done when complex currents of change made the old Puritan beliefs less serviceable. Within the more liberal church, less intent on sin and retribution than on emerging social issues, there was an internecine split on abolition. While the Hosmers seem to have taken a moderate stance on the question, like many of their

neighbors not ready for radical action, there were those in the congregation who went to hear the uncompromising Theodore Parker and the eloquent Wendell Phillips in the town hall.

With the Charles River virtually in her front yard, Hatty spent many hours playing there or watching fishermen pull in their nets filled with shad. She swam in the river during the summer and skated on the frozen surface in winter. Her father had a gondola built for her, one with a silver prow and velvet cushions, quite the envy of the neighborhood. All the same, her companions were terrified of riding in it with the daredevil Hatty as gondolier. One man, a family friend, was heard to say, "Too much spoiling—too much spoiling."[18]

In a secret studio tucked away under the natural overhang of the riverbank, she began to model in clay from a pit in her own yard. There she surrounded herself with a collection of specimens dead and alive— frogs, rats, and snakes. Besides her pet dog, who followed her everywhere, a large yellow cat that served as model for a tiger skulked about. A young playmate later recalled Hatty, in her worker's smock, brandishing a small ivory handgun tipped with silver. She had used it to shoot a robin that she needed to examine, "just to get it right," she argued.[19]

Inside the house, Hatty had the run of her father's office, situated on one side of the center hall. There she was perfectly at home with the resident skeleton, pulling clothes borrowed from her cousin Alfred Hosmer up over the articulated bones as another child might dress a doll. Upstairs in her room were Cinderella and Red Riding Hood puppets that she had made with meticulous care and kept secreted behind a curtain. She was also adept at fixing household objects and making mechanical things work.

Neighbors remembered her as a round-faced, dimpled child, holding a black dog that she had rigged up in red ribbons and bells. Although she was appealing to those who knew her well, Hatty was looked upon by the townsfolk as very peculiar.[20] She was a tomboy who climbed tall trees with impunity. She was a crack shot, not only with a gun, but with bow and arrow; she was intensely competitive, beating the boys at their own games; and she was a fearless rider, performing all sorts of stunts on the back of her horse. The neighbors sympathized with Dr. Hosmer both for being the widowed father of a lone surviving child and for having to cope with such a handful.

Lydia Maria Child, a sister of Convers Francis and an ardent feminist, later defended Hatty Hosmer's independent spirit, recalling what the townspeople had to say about the girl who was already hearing the cadence of a different tune. "She is so peculiar, she is so *eccentric*," they complained, while congratulating themselves "upon being mere stereo-

typed formulas of gentility or propriety." Speaking out in behalf of Hatty's strong individuality, Mrs. Child continued: "Here was a woman who, at the very outset of her life, refused to have her feet cramped by the little Chinese shoes, which society places on us all [women], and then misnames our feeble tottering, feminine grace."[21] She called Hatty "wild as a colt on the prairies and as tricksy as Puck . . . a brave, roguish boy" in her manner. The same bravado, Maria Child asserted, would have been applauded had she been a boy. In domestic imagery that came naturally to the author of *The American Frugal Housewife,* she added wryly:

> But girls are to be
> ground down enough, to flatten and bake into
> a wholesome crust,
> For household uses and proprieties.[22]

Hatty's early schooling was sketchy, even though she was already going to school at four, as her mother had reported. Others recalled her attending one of the dame schools for young children, a Miss Dane's school, at some time in her early childhood. During the intervals when she was not enrolled in school, governesses and tutors filled in the educational gap. Her brief enrollment in Nathaniel Peabody's Academy earned her a notorious reputation. The schoolmaster was a member of the prominent Peabody family of Salem and a brother-in-law of Nathaniel Hawthorne and Horace Mann. His sister Elizabeth Peabody was already distinguished as an innovative educator, but Nathaniel Peabody is scarcely remembered as a pedagogue. If his experience with a student like Harriet Hosmer is any indication of his success, he may have wished to forget that period in his life. Hatty later recalled "the long explanatory note attached to my back when I was sent home in disgrace." She had been returned to her father as an incorrigible. Each time this exercise took place—and she admitted with some show of pride to three such expulsions—Dr. Hosmer convinced himself that the rigors of a highly structured classroom were too confining for her. Books were withdrawn, and she ran free until the next time.

As for Nathaniel Peabody, his tenure as educator was brief. His nephew Julian Hawthorne recalled that he was a man of "many fine gifts and an almost excessive conscientiousness," a trait that may have been his undoing as a schoolmaster. He became instead a highly reliable homeopathic pharmacist in Boston, dispensing "the purest prescriptive drugs" in the region.[23]

Ellen Robbins, a childhood friend of Hatty's who became a successful painter, recorded their attendance at the singing school of Joseph

Bird, the principal social event of the week. As Mr. Bird attempted to teach the assembled young people choral music, Hatty delighted in harassing him by making guttural, dissonant, nonsense sounds as the others were singing their sol-fa syllables.[24] On one occasion, Robbins claimed, she saw Hosmer put a counterfeit bill in the church collection, reinforcing her reputation as miscreant.

As Hatty approached adolescence, her capers became even more colorful, flamboyant, and dangerous. She rode to Boston all alone one night, to satisfy a bet; she had a close call in a sailing frolic on Fresh Pond that gave her father new gray hairs and which may have instigated her fear of water; and she crawled through a series of long, narrow, classical columns, lying on the ground before they were raised at the new town hall, for no rational reason. The most dramatic episode, threatening to upset Watertown transportation, was the harebrained scheme to uncouple the railroad cars from the engine so that the passengers would be left behind in the cars when the train pulled out. Apparently apprehended just before the climactic moment, she had to be bailed out by her father, who paid the damages.

Years later, in a talk to the Watertown Woman's Club, Hatty called the roll of her own misdeeds, not entirely seriously, but accurately enough to corroborate other reports. She freely admitted that she was an undesirable companion for the well-behaved children of the neighborhood.

The climax to the antics of Harriet Hosmer seems to have been the affair of Dr. Morse, an incident that took place when Hatty was about fifteen. An ancient town character, Eliakim Morse was known as a very rich man, his money made from the manufacture and sale of prescription drugs in Boston. In an earlier time of vigor and enterprise, he had outfitted a merchant vessel, the *Galen,* that had gone down in the War of 1812. In his great old age he lived as a legend in a palatial mansion in the Watertown area.[25] In the sanctity of his home, Dr. Morse wore a long dressing gown that came down almost to his slippers, a garment singular enough to provoke comment. In rides about the town, he was a passenger in his own yellow chaise, driven by his sister-in-law, Miss Catherine Hunt.

Residents of Watertown regarded him as the ultimate example of longevity, virtually immortal. But Hatty must have found the old man repugnant, his thin white hair straggling out from beneath his hat. His very appearance could well have suggested decay, ugliness, even death to her. With no known provocation except what appears to be a need to be insolent, she sent a note to a Boston newspaper, reporting Dr. Morse's death.[26] Watching in secret, she saw neighbors and friends leaving their

calling cards and other expressions of condolence at the Morse home only to be informed that Dr. Morse was among the living. It was apparent to all that a cruel hoax had been played on Eliakim Morse and his family. Hatty was quickly apprehended as the culprit and called to stand before her father for the inevitable reckoning.

Faced with this irresponsible escapade, Hiram Hosmer knew that he had to chart a new course for his recalcitrant daughter. It was obvious that she needed a more disciplined environment and the supervision of someone who specialized in bridling unruly youths. However much he would miss her, he decided to send Hatty away to a boarding school. There is no way of knowing exactly how he arrived at his decision. Convers Francis, a wise counselor, may have offered the key suggestion. Hatty herself reported that after covering for her in the uncoupling of the cars and the reported demise of Dr. Morse, her father sent her away "for the greater tranquillity of the town."[27] However it came about, Dr. Hosmer's resolution to send his daughter to Mrs. Sedgwick's School at Lenox, Massachusetts, was the perfect prescription.

2
Mrs. Sedgwick's School: A Turning Point

The years at Lenox were not merely a milestone in Harriet Hosmer's life; they were a critical turning point, shaping her character more than any other single influence. Everything about the place helped to create a congenial environment for her development. The Berkshire region, with its pine forests, cold running streams, and mirrorlike lakes, was a setting of great natural beauty. The atmosphere of the schoolroom was disciplined but stimulating and periodically enriched by the presence of visiting literary figures. But it was probably the pedagogy of Elizabeth Sedgwick, reinforced by her loving concern for the motherless Hatty, that worked the miracle.

Known to be successful with those considered to be "difficult cases," Mrs. Sedgwick had been fully informed of Hatty's peculiarities. When Dr. Hosmer, the indulgent and anxious father, turned Hatty over to her, Elizabeth Sedgwick said, "I have a reputation for training wild colts, and I will try this one."[1]

In spite of the metaphor that suggested rigid compulsion and little else, Mrs. Sedgwick was a progressive educator and a woman of great warmth and keen intelligence. She and her husband Charles were members of the family whose very name was synonymous with the towns of Lenox and Stockbridge. To many they were almost household gods, so venerated that even the crickets were said to sing, "Sedgwick! Sedgwick!"[2]

Both the Sedgwicks and Elizabeth's family, the Dwights, descendants of the Puritans, had been strictly Calvinist but had moved into the Unitarian stream along with others of their liberal social persuasion. Their sensitivity to injustice was often acted upon. During a previous period when they had lived in New York, the two had sheltered a woman accused but acquitted of stabbing a man who had seduced her. Elizabeth Sedgwick nursed the woman through a severe mental illness that ended in death, her derangement brought on by the trauma of her experience at the hands of the assailant and in the courts.[3]

Returning to the Berkshire region, the Sedgwicks established their home in Lenox in a comfortable, spacious house christened The Hive, a dwelling similar in its design to Hatty's own home in Watertown. Charles Sedgwick, who nursed the feeling that he was neither as bright nor as enterprising as his brothers, who were New York lawyers, became the Lenox clerk of court while his wife established Mrs. Charles Sedgwick's School for Girls, which she directed personally from 1828 to 1864.

Lenox was from the first a cultural phenomenon, drawing to it the most distinguished American and foreign literary visitors. The tradition of an academy education for both boys and girls had existed from the town's earliest days, so Mrs. Sedgwick's school was not unique. Outpost though it was, accessible by stagecoach, Lenox was actually regarded as competitive with Boston as a center for refinement and learning. In the academies, education was offered democratically in these years when the American Revolution had broken the barriers of class, and money had not yet become the measure for a new aristocracy. An early school building bore the date 1803, and Miss Sally Pierce's Litchfield Female Academy can be traced to 1792. As Miss Pierce's school declined, closing its doors in 1832, Mrs. Sedgwick's school came into prominence.[4]

While Elizabeth Sedgwick described her school as a "character factory," she did not, as Maria Child had written, grind the girls down "to flatten and bake into a wholesome crust, / For household uses and proprieties." But discipline, kindly administered, was an important ingredient in the honing of their minds and the shaping of their characters. Courtesy was inbred in Lenox students. Hurrying, for example, was looked upon as "a weakness of the illbred." The curriculum included Greek, Latin, and hygiene, an innovation that must have pleased Dr. Hosmer. And there were studies in French, for Hatty was often called upon to entertain with a recitation of comic doggerel that she wrote in a fractured mix of French and English.[5]

The young women students took a constitutional, whatever the weather. The vigorous climate that moved from the vivid color of autumn to the still, white snows of winter offered challenge but no excuse. A decade later, as several of the Lenox girls gathered around a fire in Florence, Hatty said that their shivering self-indulgence would have been considered by Mrs. Sedgwick to be "frightful degeneracy."[6]

Laughter to the point of hysteria, was infectious, Hatty later remembered with nostalgia. High spirited and good humored, she was called "the life of the house," but she had a serious side that was appealing to older people as well as to the other girls. Still, she didn't entirely abandon her spectacular stunts. On one occasion at least, she climbed recklessly to the top of a tree forty feet high to retrieve a crow's nest.

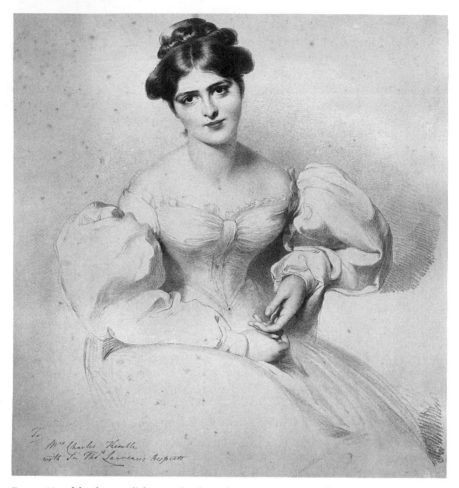

Fanny Kemble, from a lithograph after Thomas Lawrence, date unknown. Library of Congress.

The presence of Frances Anne Kemble, as a neighbor and frequent guest, colored Hatty's years at Lenox, for she was one of the adults who was drawn to Hatty and who became an enduring friend. The celebrated actress had come to prominence in England as one of the younger members of the theater family that included her father, Charles Kemble, an actor who at one time also owned and managed Covent Garden, her uncle John Philip Kemble, and her aunt Sarah Siddons.

When Fanny Kemble came to the United States with her father, the handsome young English actress was idolized by her audiences until she began to criticize American ways. She married Pierce Butler of Philadelphia, a man of property who had changed his name from Mease to

Butler in order to inherit from his maternal side. His holdings included plantations worked by slaves in the Sea Islands of Georgia, as well as property in Philadelphia.

The marriage was a disaster, and the denouement was hastened by Fanny's brief residence on Butler's plantation on St. Simons Island in Georgia, where she kept a journal in the form of letters written to a close friend. Elizabeth Sedgwick was the friend, their bond beginning during Fanny's earliest days in America when she had met the writer Catharine Maria Sedgwick in New York and, subsequently, Catharine's sister-in-law Elizabeth. The latter and her daughter Kate became Fanny Kemble's closest confidantes. The collapse of Fanny's marriage to Pierce Butler in the 1840s, in which her abhorrence of slavery surely played a part, was exacerbated by Butler's attempt to forbid her from communicating with the Sedgwicks, whose feelings for him had turned to contempt.

Following her divorce, the actress spent extended periods of time at her Lenox cottage, The Perch, a frame building with steep gables and eaves, neo-Gothic in style. At first, her unconventional behavior had lifted eyebrows, as she fished the streams wearing pantaloons, having divested herself of the petticoats her friend Elizabeth wore. She was outspoken in her dislike of American euphemisms for ordinary words (women had no "legs," only "limbs"). She had no patience with such prissiness.[7]

She found the Quaker farmers who tilled her field a happy contrast to the pitiable slaves of the South, not to mention the "poor-whites," who were nearly as degraded if not more. But she made a mistake in offering her neighbors beer and wine after they had mowed her meadow. She desisted when Charles Sedgwick accused her of introducing "a mischievous need."[8]

By the time that Harriet Hosmer went to Lenox, Fanny Kemble's presence was highly appreciated by the townspeople, willing as she was to give readings to benefit the poor (although she soon found that there were no indigent in Lenox). The library eventually came to be one of the recipients of her munificence, but in Hatty's time Mrs. Kemble gave generously of her genius to the students, recollections of which they would cherish to the end of their days. On Saturday afternoons she would appear in the recitation room of the school to begin the reading of a Shakespearean play. The dramatic monologue would continue in the evening at her cottage down the street, where the girls would reassemble for the conclusion. Depending on the mood left by the play, comic or tragic, the group would unwind with amateur theatricals, charades, songs, or dances that Fanny Kemble would accompany on the piano. Like other artists of her time, she was versatile, and examples of her poetry are found in collections of the period. When she returned to

the theater, her repertory included the one-woman readings that she had performed at Lenox.

Another esteemed member of the community was Catharine Sedgwick, the sister of Charles Sedgwick. She spent long periods of time at The Hive with her family, interspersed with her residence in New York. More moderate on the question of abolition than other members of the Sedgwick family, she was nonetheless a person of strong moral principles and impeccable conduct. A highly successful writer on a number of different subjects, she was the author of *A New England Tale* and a two-volume work entitled *Married or Single,* as well as other books.[9] She had a distinguished group of friends at home and abroad. A lifelong friend was William Cullen Bryant of New York, known in his own time as editor of the *New York Evening Post* and as a civic leader, rather than as a poet. In Europe, where she had traveled, she was admired and respected by Charles Dickens, William Makepeace Thackeray, the Marquis de Lafayette, and Thomas Carlyle.[10]

There was a steady stream of visitors at The Hive, a house appropriately named. Over the years the roster included Emerson, William Ellery Channing, Charles Sumner, and Nathaniel Hawthorne, who brought his little Una to Mrs. Sedgwick's classroom. Progressive women were drawn toward the liberal ambience. Harriet Martineau, the English writer on the condition of women, visited; so did Fredrika Bremer, the Swedish writer, happy to see that American girls were learning mathematics and the classics. It was an atmosphere where feminism did not have to be articulated; it was inbred.

In a personal sense, Hatty's greatest legacy from school at Lenox was her friendship with Cornelia Crow, her beloved "Corny," a name only Hatty dared use. Cornelia, who lived in St. Louis, was a bright, pretty girl nearly three years younger than sixteen-year-old Hatty, although possibly more mature emotionally. She became the "chosen classmate," confidante, and "sister mine."

The community of adolescent females at Mrs. Sedgwick's followed a pattern for nineteenth-century women; it was the "world of female intimacy," where closeness, both physical and emotional, was not taboo.[11] The loving, caring environment that encouraged creative expression was exactly what Hatty needed. Some might argue that her emotional maturity never went beyond the schoolgirl level, as she continued to play Peter Pan, the eternal juvenile male. But such a stance may have been her way of resisting the repressive strictures placed upon women, whether married or single. The boarding school persona represented a halcyon time in her life, and she was loath to part with it.

Dr. Hosmer was undoubtedly gratified by his daughter's progress

under Mrs. Sedgwick's tutelage. Without losing her individuality or her spontaneity, she was becoming more responsible. Always worried that she might not turn out to be a credit to him, he wrote her a little sermon about an old man who had reason to repent a profligate youth and added, "My daughter, read the above with attention, remember it, and make it serve you as a guide and a beacon in establishing a character, a good character, without which life is certainly a failure." Lest she over-look it, he reminded her, "This is written before the arrival of an answer to my last, sent with the books you wished."[12]

Elizabeth Sedgwick called Hatty "the most difficult pupil to manage that I ever saw but I think I never saw one in whom I took so deep an interest and whom I learned to love so well."[13] When Hatty left Lenox, the two began a correspondence, and after Hatty went to Rome, a visit to Lenox was always included in her trips home. Exuberantly, she once wrote that she would like to have forty daughters—but only so that she could send them all to Mrs. Sedgwick's school. If there were days that had fallen short of perfection, they were forgotten.

The school educated a number of women who became prominent. There would be more to follow after Hatty, like Jenny Jerome, the American mother of Winston Churchill. But it hardly seems possible that any pupil could ever have received more from her days at Lenox than Harriet Hosmer. For one of her temperament and intellectual gifts, and in the face of her desperate need, it was clearly the right solution.

3
St. Louis Opens Its Doors

Her schooling at Lenox completed, Hatty went home in the fall of 1849 with a new sense of purpose. She was now certain that she wanted to be a sculptor. Whether the thought came to her in a moment of shining epiphany or was born of an idea germinated in her backyard clay pit is not known. But with Yankee determination, she and her father put their heads together to see how her goal could be accomplished.

How did such a notion occur to her? The strong women at Lenox—Elizabeth and Catharine Sedgwick and Fanny Kemble—must have had something to do with it, models as they were for self-determination. Women had the God-given right, they thought, to follow any calling for which they had the ability. To be an actress, writer, musician, painter, poet, even astronomer, like Maria Mitchell, was possible for a woman willing to study, work hard, endure ridicule, and step over the stumbling blocks in her path. Could a woman become a sculptor? Why ever not?

There was an understanding between Hatty and her father that sculpture was to be a profession, not a polite, pretty hobby. She must not be satisfied with carving ivory umbrella handles, a refinement of the scrimshaw craft. Nor should the cutting of cameos, a genteel occupation, be her calling. So she began her studies in modeling and drawing with Peter Stephenson, an English-born sculptor teaching in Boston. Soon she produced a head of Byron in wax and the portrait bust of a child.[1]

While Hatty was growing up, the Boston Athenaeum played a vital role in stimulating her craving for sculpture. On exhibition in 1839 were eighty pieces that included several copies of well-known ancient works along with images of popular characters from mythology. Even a copy in marble of the head of the *Apollo Belvedere* could be admired and studied. Casts of many of the antique masterpieces were represented in the growing collections of the Athenaeum. By writing for permission, an artist might copy from the *Venus di Medici* or the *Laocoön,* an unbelievable privilege. Although the human figure was the only sculptural form

22

conceived of, drawing from life was almost unheard of in puritanical America.

In the Athenaeum, portrait busts of contemporary statesmen began to take their places alongside their Roman counterparts. The subjects of Horatio Greenough, John Frazee, and Shobal Clevenger were attired in toga and tunic, like their ancient prototypes. An important acquisition was Thomas Crawford's *Orpheus,* a full-length figure in the round that combined the elements of ideal form with the prevailing literary themes in sculpture. The work of a woman, too, was represented in the enlightened environs of the Athenaeum. In 1848, Joanna Quiner of Beverly, Massachusetts, described as "a mature artist," showed a bust of Robert Rantoul.[2]

But the resources of the Athenaeum, however advanced, were not enough, and Hatty and Dr. Hosmer recognized that a sculptor must have a thorough grounding in anatomy. Hatty had been on easy terms with her father's office skeleton as long as she could recall. She and her cousin Alfred Hosmer had played with it and dressed it in his clothes. Now, Alf was preparing to enter Harvard to study medicine, a privilege reserved for men. Nonetheless, Dr. Hosmer asked the Boston Medical Society if his daughter might attend lectures in anatomy. Those in charge were shocked. Hatty's champion, Lydia Maria Child, later reported that "it seemed to them a gross impropriety for women to be thus inquiring into the structure of the human frame."[3]

In the fall of 1850 Hatty packed her portmanteau to travel to the West, ostensibly to visit her classmate Cornelia Crow, whose father, Wayman Crow, was one of St. Louis's leading citizens. Crow was successful not only in the dry-goods business but in diversified industries as well. He also had a strong interest in St. Louis's educational and cultural development, with his hand visible in every effort being initiated at the time.

The trip to St. Louis seems to have been taken with the firm expectation that the doors of the Missouri Medical College could be nudged open wide enough to admit a woman, particularly one who had the support of such an influential civic leader as Crow. On November 6, 1850, Hatty matriculated at the college to begin her courses in anatomy.[4] It was the first successful strategy to ignore obstacles and find new directions to achieve her goal.

The director of the school was Joseph Nash McDowell, who, like Crow, was a native of Kentucky. He was proud forever after that he, a southerner, had given the sculptor Harriet Hosmer the start denied her by northern medical schools. She later recalled that in accepting her as a student, "he tossed back his iron gray hair as he said, 'I told Miss

Hosmer she *might* study here, and that if anybody attempted to inter-fere with her, he would have to walk over my dead body first.'"

McDowell had a splendid education in anatomy and surgery, and he was widely regarded as a brilliant doctor and teacher. But it was his idiosyncrasies that immortalized him, for he was a living legend of eccentricity and whimsy. He protected his school with guns, and on national holidays like the Fourth of July, he called the students out for maneuvers with firearms, he giving the orders in a three-cornered hat and wearing a cavalry saber at his side. In sharp contrast to this bravado, he was terrified of certain natural phenomena like thunderstorms, hid-ing himself in a feather bed to block out the thunder and lightning.

The procurement of cadavers in medical school was a haphazard business with little orthodoxy about it. With some justification, stu-dents and faculty alike were looked upon as diabolical. Sometimes students and professors, even McDowell himself, had a hand in the ghoulish pursuit. With grim humor, body snatchers were called "resur-rectionists," because they raised the dead from their graves. While he was not one to turn down a specimen, McDowell was often plagued by the manifestations of ghostly apparitions, emanating from his firm be-lief in spiritualism.[5]

He was having niches built in the central column of an octagonal building that would serve as his family's mausoleum. As he awaited the completion of the grave sites, he carefully preserved the bodies of de-parted family members in copper receptacles filled with alcohol and tightly sealed. He then had students carry them by torchlight to a secret cave, where they were stored until their interment.[6]

At the end of the five-month term, there was a grand commencement, with McDowell playing the violin like a minstrel as he led his students in the procession. He entertained with a few tunes before beginning his oration, one always sure to be eloquent. His opening, addressed to "Gentlemen," commended the students for their hard work. The term of address demonstrates that the presence of a woman was extraordinary, although in addition to Harriet Hosmer, there was another girl, Jane Peck, enrolled as a student in chemistry.

Violent and vindictive with those he thought to be his enemies, McDowell could also be abusive and profane with his students. Still, they lent him money and took him home when he was too drunk to make it on his own. With his female student he was courtly and protec-tive, making it clear to the rough fellows, which medical students actu-ally were in that frontier town, that no one was to bother her. The rumor that she carried a handgun is probably exaggerated, but the very sug-gestion that she was a crack shot may have been effective protection as

she walked from the Crow house to the medical college, in the vicinity of Eighth and Gratiot streets, about a mile away through an area quite unsettled.

Coincidentally, McDowell had previously instructed two sculptors in anatomy when he was teaching in Cincinnati. Both Hiram Powers and Shobal Clevenger, his pupils, had gone on to study in Italy, receiving wide recognition for their work.

Each day, McDowell went over the day's lecture privately with Hatty, "with intuitive delicacy," Cornelia Crow later said. Although Hatty had studied the specimens before they were presented in class, she never missed a session, occupying the same spot on a hard bench in the amphitheater. During those months, she wore a brown bonnet that became her trademark; years later, St. Louisans who visited her studio in Rome continued to joke about it.

In the Crow home at Eighth and Olive streets, Isabella Conn Crow was mistress of a gracious household where sociability stemmed from the southern traditions of forebears from Virginia and Kentucky. Household needs were looked after by the servants, Tom, Emily, and Jane, who were, in fact, slaves. Adhering to his moderate Whig philosophy that urged the gradual, voluntary manumission of slaves, Wayman Crow gave these servants their freedom in 1853, an act that Hatty applauded when she received the news in Rome. But during her St. Louis sojourn, she saw no wrong in owning slaves, for she felt that Crow could do no wrong. Even later, she thought that Tom, Emily, and Jane would never be as happy as free people as they were under such a kindly master, bound as they were to him by "chains of love and gratitude"—so superficial was her understanding of their true situation.[7]

Isabella Crow, in spite of her delicate appearance, was a strong woman who bore her children with relative ease. Cornelia, the oldest child, was born when her mother was only nineteen. Wayman Crow was then a merchant in Cadiz, Kentucky. Recalling the occasion, he later wrote to his grown daughter to tell her that on June 8, 1833, her mother had felt so well that she rode her horse to the home of a nearby relative to have dinner there. After the late meal, a storm came up to hurry her home. At the height of the deluge, accompanied by thunder and lightning, she had to send for "Dr. Dozier, who went through a torrent four feet high in the street" in order to reach the house and deliver Cornelia shortly afterwards.[8]

A subsequent daughter, Medora, died at ten months in 1838, and a child named Alice died at four in 1849. Younger daughters at home during Hatty's stay were Emma and Mary; a son, Wayman Crow, Jr., would arrive in 1853, after Hatty had gone to Rome. The birth of little

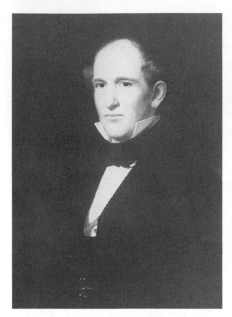 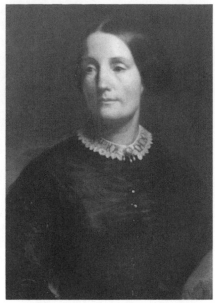

Wayman Crow, artist and date un-
known, oil on canvas, 24″ × 29″. Pri-
vate collection. Photograph courtesy
Schlesinger Library, Radcliffe College.

Isabella Conn Crow, artist and date un-
known, oil on canvas, 33″ × 38″. Pri-
vate collection. Photograph courtesy
Schlesinger Library, Radcliffe College.

Isabel, or Isabella, a name passed from one generation in the family to
the next, born in 1856, completed the family circle. By that time, Isa-
bella Crow was forty-two.

Wayman Crow took a special interest in the young houseguest.
Hatty's lively personality and obvious admiration of him were winning
attributes that made him want to help further the career that she planned.
While he had little formal schooling himself, he had a keen mind and a
strong interest in intellectual and cultural subjects. He also liked chal-
lenge and knew no obstacles.

Besides his business and civic enterprises, Crow was a state legislator.
When he took off for the winter term of the legislature at Jefferson City,
Hatty kept him abreast of the local news and gossip. Apologizing for
not answering a letter he sent her, she explained that she was prevented
"by the pressure of business," which turned out to be a large New Year's
party for nearly a hundred guests at the Crow home, a gathering that
featured a beautiful, bountiful table and a "company gay and brilliant."
Cornelia, already a belle, enjoyed the attentions of a Mr. Coy as well as
the favors of his younger brother. Hatty, on the other hand, was gauche

and lacking in feminine wiles. She made it clear that she would have welcomed the chance to box the ears of Willis L. Williams, who failed to show up on New Year's, an obvious slight. "My wrath waxeth strong," she wrote to Wayman Crow, "when I reflect that, judging from the character of the man, he would have felt the smart *so high up*," a statement intended to call attention to Williams's allegedly low character.[9]

In St. Louis, a popular lecture series and a new theater had just opened, but much of the fun was homemade. Carefully planned was a "Grand Pic-nic," boasting an elaborately hand-printed programme for an affair that would begin "at 8 o'clock precisely," when "the victims" were to assemble for "mutual condolence." The ladies and gentlemen were to form a procession, "funereal like" in order to arrive at the grounds together "when the band will strike up a popular dirge." The writers of the programme claimed that "a large number of trees" had been "felled for the purpose and the ground newly ploughed," the dancing to begin at nine o'clock in the morning and continue until noon if the weather permitted. Pursuing the grisly satire, the hostesses reported that "six men will be stationed at a convenient distance for the purpose of exhuming such individuals as may require their assistance." With realistic appraisal of the St. Louis climate, there would be "fifteen nimble lads" available "to banish mosquitoes, gnats, etc. etc."

Instructive, lofty addresses and sad, lugubrious songs were to be the order of the day. A certain Lucien Carr would sing *The Old Gray Goose,* but no one was to think for a minute that the song applied "to him or her-self." "Comfortable stumps" would be provided for the ladies to sit upon, but the gentlemen would be expected "to sit on their hats," as the "elegant collation" was served. "For dessert," Mr. Carr would again sing, this time the sentimental Irish ballad *I'm Sitting on the Style, Mary.* The picnic would go on all day except for three hours of "universal napping." That "no one who is present on the occasion will sleep on the two preceding nights" was a firm order to the prospective guests. The picnic would be concluded at seven, when "the martyrs will be escorted off the grounds by the band playing a favorite quick step."

The planned affair must surely have been influenced by Hatty's studies at the medical college, known for rough, macabre humor and high jinks. It was also a parody of the classic southern barbecue and an outing at one of the popular spas. The programme was carefully lettered in the same style that Hatty used to label her myology drawings. Whether the event ever was to come off was moot; the creators and organizers, Hatty and Cornelia, announced vaguely that "due notice will be given when the precise day is fixed upon."[10]

Commenting to Wayman Crow on the birth of a baby to "Mrs. McC," probably Mrs. McCreery, the wife of Crow's partner in the dry-goods business, Hatty said that if the population in every St. Louis street increased as fast as it had on Olive Street, where the Crows lived, the growth of the city would be enormous. St. Louis was indeed a fast-growing, energetic city in 1850, with a population of nearly seventy-eight thousand. New political elements, fed by the arrival of the German immigrants, were forming within the community, but still down the road was the volatile issue of slavery and its extension to the new territories of the West—an issue that would explode of its own intensity. The hand-some, Greek Revival courthouse, its cupola still under construction, had already been the venue for the first trial of Dred Scott's suit for his freedom.[11]

The life force of the city was, of course, the magnificent Mississippi, which arose as a thin, fragile stream in the wilds of Minnesota to gather strength, depth, and enormous width before it fanned out into the delta two thousand miles to the south. In St. Louis, strategically located as the gateway to the West, steamboats with cargo of every description were lined up along the Mississippi levee two and three deep, participants in the commerce that characterized the midwestern port. In a single year, three thousand paddle wheelers or more might dock there for business. It was natural that Hatty should be strongly drawn to the river, infinitely more powerful than her native Charles but seductive in the same mag-netic way as the path to adventure and exploration. Its dangers were well known: swift currents and a changing course that often left shoals on which a hapless ship could run aground. But according to its best-known pilot, the young Samuel Clemens, the river "was a book that had a new story to tell every day," and along its many miles, there was "never a page void of interest." Clemens, or Mark Twain, told how the pas-senger might be "charmed with a dimple" on the shining surface while the captain could read the harmless-looking eddy as a wreck or a rock "that could tear the life out of the strongest vessel that ever floated."[12]

Disaster could stem from the ship itself. A flue might collapse or some other mechanical disorder could cause a fire, the dread of every river traveler and a commonplace happening. So, the trip down the Mississippi to the Delta planned by Hatty and Cornelia Crow was not undertaken without some degree of hesitation. Traveling on the com-modious *Pacific,* one of the larger steamboats making the trip from St. Louis to New Orleans, they had been on the river for less than two days when the boat began a succession of groundings, occurring every few hours. It settled at last on a sandbar from which it couldn't be budged. Cornelia, her patience exhausted, took the opportunity offered to dis-

embark and returned to St. Louis on a passing boat. The twenty-year-old Hatty continued on alone, an introduction to the life-style of an emancipated woman that the Crows may not have entirely approved of.

The *Pacific* sat for two more days before a smaller boat took the passengers on board to push on down the river to Cairo, the Illinois town that marks the juncture with the Ohio River, where a larger craft would be waiting. Writing from the smaller boat, the *Whirlwind,* Hatty reported that "there were a great many passengers for us to pick to pieces," apparently one of their girlish pastimes. Cape Girardeau was the largest town she had passed, but "Godforsaken." Aground at Sainte Genevieve were the prestigious *Aleck Scott,* the *Di Vernon* and the *Lawrence.* Suffering an even worse plight was the *Cambria,* which had passed them earlier, now sunk in the treacherous stream.[13]

Still some hours from Cairo as she wrote, the *Whirlwind* was plowing her way through a particularly dangerous stretch of water. Mark Twain calculated one wreck for each mile between St. Louis and Cairo—small comfort to travelers, whether they stood on an airy upper deck with sparkling white gingerbread trim or sat in a showy cabin decorated with red and gold curtains and ornate gold cuspidors.[14] A barge accompanied the *Whirlwind* to unload freight if the boat should become moored to some unseen hazard.

There was plenty of opportunity for sightseeing at Memphis and New Orleans, but the traveler, eager to return to her studies, decided not to continue on to Galveston and turned back to St. Louis. Her curiosity about the great river was not satisfied, nor was her itch to see its upper reaches. In the spring, she set out on the portion that she came to consider the more beautiful; the river continued to amaze her that it could be "so long and so wide—and apparently made expressly for America."[15] The Upper Mississippi, rich in history and Indian lore, flows past towns like Moline, Rock Island, and Davenport. Marquette and Joliet camped on its banks, and sites associated with conflict are graphically recalled in names like Tête de Mort, Death's Head, where the French offered the Indians the choice of jumping from the steep embankment or starving.[16]

Chronicled in the ruins at Nauvoo, Illinois, was a more recent struggle. The community that the Mormons had established there had been destroyed by a mob only seven years before. After their leader, Joseph Smith, and his brother Hyrum had been killed, the Mormons, led by Brigham Young, moved farther west. But their dreams of a temple of worship could still be seen in the ruins. As the boat passed the site, Hatty was impressed with what "must have been a splendid building when it was in its glory."[17]

Anatomical drawing of the human muscle system done by Harriet Hosmer while she was a student at Missouri Medical College, 1850, reproduction from pen and wash, 34″ × 24″, signed *Hosmer pinxit, St. Louis, 1850.* Schlesinger Library, Radcliffe College.

She spent hours in the pilot house learning all she could about the ship's whereabouts. But she told Cornelia, "Dear Honey," that she took time out to study "my muscles." Several large drawings meticulously done testify to the seriousness of her intentions and the completion of her myology course. For leisure reading there was *David Copperfield* to entertain her. A new valise, cheaply bought, made finding her belongings easier; and she had a stateroom to herself, a privacy never taken for granted in travel. Except for "two or three squalling babies," soon to leave the boat, the passengers were few and pleasant, particularly the wife of one of the pilots.

She accepted an invitation to go with a group to see a lead mine in Iowa. When the vessel reached Dubuque, where they would presently transfer to another boat, the small company descended into the mine, transported one-by-one in a bucket. The carrier, insubstantial and shaky, threatened to spill Hatty out into the dark void. Panicked, she thought how far she was from home and wondered how those who loved her would know her whereabouts if the bucket foundered.[18]

The water turned a deep green as the paddle wheel went beyond Dubuque, with majestic cliffs and crenellated castles of rock rising above the shimmering river on either side. Indians continued to live along the banks in the primeval wilderness, and Hatty smoked the peace pipe with at least one Dakota chief as the travelers made their way upriver. At a point near the town of Lansing, Iowa, some of the young people aboard were boasting of their prowess, and presently, bets were being taken to see who could climb to the top of a bluff, one of a series along the river. The captain tied up, and the race was run to the top of a hill that rises four hundred feet from the Mississippi below. Hatty, never one to shrink from competition, scrambled to the top ahead of the others. The unnamed hill was christened Mount Hosmer and later became a city park. Not certain that the name was official, Hatty was amused to see the title verified many years later. It was perhaps the earliest recognition to come to the young artist.[19]

For all of the adventure, there was time for meditation under the stars and moon, moments of loneliness and introspection. She thought of Cornelia, back in St. Louis, as "an apparition [that] comes before my eyes with a face that I love and a dress that I like and an apron that I don't like." More seriously she reflected that moments of friendship are not sufficiently appreciated until they have passed. Her mood became darker as she thought of those whom she had loved "so dearly and who were now gone." Blaming her melancholy on the grandeur and beauty of the natural wonders around her and on the profound quiet of the night, she put aside thoughts of life's "trials, its miseries, and selfishness" and returned to her usual optimism to sleep on.[20]

As the Mississippi reached its upper limits, Hatty disembarked to go by carriage to see the Falls of St. Anthony, stretching across the river for fifteen hundred feet and dropping spectacularly for more than eighty. She called it "sublime," a word that had a special meaning in the nineteenth century, of raising the ordinary, even the base, to the height of perfection. It was the ultimate word used for spectacles that inspired awe and wonder. On one side of the falls was the tiny village of St. Paul's, which, so Mark Twain said, had a population of three people at the time of his birth in 1835. On the other side, the community St. Peter's had "half as many," according to Twain. The concept of the city that would be called Minneapolis was well in the future. After visiting both these small communities near the source of the Mississippi, Hatty rode back in the carriage to her steamboat *Nominee,* bound for Galena, where she would have to change again for St. Louis.

Some years before, another New England woman, Margaret Fuller, had taken an adventurous trip to the great West, visiting in Chicago and in desolate areas of the Great Lakes. There is some coincidence perhaps in the fact that each of these women traveled in the West before going to Italy. But while Hatty, perhaps because of her artistic nature, was especially tuned to the magnificence of the wilderness, Margaret Fuller was uneasy in the natural world. She was sensitive, however, to social inequities, finding the lives of the Indians—women, in particular— bleak and the outlook for improvement even grimmer.[21] Hatty, less intense than her predecessor, probably gave little thought to the plight of the women of the wilderness, but had any of them expressed a desire to become an artist, she would have been the first to applaud such an ambition. In years to come, she would offer friendship and encouragement to a young female sculptor of Indian blood, arriving in Rome to study.[22]

Hatty left for home in the early summer of 1851, her studies and her western travels completed. Having had her as a guest for nearly nine months, the Crows may have found her departure something of a relief, but such feelings were never expressed. Instead, she had become a beloved member of their family circle, and it would always be so. Dr. McDowell wrote an ardent farewell: "Dear Hat, I like, not love you, for my poor old heart . . . chilled by the winters of adversity, cannot now love." Could he love anyone, he continued, it would be "the child" Hatty. He begged her not to forget him, saying that he would never consider her lost to him "unless you prove that you have forgotten me." He hoped to recall her presence by calling on "our mutual friend J.," probably Jane Peck, the chemistry student, but his warmest feelings were reserved for Hatty. "The bench you sat upon has never been filled since you were

there. I often turn to the spot and think I can see the little Quaker girl in the brown sacque and close fitting bonnet, and an eye that beamed with pleasure at the exhibition of Nature and Nature's work."[23]

A decade later, when the Civil War began, McDowell, a valuable military surgeon, cast his lot with the Confederacy, while the Union took over the medical college. When the war was over and after a period of reconciliation, he returned to the college, which would become the Washington University medical college.

For Hatty, the months spent in St. Louis and the West were a training exercise for the greater adventure that lay ahead. She had proved that she could be independent of chaperone and companion, an extraordinary departure from the prescribed rules for young women of good background. She had made strong friends in St. Louis, and visitors from the River City would always be received with special cordiality in her studio in Rome. The city itself occupied a special place in her affection. More than any other spot thus far, it had opened its doors to offer her the chance to be a sculptor. She would not forget it.

4
On "the Eve of a New Life" in Italy

Her exuberance spilling over, Hatty Hosmer returned home after the long absence. Her museum room at the top of the center stairway was waiting for her. There, on a rustic stand, was the crow's nest that she had wrested from the top of a tree forty feet high, along with curious twigs and branches, a lemon brushed with gold paint, and a gathering of things best described as found objects. Beetles, bugs, and trays of butterflies—some caught many years before by Hatty and her sister—were in their glass cases. Various specimens of stuffed birds peered at her, reminders of the days when she roamed the woods around Watertown. Two items yet to be added were the Indian peace pipe and the minerals brought up in the almost disastrous incident at the Iowa lead mine. Presently, she was christening a new inkwell, she wrote Cornelia—"nothing more than the head of a kingfisher superbly ornamented with feathers" that she had combined with a seagull's egg to hold ink.[1]

In another letter to Cornelia, Hatty described the creatures that surrounded her. Some fish of several kinds swam in a tumbler on her writing table. Somewhere on the floor was "a most elegant snake, a dear darling little thing," who glided about her feet as she wrote. Soon, a monkey was added to her menagerie, "the most mischievous, ludicrous, funny thing you ever knew." Frisking about the house, the little creature was adept at pulling up the edge of her skirt with great fastidiousness. He had picked the thread out of the hem, she told Cornelia, "as nicely as you could have done it."

Her cousin Alfred, two years younger than Hatty, was again spending his vacation with the Hosmers, where he was completely at home. Hatty and Alf, who was studying medicine at Harvard, still shared an interest in physiology. Although she called her pets her "daughters," she confessed that her interest was "unnatural." Indeed, "Alf and I panted for something to dissect," so a pet cat fell to the scalpel.[2]

She wished that she could see all of the Crow family. To Wayman Crow she wrote that the sight of a St. Louis friend visiting in the East

"would do me an infinity of good and almost make me think I was back in St. Louis once more. How I should like to walk in upon you if only for five minutes 'and have a good smack all round.'" Not long after her return, Hatty was surprised to receive a letter from Cornelia Crow postmarked from Lenox. In spite of the distance, the Crow family seems to have retreated to the Berkshires and also to the seashore at Newport to escape the oppressive summer heat in St. Louis. Should Wayman Crow be anywhere near, she wrote, "indeed you can't think of not coming to see me." She had found some dolls for Emma and Mary, who "must stay long enough to learn to swim as Emma says she wants to learn to row a boat." To Crow, she complained bitterly of Corny's impending engagement to Lucien Carr, her St. Louis suitor. "Don't let her be married too young," she begged, adding that she would be losing Corny forever. She simply wouldn't hear of it, she told Cornelia: "I swear by all my grandmother's old shoes—by the Gates of Gaza that I will never speak another word to you."[3]

Although Hatty exaggerated her feelings, there was a genuine fear of separation from her school friends as they began to marry and have children. She wrote of the marriage of Carrie Wain and of the festive christening of Carrie Parker's baby. Another Lenox friend, named Lydia, was engaged to marry a man sixteen years her senior, a dismal prospect. Hatty was not alone in looking at marriage as a moment when the days of clowning and laughter must end. Young women generally expressed misgivings when they observed the barrier that matrimony built, and a young matron, bound to live up to the dignity of her new status, took on an unrecognizable mien. Marriage was a serious step, nearly irrevocable except by death. Hatty hoped that Corny, still in her teens, would not take it too soon.

As for Hatty herself, she was thoroughly enjoying the cultural advantages of Boston in company with school friends. She went to Boston every Friday, the day she called her Sabbath. "Once a week, at least, I am raised to a higher humanity," she told Cornelia. She confessed herself to be "drunk with beauty." Her companion for these sorties was Lydia, who shared Hatty's taste for literature and art. Hatty described the two of them as "going frantic together over Tennyson and Browning." On her day out, Hatty's first stop was the Athenaeum. The building on Beacon Street was now lighted by gas, creating "a fine effect on the sculpture." She was more certain than ever of sculpture's superiority over painting, for it was a "thousand times more expressive" than color on canvas. What was not said in the calm, pure whiteness of the marble was delineated in form. The plastic art was the more difficult, she judged, for the "great thought" that must be embodied in a work of

sculpture is not easy to comprehend. "That is the reason why Michael Angelo is so little understood," she argued. She told of a woman looking at the casts of *Day* and *Night,* exhibited in the Athenaeum. "Why don't they take them away and put up something decent?" was the observer's comment. "Oh, shades of the departed!" concluded the aspiring sculptor, already one of the culturally elite.[4]

In the afternoon, Hatty and Lydia went to Tremont Temple, the music hall, to hear the rehearsal performances of the Boston Orchestra. In addition, Hatty went to music halls and vaudeville. A young singer, Catherine Hayes, from Limerick, won Hatty's approval with a voice equal to that of Jenny Lind, she told Cornelia. But she was highly indignant at the appearance of the sensational Lola Montez. Montez, who was performing her Spanish dances in America, was the famous courtesan of King Ludwig I of Bavaria, a folly that cost him his crown. Like many American women, Hatty was disgusted that Montez would even put her "vile foot" in America. She hoped self-righteously that the dancer would be greeted by "hisses."[5] Neither artist, writer, nor performer was exempt from the standard of puritanical conduct implicit in nineteenth-century codes. Straying from the approved patterns of behavior, if publicly perceived, could ruin a career. (Coincidentally, Hatty later became an admirer of Ludwig I, who often visited her studio in Rome. She considered him to be "the artist-king," his earlier transgressions forgotten in light of his achievements on behalf of the arts.)

During that year in Watertown, Hatty met Lydia Maria Child, the foremost woman writer of her time and an old friend of Dr. Hosmer's. A literary figure of amazing range, she wrote novels, children's books, poems, and countless essays on a variety of subjects. She was active in nearly every area of social reform, including women's rights, religious freedom, the fight against capital punishment, prison reform, and, most significantly, abolition. Her pamphlet, *An Appeal in Favor of That Class of Americans Called Africans,* was the first antislavery literature published in America.[6] The publication of it in 1833 brought ostracism and financial ruin, for even in libertarian New England, abolitionists were looked upon as dangerous radicals who would upset the balance of commerce maintained between the southern raw materials industry, which depended on slave labor, and the New England textile industries, which depended on low-paid, poorly educated laborers, who increasingly were immigrants.

Maria Child had grown up in Watertown. She was a sister of Convers Francis, and she, too, had lived next door to the Hosmers in the earliest days of Hiram Hosmer's practice. She was nurtured in the intellectual atmosphere of the time and place, and even the most conde-

scending males acknowledged her many gifts. Henry James, in his patronizing assessment of the epoque, wrote, "If they were pleased with themselves and with others, they were pleased for the most part with everyone else, from Goethe to Lydia Maria Child."[7] So instantly identifiable was her name in her own time.

She and her husband, David Child, had lived for a number of years in New York, where she edited the journal the *Anti-Slavery Standard* for William Lloyd Garrison. Returning home, she settled at Wayland, one of many farm homes that she inhabited. She had a talent for making do with little, which was fortunate in the face of her husband's ineffectiveness and profligacy. In the first year of her marriage, she had written *The American Frugal Housewife,* a book filled with household hints, commonsense advice, and pithy wisdom.

Hiram Hosmer was eager for his old friend to meet his accomplished daughter. One evening during the summer months, he and Miss Coolidge rode out to pay a call on the Childs, with Hatty riding along on her horse. It was apparently Hatty's first meeting with Maria Child, even though she knew her by reputation and as an old friend of the family. She may have expected someone better looking, for Mrs. Child was extremely plain. (She herself said she had the face of a reformer.) She was, wrote Hatty, "not quite the looking personage I supposed" but was very pleasant and likable.

Maria Child found Hatty abrasive on that first meeting. She reported to her friend and fellow abolitionist Francis George Shaw that she had not liked the girl "because her voice seemed unmodulated and her manners brusque."[8] It is possible that on that occasion, so soon after Hatty's return from the comfortable southern household of Wayman Crow, the two may have discussed slavery. Hatty may have attempted to articulate Crow's moderate stand of gradual manumission, with little good to say about the abolitionists who were her hostess's most esteemed friends. In a letter written in 1860, when popular opinion and support had caught up with the enemies of slavery, Mrs. Child, with good humor, recalled the "little Missouri ruffian" who would gladly have hanged antislavery people like John Greenleaf Whittier, James Russell Lowell, Ralph Waldo Emerson, Wendell Phillips, and the "noblest Roman of them all," William Lloyd Garrison.[9] In spite of the inauspicious beginning, Maria Child quickly grew to like Hatty and became her loyal correspondent and friend.

Maria Child, like so many others, was interested in the supernatural. She considered Hatty clairvoyant to be able to see a figure "hidden in the shapeless mass of marble." The two shared an interest in the occult, and it is perhaps coincidental that Hatty had an experience that she described

as strange and supernatural on the way home from that first visit. Her father and Miss Coolidge going ahead in the chaise, she "lagged behind to see the moon and stars and to have a good *think*." Lonely, night thoughts must have stimulated her imagination, and she seemed to see the long, thin rail of a fence raise itself and move to a spot at a distance of several yards, where it stood and remained upright. She told Cornelia that she was not joking. "Make what you can out of it. I have thought about it seriously."[10]

The incident seems trivial, but later, in the widespread vogue for the occult that immersed followers in Europe and America, Lydia Maria Child, writing for a magazine, asked for permission to tell of other psychic experiences that Hatty had. Cornelia and some others considered her gifted with "second sight." She herself argued that her ability to sense unseen events was not supernatural but was related to some "natural law by which things invisible to the human eye may be projected on the mental screen." The idea was no wilder, she said, than the magic of the photograph.

In her "shop," the studio her father had built at the back of the yard, she worked on her sculpture. A medallion of Dr. McDowell's profile— "an undeserved monument of esteem," McDowell called it—was given high priority until it was finished. The silhouette, done in low relief, was like an enlarged cameo and was copied from a bust of McDowell by another of his artist pupils, Shobal Clevenger.

In her eagerness to finish, Hatty had risen at three thirty one morning to work on the medallion. Finally it was ready to be crated and shipped to St. Louis. Its long passage through the Great Lakes worried her, as she "fancied the Dr. resting quietly in a watery grave," a real and practical concern. Thankful when the medallion had arrived safely, she was also gratified that her friend Wayman Crow had seen to the display of it. The painter Martin Johnson Heade was spending a year in St. Louis, and it was he who arranged the all-important lighting for its viewing. Heade was well known to the Crow family, and it was not long after that Hatty spoke of his "immortalizing Emma and Mary," as they posed in Scottish dress for their portraits. Whether such a painting was ever completed is not known.[11]

The young sculptor was already learning to take criticism. She would be happy, she said, if her image of McDowell was called "a passable likeness." If, as Crow indicated, the only criticism was "the absence of wrinkles," then she would "put that down as no fault—tiers of wrinkles being scarcely admissible." During this period, she apparently began to attend modeling classes again in Boston. One of her works, a bust of Clytie copied from a plaster cast, was declared "the best in the class."

But, she said, "I almost broke my back casting 'Clytie.'" Alfred Hosmer, spending time with his cousin, helped with the heavy work. Replaying their childish stunts, she dressed him in her old skirts, puffed out fashionably with the help of "a large *tire*."[12]

As Thanksgiving Day approached, she wrote to Crow, speaking of the traditional holiday as approaching "with all of its terrors." Rebelliously, she had always thought it "the most stupid day of the year," and still did, for she did not "depend upon the nature of days for the enjoyment of them. My services will be held in my shop and my Thanksgiving will be in proportion to the work I do."[13]

At this time, Hatty began to mention the name of Charlotte Saunders Cushman, the celebrated American actress and a native of Boston. During a three-week engagement in her home city, Cushman played some of her most famous roles from a repertoire that included Lady Macbeth, Queen Katharine in Shakespeare's *Henry VIII,* Nancy Sikes, the gruesome gypsy Meg Merrilies from *Guy Mannering,* and the male characters Romeo and Hamlet. Women, or even precocious children, were cast in heroic, adult male roles, a ludicrous caprice of the nineteenth century. For Charlotte Cushman, expanded rather than limited by the strength of her masculine looks, this custom provided an opportunity to compete with men in the most sought-after portrayals of the English-speaking stage. Moreover, it permitted her appearance in male costume, her long, splendid legs revealed in the hose of Elizabethan costume.

Cushman had come into the theater by way of the operatic stage. Her voice showed promise at an early age, and after studying music, she began a career in opera. When she suffered a traumatic loss of singing voice, she became an actress. Hard work and perseverance, along with the undeniable power of her acting, served to make her America's first native-born actress of real distinction. She played opposite the best-known actors of the era, William Charles Macready, Edwin Forrest, and Edwin Booth. By the time the young Hosmer met her, she had achieved an international success after performing in England.[14]

No one ever called Charlotte Cushman beautiful, although the Italian writer Diego Angeli gallantly described her as *bellissima.* She had a square jaw and piercing eyes, but her biographer and intimate companion, Emma Stebbins, said that she possessed "the finest eyes in the world" and a most beautiful head of hair. Henry James found her "markedly destitute of beauty" or of feminine attractions, but able, through her intelligent acting, aided by a voice of great sonority, to convey "some special mastery of the gaunt and grim."[15]

She was a very complex woman with deep emotional needs and self

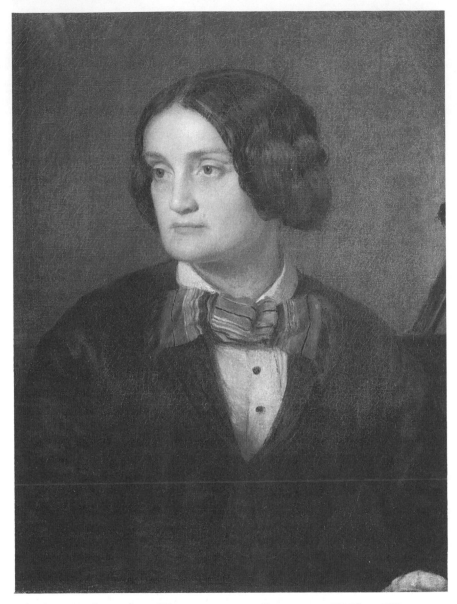

Charlotte Cushman, by William Page, 1853, oil on canvas, 27.5″ × 22″.
National Portrait Gallery, Smithsonian Institution.

doubts. One or two close associations with men had ended in disenchantment. Far more natural to Charlotte Cushman, after these unhappy relationships, were her intense attachments to women. Her intimate friend and protégée at this time—they were always mentioned together in the Hosmer letters—was a woman named Matilda Hayes. She had some claim to being a writer, although Cushman seems to have been drawn to her as one who had some talent for the theater. Only a little later, she was described as the translator of the works of George Sand, the French writer very much in vogue among emancipated women. Hayes was observed wearing masculine garb, but only from the waist up, an outfit that included a waistcoat, collar, cravat, and jacket, scarcely as sensational as the trousered elegance of the notorious George Sand.[16]

To assess the bond between Charlotte Cushman and Matilda Hayes, one must jump ahead to their stop in Paris some months later when they met the Brownings. All of them had gathered on the balcony of Fraser Corkran, Paris correspondent of the London *Morning Chronicle,* to watch a procession headed by Louis-Napoleon only weeks prior to his declaring himself emperor. Elizabeth Barrett Browning, there with her husband, Robert, and their son, Penini, observed the American actress and wrote the following to her sister: "I understand that she [Charlotte Cushman] & Miss Hayes have made vows of celibacy & of eternal attachment to each other—they live together, dress alike, . . ; it is a female marriage. I happened to say, 'Well, I never heard of such a thing before.' 'Haven't you?' said Mrs Corkrane, . . 'oh, it is by no means uncommon.'"[17]

Women in the nineteenth century did indeed have strong, intimate relationships that were viewed as normal.[18] They were, quite naturally, varied in their manifestations, although recent examination of these alliances reveals a pattern of some consistency. Many were relationships born of the need to cling together for human society, comfort, and support, and involved married as well as single women. A husband could not always be counted on for the closeness and sympathy extended by one woman to another. The tradition of women's friendships was passed on from one generation to the next, mother to daughter, as a safeguard against loneliness and alienation. Some of these bondings, but not nearly all, were expressions of homosexuality, latent or otherwise. Most stemmed from the basic need to reach out to another human being. It should be remembered that within the social and cultural milieu of the time, it was not easy for unmarried women to form close relationships with men unless those males were fathers, brothers, or somehow related. The "kissing cousin" kinship often covered for a less acceptable

linkage, and the passionate devotion to parent or sibling often siphoned off subliminal sexual feelings.

As for Elizabeth Browning's comment, it clearly demonstrates that while she considered the statement made by the two women in their identical outfits curious, it was not scandalous or particularly aberrant. In her letter, she combined gratuitous insult with an encomium rarely accorded to women of the theater: "Though an actress . . . Miss Cushman has an unimpeachable character, & is as much distinguished for her general intelligence as for her professional aptitude—a little more, perhaps."[19]

Hatty Hosmer was taken backstage to meet the greatly admired actress by a Lenox friend, Virginia Vaughan. "Ginny" even spent a week with Charlotte Cushman and Matilda Hayes in Buffalo and the region of Lake Superior, a matter Hatty mentioned to Cornelia Crow. Soon Hatty was going to rehearsals with Miss Cushman, wandering into the set and prop rooms and actors' lounges. She was even being received into the sanctum sanctorum, the star's dressing room. Although she had enjoyed the privilege of seeing informal performances of Fanny Kemble, considered by many in her time to be peerless, this was Hatty's first brush with the glamour of the theater. She apparently took in all of Charlotte Cushman's performances, calling the experience "grand."[20] Cushman's compelling presence, along with her responsiveness to the attentions of stagestruck girls, created a flock of followers.

While the course of events is not entirely certain, it is evident that Charlotte Cushman soon became friendly with Dr. Hosmer as well as with Hatty, and Hatty's future was undoubtedly a subject of discussion. When Charlotte Cushman learned that Hatty was preparing to become a sculptor, she immediately took an interest. Here was an opportunity to help a young artist, the kind of patronage that appealed to a woman who had acquired personal wealth and prestige. Even more provocative was Hatty's determination to compete in a field considered to be exclusively male.

It was inevitable that Harriet Hosmer should be drawn to Italy. Everything in her education and present life was pointing her in that direction. Since the earlier years of the Romantic period, exotic Italy, the repository of the ancients, was the haven for poets, scholars, travelers, and artists. The Romantic poets, Shelley, Byron, and Keats, had converged in Italy, and more ordinary souls found that they had exaggerated only slightly in their rhapsodies of Italy's magical charm. New England intellectuals were well acquainted with the works of Petrarch, Ariosto, Tasso, and Dante, which were second in importance only to the works of the German writers, principally Goethe. New England painter Wash-

ington Allston used the Italian landscape as a background for his romantic paintings; later his young friend Horatio Greenough became the first American to study sculpture in Italy.

Paramount in the Hosmers' decision for Hatty to go to Italy was its superiority as an artistic environment. It was the only place where a sculptor might receive the best training. Lacking a true native expression at this time, American sculptors looked to the neoclassical practitioners who held sway in the studios of Rome and Florence. Besides the presence of the masters of the plastic art, there were the real antique marbles to learn from; the live models, impossible to come by in America; skilled marble craftsmen; and the marble itself—essential commodities for the art of the sculptor. By Thanksgiving, 1851, at work in her studio every day including Sundays and holidays, Hatty was already dreaming of Italy and planning to go there. Pleased to hear that Cornelia was going to Europe in the spring or summer, Hatty wrote Wayman Crow that she, too, hoped to be there.

The perils of the sea were a daily fact of life in New England, not to be minimized; anxieties can easily be imagined. The trip across the wide expanse of ocean was enough to intimidate even the most stalwart adventurer. Hatty, intrepid in so many ways, had a genuine dread of the voyage. Not absent from anyone's memory must have been the disaster that overtook the ship *Elizabeth* in July, 1850, when Margaret Fuller Ossoli, her Italian husband and child, and others on the vessel, returning from Italy, had perished within sight of land, off Fire Island, New York.

More openly expressed was the uneasiness about the political situation in Italy. The pope was both pontiff of the Roman Catholic church and the secular sovereign of Rome and the Papal States, a position becoming increasingly ambiguous as the movement to unite Italy progressed. The leadership of Giuseppe Mazzini, the voice of the *risorgimento,* and the popular nationalist Giuseppe Garibaldi combined to establish a Roman republic in 1849 for a brief period. When Pope Pius IX's minister, Count Pellegrino Rossi, was assassinated, the pope fled to Gaeta in the kingdom of Naples, leaving the void to be filled by republican forces. At the same time, the Austrian rule in Tuscany had been overturned, and Grand Duke Leopold II of Tuscany joined the pope in Gaeta for a brief exile.

It was all quickly over. The pope, protected by the French troops of Louis-Napoleon, returned to Rome after a successful siege of the city had defeated Mazzini, Garibaldi, and their followers. Pius IX, who had begun his reign with some tendency to liberalize the Roman government, returned a chastened conservative. A stricter censorship was being enforced in Rome, where even the most innocent allusion, in art or in

opera, as Giuseppe Verdi would discover, could be interpreted as dangerously seditious. Verdi came up against the censors on several occasions when his libretti seemed to threaten the existing political authority. *Rigoletto,* performed first in Venice in 1851, had to be altered to please the Venetian censors. In 1859, when his opera *Un Ballo in Maschera* was to premiere in Rome, he had to move the setting of the work to Boston to escape the suggestion of social realism.[21]

In Florence, where the Austrian authority had been returned to power, a passionately disappointed Elizabeth Browning had voiced her fervor for "la bella liberta" in *Casa Guidi Windows.* The Italian struggle for unity posed a dilemma for freedom-loving Americans, particularly as it applied to Rome, where the pope ruled in a dual capacity as secular and sacred monarch. Many American Protestants disdained Roman Catholicism; but Rome was looked upon as the Eternal City, there was continuity in the papal rule, and the popes themselves, particularly the popular Pius IX, were regarded with a certain respect and awe. Since the Middle Ages, many popes had been collectors of antique art and had been patrons of emerging and established artists. Although brief, the Roman revolution had been bloody, threatening the cherished order of centuries.

Hatty voiced the ambivalent feelings of many who had a stake in Italian affairs. Struggling with her American conscience, she asked herself and Crow "whether it is selfish or not to fear a revolution." With the condescension shown by many Americans toward the Italians, she added, "They are not Yankees enough to do anything in the right time." That the Austrians who ruled certain Italian provinces had "prohibited the meetings of Protestants argues no good," she reasoned, but "it is inexcusable to borrow trouble when there is enough ready made to be found."[22]

She overcame her qualms by her strong desire to go, and presently her dream began to be palpable. Charlotte Cushman was planning a lengthy sojourn in Rome, a "retirement," and gladly offered to include Hatty in the household along with Matilda Hayes and a lively young woman named Sara Jane Clarke, who used the pen name Grace Greenwood, which later reminded Henry James of the New York cemetery. Ginny Vaughan was certainly going, Hatty told Cornelia, and the prospect was "sublime." Meanwhile, she was busy in her studio, the rough work having "beaten my hands to pieces." She had turned out a bust of Napoleon for her father, and now it was time to attempt her first original work, an ideal bust of *Hesper,* the mythological maiden of the Evening Star.

It is not surprising that she found her theme in poetry. Earlier she had

described herself and Lydia as "going frantic over Tennyson and Browning." It would be easy to dismiss this enthusiasm as a schoolgirl phase, for young nineteenth-century readers were avidly interested in poetry and had their poet-heroes, much as later generations of youth would become infatuated with popular music and film personalities. But Hosmer's interest was genuine and lasting, and it was a strong link with her art.

Tennyson's *In Memoriam,* a grand elegy about the longing for the transcendency of the soul over separation and death, was published in 1850, so it was a recent work when Hatty turned to it. She had learned much of the poem by heart, she said, and had "lost my wits over it," calling the sad Hesper "one of the most beautiful ideas in the English language."[23] Even more than the poem's moving theme, it was probably the romantic imagery of the Evening Star Hesper, falling asleep to awaken as Phosphor, the Morning Star, that inspired her. The first stanza reads:

> Sad Hesper o'er the buried sun
> And ready, thou, to die with him,
> Thou watchest all things ever dim
> And dimmer, and a glory done.

The finished *Hesper* was the object of local acclaim and admiration. Especially interesting and quite astonishing was the fact that the sculptor, a small woman with delicate hands, had executed *Hesper* from clay model to marble entirely alone, a feat of physical strength and endurance. Carefully but surely directing the chisel with the ponderous mallet, she had worked eight to ten hours a day in her frenzied effort to finish the work. A workman was hired to chop off only the largest chunks of marble on the corners of the precious block, but he was tolerated for only a day and a half, so cautious was the artist about the working surface of the material.

By this time, Lydia Maria Child was firmly convinced that "if she [Hatty] keeps on as she has begun, she will do much for the cause of womanhood." Writing to her friend Francis George Shaw, Mrs. Child underlined the fact that Hatty intended to become "a *sculptor by profession.*" The girl would be going to Rome in the coming October, she told Shaw, "accompanied by her father, a plain, sensible man of competent property." If Shaw should happen to meet Hatty, Maria Child urged, "pray speak encouraging words."[24]

Seeing the ideal bust of *Hesper,* Maria Child called it "a remarkably good piece of statuary," an opinion echoed by all who saw it exhibited in a well-known bookstore. Enthusiastically, Mrs. Child sent an unsigned

Hesper, by Harriet Hosmer, 1852, marble, height 24″. Watertown Free Public Library.

letter to the *New York Tribune* so that New Yorkers might know what Parnassian achievement was going on in the Boston area:

> This beautiful production has the face of a lovely maiden gently falling asleep to the sound of distant music. Her hair is gracefully entertwined with capsules of the poppy. A polished star gleams on her forehead and under her breast lies the crescent moon. The hush of evening breathes from the serene countenance and the heavily-drooping eyelids.

Praising the artist's technical skill, she continued:

> The mechanical execution of the bust is worthy of its lovely and life-like expression. The swell of cheek and breast is like pure, young, healthy flesh, and the muscles of the beautiful mouth are so delicately cut that it seems like a thing that breathes.[25]

Visitors were invited to the Hosmer home and studio shortly before Hatty left for Italy in what appears to have been a guided tour given by a self-assured young woman who wore a brown and white figured dress of a fine lawn fabric, made with a yoke, belt, and plain skirt. She artfully carried a little gold watch and chain. After the callers had seen her museum room, she offered them palm leaf fans and suggested that they go to the studio, situated in a grove of trees, in order to cool off. There they could see evidence of the activity that had been going on so recently. Her tools—rasp, chisels of various kinds, mallet, punch, and auger—were objects of interest along with her working suit that hung nearby. Marble dust was everywhere, coating everything with a fine film. With a sense of the theatrical, Hatty whipped off the dark cloth covering the bust of *Hesper* and announced grandly, "Now, ladies, I will show you what I have been about these last few months."[26]

An *oeuvre* in marble was a wonder in itself. How did she do it? How could she wield such heavy tools? "Only a knack of the trade, that's all!" she is said to have answered, possibly intent on separating the manual task from the sculptural conception. In Italy she would have workmen to do this backbreaking labor, an alteration that would in no way detract from the creative process of the sculptor.

As the time approached for their departure, Hiram Hosmer revealed his deep love for his daughter in touching little ways. It was strange, she thought, that "Father went so long without visiting my shop and now comes first thing in the morning and the last thing at night." Already anticipating her return from Italy, he was planning to build her "a fine new studio."[27]

Dr. McDowell, having received the medallion, wrote an impassioned farewell, promising that he would see Hatty again. "Until then, believe

my feelings for you are, as ever, pure as Nature and as enduring. Hattie, I have covered the marble you sent me, in white crepe, not to mourn for the loss of a friend, but for the absence of the one who wrought it and to preserve it as pure as the one who gave it to me."[28]

Cornelia was by now traveling in Europe, her letters forwarded by the New York banking firm of J. J. Stuart, the address that Hatty would soon be using in writing to Wayman Crow. Admonishing Corny to answer as promptly as she did—"and I mean within three days"—she complained about her friend's constant change of address. By July the Cushman party had arrived in England after a record trip of ten and a half days on the *Asia*. The Hosmers would meet them about the twentieth of October in Paris to spend a few days before going on to Rome.[29]

Hatty was disappointed not to see Mrs. Crow and Cornelia's sisters, Emma and Mary. She had been "cheated out of a farewell" not only by them but by Jane Peck, her former classmate, who had also failed to fulfill her promise to go East. As the late September sailing date approached—"four weeks from Wednesday" on the *Niagara* from Boston—Hatty was more than ready to go. Reading to prepare herself for contemporary Rome, she told Cornelia that she was trying to acquaint herself with the "churches, temples, ruins, streets, and everything therein." Noting that she was writing her last letter from that side of the Atlantic for some time to come, she looked forward to "the eve of a new life" in Italy, confessing herself to be most dissatisfied with her American way of life. "I ought to be accomplishing thrice as much as now, and feel that I am soul-bound and thought-bound in this land of dollars and cents."[30]

The state of affairs in Rome was still disquieting. Matilda Hayes had written that some "hubbub" was anticipated "in less than a month." By this time, Hatty had adopted a conservative political point of view regarding Rome. Calling Mazzini "blind with enthusiasm," she was surprised that he had not fixed an even earlier date for his next effort to unseat the pope from his secular throne. Counting heavily on the French forces of Louis-Napoleon, who were protecting the pope's position, Hatty said that Mazzini had failed to notice that, should the French withdraw, thirty thousand Austrians were "ready to take their place."[31]

Good-byes were said to many friends, including Lydia Maria Child, who recalled that Hatty said she would be happy, even so far from home, if her health continued to be good and if she could have "a bit of marble" at her disposal. Looking at the girl who appeared so much younger and thinner than any picture of her disclosed, Maria Child sensed her friend Hatty's vulnerability. Nonetheless, Mrs. Child recognized that she was the same confident, direct, vivacious young person as before. Even as she

prepared to go to Italy, there were no added airs or pretense.[32] There was no way of knowing when they would see each other again.

At last the great moment arrived. Trunks, valises, and portmanteaus were packed for a long stay. Letters for Fanny Kemble, waiting eagerly in London for word of her daughters, were carefully stowed away. And there was another packet that would prove to be an important entrée into her artistic life—two daguerreotypes of *Hesper,* front and profile, and the diploma in anatomy from the Missouri Medical College. The Roman adventure was about to begin.

5
The Gates of Rome

An enormous stagecoach drawn by six horses clattered over the cobblestones of the ancient Flaminian Way bound for Rome. Three postilions did their best to steady the course of the heavy, clumsy diligence while the trunks, portmanteaus, and valises piled precariously on top rattled and swayed on this last leg of the passengers' long journey.

The road to Rome from the seaport town of Civitavecchia (then written as two words) was desolate and dusty once the coast was left behind. It stretched out forlornly for thirty miles, an eight-hour trip by stage or *vettura,* a carriage for hire. Stories of brigands ready to pounce on wayfarers, frequently holding errant strangers for ransom, were all too well documented. Even Harriet Hosmer, one of the passengers, might have wished for a strong character out of the American West to ride shotgun.

The exhausted travelers had been bounced, jostled, and rocked in every conveyance that the era offered. Sara Jane Clarke reported that after Charlotte Cushman's party, of which she was a part, had joined with Hatty and Dr. Hosmer, they had all taken a train, which was the last word in speed if not in comfort or cleanliness. Arriving in the port of Marseilles, they had embarked on a filthy, crowded English steamer for Genoa to alight for the first time on Italian soil. Next, putting their lives in the hands of a *vetturino,* the driver of his own carriage, the party continued to Pisa on the tortuous, narrow, bumpy road before mounting the train once more for the short hop to Livorno, known to the English-speaking world as Leghorn. Still another sea voyage followed, this time on an insubstantial French mail steamer bound for Civitavecchia. Mattresses flung on the floor of the main cabin were the only beds, making a seat on the upper deck the best of a lot of poor choices.[1]

The "many miles of salt water" were particularly unsettling to Hatty, making a lasting impression that was hard to erase. She freely confessed that she despised ocean voyages, feeling herself to be neither on earth nor in the sky but suspended in space "like Mahomet's coffin." She

thought of the Atlantic as an "impassable barrier" to be avoided at all costs "until I am put in a black box and hermetically sealed."[2] In later years, a successful trip was one on which she did not lose too much of her "inside furniture."

Arriving by sea for Rome, travelers had to tackle the hubbub of Civitavecchia, a seedy town where passport inspectors, customs officials, soldiers, and *vetturini* looking for passengers all vied for the attention of tired tourists. "Vetchy-Vatch," as one Yankee ship captain called the noisy town, had only one hostelry, Orlandi's Hotel Sovero, "where the fleas perform on their own hook," as Hatty later put it.[3]

In spite of the fatigue, frustration, and discomfort, when the dome of St. Peter's loomed up on the landscape some ten miles in the distance, "every heart stood still at the sight"—surely none more than the heart of the student-sculptor who had come so far and who hoped for so much as she and the others approached the gates of Rome. It was November 12, 1852.

Travelers usually came into the city through the Porta del Popolo; just adjacent was the Church of Santa Maria del Popolo. While the great gate was a reminder of ancient triumphs, it was also the first sign of baroque Rome. On the piazza side was a relief sculpture commemorating Queen Christina's entry into Rome, carved by Gianlorenzo Bernini in 1655. There was also the Flaminian obelisk, crowned with the bronze symbols of Catholic Christianity, to announce the church's supremacy over paganism. The sightseer, then as now, could expect to see many repetitions of the needlelike forms, brought to Rome by the Caesars.

In 1814, during the Napoleonic occupation of Rome, the architect Giuseppe Valadier had renovated the Piazza del Popolo, creating a cascade of arches in the neoclassic style that carried the eye upward to the Pincian Hill. But the scene within the great square was still surprisingly bucolic. Farm animals lunched lazily on the fragments of vegetables sold from carts, and at certain seasons of the year, sheep were herded through the square, urged along by shepherds in shaggy garments.

Women with baskets of bread on their heads paused to chat at the fountains while black-frocked priests with broad-brimmed hats strolled two-by-two in the open piazza. It was, as Harriet Hosmer later put it, the closing of a door on the hurly-burly of the nineteenth century. Rome was, in fact, remarkably pastoral, in striking contrast to Paris or London. The population at mid-century had not reached two hundred thousand, and there was little commerce beyond the vast business created by the presence of the pope. Tourism, the principal industry of the Eternal City, was sustained by those who could afford it or who were subsidized for study. More and more Americans were making the journey to Rome

to wonder at the artifacts of antiquity and the treasures of the Renaissance. The tourist trade generated a variety of by-products. Cameo cutting, mosaic making, the reproduction of masterpieces of painting and sculpture by copy artists—all added up to what an unidentified female sculptor called "sculpture by the pound and paintings by the yard."[4] Nonetheless, the economy outside the walls was agricultural. In Rome itself, Prince Doria-Pamphili was known to make and sell the best butter available.

From their vantage point in the stagecoach, the American passengers could make out the three avenues of the Trident with the two churches, seemingly identical, marking the site. Up and down the three streets, the Corso, Babuino, and the Ripetta, that ran along the Tiber lived the *anglosassoni,* the Italian name for northern Europeans, English, and Americans. The artists were, for the most part, a good-humored lot, living closer to the native population than did their visiting countrymen, who were isolated by their wealth from the Roman inhabitants. But all travelers, whatever their purpose, gravitated to the city as though some invisible magnet concealed in the tip of an obelisk was pulling them there.

The Tiber, or Tevere, was a living force in Rome and its environs, flowing freely then without man-made embankments, an avenue of commerce into the very heart of the city. Wharfs at various points along the river were convenient places to unload special cargoes. Timber was taken off at the Porta di Ripetta, or marble from Carrara and Serravezza at Marmorata. Untamed, the Tiber often overflowed its banks, leaving an ugly blanket of yellow mud clear up into the Via Margutta, where many sculptors had their studios. Then the progress of their work became agonizingly slow, they complained, as Italian workers prayed for deliverance but did little to assist in the divine process.

The Hosmer party surely headed directly for their lodgings at 28 Via del Corso, past the house where Goethe had lived while he relished Rome. Sara Jane Clarke, dutifully keeping her journal, reported that the house was "hemmed in and towered over by other houses," a disappointment to these New Englanders who were accustomed to pleasant lawns and open spaces.[5]

At carnival time, wild horses would plummet down the Corso, reenacting an ancient contest. But the street was scarcely wide enough for two carriages, let alone a barrage of wild horses, and the house at number 28 was dark and damp in winter. However, Hatty was certain that inspiration would be absorbed from the very atmosphere. Her motto, she decided optimistically, would be "'Live well, do well, and all will *be* well.'"

An early caller was William Wetmore Story, offering his assistance and extending the courtesy of a proper Bostonian in Rome. He was the son of Supreme Court Justice Joseph Story and had taken up sculpture as a serious pursuit when he was asked to do a statue of his late father for the Bigelow Chapel at Mount Auburn Cemetery. Those who knew him were quite confident that Story, already a lawyer and a writer of note, could also successfully "do" sculpture, which was his avocation, if he put his mind to it.

Story, accompanied by his wife and children, had not yet committed himself to permanent residence in Rome but was again in the midst of one of his several study trips. He was by this time an old Roman hand. He had seen the brief Roman republic at close range in 1849 as one of the few Americans who had some sympathy for the views of Margaret Fuller and her Italian count. This curious couple, the emancipated New Englander and the Roman aristocrat, had fought valiantly for the republic, their world toppling around them when the pope's kingdom was restored.

The Storys had gone home but were now once again in Rome at 93 Piazza di Spagna, at the foot of the Spanish Steps, only steps from Hooker's Bank and Spillmann's ice cream parlor, indispensable institutions to serve the expatriates. He kept up a lively correspondence, relaying tidbits of Roman gossip to his friend James Russell Lowell.

> And apropos of your Poems, you are creating at this time a furore in 28 Corso, Wood's harem (scarem) as I call it—among the emancipated females who dwell there in heavenly unity—viz the Cushman, Grace Greenwood, Hosmer-Smith & Co—not forgetting the Bayne (who is here without his antidote)—and for fear I should forget them let me tell you of them. They live all together under the superintendence of Wood—who calls them Charlotte, Hatty &c, & who dances attendance upon them every where, even to the great subscription ball the other ev[enin]g—& I could not help thinking what a pity it was that he could not dance polkas & waltzes as well as attendance, when he went stumbling round the room with his partner just as he stumbles through his speech.[6]

Shakspere Wood, the target of Story's remarks, was a young English sculptor, just three years older than Hatty Hosmer. He had come to Rome the previous year after studying at the Royal Academy in London. However awkward his demeanor, he apparently ingratiated himself. Hatty, writing to Cornelia Crow two weeks after her arrival, indicated that she had found a friend, or at least someone who wished to be of service. "Now darling write me soon—address to 'Shakespere [*sic*] Wood Esq.—Cafe Greco, Via Condotti, Rome, Italy—for Miss Hos-

mer.'"[7] The famous Caffè Greco was a *poste restante* where mail, domestic and foreign, was left. Although Wayman Crow was directing mail to Hatty through the American artist Luther Terry, known to be reliable, Hatty had taken matters into her own hands. It would not be the last time.

The Hosmers' most urgent task, not to be postponed for scarcely a day, was to secure a teacher for Hatty, one of genuine distinction. "While I am about it, I want the best," she had written confidently to Cornelia.[8] Earlier, they had seriously considered Thomas Crawford, who had come to Rome in 1835. Highly respected, he would earn an international reputation as the artist designated to do the pediment sculpture on the Senate wing of the Capitol as well as the figure atop the dome. But according to Hatty's best inside information, Crawford might not give full attention to a pupil. Rather, she would prefer to work under the tutelage of John Gibson, the English neoclassicist, should she be lucky enough.

John Gibson, who had lived in Rome since 1817, had studied with the Danish sculptor Bertel Thorwaldsen and with Antonio Canova, who was without peer in American eyes. "Old Canove," Thomas Jefferson had called him, when the young republic had first begun to memorialize its heroes. Wearing the mantle passed on to him by these distinguished neoclassicists, Gibson was at the zenith of his illustrious career, enjoying his success with modest equanimity. He had only recently done a full-length statue of Queen Victoria, the highest accolade imaginable for a British sculptor.

Persuading Gibson to take the young American girl as a pupil was a prospect formidable enough to quell even these redoubtable Yankees. He generally did not take pupils at all, much less a young woman. Females, it was thought, were not suited to the rigors of such a demanding discipline as sculpture, nor were they inclined to persevere in the pursuit of the plastic art. Everyone claimed a part in what turned out to be a successful maneuver. Story, who had had a role in laying the groundwork, wrote petulantly to Lowell that he had "got Miss H[osmer] a place in Gibson's studio, but Wood took the credit of it."[9]

Wood, eager to help, approached John Gibson in the Caffè Greco, so the story goes, probably at the very early hour when the celebrated sculptor breakfasted. Gibson, after eating his customary light meal of a little roll—a *panino*—dunked in his coffee, would then read his particular newspaper, *Diario di Roma*. That newspaper, James E. Freeman had observed earlier, was "a miserable little sheet about the size of *The New York Herald* in its extreme infancy," but hardly comparable in any other respect.[10] Gibson's choice of a journal is one detail that makes him

singular, for most English-speaking people read the *Galignani's Messenger,* founded in 1814 to bring them the news.

Wood carefully put before Gibson two daguerreotypes of Harriet Hosmer's original work *Hesper,* front and profile, along with the prized certificate of proficiency in anatomy earned at the Missouri Medical College, precious items that had come all the way from home with the Hosmers. Gibson, always deliberate in his movements, looked at the pictures and the diploma very intently, studying them without a word. He was perhaps surprised to see the quality of Hatty's work, although Story had already made overtures. Gibson announced crisply that the Hosmers were to come at once to his studio, not a minute to be wasted. The message was quickly relayed to the aspiring sculptor and her father, no doubt waiting expectantly somewhere in the wings.

The Hosmers lost no time getting to Gibson's studio at number 4 in the Via Fontanella, just around the corner from their lodgings on the Corso. The entrance to Gibson's studio was shabby with what appeared to be the rubble of centuries, surely giving no clue to what lay inside. Once the rough-hewn door was opened, in response to a bell rung by pulling a knotted cord extending from a hole in the door, the caller entered a courtyard, fragrant with orange and lemon trees. A fountain played, and the sun trickled through trellises, dappling the walks with shifting designs of light and shadow. A shed with an earthen floor housed pedestals, materials, bits and pieces of marble, perhaps even a fragment of an old sarcophagus of the kind that Hawthorne saw in such profusion. Models of Gibson's ideal works, *Narcissus, Cupid and Butterfly, Psyche Borne by Zephyrs,* as well as a *basso relievo* of *Phaeton and the Hours,* were there to be seen and admired.[11]

When Harriet Hosmer arrived, John Gibson was at work on the knee of the *Wounded Amazon.* Jokingly recalling the moment, she professed a special affection for that particular joint of the female figure's anatomy. At the time, the two exchanged only the sparsest of comments. "I wish to become your pupil," said Hatty forthrightly. "I will teach you all I know myself," Gibson replied. It was enough to seal the pact.

The relationship between master and student began tentatively. Gibson, vague in the outside world but serene and confident within the walls of his own studio, suggested thoughtfully that Hatty take a few days to see the sights of Rome. Seldom shy but awed this once in the presence of Rome's foremost sculptor, she answered, "I shall come tomorrow." She began her apprenticeship the next day, making her way past the cavalcade of marble figures. Gibson showed her to a little workroom at the top of the garden stairway where Canova had once worked. She hoped to draw inspiration from its walls.

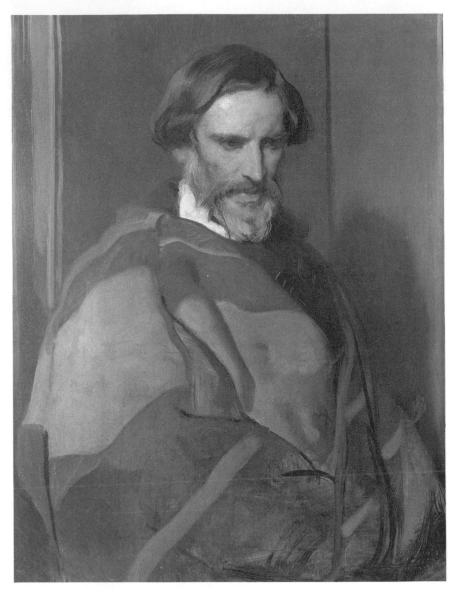

John Gibson, by Sir Edwin Landseer, ca. 1850, oil on canvas, 35″ × 27″. Royal Academy of Arts, Piccadilly, London.

Harriet Hosmer, artist unknown, ca. 1850, charcoal or pencil, oval, 22″ × 17″. Although this portrait is believed to have been executed about 1850, the costume suggests that the portrait might have been done after Hosmer went to Rome. It is not unlike sketches done of Elizabeth Barrett Browning and John Gibson by Field Talfourd in 1859. Watertown Free Public Library.

Gibson's recent loss of the companionship of his younger brother may have made him more inclined to accept Hatty into his studio. Benjamin, a sculptor of lesser gifts, had joined his older brother in the Roman studio in 1837. Always walking a reverential step or two behind the older sibling whom he worshiped, Benjamin, a scrawny little fellow in ill-fitting clothes, carried a well-worn copy of Horace in his right-hand pocket. Even so light a volume upset his delicate balance, giving a curious lopsided aspect to his stance and gait.[12]

He was a true carbon copy of his older brother, only reduced to a miniature size. His works were often reiterations of John Gibson's statues in the round, but they were faint echoes in low relief, symbolic of his own condition. He was infinitely content to live in his brother's tall shadow, making his modest contribution principally as a classical scholar.

Benjamin Gibson's death the previous year at Bagni di Lucca, of unknown causes at age forty, was a loss to his older brother that Hatty would help to fill. For all the dignity of his bearing and the nobility of his patrician profile, John Gibson was a simple man, "an old Greek soul, born by haphazard in a Welsh village," as the Irish feminist Frances Power Cobbe had affectionately described him. Gibson once confided to James E. Freeman during a stroll on the Pincian Hill that an American visitor to his studio had mistaken him for one of his Italian workmen. Fearful that he might embarrass the guest, Gibson accepted the two *pauls* offered him, a gratuity of about twenty cents for the master sculptor.

Gibson had an almost invariable routine during the Roman work year. After the early breakfast at the Caffè Greco, he worked in his studio until it was time to go to Lepre's for his midday meal. He had eaten there for years, becoming so accustomed to the plain, unpretentious place that he absentmindedly wiped tumbler, knives, and forks with his napkin while dining at the home of a titled Englishwoman. Rather than taking offense, she was pleased that he felt at home.

His luxuriant black hair and beard, grizzled by the time that Hatty went to him, and his fine classical features made him a figure to be admired in spite of his disregard for his costume. Even the look of careless bohemian elegance that artists affected, studiously casual in their shabby frogged velvet jackets, was lost on him. He had a host of devoted women friends who liked to care for him in motherly fashion as well as several male cronies, among them Benjamin Spence and Penry Williams. He never seems to have had a love affair, although there was rumor of some temptation that brushed up against him in his early days in Liverpool—one that was successfully circumvented, however. The possibility of marriage with Gibson was likened to matrimony with a

merman. One observer put it this way, with the delicacy of a true Victorian: "'The mightiest of all instincts,' as Macauley calls it, seems barely to have awakened from its repose in the sculptor's heart."[13]

This asexuality, if indeed that was his condition, may have been the very attribute that allowed him to relate so ideally and unselfishly to his attractive young female pupil. Their association seems to have been one of harmonious communion despite vast differences in temperament. That they were male and female does not seem to have affected their working relationship. Gibson did not condescend to Hatty, and he put her through the most exacting exercises to determine her capabilities; but when his word was needed to substantiate her credentials, he was ready to affirm them.

Gibson was the subject of a thousand anecdotes, some of which were passed down by his young female pupil. Hatty recalled coming into the studio to find her "Maestro" writing down tiny marks on a large sheet of paper. "There were seven rows and seven in each row," she said.

"Signor Giovanni, what are you doing?"

"Trying to find out how much is seven times seven."

When she gave him the answer, "Why, forty-nine," he looked at her in astonishment, remarking that she must know the multiplication table. "I replied that I did, and he frankly confessed that he 'never could learn the thing.'"[14]

Gibson's ignorance of simple Christianity was the subject of frequent anecdote. Browning was fond of one story that involved Gibson's friend Penry Williams and another artist. The artist said to Williams, "I'll bet you a dollar you can't repeat the Lord's Prayer!" Williams accepted the challenge and obliged by reciting "How doth the little busy Bee, Improve each shining hour," a simple, moral ditty from *Divine Songs for Children* by Isaac Watts. But the challenger handed over the money, saying, "I didn't expect you could say it!" When someone told the joke to Gibson, his response was, "Yes—you see, he believed Williams could not say it—Yes!"[15]

There were variations of this story. Sometimes it was a fellow who satisfied the wager with "Now I Lay Me Down to Sleep." It was all one to Gibson. It was said that the element of Hebraism that had influenced Western heritage so strongly, with its burden of sin and guilt, was largely omitted from Gibson's makeup.

Hatty often called Gibson "a god in his own studio," adding, "But God help him—out of it," for he was an innocent anachronism in the age of steam, prone to wander about vaguely when he traveled alone. He couldn't understand why trains did not stop wherever he had a mind to get off. Traveling in England, he was so oblivious to what was going

on, that a conductor, frustrated in his attempts to communicate, asked Gibson if he were a foreigner. "No, I am a sculptor," he answered simply.

Starting on a jaunt to Switzerland with Hatty, he once carried a hatbox that seemed to be completely empty. Had he forgotten to put in his hat? No. Did he intend to buy a new one on the trip? Again, no. The container's only function was to round out the pieces of luggage that he carried to the magic number three, an integer especially favored by his models the Greeks. Gibson worshiped his Greek icons with fanatical loyalty; nonetheless, he was a true original for whom there was no mold.

Exhausted when she left Watertown after the backbreaking work on the marble *Hesper,* Hatty was prepared to appreciate the process of sculpture as it was practiced in the Italian studios of the leading neo-classicists. A well-staffed studio like Gibson's had a sizable complement of skilled artisans to implement the sculptor's creation. Widely accepted and practiced, this method had been used earlier in the nineteenth century by Antonio Canova when the number of his commissions made it impossible for him to carve each of his works. Having conceived of the work, the sculptor worked on a succession of clay models until he was satisfied; then apprentices and marble workers took over. This was not the end of it, however, for in Canova's studio, works were known to backlog for many months, waiting for the final, animating touches to be added by the master sculptor.[16]

The first step in the whole process of sculpture was the idea, or *concetto.* It was an exercise of the brain, inspired by the imagination and tempered by taste and a thorough knowledge of the plastic art. The notion of an original concept had its roots in classical aesthetics; that the artist must have the idea fully envisioned in his mind was a given among those who understood sculpture. So it was ridiculous and disconcerting when studio visitors, ignorant of the process, assumed that the artist might be surprised with what emerged from the marble. "What are you going to call it?" was a question that invited indignation.

The artist translated the *concetto* into a rough model, the *bozzetto,* usually smaller than the finished product would be. Harriet Hosmer herself described the making of the small clay model, a careful exercise that might have to be repeated again and again. Gianlorenzo Bernini frequently fired some of these *bozzetti,* and such terracotta pieces survive to illustrate the steps that the great baroque master took. Some sculptors routinely did another model, the *due palmi,* a figure about two palms or eighteen inches high.[17]

When the sculptor was satisfied with the model, the studio workers whose specialty it was, built a skeleton to support a full-size clay model,

the *modello grande*. John Gibson, arriving in Rome in 1817, was allowed to work in Canova's studio, where he learned the principles of armature through trial and error. He began to model a large statue without the proper support system to undergird it. In a few days, the whole thing collapsed, which came as no surprise to Canova, who had told his foreman that the work would fall. "For you see," said Canova, "that he knows nothing of the skeleton work—but let him proceed, and when his figure comes down, show him how the mechanical part is done."[18] It was a lesson that Gibson passed on to his pupil Hosmer, who described the making of the armature. It took a blacksmith, she said, heating irons and bending them to the angles needed for the structure. Wood and wire were added, their shape and size corresponding to the size and shape of the projected figure. They had to be crisscrossed, laced, and intertwined. Some called the pieces of wood fixed with wire "butterflies."[19]

The function of all of these contrivances was the support of the heavy mass of clay. Roman clay was even less tenacious, it was said, than the potter's clay in England and America, and it was far weightier and less wieldy. The workmen pressed great blobs of it upon the skeleton, which resembled the remains of a prehistoric monster. Done "with strong hands and a wooden mallet," as Harriet Hosmer described it, the thing at last changed "from a clumsy and shapeless mass," to something having "some resemblance to human form." Once finished, it called the sculptor back to work for the greater part of the task. Every aspect of the work was studied and corrected. The sculptor's idea had to be compared with a living, breathing model, and the important element of classical drapery had to be arranged on the *lay figure,* a wooden mannequin whose limbs could be twisted and turned. This refinement and finishing could involve the sculptor for many weeks or months. Besides the creative energy involved in animating the work, the task was intensely physical and demanding, the artist often working from a high platform in an atmosphere clammy with the moisture needed for the clay.

Once again, the work passed from the sculptor's hands as it was enveloped in plaster to create a full-size pattern for the marble workers. These highly skilled artisans knew how to transfer the pattern mechanically, duplicating the sculptor's dimensions or making them greater or smaller as needed. A system of rectangular frames and plumb lines dropped vertically was the method used for "pointing," the process used to measure every possible angle of the model for its reproduction to greater or lesser size. Calipers of various sizes, some like giant ice tongs, measured the distance between the points. The stigmata of the pointing method can often be detected on models seen in old studio photographs. The gesso original for Canova's *Terpsicore* in the Villa Carlotta looks as

pockmarked on head and shoulders as though she had suffered from some hideous eruptive ailment.[20]

After the first heavy blocking out of the marble, the work became increasingly detailed and tedious as the chisel gave way to the tools of fine finishing. The last step was the polishing of the marble to give it a smooth, silky surface, fabric often contrasting with flesh in the difference of the finish. Figures made from marble, the material associated so strongly with all that was rich and fabled, especially impressed the Americans and provided a cultural conduit from Italy for many years.

Some sculptors, notably Hiram Powers, chose to put the finishing touches on the marble themselves, even as Michelangelo had done. But Harriet Hosmer later declared that most sculptors, herself included, satisfied that the creative process of the artist had been set in motion and was being carried out by the artisans, were eager to get on to other projects. A metaphor attributed to Thorwaldsen was highly appealing to the Victorians. The artist symbolized a godlike creator; the modeling of the clay was likened to birth; the casting into plaster, death, as the chilling white substance shrouded the warm clay; and the freeing of the form from the marble, resurrection. That this miracle was not accomplished by the strokes of a single hand did not detract from the artist's accomplishment. The mechanics were not to be confused with the conception.

In Gibson's studio, as in those of other successful sculptors, workers specialized in certain particulars of marble carving. Drapery, more than any other element except the figure itself, was delegated to the most skillful. Seeing the diaphanous fabric, with the illusion of semitransparency to clearly reveal the forms of the body beneath, one is convinced of the consummate skill of the carver in carrying out the design of the sculptor. Besides the drapery, other descriptive paraphernalia such as jewelry, coiffures, and chains had to be dealt with, even on *nudos*. Camillo, one of the most valuable and trusted of Gibson's men, described as "slight, effeminate, with artistic power and feeling," could do it all.

Gibson put Hatty Hosmer to work copying classical statues, rendering them in sizes at some variance with the originals, an academic exercise to test her skill. A replica of a torso in the British Museum she made larger than the model before her; the Praxiteles *Cupid* became smaller, a more difficult task for the artist, Hosmer later said. A copy of the bust of *Venus de Milo* occupied her for several months until Gibson was satisfied with "the correctness of her eye" and she was ready to begin original creations.[21] None of this sequence was lost on her fellow artists, particularly William Story, who gives a better account of Hatty than she

does of herself during the first busy month. He summarized her progress with the superiority of a male artist who had already established himself in Rome:

> Miss H[osmer] is also, to say the word, very wilful & too independent by half—& is mixed up with a set whom I do not like & I can therefore do little for her. . . . She is doing very well & shows a capital spirit—& I have no doubt will succeed. But it is one thing to copy & another to create. She may or may not have inventive powers as an artist. If she have, will she not be the first woman who ever had?[22]

Story's notion that women were not inherently original or creative in the arts was a prevalent one. They were able only to imitate their male counterparts, it was widely believed, an idea so universally accepted by both men and women that few recognized it as repressive, discriminatory, or spurious.

Meanwhile, Hatty was drinking in all that Gibson had to teach her. He passed on to her the canons of their profession articulated by Johann Winckelmann in the previous century—that "ideal beauty," as exemplified by the Greeks, existed solely in the intellect, a premise that harmonized completely with the principles of the Enlightenment. The discipline of the classical approach to art would enable the artist to discover his own creativity far more readily than simple observation of the natural world. Hatty would soon begin the quest for her own creative impulses, infusing her statues with something of her own individuality.

When certain aspects of Harriet Hosmer's personality are considered, the neoclassic idiom seems oddly alien to her nature. How could a woman who cared so little for rules and regulations immerse herself in so academic an interpretation of art? Why would one so vivacious and animated wish to represent in her works the Greek ideals of repose and serenity, characteristics often lacking in her own demeanor? How could she embrace the Greek ideals of restraint and forbearance when she herself was so outspoken, forthright, and combative, sometimes spoiling for a fight?

Her fidelity to the Greek ideal was one of the love affairs of her life. Her apprenticeship with Gibson undoubtedly sealed the bond forever. The Greek eye, she said, "could rarely rest on an unlovely object. Their attire was grace itself." In a conversation with Thomas Carlyle, Hatty heard the sage of Cheyne Row boast of seeing an exhibition of Japanese art that pleased him because the figures were "thoroughly bestial in form." "Art is not dead yet," he added, because the figures looked "natural." Was this his idea of art, she asked, for she devoutly believed art to be the study of beauty.[23] That this could best be accomplished by

a loyalty to the Greek ideals was a belief that she never recanted. Only one critic later speculated about "what might have been" had Harriet Hosmer gone to Paris to study with the great *animalier* Antoine-Louis Barye. Her vigor and spirit might have matched his, it was thought.[24]

Almost from the first, her presence added brightness and laughter to Gibson's life. No day ever passed without some exchange of banter between master and pupil. The bond between them was built on the relation of teacher to disciple, but it was decorated with playfulness and a kind of coquetry after studio hours. He teased her about her diminutive size, and in little personal notes, he reversed the relationship, signing himself "Your slave." Gibson guided her to a strong place in her profession, satisfying her need to excel, the drive that is authentic in the sexuality of both women and men. In their personal relationship, her confidence in herself as a woman flourished. The rough edges of her personality, seen by some as abrasive, were smoothed and polished, even as a piece of marble was refined in the studio.

Ecstatically, she recognized that "fortune had smiled most benignantly" upon her. "The dearest wish of my heart is gratified, in that I am acknowledged by Gibson as a pupil. He has been resident in Rome for thirty-four years and leads the van. I am greatly in luck."[25]

6
A High-handed Yankee Girl

"I never loved you more than at the present time when I am so far distant from you," Hatty wrote to Cornelia Crow less than a month after arriving in Rome. But there was no suggestion of homesickness in the message. Quite the contrary, for she was happy in her work, and she had quickly been taken into the expatriate social circle in a manner quite heartwarming to one so far from home.

The artists' colony had welcomed her. C. G. Thompson, the genial painter who was to add greatly to Hawthorne's enjoyment of Rome, had already called more than once. She had seen Luther Terry, known to the Crow family, in a company that included sculptors John Gibson, Thomas Crawford, Joseph Mozier, and Gibson's friend Spence. Hatty may have attended the memorial service that his fellow artists held for Horatio Greenough, but it is also probable that she had found her way to the Caffè Greco, the social headquarters for artists and writers of every nation.

"Tell Mr. Heade," she directed Cornelia, "that I've talked him all to pieces with Mr. Terry." (Martin Johnson Heade was spending a year in St. Louis.) Of Luther Terry she said that he was not "the ugliest man I ever saw," responding perhaps to a previous discussion of Terry's appearance, but had rather "a nice good face."[1] Hiram Hosmer did his best to fit in with the women at 28 Via del Corso, even answering quite seriously to the soubriquet "Elizabeth," so William Story reported to his friend James Russell Lowell, who knew the Watertown doctor as the physician who had delivered his first child. Story, trying his best to extend every courtesy, had done what he could for Dr. Hosmer, "but he did not like to be done for."[2] Although Story reported him "almost *fou*" in his obsessive concern for his daughter Hatty, Dr. Hosmer apparently took off for home as quickly as he could, presumably satisfied that he was leaving her in good hands. He was already planning her return, when he would build her a new, larger studio right in his own backyard. With his departure, he was summarily dismissed by all observers, in-

cluding his daughter, quite as though he had evaporated, not the first parent to be given such short shrift after his usefulness had been dispatched.

Along with his farewells, Dr. Hosmer admonished Hatty not to neglect her program of outdoor exercise, an antidote to the rigors of her work in the clammy atmosphere of the studio with marble dust everywhere. Following her father's instructions and suiting herself at the same time, Hatty went about town on her horse, riding *en cavalier*. Riding—or even walking—alone in Rome was an uncommon thing for a woman to do. A woman on horseback, perhaps reining in her horse at one of the neighborhood's fountains as she might have done at a trough in Watertown, did not escape attention. Her deportment wasn't lost on William Story as he reported to Lowell: "The Hosmer takes a high hand here with Rome—& would have the Romans know that a Yankee girl can do anything she pleases, walk alone, ride on horseback alone & laugh at their rules." Presently, in response to the complaints of the natives, who were highly upset by the commotion she caused, the authorities gave her her comeuppance: "The Police interfered and countermanded the riding alone on acc[oun]t of the row it made in the streets—& I believe *that* is over—but I cannot affirm."3

The American chargé d'affaires is said to have offered Hosmer his protection, and she jokingly offered him hers. Soon she was riding in the Roman Campagna, a succession of travertine hills and valleys that stretched around the city for miles. The open areas, dotted with the fragments of antiquity, could be reached from Rome itself through one of several ancient gates, built when little villages nestled around them at the city's limits.

The "shaggy Campagna," as Hawthorne called it, with all of its ancient, mythic associations, became a retreat for Hosmer. There, after confining days in the studio, she could regenerate her energies by riding her horse across the open areas or near the extant towns. The country folk, who wore colorful red and blue dress, were looked upon as "picturesque" by the tourists. The foreigners, *stranieri*, loved to attend the festivals in the Campagna, frequent celebrations that mitigated daily hardships with music, dancing, and singing. As the seasons changed, one *festa* succeeded another in the church calendar, each linked to a saint or sacred event.

Hatty came to love the Roman Campagna almost as much as she cared for Rome itself. Soon, she began to take pride in guiding favored visitors there in her capacity as expert escort. Not that every sightseer appreciated the history that lay hidden in the stones. Hatty liked to tell of a stout American lady, puffing up behind her on the Appian Way. The

visitor looked with awe on the vista before them, one of desolation scattered with the artifacts of an ancient civilization. Sighing, she said, "Oh, what a vast country there is yet *unbuilt*."

Fortunately, Hatty readily adapted to the customs of papal Rome. She and Charlotte Cushman occasionally rode together, one time returning from a gallop on the Porta Angelica Road. Catching sight of the advance guard of the pope, they quickly dismounted before he passed. When Sara Jane Clarke, staunchly Protestant (she was a descendent of Jonathan Edwards), asked why they felt it necessary to pay such homage, Hatty answered logically: "Why not? The worthy old gentleman was on foot, and all the Catholics in his way were on their knees." Acknowledging the authority that she had previously provoked, she added, "The guard would have commanded us to dismount if we had not done so of our own accord."[4]

Unlike Hatty, with her horse to ride and a stipend that was adequate if not extravagant, other artists had saved for years to be able to study in Italy. Margaret Fuller had reported that a thousand dollars was the very least that would take and tide over those who wanted to come for a year's time. A few had the support of munificent visionaries like Nicholas Longworth of Cincinnati, who had helped Hiram Powers and Shobal Clevenger to get their starts in Florence. Whatever their respective situations, however, the artists huddled together for warmth, as Hawthorne expressed it, not really caring a whit about one another's work but providing help and comfort when adversity or illness touched one of their number.

Their living conditions ranged from palatial to modest, even squalid— whatever the purse would permit. While some ended up living, like Story, in palaces or, like Crawford, in lovely villas, others like Edward Bartholomew lived in tenements. Bartholomew's water and materials for modeling had to be hoisted up or let down several stories by means of pulleys, the clay models teetering tentatively in their descent. But whether solvent or wanting, the Americans were a hardworking lot whose very mistakes, wrote Henry James, took on a certain charm, colored as they were by pleasant manners, warm friendships, and the intensity and exuberance of the period played out against the lush Italian background.[5]

Complementing the artists' colony was the group of expatriates who took up residence in Rome for weeks, months, or years. Many of these were English, drawn to Italy for the same reasons that had brought Byron, Keats, and Shelley as well as a cavalcade of lesser known pilgrims. In the winter of 1852–1853, the most glittering musical circle was presided over by Adelaide Sartoris, the younger sister of Frances Anne

Kemble. Every Wednesday and Sunday, Hatty Hosmer joined a group at the Sartoris apartment near the top of the Spanish Steps for an evening of sociability. In this superb location, the great windows were thrown open to a magnificent view across the Tiber. In the grand *salone,* there was the seductive sway of lighted lamps, the mingled colors of paintings and fragrant flowers, and tables piled high with books for friends to peruse at leisure.[6]

For these musical evenings, a large piano was drawn out and opened, a reminder to the privileged company that their hostess had relinquished an opera career at its height to marry Edward Sartoris, a man of means. She had triumphed in *Norma* at Covent Garden, but in these days and beyond, she epitomized the role of the beautiful older woman, attracting, as she did, the attentions of devoted younger men. Sara Jane Clarke noted that it was recognized "at a glance" that she was one "of that royal family of Kemble," a woman of "strong, impassioned nature" and warm, luminous presence.

Adelaide Sartoris, "Aunt Tottie" as she was known to the Lenox girls, was a devastating mimic as well as a singer of great distinction. Poking fun at the foibles seen in society, often with clever double entendre, she entertained her guests with amusing monologues. Then, in her magnificent voice, without histrionics or artifice, she would deliver Shelley's poem *Good Night,* accompanied by the ripple of an obbligato on the piano.

> Good-night? ah! no; the hour is ill
> Which severs those it should unite;
> Let us remain together still,
> Then it will be *good* night.

It was a rendering so achingly sweet that it might have stirred the shade of Shelley himself, wandering disembodied near his former abode nearby on the Via Sistina. Her performance could reduce or exalt her audience to tears. A large woman, who would become even more Junoesque, she is remembered receiving her guests in a lustrous, pearly satin tea gown, a Muse or Sibyl in eyeglasses of aquamarine.[7]

Her critics found her too imposing, but Hatty's admiration for Adelaide Sartoris was unbounded, a feeling entirely returned. The two Kemble sisters, she wrote, are "like two mothers to me." She might well have exaggerated the older woman's affection for her, deprived as she had been of a maternal presence, but letters from Mrs. Sartoris, written not too long after this happy time, recall with great nostalgia the Roman days when the two women saw each other nearly every day. "I wish you really were my daughter," she said, signing herself "Your loving mother."[8]

Adelaide was the natural mother of three children, the youngest an infant born in 1852. She appears to have mothered them warmly with a heart and nature big enough to advise and care for Hatty. In turn, the young sculptor's adulation and appreciation of her company may have been balm to a woman who had not only given up the excitement of the operatic theater and the heady response of an audience but never ceased to miss it.

Adelaide's older sister Fanny Kemble, still smarting from the divorce from Pierce Butler, arrived in Rome shortly after Hatty. She had seen the Hosmers briefly in London when Hatty had hand-delivered letters from the actress's daughter Sarah Butler, estranged from her along with a younger child, Fanny. The harsh, unjust terms of her divorce settlement in America, dictated by the social inequities of the law, had embittered her; nonetheless, she was capable of being clever and amusing company. Handsome rather than beautiful, with splendid eyes and an enchanting smile, she had been painted by Thomas Sully many times. The gifts that distinguished her as a member of England's first family of actors continued to sustain her even in adversity.

The relationship between the two Kemble women was very close. Fanny called her sister Adelaide "a thousand times quicker, keener, finer, shrewder, and sweeter than I am," an appraisal that many would have agreed with. While Adelaide was forthright in a refreshing way—"her milk has had time to stand and turn to cream in happy family relations," said Elizabeth Browning—Fanny Kemble was often blunt, acerbic, and pontifical. One who knew her said that although her marriage to Butler had been an utter mismatch, she was so imperious that "*no one* could have lived with dear Mrs. Kemble." Thackeray, one of those at home in this Roman circle, was heard to say that he had "learned to admire Mrs. Kemble but not to endure her."9

Hatty was very fond of Mrs. Kemble in spite of the outspokenness that Fanny herself called "my suddenness." Hers was a restless spirit, never satisfied, one that others found it difficult to live with or live up to. Hatty recognized that relationships between the actress and her daughters would never be ideal. But the gift of Fanny's genius to the girls at Lenox had a lasting influence on Harriet Hosmer, who appreciated literature and the theater more profoundly because of her. Fanny Kemble may also have helped Hatty to reach her decision to be a sculptor; she heartily approved and endorsed it. But her example as a woman whose profession was the theater and whose marriage had foundered may also have had a subtle effect on Hatty. One could manage a career or domesticity but not both; Hatty would have to face up to that choice.

Fanny Kemble later wrote to Wayman Crow to give her approval of

his encouragement of "your young countrywoman's genius." She was convinced, as were others, that Hatty would distinguish herself, "for she not only is gifted with an unusual artistic capacity, but she has energy, perseverance, and industry." Unhappily, such qualities were often lacking in the personality of the genius, and were "extremely seldom possessed or exercised in any effectual manner by women." While she readily recognized Hatty Hosmer's gifts, her insensitivity to the reasons that lay behind women's impotence is curious, given her powers of perception and her own bitter matrimonial experience.

Fanny Kemble was no sage, however, for her prediction of Hatty's social success, or lack of it, falls short of the mark. What she does show is a commendable tolerance, believing that any genius, male or female, had the right to behave unconventionally. Her letter to Wayman Crow continued: "Hatty's peculiarities will stand in the way of her success with people of society and the world, and I wish for her own sake that some of them were less decided and singular, but it is perhaps unreasonable to expect a person to be singular in their gifts and graces alone, and not to be equally unlike people in other matters."[10] The "peculiarities," as Cornelia Crow later explained them, were a total disregard for conventional ideas of dress and manners. In generations to come, such vagaries would simply be regarded as informality. Hatty saw no reason to wear impractical clothing for her work in the studio. She quickly discarded the brown bonnet that had been her trademark in St. Louis. Often bareheaded as she walked down the Corso to Gibson's studio on the Via Fontanella, she still had an affinity for costume. It was metaphor for her, a moment to dress up, to play the clown, or to cause comment. The riding hat that she dismissed with such indifference was actually very elegant and becoming, with its drooping plume and rakish angle. Even the "absurd miniature round straw hat," that Thomas Crawford later criticized, its edges curled and its decoration an "economical feather," may have been more studied than not.[11]

In the spring, the Sartoris set took to the Campagna for a succession of picnics, opening hampers of food for feasts among the ruins. Besides Hatty, others in the group who were young and single included the witty French historian J.-J. Ampère, Charles Hamilton Aïdé, and Richard Bickerton Pemell Lyons, a young English career diplomat whom Hatty especially liked. Most interesting of the men was the handsome English artist, Frederic Leighton, who arrived in Rome the very week after the Hosmers. Both painter and sculptor, he had studied art first in Florence and then in Germany with the Pre-Raphaelites and with Edward von Steinle, one of the Nazarenes, who were proponents of the prevailing German romantic school. Leighton was the same age as Hatty, and, like

her, he was the child of a doctor. His grandfather had been court physician to the Romanov czar at St. Petersburg for many years, and the family had lived abroad. Brought up in a cosmopolitan environment, young Leighton was an accomplished linguist as well as artist. His Italian was faintly accented with the Tuscan dialect of a Florentine, the most prestigious in an Italy of many provinces and tongues.

With his finely chiseled features, slightly disdainful mouth, and fair curling hair, Leighton was the very model, in appearance at least, of a Byronic hero. He often dressed in the velvet coat and flowing tie that artists wore, seeming somehow to strike exactly the right note, neither too foppish nor too careless. His intimate friends, including Hatty Hosmer, called him "Fay." Although he was said to be a superb dancer, able to waltz splendidly, he seems to have given up that frivolity for only an occasional quadrille. He had a fine tenor voice that served him well in the Sartoris musical circle, and he conversed brilliantly in a manner that was amiable and self-confident rather than haughty or arrogant. With all these virtues, he was also thought to be courteous, kind, punctual, economical, and sober.[12]

Hatty met Frederic Leighton when he appeared at her studio door, saying in his flawless Tuscan-Italian, "È permesso?" for leave to come in. "Entra pure," she responded, thinking to herself that his handsome face and figure were like that of a young Raphael. The resemblance in her mind and eye was especially telling, for Raffaello was admired by the nineteenth-century artists for the highest beauty of body and soul and as a direct heir to the ancients. There could be no greater accolade. "Unless you prefer a foreign tongue," said Hatty, not yet entirely comfortable with Italian, "let us try English," a suggestion that made Leighton laugh. He explained that John Gibson had given him permission to draw from a horse's skull, kept behind an old green curtain that was used as a background for live models. The studio boy Pietro extricated the skull, and when it was arranged in the proper light, Leighton began to sketch while he and Hatty continued to talk and laugh.[13] It was the beginning of a long, enduring friendship.

In a letter home, Leighton described Hatty as "a little American sculptress of great talent, the queerest, best-natured little chap possible."[14] Her epicene studio costume and short hairstyle undoubtedly made her seem very different indeed from other young women that Leighton knew. But it may have been her boyish demeanor that made it possible for the two to have an easy, informal relationship, uncommon in a time when intimacy was reserved for companions of one's own gender.

The combination of the handsome, sensitive young English artist

and the beguiling American sculptor invites romantic speculation. But what really happened is quite different, for Frederic Leighton instead became a lifelong admirer and devoted follower of Adelaide Sartoris, whom he looked upon as perfection itself, a Muse to encourage, inspire, and often criticize his works. Their enigmatic relationship is thought to have been platonic, but to attempt to categorize it too simplistically is to deny the complexity of human sexuality.

Leighton was taken into the Sartoris circle early in 1853, just as Hatty Hosmer was. He appears to have dined at the apartment on Piazza Santa Trinita at least twice weekly. He called Adelaide Sartoris "my great resource" and saw her daily.[15] Leighton's biographers argue that, rather than preventing his marriage to someone eligible, the alliance provided the feminine companionship that might otherwise have been missing from his life of deliberate celibacy. Apart from the sociable, gregarious exterior that the world saw in Leighton, there was another nature, aloof and withdrawn.

The two, an older woman and her attractive swain, did not entirely escape notice, but the high moral standard of their conduct and their very characters seem to have discouraged most gossip. There was some innuendo when Leighton followed the Sartoris household to Bagni di Lucca in the summer of 1853, carefully neglecting to inform his mother that Edward Sartoris would not be there. "Sartoris . . . is coming to England for the season and leaving his wife in Rome," Thackeray said insinuatingly.[16] But Leighton was not Adelaide Sartoris's houseguest, and he spent much of his time with his friends Hamilton Aïdé and Hatty Hosmer. On a typical Sunday afternoon at Bagni di Lucca, Adelaide could be found reading to Leighton, Aïdé, and Hosmer from the uplifting sermons of the great Unitarian theologian William Ellery Channing. Leighton once responded to remarks about his relationship with Adelaide, made by his mother, to say that he had "derived from her more moral improvement and refinement (you know it)" and from her circle than from all of his other "acquaintances twice over."[17]

Leighton's *Cimabue,* the painting that prompted his first call at Gibson's studio, received wide attention, even before its completion. The huge canvas, whose full title is *Cimabue's Celebrated Madonna Is Carried in Procession through the Streets of Florence,* was done with painstaking accuracy and detail. In spite of the approbation of all who saw it, Leighton painted the whole left side over when the German artist Peter von Cornelius said that it was too perfectly balanced.[18] Hatty witnessed the progress of this ambitious *oeuvre,* following it through every phase with an intense personal interest, especially, she said, "when it came about that Gonfallier was to ride a horse which at that time I

chanced to own, very good looking, but which, I told Leighton, got nearer the 'brush' in his studio than he ever did in the hunting field."[19] Seeing the finished painting on the first day of the Royal Academy exhibition in 1855, Queen Victoria purchased it for the royal collection. (Another of Leighton's paintings, *The Reconciliation of the Montagues and Capulets over the Dead Bodies of Romeo and Juliet,* done almost at the same time, was singularly less successful.)

In Rome, Leighton had become known for his generosity, dipping quietly into his pocket to help hapless artists like George Mason and the Italian painter and patriot Giovanni Costa. When the mercurial Adelaide Sartoris, still in many ways the diva, picked up her family in 1855 to move, first to Paris, then to London, Leighton, too, was ready to go. At the farewell dinner that his friends organized in his honor, Hatty's contribution was a basket of flowers. Later, in the gathering in Adelaide Sartoris's *salone,* he thanked Hatty for remembering him. "When next I send you a basket of flowers," she replied, "you will be President of the Royal Academy," a promise carried out at the proper moment. Closing his studio in the Via Sistina, Leighton gave her a parting gift to recall the good times. The study of the horse's skull, the focus of their first encounter in Gibson's studio, and a drawing of a boy, Angelo, who had been Leighton's model for the young Giotto in his *Cimabue,* were souvenirs that she treasured.

In 1856, Leighton's painting *The Triumph of Music* had a disastrous reception. Hatty thought that the subject was less sympathetic and that the "success of *Cimabue* had wounded the susceptibilities of certain brother artists," both contributing factors to the criticism of the painting. Recalling the events of those months, she said that he was not depressed by them. Adelaide Sartoris, whom she called "a friend standing near him," wrote her from Paris to say: "Fay is no whit discouraged by the failure of his picture, but says, 'Next time I mean to do better.'"

For the next decade, Hatty saw little of Leighton, but on what she called "the occasions of his flying visits to Rome," he always dined with her. On one visit, she was in the process of moving her "lares and penates" to a new apartment in the Palazzetto Barberini. With the apartment "in the condition attendant upon such domestic events, our dinner was served on a packing case," she reported, "and two smaller packing cases served as chairs." Leighton described the house that he was building in Holland Park Road, its completion contingent on his earning the money. After dinner, he balanced a box lid on his knee and sketched his plan for the house, designed to his specifications by his friend George Aitchison.

Hatty reminded him of that evening each time she visited the exotic

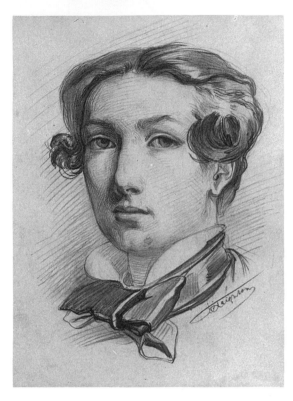

Frederic L. Leighton, self-portrait, ca. 1849, pencil, 7.75" × 6". National Portrait Gallery, London.

London showplace, which Leighton had supervised in every detail of construction and interior design. The house combines elements of his own eclecticism with styles of the period. The Arab hall features a pool and fountain of black marble, exquisite wooden screens covering the windows, and antique tiles brought from Rhodes, Damascus, and Cairo by Leighton and his friends. Sir Joseph Edgar Boehm, Queen Victoria's own sculptor, decorated the capitals of marble columns.

To the end of Leighton's days, his letters to Hatty reflect the fun they had together in Rome. His greeting "Beloved My Hat" reflected the ways that her close friends played with her nickname and the rebus that she used as signature. A cartoon of himself with his mouth puckered up to kiss a hat reveals a Leighton who was never stuffy as Hatty's comrade. It may have been her special talent to draw from him what was boyish and playful in his nature to match like qualities in herself.

Writing to Hatty in later years, Adelaide Sartoris testified to Frederic Leighton's unchanging constancy toward her. Speaking of a painting in progress, "Paris coming with his friends to fetch Juliet," she added that he was also doing a picture of Samson and Delilah, "and of course a

A short and playful note from Sir Frederic Leighton to Harriet Hosmer. Schlesinger Library, Radcliffe College.

portrait of me," she added. "I suppose he will go on painting me until one day it will suddenly flash upon him that I haven't got a hair *on* my head or a tooth in my head."[20]

There were others who came and went during the first years in Rome. Elizabeth and Robert Browning, the warmest of friends during this period, deserve their own space. Hatty also forged lasting bonds with sculptor William Story and his family. But some associations deteriorated in the ingrown expatriate circle. The high standards of civility that the Americans demanded of themselves and others did not always imply intimacy or even trust.

A tantalizing figure in this Roman company is that of William Page. Henry James speaks of "the shade of Page . . . who peeps unseizably, almost tormentingly, out of other letters . . . who offers the rare case of an artist of real distinction . . . almost untraceable less than half a century after his death."[21] He was called "the American Titian," for he attempted to reproduce the Venetian master's rich, somber hues, so successfully at first that Italian authorities took one of his productions for a genuine Titian. But most of the paintings, purposely blackened by

Page, continued to darken. Still he was admired tremendously, and his services as a portrait painter were widely sought. Fanny Kemble wrote to Wayman Crow, "We have here a Mr. Page, a painter from Massachusetts whose portraits are among the best modern pictures I have seen."[22] Shortly after Charlotte Cushman's arrival in Rome, Page was painting her likeness, which William Story called "wonderfully fine," the kind of praise that Page's peers heaped upon him. Page began a portrait of Hatty sometime in 1854, but he must have worked on it sporadically. The busy sculptor may have been a difficult subject to capture. Also, Page, as well as others in the expatriate colony, had a bout with the Roman fever in the spring of 1854, falling ill three times in one week, according to the solicitous Elizabeth Barrett Browning.[23]

But it was the exigencies of Page's marital life that may have occupied his attention. Married for the second time—his first marriage ended in divorce—Page was deserted by his wife, Sarah, for a young Italian aristocrat, Don Alfonso Cirella, with whom she had been carrying on a sustained affair. The scandal broke late in 1854, although it is difficult to tell whether Robert Browning knew of the denouement when he wrote to Hatty, asking her, "How does your portrait get on, and is there anything else about Page that you can tell me? I am quite happy to think of you and that noble Page together. Stick to him like a leech, for it is real life blood you will get out of him, real thoughts and facts, nothing like sham and conventionalism. I carry in my mind all I can of his doctrine about the true proportions of the human figure, and test it by whatever strikes me as beautiful, or the reverse."[24] The following month, December, Browning spoke with sadness and regret of the whole affair, sympathizing with "dear noble Page" but remembering his wife's kindness and affection to both of them and to Penini. Page would be "merciful and just," Browning thought, concluding his reflections with "Page & Cirella—a man & a wisp of straw!"[25]

Hatty was less charitable in her account, written to the Brownings in January 1855.

> You ask about Page and that wretched Mrs. Page & wretched she is if all accounts are true. I suppose she has behaved about as vilely as possible. They say that before she went away she provided herself with a fine wardrobe & contracted no end of debts which of course were left for her husband to pay. It seems she left Rome with a false passport & joined Cirella in Albano. . . . Some say they are in Naples but I believe they are somewhere in Sicily. God knows where. Did you ever know such a thing? Page himself told me she was on her way to America but nobody believes that but then he said with a very peculiar emphasis "if she ever gets as far as America I don't suppose she will ever come back."

Page was suffering from a cold, Hatty said, and she had not seen him for several days. "Certainly that man has had his share of trouble & I am inclined to think his daughters are not the joy of his heart," she said of his two girls by the first marriage. "The only thing I wonder at," she continued, "is that he could allow that fellow to be in his house so much & Mrs. Page never stirred a foot without him—either he was blind & couldn't see or he wouldn't see—which was the worst?"[26]

Page's portrait of Hatty was still unfinished when Robert Browning wrote to her in 1858, asking whether the work was "nearing completion by a touch or two."[27] But this was not before Hatty had reported Page's growing attachment to Sophia S. Hitchcock to her correspondent Lydia Maria Child. Mrs. Child passed the gossip on to her friend Sarah Shaw.

> She [Hatty] thinks his new love is a very shallow, pretensious woman, who gained influence over him solely through his vanity. She offered me a large wager that in one year's time they would dislike each other, and that five years hence, they would be living apart. Considering artists "mighty unsartain" to bet upon, in general, and Page, in particular, I did *not* take up the wager.[28]

The third union seems to have prospered, however, in spite of Hatty's predictions, as Robert Browning reported. "Page has got a babe—we see him & love him as before: he has painted a Venus and other pictures in his peculiar, remarkable way. His wife adores him & he is wrapped up in her, so that things mend at the worst."[29]

Charlotte Cushman and the entourage that included Matilda Hayes and her loyal, efficient servant-companion, Sallie Mercer, stayed only through the winter. Hatty's early letters fail to mention "Miss Cushman" at all, a surprising omission. Her immediate absorption in her work along with the warm acceptance that she received apparently denied the older actress the maternal role that she had foreseen for herself. Cushman, who had a deserved reputation for generosity and kindness, was also managerial and possessive. It is likely that Hatty learned with amazing speed to turn a deaf ear to her advice and supervision.

Charlotte Cushman was probably disappointed in the Roman life as it opened up to her. She may have felt the dislike of some of the men like William Story. He, along with his wife, the former Emelyn Eldridge, enjoyed the distinction of being the first Americans accepted into the social circles of Roman aristocrats, a perquisite not granted to Charlotte Cushman. Story wrote scornfully to James Russell Lowell: "The Cushman sings savage ballads in a hoarse manny voice, & requests people recitatively to forget her not. I'm sure I shall not."[30] She had a repertoire

of songs, some amusing, some very sad, which she sang on occasion to entertain. Her rendition of "Mary, Go and Ca' the Cattle Home" caused one listener to hold his breath and shiver as she sang dramatically of "the cruel foam—the hungry, crawling foam." In order not to offend, she would hold her ethnic number, "Father Molloy," delivered in a thick Irish brogue, until all the Roman Catholics had gone home. She was a powerful actress, and invitations to perform in England were tempting. She was, after all, only forty-one, and there were eager audiences awaiting her. She would return in due time.

Sara Jane Clarke, the vivacious "Grace Greenwood," stayed in "Old Maids' Hall" into the spring of 1853, keeping her journal current for later translation into her book *Haps and Mishaps of a Tour in Europe.* Her record of Hatty's progress, after three months together, notes that the young sculptor was highly regarded by the foremost artists of Rome. Clarke was also charmed by Hatty's personality: "How shall I speak of the friend, of the woman, of the *child-woman,* as I call her?" Remarking on the piquant combination of Hatty's makeup, she spoke of refinement coupled with exuberance, originality, and independence without "extravagance or pretension of any kind." Calling her a "simple earnest, truthful girl" with a "strong and cheerful heart" equal to her intellect, she concluded that Hatty's generosity of spirit and her kindliness were felt more than "her genius." She didn't doubt for a minute that Harriet Hosmer would have "a brilliant and peculiar" career ahead of her, one that would be followed by her friend with "loving pride as by admiring interest."[31]

Virginia Vaughan, the friend from Lenox days who had introduced Hatty to Charlotte Cushman, remained in Rome for a time, long enough to get into some kind of trouble alluded to later in a letter to Hatty from Adelaide Sartoris: "It was next to an impossibility that she shouldn't get into some mischief—the arrangement of her mind was so like the arrangement of her days."[32] Whatever her sin, it must have been venial, for the societal standard of behavior in the Roman community was very high. In spite of a few noted exceptions such as the Page affair, the expatriates seem to have conducted themselves with astonishing rectitude. Besides the pervasive, insistent Puritan background that so many of the men were directly heir to, the presence of their spouses and a constant vigilance on the part of their peers were deterrents to dalliance. As for the women, their early training and their initiation into the rites of womanhood included a thorough inculcation on the necessity for high moral behavior and the awful price paid by females who stumbled.

With so many friends and acquaintances to offer hospitality, it is a wonder that Hatty accomplished any work at all. She had enormous

energy and was apparently successful in meeting the demands of studio and *salone*. At the end of her first year in Rome, she was clearly euphoric. There was no place on earth that she would rather be, and she had determined to stay in Rome for at least five years, "unless recalled by accident." Dr. Hosmer could come see her in about three years, she reasoned, "or when he wants very much to see me." She would then take a turn at visiting him.

> Don't ask me if I was happy before, don't ask me if I am happy now, but ask me if my constant state of mind is felicitous, beatific, and I will reply, "yes." It never entered into my head that anybody could be so content on this earth, as I am here. I wouldn't live anywhere else but Rome, if you would give me the Gates of Paradise and all the Apostles thrown in. I can learn more and do more here, in one year, than I could in America in ten.[33]

Although her letter was addressed to Cornelia, it is possible that Hatty, in her exuberance, expressed the same sentiments to her father. Such a statement may have led him to believe that enough could be learned in one year to equal a decade at home. It was a notion that took root, fed by his yearning to have her home again. A year must have seemed a very long time to him, and Rome an unconscionable distance from Watertown.

7
Daphne and *Medusa:*
Themes from Mythology

Her exercises in copying completed to John Gibson's exacting satisfaction, Harriet Hosmer began her first original work, the leap that would either establish her in her career as a sculptor or relegate her to the ranks of the copyists. While some artists, often women, spent their entire careers duplicating the works of others, Hatty herself would have been the first to affirm that the true test of a sculptor was creativity.

During the first busy months, there had been little time for correspondence between Hatty and her friend Wayman Crow. Crow had written, sending his letter in care of the American painter Luther Terry, a move that resulted in confusion and delay. Hatty had not written at all, a lapse that she acknowledged. Nonetheless, she playfully reproached him. "Had it not been for my god-like faith in human nature and for my natural supposition that others were as busy as myself, I should have begun to fear that you had forgotten Miss Hosmer."[1]

Crow might easily have pled other priorities. His only son and namesake had been born earlier in 1853, an event of enormous importance to him. Hatty wrote warm congratulations. She added pensively that the baby boy might be quite a "young gentleman" before she saw him, when "it would be highly improper to kiss him, so supposing you do it for me with all my good wishes." Picturing him running about the house that she knew to the least corner, she prayed that "he may be spared to be the joy of your house," intimation of the anxiety that she felt for the survival of infants. The ghosts of her young brothers had not been completely put to rest.

Crow's letter brought a real windfall, a draft for three hundred pounds to commission the young sculptor's first full-length work, in fulfillment of a promise he made to her when she went to Rome. Gibson cheered when he heard the news and reminded his pupil that only a very few could say that "the first benefit conferred on them was of such a princely nature." Fanny Kemble was one of those who could scarcely

believe Hatty's good fortune. Soon others were congratulating her "on the strength of it."

It would be awhile, she cautioned Crow, before she could produce a work worthy of such generous confidence in her. Meanwhile, she was concentrating on her first piece of original sculpture, "which was destined for you from the beginning." It would come purely as "a love-gift, as a love-gift for the whole family as a very slight return for the many kindnesses I received when I was with you."

The work was an "ideal bust" of a mythological subject of ideal beauty. Such an *oeuvre* contrasted with the popular portrait bust made for a client in search of a likeness. Even so, if the prospective subject was homely, the sculptor might soften the effect of a less pleasing countenance rather than render it in harshest realism. As her career began, Harriet Hosmer infinitely preferred beautiful examples, shying away from portrait sculpture. "Her name is Daphne," Hatty told her friend Crow, "and she is represented as just sinking into the laurel leaves."

The Roman poet Ovid in *Metamorphoses* told the story of the maiden Daphne, who preferred running unfettered in the forest to accepting the bonds of love or marriage. Her father, the river god Peneus, tried to coax her to marry one of the handsome youths who courted her, but she was indifferent to his urging. Mischievous Cupid, in his constant quest for trouble, shot an arrow at Daphne that would counteract any feelings of passion that might arise in her. Perversely, he also hit the god Apollo with a dart that enflamed him with desire for Daphne. Divine ardor seldom needed any prodding. Classical mythology is filled with the caprices of the gods. Many a maid had to do away with a misbegotten child of a god or be killed or, worse yet, exiled. Apollo's determination to have Daphne terrified her. Pursuing her, he called out, seeking to reassure her that he was no simple shepherd, churl, "nor countrie clown" but the lord Apollo honoring her with his love.[2]

Daphne's prayers for help were answered in an astonishing way. Just as Apollo overtook her, she was turned into a tree, her feet rooted, her lissome body quickly encased in a trunk. Apollo, still able to feel the beating of her heart beneath the emerging bark, exclaimed with dismay that nonetheless she would be his tree, a laurel, her leaves forever after to crown the heroes who were victorious in the god Apollo's contests.

Daphne was a natural choice for the young Hosmer's first work. The Greek myths were beloved by the Greek-smitten Victorians, and the expatriate sculptors in Rome drew heavily on the antique sources for their themes. Hosmer had been brought up on mythology, often the key to interpretation of art and literature. The choice of Daphne was not intended to be original. There had been previous Daphnes, and there

would be more to come. In her early days in Rome, "Grace Greenwood" had visited the sculptors' studios and reported seeing a *Daphne* in the atelier of Joseph Mozier. The reiteration of characters from mythology was just as apt in sculpture as the retelling of the ancient family quarrels in the houses of Atreus and Thebes had been for the Greek dramatic poets and their successors.

Surely the most dazzling treatment of the story could be found in the Villa Borghese just up the hill from Gibson's studio. *Apollo and Daphne,* Bernini's seventeenth-century rendering of the myth, has been called perhaps the most successful illustration of a literary theme ever executed. The two full-length figures are caught at the very moment of Daphne's metamorphosis. Apollo is about to capture his prize just as she is transformed into a tree, her fingers leafing out, her toes taking root. For his figure of Apollo, Bernini actually paraphrased the *Apollo Belvedere* of the Vatican, but he depicted the god in action rather than repose, in stress rather than serenity.[3] The bodies are tense with emotion, arms intruding into space, a repudiation of the tranquillity that the Greeks valued so highly. Although Hosmer, in her later years, paid tribute to Bernini's genius, she also spoke of the "revulsion of taste" against "the contortions" of the Bernini school. It is doubtful, then, that *Apollo and Daphne* would have influenced her earlier. The shift in taste caused nineteenth-century artists to reject Bernini's personal style.

The finished *Daphne* is a graceful piece, simple and restrained but neither cold nor remote. The face is classically stylized, the eyes "unworked," or blank. Earlier Italian sculptors had used this technique as well as the sculptured eye. The latter form traced its heritage from a sophisticated Hellenistic treatment modeled, in turn, after the polychromed eye of much earlier Greek figures.[4] Daphne's hair is drawn back into an easy chignon, tidier and more sculptural than Ovid's maiden with her locks "unordred . . . scarse in a fillet tide." (The classical scholar Edith Hamilton points out that the Roman Ovid puts words in the mouth of Apollo that no true Greek would have thought of, for Apollo wondered how Daphne might look in a proper chiton instead of her hunting dress, with her disheveled hair done in a neat arrangement.)

Daphne's shoulders and nubile breasts are bare and beautifully modeled, substantiating John Gibson's tribute to his pupil. Of her skill in depicting the "roundness of the flesh," he had "never seen it surpassed," he said, "and seldom equalled." The bust terminates in a garland of laurel leaves and berries, exquisitely carved but not excessive or distracting. Daphne's expression is calm, for the Greek world was one of resignation rather than terror. Like a Sophoclean drama, Hosmer's statement

is one of compassion for her subject, seen with classical detachment and economy.

To complement *Daphne,* Hosmer began to model a companion piece, a *pendant,* as it was often called. Such pairs were a popular idea in Victorian sculpture, arising quite logically from the architectural concept of symmetry and balance, so harmoniously illustrated in the interior design of the eighteenth century. Lamps, bric-a-brac, and china dogs came more often than not in pairs, though eventually, objects in twos came to be a banal notion.

Daphne's companion, another ideal bust, was the Greek maiden *Medusa,* seemingly a surprising choice. Was she not the Gorgon with face so hideous that the hero Perseus could look at her likeness only in the reflection of Athena's shield lest he be turned to stone? Averting his eyes, he needed the goddess's help so that he could guide his sword to the fatal spot to kill this, the only Gorgon who was mortal. There is, however, a parallel tradition, quite as sound as that of the grotesque Medusa and one that Hatty undoubtedly knew. In Edward Hake's sixteenth-century sonnet *The Infant Medusa,* the poet speaks of "the countenance of touching beauty." In Golding's early translation of Ovid's *Metamorphoses,* Medusa's enchanting beauty—"from top to toe most bewtifull she were"—brought about Poseidon's ruthless attack on her. She was seduced in the very temple of Athena herself, "Pallas church." Athena, furious with Poseidon, found the perfect vengeance. She turned Medusa's hair—"in all hir bodie was no part more goodly"—to a mass of "lothly snakes." But Medusa's face remained beautiful to compound the tragedy.[5]

Although the lovely Medusa had its scholarly disciples, the ugly counterpart was the older tradition. It was also the better known because it was more compelling. Hatty Hosmer was well aware of the popular appetite for sensationalism. She later spoke of "our love of the grotesque," demonstrated in "the highly spiced palates of the present day." "Caricature," she said, "provides acuter sensation than does Beauty. You do not say keener but more acute."[6]

While a contemporary critic described the Hosmer *Medusa* as "intense in its expression of grief and agony at the transformation," to the modern observer she appears quietly desperate rather than agonized. Hosmer's *Medusa* is indeed beautiful, even with her coiffure of snakes. Her face shows a tragic resignation to an inexorable fate in the authentic spirit of the Greeks. The shoulders and breasts are bare, terminating in a knot of serpents gracefully entwined, but their patterned skins and decorative arrangement do not obliterate entirely the menace they suggest. The knotted serpents nestling under Medusa's breasts recall an

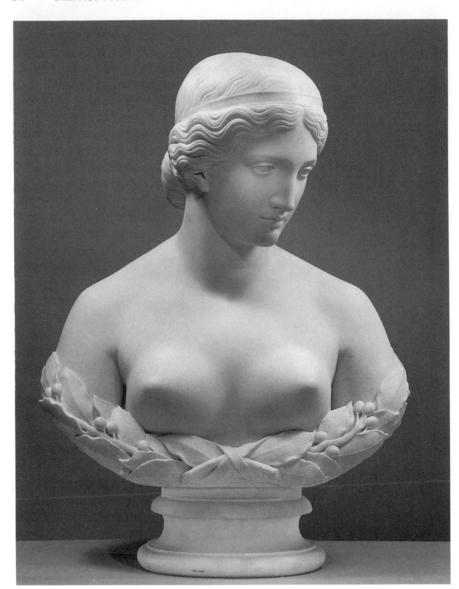

Daphne, 1853, marble, height 27.5", signed and inscribed "HARRIET HOSMER/FECIT ROMAE." The Metropolitan Museum of Art, Morris K. Jesup Fund, 1973.

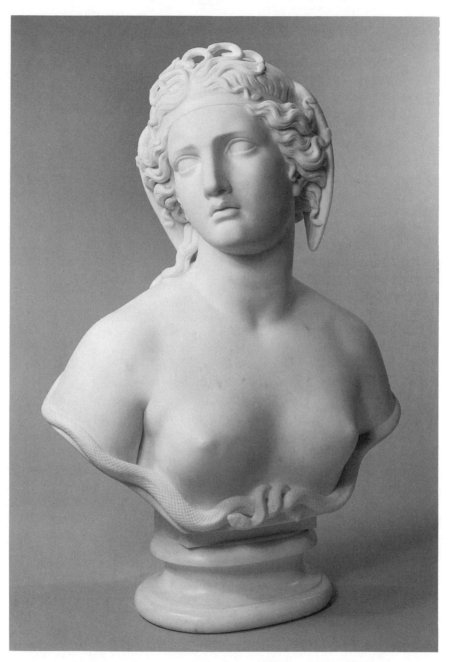

Medusa, by Harriet Hosmer, 1854, marble, height 27". Founders Society, Detroit Institute of Arts, Detroit, Michigan, Founders Society Purchase, Robert H. Tannahill Foundation Fund.

anecdote about the modeling of the work. The artist is said to have captured a snake in the Campagna to study its lines and texture more closely, just as she had done in her Watertown studio with creatures of all kinds. After the snake had been lightly anesthetized, she made a *moulage,* or impression, of it, then revived it and allowed it to return to the freedom of the Campagna.[7]

The termination of both busts has been identified as more refined than that of *Hesper.* The framing of the busts with some manner of decorative motif was indeed a more artful conclusion than mere dissolution of the figure into nothingness. The problem of termination has always been present in doing a bust, the sculptor endeavoring to overcome the truncated look of a dismembered torso.[8] Bernini had used flowing, volatile drapery to finish his bust of Louis XIV, but nineteenth-century sculptors, following a neoclassical mode, were more inclined toward static forms of decorative detail. Often these details were the clue to the subject's identity.

The experience shared by Daphne and Medusa was metamorphosis, a fascinating subject in literature and art since ancient times. Ovid told of mutations in animal, vegetable, and mineral in a world where nature was often unpredictable and violent. Among Gothic writers, from Ann Radcliffe, Horace Walpole, and "Monk" Lewis, in the late eighteenth century, to Mary Shelley and Edgar Allan Poe in the nineteenth, there was a rekindled and romanticized interest in metamorphosis. Writers delved into the mysteries of medievalism, pseudoscience and metaphysics, everything in the boiling cauldron from alchemy to original sin. Stories from both European and American authors were charged with innumerable instances of beautiful but evil women who deteriorated into hideous witches, either slowly and excruciatingly, or with diabolical suddenness.

In Victorian literature, metamorphosis is seen as transformation of the human character, which moves toward perfectibility—"the progress of the soul"—or toward sin and ruin. This high moral message in the poetry of Tennyson and Browning, as well as in the works of Hawthorne and Melville, appealed strongly to the Victorians; they sought it not only in literature but in art.

While the depictions of Daphne and Medusa are in no way dramatizations of the myths, they are symbols of the ancient lore. What drew Harriet Hosmer to these mythological female figures for her first original works? Since myths are the mirrors of universal, atavistic images that reflect our deepest existential concerns, her choices may reveal something about her that she herself only dimly comprehended—something about her aspirations, doubts, and hidden terrors.[9]

It is not difficult to understand her attraction to the free-spirited Daphne; Hatty realized that a romantic involvement or matrimony could put an end to her ambitions for a career as a sculptor. Searching for her identification with Medusa is a quest far more arcane. The coiffure of snakes, Athena's vengeance, is neither the beginning nor the end of the tale. Still not sated, Athena at last helps Perseus to slay Medusa. From the blood of the victim's neck, the warrior Chrysaor and the horse Pegasus emerge as nightmare images, the bizarre offspring of Medusa's unwilling union with Poseidon. At the root of Hosmer's fascination with Medusa may have lurked a fear of sexuality and its consequences, not unnatural in any time or society. Her instinctive way of compensating for these subliminal terrors may have been her re-creation of these two figures, resuscitated in wholeness and the purity of marble.

Both *Daphne* and *Medusa* received high praise. One unidentified critic, commenting on Hosmer's distinctive style, wrote that she "reads Greek fable with an eye of her own."[10] Later, an anonymous visitor, especially moved at the sight of *Medusa,* called the bust "the glory" of Hosmer's studio.

> I have always thought that to fulfill the true idea of the old myth, Medusa should be wonderfully beautiful, but I never saw her so represented before. This is the head of a lovely maiden; her rich hair kept back by a fillet, off the brow, seems at first to recede in waves, and, when you see that these waves terminate in serpents, it strikes you with no feeling of revulsion. The face, whose eyes look upward, is full of sadness, to which the serpents add mystery and gloom and make the beauty more thrilling. The folded wings above the hair on each side of the face give an air of majesty to the head. It was hard for me to look away from this statue; if long gazing could have turned one to stone, the old tradition would have been fulfilled.[11]

Along with the ideal busts, Hatty had been working on a series of ten designs for *bassi relievi,* she told Crow. After a winter of hard work, she and Virginia Vaughan were "keeping Old Maids' Hall," their place in the Corso, "as happy as clams." Rome was deserted: their mutual acquaintance Luther Terry had gone to America; and Fanny Kemble and Adelaide Sartoris were summering in Sorrento, where Hatty would join them about the first of July. Until then her studio work would occupy her. She spoke pensively of Lenox, where the Crow family would soon be enjoying the cool breezes and warm hospitality at The Hive with the Sedgwicks.

In response to Crow's declaration that she ought to be happy under such fortunate circumstances, she answered, "And so indeed I am." She

confessed that she had not known before what happiness really meant. She loved her work and in John Gibson she had "not only the best master but the kindest friend in the world." She intended to stay in his studio for another two years, she said, "for he tells me to stay as long as I please."[12] It would be longer than either of them imagined.

8
"The Perfection of All That Is Charming"

Late in the autumn of 1853, Robert and Elizabeth Barrett Browning came to Rome to spend the winter. They considered Florence to be their permanent home, but they moved around whimsically as the seasons changed. Summer sometimes sent them off to Bagni di Lucca in the mountains, and the onset of winter found them seeking to escape the Tuscan chill, more prolonged and penetrating than its Roman counterpart. With their little son, Robert Wiedemann Barrett Browning, known to all by the name he himself fashioned, "Penini," they were soon settled in an apartment on the third floor at 43 Bocca di Leone, a narrow street that turns into the Via Condotti, a stone's throw from Lepre's and the Caffè Greco. Soon after their arrival, Hatty Hosmer was regularly climbing the several flights of stairs that penetrated the space of a dank, dark hallway to find a warm welcome "when their door was gained."[1]

Both in Florence and later at Bagni di Lucca, the Brownings had enjoyed the companionship of William Story and his wife, Emelyn. Whereas the Brownings were standoffish toward their own countrymen in Florence, they found the American couple more compatible and congenial than anyone they had met. Emelyn Story had shared her coveted copy of *Jane Eyre* with her new friend Elizabeth Browning, and on the grassy turf at Bagni di Lucca, the two couples had stretched out as they read to one another.[2] They looked forward to a reunion in Rome after the Story family went on ahead by sea from Leghorn and the Brownings traveled overland in a *vettura*.

The Brownings' entourage, which always included their English servant Elizabeth Wilson, arrived on the eve of the death of six-year-old Joseph Story, who had suffered from convulsions precipitated by an attack of gastric fever, "tending to the brain," so Elizabeth Browning wrote to her friend Eliza Ogilvy. Edith Story, who was nine, was brought by a servant to the Brownings' third-floor rooms. When she became ill also and it was impossible to move her from the building, she was received into the apartment below by the American artist William

Page. There the Storys, leaving the unburied body of Joe, went to nurse her.[3]

To compound the troubles, Emma Page, the artist's youngest daughter, and the Storys' English nurse both became ill with the fever while Edith was there. It was a month before Edith could be returned to the Story household, one greatly saddened by Joseph's death, a loss that the Brownings also felt acutely. One of those most sympathetic toward the Story family in their grief was William Thackeray, resident in Rome with his two daughters, Anne and Minny. His wife was institutionalized with an incurable mental disease, and with the help of servants, Thackeray cared for his children. In spite of his reputation for being aloof and arrogant, Thackeray wept with Story over the dead child's discarded shoes and read the unpublished manuscript of *The Rose and the Ring* to Edith at her bedside. In better times, Story, in turn, took Anne Thackeray to her first ball at the Hotel de Ville.[4]

Thackeray lived very nearby in the Via delle Croce in an old *palazzo,* the one with Spillmann's ice cream store on the street level. He frequently called on the Brownings, with whom he engaged in deep discussions overheard by his daughter Anne, who said that "the deliberate notes" of his voice always sounded a little sad to her.[5]

Elizabeth Barrett Browning described Thackeray's malaise in a letter to her sister Henrietta Cook, written on December 30, 1853: "Mr. Thackeray, on the other hand, complains of dulness—he is disabled from work by the dulness. He 'can't write in the morning without his good dinner and two parties overnight.' From such a soil spring the Vanity Fairs! He is an amusing man-mountain enough and very courteous to us—but I never should get on with him much, I think—he is not sympathetical to me." In the same letter, Elizabeth spoke of Hatty and the others who were living in the house at 28 Via del Corso: "Oh—there's a house of what I call emancipated women—a young sculptress—American, Miss Hosmer, a pupil of Gibson's, very clever and very strange."

Matilda Hayes, whom Elizabeth had met previously in Paris, was also one of the group of "emancipated women." Said to be the translator of George Sand, Hayes dressed "'like a man down to the waist' (so the accusation runs)," Elizabeth wrote. "Certainly there's the waistcoat which I like—and the collar, neckcloth, and jacket made with a sort of wag-tail behind, which I don't like." Miss Hayes was "a peculiar person altogether," Elizabeth said, "decided, direct, truthful it seems to me."[6] Both women, Hatty and Matilda Hayes, were coming to the Brownings that evening along with Isa Blagden, who lived on the floor below the women. She was already an intimate friend of the Brownings and a correspondent to whom they wrote copious letters.

Soon Hatty was a frequent caller, and Elizabeth and Robert Browning were on close enough terms with her to drop in at her studio to give her news of Isa Blagden, who had left Rome. They arrived "& found her tête à tête or rather corps à corps with a model."

> She invited us in, & Robert accepted. For my part I felt rather shy, & preferred the company of Mr. Gibson's painted Venus [Gibson's controversial work], who is only *nearly* as bad (when all's said) as any natural nudity. Robert was quite vexed at me for this piece of prudery,—but not being 'professional' there was not much reason I thought, to struggle against my womanly instincts in the case. One's a woman after all, and weak: I would rather see a nude male model in the company of a man (though my husband) than a nude female model—and I would rather *not* see either.

Elizabeth liked Hatty "more and more," she told Isa. "She is modelling a lovely, expressive 'lost pleiad', & is better herself than her statues—A pure, simple, upright nature like hers is a thing to wonder over among the crawling social falsities one has to step carefully n[ot] to tread on—I shall take to wearing goloshes." She also revealed that she found John Gibson extremely attractive. "By the way I think I too may end in falling in love with Gibson. I feel myself going."[7]

Before long, Hatty was one of the British and American circle that gathered to summon the dead from a world beyond. Spiritualism was a craze both in Europe and America, and exercises in the supernatural were taken with the utmost seriousness by some, like Elizabeth Barrett Browning, and in the spirit of fun, as a social diversion, by others. Hatty's supernatural world was inhabited with small shining creatures, probably the product of a highly susceptible imagination but quite believable to Elizabeth, who reported Hatty's interest in the occult in a letter to her sister Henrietta.

> Harriet Hosmer the American sculptress—(very clever she is, only twenty four, and one of the frankest, bluntest, nicest little creatures that ever took my fancy) was telling me how the other night on entering her bedroom, a spirit, some three feet high, exquisitely formed, came running, dancing to her from the furthest end of the room close up to her knees, when as she stooped towards it, it vanished.[8]

Hatty had "other visions, & is a writing-medium," Elizabeth said. Penini was asked by his mother if he wouldn't have liked to see Hatty's luminous little sprite. "'Oh yes,' said he, 'velly mush! a little pretty spillet lite lat!—but (holding his head on one side in an attitude of consideration)," Elizabeth continued, "'I sint if a velly large angel tame, I be rather aflaid.'" Referring to Hatty as "lat woman," Penini spoke of a

silver angel that came to see her sometimes, but it was Hatty's pretty little dog that he really coveted. By now the Brownings' own faithful spaniel, Flush-my-dog, was suffering from what Hatty later called "Anno-domini," showing "but faint traces of his former beauty."[9]

Sometime in the winter of 1853–1854, Hatty Hosmer conceived the idea of casting the entwined hands of the two poets. When she asked them if they would consent, Hosmer reported that Elizabeth said that she would, "provided you will cast them yourself, but I will not sit for the Formatore," the artisan who specialized in applying the heavy shroud of plaster.[10] Hatty did the moulage, an exercise she is said to have practiced at Lenox, arranging the two right hands, one lightly clasped by the other, Elizabeth's delicately outlined in a thin border of embroidery and Robert's delineated by a narrow cuff.

The *Clasped Hands* was highly praised. In *The Marble Faun* Hawthorne said that it symbolized "the individuality and heroic union of two, high, poetic lives." But in spite of the attention that the piece received, it remained in its original plaster form until many years later, when, with contributions from patrons, it was cast in bronze. Hosmer explained "what some might call a lack of finish of the Bronze" with an anecdote. She had been invited, she said, to look at "a marble statue of a Bacchante," which a woman in Rome had recently purchased. The sculptor admired the work, calling it a "beautiful composition." But the owner cared nothing for such an opinion, saying instead, "But I *do* think these grapes are beautifully polished." Hatty called this the sacrifice of "a primary to a secondary object." In contrast to the bacchante, the *Hands* had been left exactly as they had come from the mold "to preserve at the expense of finish all their characteristics of texture."

The work has been a source of insight into the physiology of the two poets. Analysts claim to see tubercular features in the bone structure of Elizabeth's frail hand. Her husband's hand is not much bigger; indeed, it seems impossible that the measurements of the bronze hands are those of living human beings, not Lilliputian dolls.[11] Both Brownings were exceedingly small-boned, although Robert, short in stature, appeared taller when he was seated at table. The *Clasped Hands* carried a more sensual message in the nineteenth-century world, where the touch of a hand hinted at a great deal more. Hosmer's casting of the poets' hands and the experience involved in the process may have inspired the metaphor in *Andrea del Sarto,* composed by Robert Browning in the following year: "Your soft hand is a woman of itself, / And mine the man's bared breast she curls inside."

Elizabeth wore the familiar sculptured curls (already out-of-date in her own time), framing a face "plain in feature, but redeemed by won-

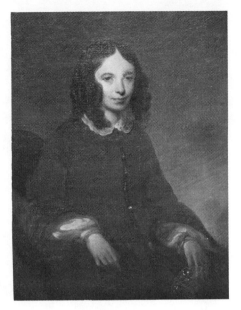

Elizabeth Barrett Browning, by Thomas Buchanan Read, 1853, oil on canvas, 16″ × 13″. The Historical Society of Pennsylvania, Philadelphia.

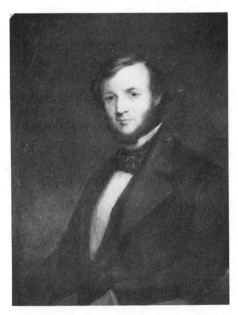

Robert Browning, by Thomas Buchanan Read, 1853, oil on canvas, 15.75″ × 12.75″. The Historical Society of Pennsylvania.

derful dark eyes, large and loving and luminous as stars," Harriet Hosmer later recorded. Her nose turned upward slightly, and her full-lipped mouth was too voluptuous to be considered beautiful. In later years, Hosmer reflected that the sensual lips may have been "a key to some of

The Clasped Hands of the Brownings, by Harriet Hosmer, 1853, plaster casting, also in bronze, length ca. 8". Photograph courtesy Armstrong-Browning Library, Baylor University, Waco, Texas.

Mrs. Browning's less delicate verse," surely a curious judgment but one that came in Hosmer's own middle years.[12] One of the Victorian notions that became firmly ingrained was that poems of social criticism were indelicate and no fit pursuit for a female poet.

Dressed in lustrous dark silk with a thin, gold chain around her neck, she would covertly tuck the manuscript that she was working on at the moment under a sofa pillow to hide it quickly when visitors came. She liked small objects because of her own diminutive size and numbered among her cherished possessions miniature editions of the classics. A tiny pen could be secreted in the palm of her hand. To some observers, she was an insubstantial dollhouse character, but Harriet Hosmer identified her as another mother.

Anne Thackeray also saw the maternal figure, an image of Elizabeth Browning that has receded from the more insistent persona of poet and legendary lover. She had a quality with young people and children that went beyond kindness, treating them as equals with great simplicity of manner. The Thackeray sisters had ample opportunity to experience her warmth, for they were often sent by their father and delivered by

their cook to spend the evening at the Brownings' fireside. There they would visit with Elizabeth and Penini, curled up beside her in his embroidered jackets. At ten the "donna" would reappear to escort the girls home, carrying, as Anne Thackeray described it, "the huge key of our somewhat imposing *palazzo.*"[13]

Elizabeth Barrett Browning and Harriet Hosmer had backgrounds of common experience. Both had lost their mothers at an early age, and Elizabeth's childhood had been lived actively out-of-doors in the Malvern Hills in pastimes not too different from Hatty's own athletic pursuits in Watertown. Elizabeth learned the elements of Greek from her brother Edward's tutor, an achievement that led to her avid reading of the classics. At the age of thirteen, she wrote her own epic, *The Battle of Marathon.* Hatty had shown some of the same precocity, but much of her energy had been acted out in unruliness. But Hatty was robust, and Elizabeth, from adolescence on, was often confined to her room with largely unexplained illnesses.

For all her invalidism, Elizabeth Barrett Browning was intellectually and sexually emancipated, a woman of strong ideas. She had burned with libertarian fervor during the Italian uprisings of 1849. Disappointed, indeed devastated when the Austrian rulers were returned to power in Florence, she took up her pen with passion to write *Casa Guidi Windows,* published in 1851, just two years before Hatty's friendship with the Brownings began. From the message of hope in the first part of *Casa Guidi Windows,* optimism dissolved into cynicism. During these years, she was at work on the poem that would be known as *Aurora Leigh,* the long work that expressed the reality rather than the romanticism of the feminine condition. When Hatty was asked her opinion as Elizabeth vacillated between the names Laura and Aurora for the heroine, Hatty favored Aurora because "Laura Leigh lacks backbone."[14]

Although she was a person of intense feelings, Elizabeth was very shy, her soft speech hesitant as though talking was an effort, as it may well have been. Her voice had a peculiar and most compelling quality. Anne Thackeray described it as intoned on "a faint minor chord," the "r" distorted a little as she uttered from time to time a remonstrating "Robert."[15]

In contrast to his wife, Robert Browning was outgoing, genial, and hearty. He had a kind of lisp, perhaps an affectation. His hair, when Hatty met him, was black and wavy, his gray eyes keen and clear. That he did not smoke was considered a terrible shortcoming by his friend Story, but he was otherwise considered to be good company. Although some observers, like Henry James, did not equate his joviality with

genuine humor, he was admired for the intensity that he put into living, indifferent as he was to practically nothing. Since life was essentially good, he was confident that things would turn out right in the end.[16]

Browning had a quick temper that occasionally came to the surface, his face becoming livid with anger. But that was seldom exhibited in these happy days. He behaved with the greatest patience and concern toward his older colleagues. A houseguest in the winter of 1853–1854 was literary critic John Lockhart, old, ill, and irascible. Crusty and outspoken, he admired Browning because he was not at all "like a damned literary man." At last, Lockhart returned to England to benefit from a restorative dose of "the native beef & beer," as Elizabeth Browning put it.[17] Browning's special kindnesses to an ailing Walter Savage Landor did not go unnoticed. Such solicitude was one of his most endearing qualities, and as Anne Thackeray observed, "one of the best measures of his worth."

Browning enjoyed the company of women, and was always interested in the comings and goings of a number of female friends. For Hatty he was another male figure with whom she could be playful, even flirtatious, with impunity. But there is no doubting his utter devotion and loyalty to his wife. That he cared for her with the greatest tenderness was witnessed by everyone who knew them. Fanny Kemble was heard to say that he was the only man she had ever seen who treated his wife "like a Christian."[18] How other spouses reacted to her remark is not recorded.

Of the chosen group in which she had her own place, Hatty wrote delightedly to Cornelia, calling her friends "the most charming circle of people that you ever saw." Cornelia knew both Fanny Kemble and Adelaide Sartoris from their school days at Lenox. Now in Rome, Hatty went every Wednesday and Sunday to "the family party," as Adelaide Sartoris called her twice weekly gatherings. There the Kemble sisters, the Brownings, "two young artists," one of whom was Frederic Leighton, and "your humble servant" assembled, Hatty wrote. "Mrs. Sartoris sings and Mrs. Kemble sometimes reads and all in all it is the perfection of all that is charming and sociable." Elizabeth, too, appreciated the good fortune of knowing the Kembles. "They fail in nothing as you see them nearer," she said in a letter to Robert's sister Sarianna. "Noble and upright women, whose social brilliancy is their least distinction!"[19]

When spring came to the Roman Campagna, the grassy plain was strewn with a profusion of poppies and the air was drenched with the heavy aroma of what Fanny Kemble called "the ridiculous roses," as though they had no business showing off in such a manner. It was then that the marathon of picnics began—Robert Browning is said to have

attended no less than forty—and Elizabeth recorded their presence at numerous occasions organized by Adelaide Sartoris and Fanny Kemble, and the pleasant company in attendance, including Hatty. With the beauty of the Campagna as a backdrop, "the talk was almost too brilliant for the sentiment of the scenery, but it harmonized entirely with the mayonnaise & champagne."[20]

Elizabeth went on to describe Hatty as she saw her.

I should have mentioned, too, Miss Hosmer (but she is better than a talker) the young American sculptress, who is a great pet of mine & of Robert's, and who emancipates the eccentric life of a perfectly "emancipated female" from all shadow of blame by the purity of her's. She lives here all alone (at twenty-two) as Gibson's pupil, (while her father lives in America),—dines & breakfasts at the caffes precisely as a young man would,—works from six oclock in the morning till night, as a great artist must, . . & this with an absence of pretension & simplicity of manners which accord rather with the childish dimples in her rosy cheeks than with her broad forehead & high aims.[21]

In speaking of Hatty's "purity," Elizabeth Browning may have been thinking of George Sand as a comparative figure. Sand had captured the attention and curiosity of many of her English literary contemporaries, and interest in her was seldom mild, so sensational were her liaisons and her life-style. Both Brownings defended her against her straight-laced critics, often their own friends. Elizabeth was genuinely fascinated with the ambiguities in Sand's character at a time when intellectuals were beginning to ponder human sexuality and to have some glimmerings of its complexity. She had written two poems to Sand, which, if not paeans, were thoughtfully accepting of the French writer's androgyny. Earlier romantic writers like Shelley, Margaret Fuller, and Sand herself, had been lured by the subject of androgyny. Actual encounters with the celebrated Sand, reluctantly arranged by Robert Browning, were infinitely disappointing to Elizabeth, who deplored the "crowds of ill-bred men who adore her *a genoux bas,* betwixt a puff of smoke and an ejection of saliva." Although she called Sand "a noble woman under the mud," her ideal of the emancipated French writer was deflated by the reality.[22]

Not long before the Brownings left Rome for the summer, Robert arrived at Hatty's studio to invite her to go on a long weekend at Albano, the little hill town a few miles southeast of Rome. "Why this extravagance?" Hatty asked bluntly, since economy was important to both parties. Ticknor and Fields, Browning's American publishers, had sent an unexpected royalty, a *"buona grazia,"* Browning called it. Contracts with overseas publishers were arrived at casually, and honor, or even whim, characterized international transactions.

Frederic Leighton was the fourth member of the party, and they set out in a *vettura,* departing through the Porta San Giovanni along the Appian Way, leaving their cares and anxieties behind them "on that sweet May day," as Hatty remembered it many years later. After luncheon at the Hotel Parigi in Albano, the four friends adjourned to the terrace garden for postprandial talk. In the lofty manner characteristic of the Victorians, they discussed the relative merits of poetry, sculpture, and painting, coming to the conclusion adopted by the deposed King Ludwig I, a great favorite in Rome. He had said simply to Hatty on one occasion that "we esteem most difficult the art we love best because therein we are the most critical."[23]

The next morning all four rode donkeys around Lake Albano and up to the summit of Rocca di Papa (Pope's Rock) to enjoy a panoramic view from the top of Monte Cavo. They looked across to the town of Nemi, perched high upon a precipice above the clear, blue lake below. In May the rim of Lake Nemi is dotted with daisies, poppies, and strawberries, both wild and cultivated. Known to the ancients as Specchio di Diana (Diana's Mirror), the lake was still the repository of Caligula's enamel-decked yachts. Farther in the distance the four could see the towns of Pratica and Antium, and nearer, Lavinia, rich in the ancient lore of Aeneus. Turning in still another direction, the quartet looked out on the wide sweep of the Campagna with its green waves of sward. It reminded them of a time, the four onlookers agreed, "when this portion of our planet, so rich in human events, was still unprepared for the food of man." They picnicked under a chestnut tree. If only a painter—Leighton himself—had captured the scene, *Le Déjeuner sur l'herbe,* complete with poets, artists, rustic guide, donkeys, with the vista of the Campagna as background.

During one quiet interval, Robert Browning was called upon, by popular demand, to read the whole of his poem *Saul,* which Hatty had secreted in her portmanteau to produce at the proper moment. On the way back, Hatty told a story. Pointing to one of the ruined fragments nearby on the Appian Way, she suggested that it looked like a human head, a resemblance that the others saw also. She told how an ambitious official named Apuleius had tried to compel his beautiful daughter Apuleia to be a courtesan to the Emperor Domitian. But Apuleia loved a young captain, Belisarius, and would not submit. Apuleius had his daughter's lover brutally murdered and hid the body under the overhanging cliff adjacent to the Casa dei Spiriti. Ignorant of these sinister events, the girl withdrew to a tower where she died soon after, still waiting for Belisarius to return. Her repentant father erected a monument to her memory. As it crumbled in time, it took on the features of

Apuleia herself, known in folklore as "the weird watcher of the Roman Campagna." Hatty hoped that one of the Brownings would write a poem about the legend. Later, she and Robert Browning were walking in the Campagna and came upon the ruin again. "Don't forget the poem," she said. "Ah, that's Ba's," said Browning. "She means to record the legend, you will see—."[24] But Elizabeth Barrett Browning never recorded the legend of Apuleia; her time ran out. Hatty herself worked and reworked the story as extant manuscripts reveal. Had she modeled a figure of Apuleia, a girl betrayed by her own father, the image might have taken its place alongside *Daphne* and *Medusa* and her later works *Oenone* and *Beatrice Cenci,* each subject the victim of sexual tragedy.

Although Hatty clung to her personal recollections, it was Robert Browning who left the most lasting memory of the loveliness of the Campagna. His poem "Two in the Campagna," which at least one critic called Browning's best lyric, celebrated Rome and the countryside, the month of May, and being in love.

> I wonder do you feel today
> As I have felt since, hand in hand,
> We sat down on the grass to stray
> In spirit better through the land
> This morn of Rome and May?[25]

The Brownings left Rome for Florence on May 28 that year, packing up Penini, Wilson, their dog Flush, and the possessions that traveled with them on the four- or five-day journey. Before they went, they urged their friend Hatty Hosmer to visit them. She needed little encouragement.

9
Womanly Concerns and Girlish Escapades

The year 1854 had scarcely begun when Hatty received startling news from her father. After periodic cries of financial distress from him, complaints to which his daughter had become inured or indifferent, Hiram Hosmer announced quite firmly that he could no longer be responsible for Hatty's expenses in Rome. Long accustomed to the paradox of his preaching frugality while continuing to indulge her, she was apparently stunned by this new reality. She reported to Wayman Crow, who had also heard the dictum directly from Dr. Hosmer, that "from time to time he has alluded to his embarrassment but never till now has he told me the whole story."[1]

Since Hiram Hosmer was, as Lydia Maria Child had said, "a man of competent property," he may have exaggerated his predicament, his motives not entirely clear even to himself, in an effort to bring Hatty home. Everything of hers had been kept as she had left it a little more than a year before. Quite enough time had passed, he may have decided, for her to absorb what Rome and her teacher had to offer and to put it to use back home. If he entertained such a naive idea or believed that she would capitulate to his cutting the purse strings, he greatly underestimated the Yankee perseverance that he himself had fostered in her. Had she known the extent of his ill fortune, Hatty resolutely told Crow, she would have "adopted the course I mean to pursue, that of supporting myself."

Hatty had refused Crow's previous offers of support, not anticipating "any storms of fortune," as her "heaven of prosperity had seemed cloudless." Now passionately declaring that "the heart is often more full and warm than it can tell," she accepted his patronage. "On your kindness then, my more than friend, I am forced to rely," she told Crow with the fervent hope that she could prove her gratitude to him in her future as an artist and in the quality of her work to come.

Hatty could not refrain from making her father the scapegoat. Although Wayman Crow was Hiram Hosmer's friend and peer, she did not

hesitate to reveal to him her resentment toward her father, which gained momentum as she wrote, blaming her father for giving her responsibility for managing her own finances. "Unwise" she called her father's confidence in her ability to deal with money matters, "which I knew no more about managing than a child of five years old." He "forced" her, she said, to become "the Banker" in other transactions "when I knew none too much about looking after my own pecuniary affairs." While she confessed that she had not been prudent in the handling of her own finances, expenses that can be assumed to be lodging, subsistence, and studio costs for marble, models, and the work of artisans, she dismissed her failings as "a costly experience . . . never to be paid for again." She would put the past behind her and look for ways to economize. She would gladly get rid of her horse, but she looked upon such a move as unwise if not impossible. "If Rome were Florence, one could walk," she argued to Crow, "but you know enough of Rome to know what walks it offers, and the pure fresh air is only to be found beyond the walls." Repeating her obligation toward Crow, she announced that she would draw on him "for the sum of $1000, not immediately as I am not in immediate want but as soon as my present funds are used up," a time that came sooner than she had planned.

While she had deplored materialism in true Transcendental fashion, calling America "the land of dollars and cents," she was learning that commercial success went hand-in-hand with critical approval. Since Gibson's studio was a showcase that attracted international shoppers, she found it practical to keep the first *Daphne* in the studio and prepare a second for the "love-gift" for the Crow family.[2] But a vein in the marble, undetected until after the carving had begun, delayed the completion of the work. She wrote to Cornelia with an explanation.

> I want you so much to receive my first child. I dare say you are tired of hearing about her and never seeing her, but the fact is, her little face was not quite clear, wanted a draught of Sarsparilla to purify it, and so as I desired, of all people in the world, that you should have a fortunate facsimile of her, I ordered another one to be cut, and as it is not a trifling job of a week or so, I have been prevented from dispatching until now, but the workmen assure me it will all be finished very shortly when presto it shall go to be kissed and I hope loved by you.[3]

When she finally dispatched *Daphne,* she told Cornelia she was also sending "another daughter" to Boston which she hoped her friend would "make a point of seeing if nearby."[4] This was the finished *Medusa* that would become the property of Mrs. Samuel Appleton after it was exhibited in Boston. Should Cornelia not be able to see the work, Hatty

would send a photograph, the up-to-the-minute invention that could capture a faraway face or a work of art with its magic. To Cornelia, Hatty also spoke of Wayman Crow's giving her "such a professional lift," but she took responsibility for her own livelihood. "You know I am supporting myself nowadays." Confident of her own gender identity, she added, "I feel so frightfully *womanly* under such circumstances."

With *Daphne* and *Medusa* finished, she moved on to the matter of the commissioned statue, not yet identified to Crow, who had ordered it. She was at work on the *bozzetto,* the study model, which, along with an ideal bust for a Mrs. Shaw, probably Sarah Shaw, the friend of Lydia Maria Child, would occupy her into the spring. She fully intended to take her time in order to produce something "worthy of your approbation," she told Crow. She had had a taste of success, and, her appetite for commissions whetted, she wrote: "And if you hear of anybody who wants an equestrian statue ninety feet high or a monument in memory of some dozen departed heroes, please remember that nun-like I am ready for orders. However to be moderate and earnest, I mean that if anybody wants any small, decent-sized thing I should be glad to furnish."[5]

While her "equestrian statue ninety feet high" seems preposterous, such an ambitious undertaking was the very thing that James Jackson Jarves, one of America's first chroniclers and critics of art, later chose to censure in the work of "unfledged sculptors, among them women," who began to follow in Harriet Hosmer's footsteps. Too many of these inexperienced men and women were disposed "to begin their careers where Phidias and Michelangelo left off. Misled by inchoate imagination or crude fancy," he wrote, "they attempt the colossal, heroic, or sublime, before mastering the rudiments of art-knowledge. It is as if Columbus, with the idea of a new Orient fermenting in his brain, had embarked on the Atlantic in a skiff to find it."[6]

The protégée and patron relationship between Hatty and Wayman Crow was now official. She attempted to justify it, pointing out that "every single artist in Rome who is living or has lived owes his success to his Mr. Crow." The Duke of Devonshire had sponsored John Gibson, she noted, and "Mr. Hope," probably the English architect Thomas Hope, had been Thorwaldsen's benefactor. "I never read the life of any artist who did not date the rising of his lucky star from the hand of some beneficent friend, patron, or rather both."[7] While Crow had been a staunch friend and supporter of her career before, he now became the key figure in her life. The close alliance, expressed largely through their correspondence, was a bond that continued throughout Crow's lifetime. In a single letter to Crow, Hatty would change roles mercurially. She was

affectionate daughter or disciple or co-conspirator in the machinations to get commissions. Sometimes she was the confidential critic of her colleagues. Generally, she was the whimsical, good-natured correspondent from Rome, full of banter and endearments that intimate, on her part, a love relationship of a different sort.

More elusively, there emerges from the letters an image of inner sensitivity that was scarcely ever apparent to observers. The openness of her affection shows her to be a warm, loving woman capable of great tenderness. That this capacity for close and intimate friendship was most visibly demonstrated in her relationships with paternal or avuncular figures or with women friends thought of as sister or mother can be attributed to the social and sexual mores of her time. These were the acceptable bonds for an unmarried woman, standards that she adhered to even in the light of her independence and individuality. What romantic fantasies she may have indulged in concerning Crow, whom she very nearly adored, are recondite.

Hiram Hosmer remained the flesh-and-blood, earthly father while Crow clearly became the ideal, the ultimate father-friend in a society that sought perfection and often professed to find it. While Hatty continued to differ with her own father and often to disregard his advice, which he did not withhold, she loved him. He, in turn, concealed his love with a certain dour crustiness and constant anxiety about her health, welfare, and the management of her affairs, parental prerogative that he did not abnegate. Oddly enough, her bond with Wayman Crow caused no jealousy on Dr. Hosmer's part. Often he was the intermediary forwarding her letters to her patron. On one occasion, he retained a letter intended for Hatty from Crow for what seemed to her an unconscionable time. He may have been waiting until he had others to send or until he was good and ready to send it, perhaps to convince himself that he was still in charge. The two, father and daughter, were unanimous in their admiration for Wayman Crow, a mutuality that united them whatever their differences.

Wayman Crow became Hatty's patron just before Cornelia's engagement in the spring of 1853. Once again the intended was Lucien Carr—their earlier engagement had been suspended. He was the young man mentioned in the proposed picnic program during Hatty's St. Louis sojourn. He had attended St. Louis University in the 1840s, a Jesuit college more like an academy in those years. An anthropologist, he would soon be taking Cornelia farther west while he did research on Indian life and artifacts. It is possible that Crow was already looking ahead to losing Cornelia.

Cornelia's forthcoming marriage was a milestone for Hatty as well.

When the engagement had been previously scheduled, she had said to Cornelia, "I am beaten—don't say a word. Don't mention it—don't in any way, even the most distant, allude to it." But a more mature Hatty, thoroughly satisfied with her own life in Rome, told Cornelia in the spring of 1853 that she was "rather glad after all that you are going to marry Lucien Carr, because I think you love him better than you could ever love anybody else."[8] But she was still niggardly in her praise of Carr. He couldn't be so bad, she admitted, that "he can withstand your good and gentle influence." "Besides," she added gratuitously, "I'm sure his faults have been exaggerated." Whatever her distrust of the match, she announced that she meant to kidnap all of their children. On second thought, it was not for her: "Well, I must confess I like marble babies best. Instead of boxing their 'jaws' only, you can hose the whole of 'em and send them out of the way." With Cornelia's picture before her, she imagined that she could hear her friend's voice. She also enclosed the replacement for an unflattering picture of herself—"a Daguerre of myself in daily costume, also one for the Pater. They are, like Gilpin's hat and wig 'upon the way,'" she said, in paraphrase of William Cowper's comic character John Gilpin.[9]

After sober reflection, she sent a letter of a totally different character, one that set down her ideas about love and marriage in a serious manner, for she felt that what she had written might not have been entirely appropriate. If Cornelia was happy in her choice, one arrived at freely, she would be content. "The advice of parents and friends may be given but the happiness of a life is not to be sacrificed to the prejudices of one or to the caprices of the other." It was not a step to be taken twice, she said, "or twice with the same feelings, the same happiness and the same hopes."

She advised Cornelia that while a husband would "call forth all the finer feelings of your nature," Cornelia should not yield her opinion in every case but

> aim at that "golden mean" which will lead you to preserve harmony and good feeling without offending your own sense of self-respect. A husband who rules a wife is in my opinion quite as contemptible as a woman who rules a husband. It was never intended that a wife should *obey* a husband for that is the duty of a child toward a parent, but a husband is a friend, a companion and should be an equal.[10]

From a lengthy discussion, she turned to an appraisal of her friend's character, pointing out the differences in their personalities and purposes: "You have no ambitious restless spirit to satisfy. You can be content in the society of those you love and your happiness would

increase in proportion to theirs. Your ambition would be to please those near and dear to you, to be the bright particular star in your home, to have your image ever present to him for whom you lived and to live in the light of his smile."

Cornelia, she said, was "too gentle" to "look beyond the dear home-circle for contentment, satisfaction, or peace of mind." She, Hatty, emphatically was not. "The cold applause of the world would be little to you if you had no affectionate kindred spirit who could share its honors with you." Becoming increasingly extravagant, she added that "the crown of laurel without the approval and sympathy of him whom you loved above all things, would be to you but the crown of thorns."[11] However prolix her pronouncements, they illuminate her most serious thoughts on marriage. She knew what she thought matrimony ought to be. She also recognized herself as the "ambitious restless spirit" who must find her way outside the home and alone.

Cornelia Crow and Lucien Carr were married March 27, 1854, in the Unitarian Church at Ninth and Olive Streets. After the wedding, Hatty was her old self, not the solemn friend who signed herself "H.G. Hosmer." "Now, my dearest little pet of a Corny," she began, "you can't imagine how much good that letter of yours did me." Not only was Cornelia happy with "such a good Lucien," Hatty observed, but she had not forgotten "her loving friend and sis." Vowing that they must write more frequently, Hatty was answering Corny's letter immediately, wishing that she could give her "such a hug as you have never had before." Cornelia and Lucien must be "charmingly happy," she thought. "I declare when sculpture fails I will get a husband and live next door to you and emulate your example," she vowed. It was just as well that she had not gone to St. Louis for the wedding. Admitting her jealousy of Lucien Carr, she was afraid that she would have glared at him, "made eyes at him and scowled." Her enthusiasm rose as she thought of Cornelia as a bride: "You blessed little Lamb—to think you are Mrs. Carr!!! The wife of Mr. Carr!!!!" Girlishly, she said that her friend would always be "Corny" to her and that she would never call the new husband "Mr. Carr."

Obviously, Hatty's delight in her own situation made her friend's marriage easier to bear. She felt, she said, as though she had been born in Italy. The "dear Italian" language sounded "as natural as English." "Minor annoyances," which she didn't name, were easily overlooked in light of the moderate climate, the glorious Campagna, and the art that was everywhere. Her health had never been "so uninterruptedly good," she said. She could never take the winters at home, she thought, and "besides I shall be positively tied here after this winter. . . . I admire

America but as you know, and I hear your reproaches," she told Cornelia, "my heart's best love is for Italy."[12]

During this period, Hatty's English friends were following the progress of the Crimean War, the outcome of which would have an effect on the complicated process to unify Italy. The kingdom of Sardinia, also called Savoy or Piedmont, had entered the conflict on the side of England and France, all fighting on behalf of Turkey against Russia. Count Camille de Cavour, minister to the king of Sardinia, had urged the monarch to participate, seeing an alliance with the winning side as a place at the peace table, a scheme duly realized. Hatty, reporting on the war from Rome, had only superficial interest. "I dare say it seems as far from us as from you and when the fact of taking Sebastopol is really performed, I don't know what they will talk about. I suppose there is no danger of America taking any part; there was a report that she did intend it but would take the wrong side—that is, of course, that of Russia."[13] For all her lack of interest, the Crimean War was the first major conflict reported to those at home by journalists in the field. Even more important, perhaps, it marked the first time that women organized and carried out nursing care for sick and wounded soldiers, even though women had been serving in the capacity of nurses for centuries. The name of Florence Nightingale became widely known and used as a synonym for *nurse*.

She found herself drawing money on Crow's account sooner than she had planned. Debts for marble and other properties were encumbrances when he took over for her. "I am afraid I did something very unbusinesslike when I drew for the $1000 without notifying you previously," she wrote. She had not thought that there would be any urgency, but she had been compelled "to secure two or three pieces of marble." The sum she had drawn, reckoned as two hundred pounds, would last her a year, she thought, unlike her previous stipends. "If it does not, I will lay my head with the foxes who have nests and birds of the air who have holes or vice versa." To demonstrate her new parsimony, she wrote, "I am about to part with my gallant gray for several reasons; one of which is that he has very nearly broken my skull by quickly elevating me over his own."[14]

Her criticism of Dr. Hosmer did not abate. Rather, Crow's patronage seemed to give her greater freedom to speak bluntly. Her father was, she said, "what may be termed a queer one." Rebelliously she went on. "I know his affairs are in anything but a flourishing condition, but, as he has been preaching poverty to me ever since I have been born, I really don't know what to judge of what he says."[15] As for her work, she wished that he would just "try his hand at it," and perhaps he would

understand more fully why he had not seen the results of her efforts. Art was the most "capricious" of all professions, she thought, and "the good 'start' as we Yankees say" was all important. Without it, "one may model till one is blind and if one gets no commissions for one's work, what is the use of it, for a work can never really be finished till it is in marble." She realized her own good fortune as she looked around at artists who had been in Rome for years, "still waiting for their 'start' to turn up, as Mr. Micawber would say." Why was she "so much more blessed" than her neighbors in having her dear friend Wayman Crow?[16] He understood her situation while her father had no more idea than an unborn child what it took to be a sculptor. He seemed to think that she was prone to "squander on molasses and sugar candy" money that Crow had sent. Admitting that she had spent substantially, especially for marble, she called it "that pecuniary bread cast upon the waters" that would return "*not* after many days" but promptly in the form of orders for sculpture.[17]

Summer came, and with it the withdrawal of those who could afford to leave Rome for a cooler climate. Hatty liked the summertime in Rome, a season free of tourists. After a day's work in the studio, uninterrupted by sightseers, there was the easy camaraderie with fellow artists. She was, by this time, completely comfortable with the Italian approach to casts and models of the human figure. Thomas Crawford, her American colleague, who was also working in his Roman studio that summer, found her lack of inhibition shocking. "Miss Hosmer's want of modesty is enough to disgust a dog. She has had casts for the *entire female model* made and exhibited in a shockingly indecent manner to all the young artists who called upon her. This is going it *rather strong*."[18] When Crawford reported, she was probably enjoying the lack of restraint with some youthful defiance, feeling no need to explain her actions. But later she wrote with strong conviction that nudity was not indecent and that prurience was born in the thought and mind of the beholder.

Whether John Gibson was there or not—he was probably vacationing in Britain—his presence would not have discouraged her. He frankly decried prudishness and was said to have invented the legend of *The Wounded Amazon* so that he might model the lovely lines of a young Roman peasant.[19] Later in the summer, Hatty went to Florence, riding in company with the American sculptor Joseph Mozier and his wife. Mozier, a native of Vermont, retired as a New York businessman to pursue a career in sculpture. He had first had a studio in Florence, then had settled in Rome. Crawford, heartily disliking the Moziers and disapproving of Hatty, told his wife that, should they attempt to call on her while they were in Bagni di Lucca, she should treat them "with very chilly civility."[20]

The Brownings had remained in Florence for the summer, for the funds for trips elsewhere had failed to materialize. They were in their spacious rooms on the *piano nobile,* in a town residence known as the Palazzo Guidi. Affectionately, they called their portion of the place the Casa Guidi, the name that has clung to their Florentine home. For a year at a time, the Brownings leased six rooms—sometimes more—plus two tiny terraces, really minuscule balconies, and a kitchen. Perquisites for the occupants included a porter to carry water and to provide a light for visitors as they mounted the dark, stone staircase. Nearby was the Pitti Palace with its beautiful Boboli Gardens, where they had the privilege of walking without buying a ticket each time.[21]

In earlier years in Florence, the Brownings had been inclined to shun company, particularly those people whom they considered intellectually inferior, vulgar, or pushy. But as time went on, they became increasingly sociable. They went to operas at the Pergola, a diversion that Hatty Hosmer apparently shared with them throughout the middle 1850s. Elizabeth's physical strength seems to have been at its peak at that time, although those who saw her described her as very frail indeed. That she had managed to give birth to Penini and to survive, after a previous series of miscarriages, was a miracle.

Their dear friend Isa Blagden was also a member of the English and American circle in Florence. Remembered chiefly as "Dearest Isa" in the Brownings' letters to her, she had her own identity as a writer, with a warm circle of friends who testified to her good-hearted earnestness and loyalty. She was small, and her nut-brown complexion and black eyes suggested an East Indian heritage, so Henry James said. She rented rooms in the Villa Bricchiere, near the summit of Bellosguardo, the hill memorialized by Elizabeth Barrett Browning in *Aurora Leigh.* The house of yellowed stucco had graceful gardens with tall cypresses and pines. From the terrace, guests could look down on the city of Florence, all rosy and golden before them, with the cupola of the Duomo easily distinguishable on the horizon across the Arno.

Hatty stayed with Isa Blagden during the summer's visit and on subsequent occasions. Early in the morning, she would amble down the tortuously winding path, past the farms with goats and chickens underfoot in the barnyards, to the town below where the footing was firmer on the cobblestone streets. Anyone who follows in her footsteps can appreciate her boast that she had become "a famous walker." Adelaide Sartoris was also in Florence that summer, looking forward to seeing Hatty as soon as she had said "how dye do to Miss Blagden" and had put up a bed to welcome Hatty as an overnight guest.[22]

From early August until October, Hatty was an almost daily caller at

the Casa Guidi, mounting the stairway in the morning to join the Brownings for breakfast, sitting in her own special chair, drinking from her particular coffee cup. When she had passed the day studying the art treasures of Florence, she often stopped a second time to see the Brownings before she trudged back up Bellosguardo for the night. One evening Robert Browning read from Harriet Beecher Stowe's latest book, *Sunny Memories of Foreign Lands,* to Elizabeth, Isa, and Hatty. It struck them as uproariously funny, not quite the author's intention. "It will not add to her reasonable reputation in any country or with any class of readers, I should think," Elizabeth wrote to Sarianna Browning.[23]

At five years old, Penini still had his peculiar pronunciation of certain letters, an impediment that Elizabeth found endearing as she spelled out phonetically the sounds he uttered. "Spillets," for spirits, were still his everyday companions. He thought, he said, that *"evil spillets* have been looking round the world for somesing pretty for Penini." When his father, always suspicious of and antagonistic toward Elizabeth's belief in spiritualism, said that he was glad that Penini at least recognized the spirits as evil, the boy corrected his slip of the tongue, saying that he meant "dood, beau–tiful angels!" The pretty something was a china place setting he had seen and coveted. Hatty sent it to him anonymously, Elizabeth reported. Penini told of his delight at the surprise of receiving a big box that contained not only the dinner set but "a thing to make butter with, & a thing to hold water!"[24]

In mid-September, Hatty was suffering from a painful boil, a pestilence of the nineteenth century. Physicians were unsure of the causes of these noisome infections but believed that they could be instigated by malnutrition, poor hygiene, physical excesses, stress, or could be regenerated by germs lying dormant in clothing. Hatty was forced to lie on the sofa—"she cant sit, poor dear thing," Elizabeth told Adelaide Sartoris, ". . . and not having fairly made up her mind to be human & liable to such contingences (not found in the marble) it has gone hard with her, & she has been out of spirits to a degree which really makes a sort of *demand* upon your presence for consolation—You might as well lay the Pallas Minerva of the Vatican on a sofa—it seems as natural a prostration as dear Hatty's."[25]

One morning Robert Browning met Hatty at the bottom of the hill, as he often did when she was in Florence. The two, looking for excitement, commandeered a donkey cart owned and operated by the neighborhood vegetable dealer Girolamo. With the owner's permission, the two, seated in the brightly painted *carretta,* waited expectantly for the donkey to respond to their commands. Hatty, an old hand with horses, got nowhere with the donkey, who knew, she later said, "of what un-

practical stuff poets and sculptors are made." Asked whether the animal would go without his owner, Girolamo answered, "Oh, *Andra-Andra!* He will go, he will go!" And go he did, at first to Browning's delight. Gripping the rein, he called out, "This is great—*de gustibus non,*" his voice rising over the noise of the wheels of the cart as it clattered over the cobblestones of the street.

"You had better let go your Latin and hold on to your seat," Hatty shouted, reminding him that they were being run away with. As the donkey ran faster, vegetables for the early-morning delivery catapulted out the rear, the floorboard vanished completely, and the seat slid about precariously, threatening to throw the thrill-seekers into the street. Enumerating in snatched phrases the potential for disaster, a breathless Browning continued to call up classical references such as Hector dead at the chariot wheel of Achilles. Then suddenly, the donkey stopped abruptly at the gate of the vineyard that was his home base. Assunta, Girolamo's wife, who stood at the gate, was properly indignant in the best Italian virtuoso manner, calling the donkey all manner of colorful names and ending with an invocation to the Blessed Virgin to witness that he was "a disgrace to nature."

Very late for breakfast but refusing Assunta's offer of a ride back in the cart, the two picked their way home through cabbage leaves, stalks of fennel, "here and there a potato"—the refuse that marked their "flying progress." For the benefit of Elizabeth, who had been anxious about their late arrival, Browning assembled all of the props—vegetables, boards, a heavy piece of carved furniture to represent the cart, some ropes for reins—so that he could act out the drama. He was a consummate actor, and Elizabeth was soon laughing heartily, an exercise that Browning declared was good for "Ba." "Gazing with satisfaction at her helpless condition (from laughing) and at her face glistening with tears," Browning added, "and I will set this down as the laugh of her life."[26]

After her extended visit in the summer and early autumn of 1854, Hatty returned to Rome. A letter, written by Robert and postscripted lengthily by Elizabeth, according to their habit, recalled Hatty's presence among them.

Writing to you, dearest Hattie, is almost like breaking a spell and driving you away, or at least, putting in evidence for the first time that you are really gone, out of sight, out of hearing, out of reach—you *won't,* then, come in any more of a morning or afternoon the old way? I can tell you, and you will believe it, I think, that often and often Ba and I have seen you on the queer chair at the little end of the table, on the sofa, and in all proper old places of

yours. You are dear and good to speak to us as you do, to feel, as you say, for us—come back to us at any distance of time and you'll see whether we love you less—*more* it won't do to promise, meantime both of us wish you well with our whole heart.

For a thank-you gift of egg cups and spoons that she had sent, he chided her.

Now then, the quarrel which lovers always indulge in:—What business had you to suppose we wanted those cups and spoons to remember you by? There I found them on my return that last morning; would not a flower or two have done as well?

Browning concluded his long letter with the wistful question "What of the Greek now, pupil of mine? and what do you read or intend to read? Poetry, mind; and the sketching done once a day, and inventing something, don't you remember?"[27]
Elizabeth shared the last leaf of paper.

It has been so cold here, Hattie! warmer today, though—and we have been so wicked and ungrateful, not to have written all this time, to thank you for the mystical egg boilers, whose spirit of Amé and love must burn together!

The egg boilers would not "console us for the want of the third coffee cup," she said, going on to a description of Penini at play with his memento from Hatty.

Penini was in ecstasy, and I wonder the hinges of his writing box haven't dropped off, at this millionth time of opening and shutting. "Leally," says he, "I must say, this is a velly pretty present of dear Hattie's." That was a soliloquy I happened to overhear.

Of Hatty's work Robert was always solicitous. He wished she would describe her "little room and what's in it." Did she "draw from Teresa or any new model?" Was she considering the two Circe groups? "How goes on the bust of Mrs. Cass?"[28]
Back in Rome, Hatty moved from her previous quarters. She found just the place she wanted, but there is no mention of its location. An offhand remark made by Elizabeth to Isa Blagden, that Hatty was "quite satisfied with your Villa Moutier," may be a clue. Her landlady, in what might have been a *pensione,* was French, and the room, or rooms, were surely in the same neighborhood as before. Fanny Kemble, resident in London, begged for word of the "new lodging, how many rooms you have, and the *etage,* how is it furnished, what aspect you have, what sort of studio?" She added notes about the decor of her "smoky London

lodging," where her "precious Roman casts" were exhibited, with "marble slabs to stand on and grand looking glasses behind them."[29]

Writing to the Brownings in January, Hatty pointed out that letter writing was not her forte: "Dearest Mr. & Mrs. Browning—(I am always in doubt whether this or 'dearest friends' seems least old-maidish). So I am a 'bad, unkind, frail & forgetting Hatty' & I deny it all." The memory of her dear friends was "as dear to my heart as its aorta, an expression in which want of sentiment is made up for in anatomical force." Her boils continued to plague her. A new one "added to the list" brought the total to sixteen, mild when compared with the eighty or ninety that her friends claimed for themselves or others. She called Dr. Diomede Pantaleoni her "cook," since she was "subsisting chiefly on very nasty medicine which he gives me. He says I must never spend another summer in Italy."[30]

There was a "great hole" in Rome that winter, Hatty said, although Adelaide Sartoris was there. She had only recently moved into an old house that had been renovated. Only a familiar table with the same cloth that they knew reminded her of the times when they gathered around it so happily. Mrs. Sartoris was, Hatty said, "the same dear good blessed angel as ever," who, along with Roman comrades Leighton and Aïdé, sent love to the Brownings. Hatty had dined with John Gibson the day before, "a cosy time." He was modeling his statue *Clemency*, she reported, and he had also just colored his *Cupid*, "which I like much better than the Venus. The color of the flesh is exquisite." She ended her letter "with a kiss to little Penini & two to both of you believe me yr ever loving."[31]

On Easter Sunday Hatty planned to ride horseback, happening in at the Piazza (St. Peter's) just in time to see Pio Nono's benediction. "The only thing that would make the excursion more charming," she wrote to Elizabeth and Robert Browning, would be to have them mounted also, with "little Penini bringing up the rear." Addressing her friends as "You two dear angels," she regretted Mrs. Browning's recent illness, using it as a reason to defend the Roman climate, in competition with that of Florence, as "not so fiendish." She would never be persuaded that Florence was healthy—"in winter cold & bleak & in summer hot & boily." Her boils were still troubling her, and she complained of a fierce headache, an ailment mentioned from time to time, that had marred an otherwise pleasant trip to Frascati. She and her companions had proposed going to Ostia, but since it was under water "& we not being sea-nymphs," the plan was abandoned. But nothing compared with the fun of the previous winter, and Hatty begged Elizabeth and Robert to return. "Oh do do do come to Rome & let us make one more excur-

sion!!! Rome, or not Rome, that is the question. Whether 'tis nobler in the mind to suffer the coughs & boils of outrageous Florence or to take coach instante via Perugia and, by passports, end them?"

As usual, she continued, Adelaide Sartoris sent "no end of love & kind messages." She had been giving concerts every Friday "& singing magnificently." Mrs. Sartoris had not "the slightest idea," Hatty said, "what she is going to do this summer," apparently a distressing state of affairs. "Fancy letting her husband go on in that way! He condescended to say the other day that they should probably be in England in October—that's all she knows." They had been waiting eagerly, Hatty said, for "any accounts of Fay's pictures," and Page had painted a Venus— "You never saw anything half so lovely."[32]

The Brownings were planning a trip to France and England, one that would take them away from Italy for an extended length of time. Eager to recapture one more time the joy of their companionship, as it had been during the winter in Rome and again during the Florentine summer, Hatty apparently went to Florence in May. It would be only a matter of weeks before they left for France. An episode that probably took place during that visit involved Hatty, Elizabeth and Robert Browning, and also Elizabeth and William Burnet Kinney, Americans who had taken up residence in Florence after Kinney had served as the United States representative to the court of Sardinia at Turin. Elizabeth Browning liked the Kinneys, although her friend Isa called them "those horrid Kinneys." They were generous with their carriage and frequently took the Brownings for drives. Elizabeth Browning found William Kinney "an admirable, thoughtful, benevolent person, as liberal in politics as an American diplomate is bound to be & much more religious." Mrs. Kinney was pretty, she said, "with torrents of ringlets, & dressed perfectly—clever, literary, critical, poetical—just as you please . . . rather overlively & not over-refined . . . but a favorite of mine through her truth & frankness, besides her warm heartedness towards ourselves."[33]

It was too bad, they all agreed, that women were forbidden to enter a certain monastery that housed a fine collection of early Italian paintings. Hatty, the fifth member of the company, was unshakable in her determination to see the collection. The women would masquerade as young boys, she announced, with Browning and Kinney as their tutors. Hiram Powers assisted with the wardrobes, plaited student gowns for the women, reaching to the knees and belted at the waists. Full Turkish trousers, cloth caps, and short bobbed wigs completed the garb. For Hatty, who often wore pantaloons when she worked in her studio, the male costume was second nature. Elizabeth Kinney, pleased with her own transformation, recorded that Hatty was "short and stout" and that

her costume made her look like "a fat boy, if boy at all, and very peculiar!"[34] Elizabeth Browning, on the other hand, looked "really handsome," Mrs. Kinney thought. "For the first time I saw her without those dark, heavy curls she always wore half concealing her cheeks, and the wig of short straight hair improved her looks; excitement gave her usually pale face a fine color, and her large black eyes an unwonted brightness." Elizabeth was exhilarated, probably by "an extra dose of opium," Mrs. Kinney believed. Elizabeth Browning had indeed been addicted to mild doses of laudanum since adolescence, when she was given opium to help her sleep, a common medical practice of the time.

While Mrs. Kinney and Hatty were still regaling each other about their disguises, Elizabeth moved down into the piazza. Meanwhile, the two men, dressed as tutors, were off renting a hack so as not to attract attention to the Kinneys' carriage. They planned to pull up surreptitiously at the porte-cochere at the foot of the stairway so that the women would not be seen getting in. But when they arrived, there was Elizabeth, walking up and down, attracting the attention of the Florentines. When Hatty and Elizabeth Kinney discovered that Elizabeth had gone onstage ahead of her cue, they went to rescue her, only adding to the curiosity of those in the square. When the men arrived, they quickly whisked the women into the carriage, but the high moment had passed. Elizabeth Browning was in tears, fearing that they would find themselves in jail. The police might follow them, and the whole matter be exposed in the newspapers with their names, Browning feared. William Kinney laughed at his friends' apprehension, and Hatty, who hated to be thwarted, called Robert "a poltroon and other hard names."[35] Nonetheless, the escapade was aborted. In June, the Brownings took off. It would be a long time before Hatty would see them again.

10
Puck and *Oenone:*
A Marble "Son and Daughter"

John Gibson was proud of his female pupil. Of her recently completed works, *Daphne* and *Medusa,* he said simply, "They do her great honor." Considering his young student to have what he called "a passionate vocation for sculpture," he gave an account of Hatty to her father.

> Your daughter's industry continues unabated, and she makes progress in her profession, for her last model is her best. It is really a fine work and would do credit to many a sculptor in Rome. We have here now the greatest sculptor of the age, [Christian] Rauch of Berlin, seventy-seven years of age. He came to my studio and staid a considerable time. Your daughter was absent, but I showed him all she had done, including a small sketch-model for a statue life size [probably *Oenone*]. Rauch was much struck and pleased with her works and expressed his opinion that she would become a clever sculptor. He inquired her age and wrote her name in his pocketbook. So now you have the opinion of the greatest living sculptor concerning your daughter's merit.[1]

With such an endorsement from Christian Rauch, seconded by John Gibson, Hatty was eager to begin the full-length figure commissioned by Wayman Crow. Ideal busts were all very well for a start, she thought, but a life-sized figure would give her more opportunity to express her ideas with greater power. Her choice for the work was *Oenone*, the shepherdess mate of Paris, son of Priam and prince of Troy.

The story had been told in ancient literature by Apollodorus and reiterated by Ovid in *Heroides V.* When the oracle had foreseen that Paris would be the cause of Troy's destruction, the young prince had been hidden away in a bucolic locale to be a shepherd, his identity not known, even to himself. He and Oenone became lovers. When a competition was held to determine who was the fairest among the goddesses, Paris was chosen to be the judge. For awarding the golden apple to Aphrodite, his prize was Helen, the wife of Menelaus. Paris took his

prize. A less familiar part of the story is Paris's rejection of Oenone, left to languish in humiliation.[2]

Some years before, Alfred Tennyson had written his version of the ancient legend, telling in finely wrought verse the pathos of Oenone's passion and Paris's cruel behavior toward her. Treating the story from the standpoint of the forsaken woman allowed Tennyson to infuse the work with the kindred themes of high moral purpose and tragic love, which appealed so strongly to Victorian readers. First published to an unappreciative audience in 1833, the poem was revised, and when it appeared in a volume of Tennyson's poems in 1842, it received a more cordial reception. Elizabeth Barrett Browning, a friend and colleague of Tennyson's, praised the second *Oenone*, calling it the best work in the volume—an opinion she may have shared with Hatty Hosmer some years later in one of their talks about art and poetry.

Hatty had been partial to Tennyson since the youthful days in Watertown when she and her friend Lydia had gone "frantic" over him. Just as she had been inspired by "Sad Hesper o'er the buried sun / And ready, thou, to die with him," so was she moved by Oenone's lament as Paris leaves her:

> "Yet, mother Ida, harken ere I die
> Fairest—why fairest wife? am I not fair?
> My love hath told me so a thousand times."[3]

Hatty continued to keep the statue's identity a secret from Crow even as the work progressed. "Your _____ (I don't tell you what it is but it is neither the Lost Pleiad or Galatea) is destined for you and you are to have it and a more exquisite piece of marble is not to be found." The marble lived up to her expectations, revealing no inner flaw after the work had been begun. Calling it "your marble daughter," she told Crow that it was "getting along quite bravely." Although the statue would be finished before the winter of 1855 was over, she begged to keep it "while the strangers are here and then it will toddle off to you."[4]

It was nearly a year later when she divulged Oenone's identity to her patron, stating simply that the figure represented "Oenone abandoned by Paris," quite as though these two were everyday characters in the nineteenth-century world. To Cornelia she said that the figure was "perhaps in the same awkward predicament that you would be if Lucien should desert you for me, for instance." "Somewhere on the ocean," she wrote, "my daughter *Oenone* is probably very seasick. If you do not experience the same sensation when you see her, I shall be content."[5]

Seen today, *Oenone* seems closer to twentieth-century ideas of sculpture than do any other of Hosmer's figures. The graceful curves of the

female body, the roundness of the breasts, articulate the abstraction of forms that was yet to come. There is an inherent unity in the work and a sense of organic form, as though the piece had indeed sprung from within, freed from a single block of marble. *Oenone* seems to have dropped to the ground in an unstudied way, but the pose is supple, the head bowed in utter dejection. The fingers curve over the edge of the small oval base, etched to simulate the texture of a grassy knoll. The drapery is softly and naturally arranged on the lower body, leaving the upper torso nude. Considered to be the most important element of the modeling after the figure itself, the drapery has a simple, decorative motif at its edge and a luminous sheen as the light catches it. The flesh has a different finish, velvety, warm, and alive.[6] Moving around the freestanding figure, one has a glimpse of a foot peeping out from beneath the other, a pose that seems uncontrived but at the same time alluring. Although *Oenone* is pathetic, she is also sensual in the subtle way that the sculpture of the period communicated sexuality. The face is the stylized, classical countenance. The eyes are lowered in melancholy. A shepherd's crook, small and only softly defined, almost escapes notice. Often in such literary pieces, the accompanying props—a shell, a fisherman's net, a slave's chains—all too emphatically insured the figure's identity.

During the summer of 1855, Hatty had planned to accompany John Gibson on a trip to Britain, but a letter from her father, arriving only a day before their scheduled departure, convinced her that she should make every effort to curtail expenses and handle Crow's largesse more prudently, so she remained in Rome to devote herself to her work. Renewing her vow of poverty, Hatty "sent for," in the words of Mrs. Ellet, the young sculptor who can be presumed to be Shakspere Wood. Wood found her "pale and changed," the account went on, a condition related to the humiliating presence of the scourge of boils, revealed to Wayman Crow but possibly not to a young male colleague. Writing about women artists a few years later, Mrs. Ellet defended the relationship. "It is said that a friendship between a young man and a young woman is scarcely possible, and, perhaps, under ordinary circumstances where the woman has no engrossing interests of her own, no definite aim and pursuit in life, it may be so."[7]

Hatty casually tossed off the meeting with Wood in a letter to Wayman Crow, quite as though it was scarcely worth mentioning. Telling him that she meant to economize, she added, "Moreover I have got somebody to look after my affairs who is really a business character which I don't believe I am." The "business character" and platonic friend appears to be Shakspere Wood. Some months later, Elizabeth Barrett

Browning, writing to Isa Blagden from Paris, had heard gossip: "Mrs. Sartoris hears, through a reliable person, that Hatty is compromising herself more & more with Shakespeare Wood—What a pity! what a pity!—The Clarke influence [possibly Sarah Freeman Clarke] appears to be as impotent as others are. She's a . . . Hatty." Another mention of Hatty in the same month is enigmatic: "Dearest Isa, did it ever strike you that the 'marriage' might be with Hatty herself—Oh—I hope not."[8]

Elizabeth's confidential remarks about Hatty's behavior seem almost out of character for her, for she was a broad-minded woman who admired Hatty's free life-style. For Hatty to go about with John Gibson was not an occasion for gossip, but what was perceived as an intimate friendship with a young Englishman of her own age was something quite different. She was apparently being seen in company alone with him, enough to cause comment. It may have been this instance, rather than any gossip about Hosmer and Gibson, that Robert Browning was thinking of when he wrote in later years, "Had I believed stories about *her* [Hatty], many a long year ago, and ordered her away from people's houses on the strength of them, I should have lost a friendship I used to value highly."[9]

While the reference to marriage in Elizabeth's second note to Isa is vague, it suggests that Shakspere Wood was not yet married; at the time of his death in 1886, he left a widow and two children. One guesses that Wood may have lacked social graces, for Story had commented on his awkwardness. Nor did he measure up to the social stratum that Hatty circulated in. It is almost certain that the relationship was platonic and that nothing considered to be improper occurred, although Hatty's friendship with Wood can perhaps be seen as one of her closest encounters with an intimate and potentially romantic friendship with a male of her own age. Henry James's character Daisy Miller, in the novel that bears her name, comes to mind as one recalls the beautiful American girl traveling in Italy, virtuous but oblivious or indifferent to existing taboos. Her reputation suffers when she is severely criticized for her choice of companions. Hatty was surely not Daisy Miller; aware of the rules, she knowingly chose to do as she pleased.

During the summer of 1855, which passed without "fever or mischief," so Mrs. Ellet reported, Hatty modeled her most financially successful work to date. *Puck* was a marble figure only thirty inches high. Although the subject was probably inspired by the sprite in Shakespeare's play *A Midsummer Night's Dream,* the little figure is more nearly the image of a puckish Hosmer than the tragic marble maidens ever were. In choosing a Shakespearean character, Hosmer was appeal-

ing to a vast and devoted public, for the plays of Shakespeare were highly popular entertainment, not only in Britain, but in America.

Puck, who was to earn his weight in silver, is a chubby baby who wears a shell tilted roguishly on his curly hair. He has the squinched-up face of an infant, but his eyes are blanked out in the classical manner. Looking carefully, you can see that he has rudimentary horns, still just seminal bumps on his forehead. Protruding from his shoulders are the large wings of a bat—or a devil. That he is a demonic creature of Hatty's romantic imagination is clearly shown in a letter to Anne Dundas, a Scottish friend to whom she wrote openly and entertainingly of her life and work: "Yesterday I went into Rome [from a stay in Albano] to have photographs taken of my son and daughter [*Puck* and *Oenone*]; . . . Master Puck's god-mother, you know, is to be that dear Mrs. Emily, to whom I am going to send the portraits of her devil-born god-child as soon as they can be printed."[10]

Bent on mischief, *Puck* clutches in his right hand a scorpion that he is about to throw. In his left, he confidently grasps a lizard whose scaly tail curls up Puck's fat arm. He sits on a toadstool with one foot tucked under the other. The protruding member has the toes curled fetchingly, a fact that provoked the crown princess of Germany, later the Empress Frederick to remark: "Oh, Miss Hosmer, you have such talent for toes!" Everything about the little woodland creature, surrounded by smaller toadstools and thistles, suggests that he is fantastical. Still, he has the genitalia of an infant male.[11]

Puck was called "a laugh in marble," and indeed he was a *scherzo,* a little joke that few could find fault with. James Jackson Jarves later wrote that Puck "displays nice humor and is a spirited conception."[12] The enormous appeal of this little conceit, or "fancy piece," as such works were called, is reflected in its many repetitions, pieces that earned some thirty thousand dollars for the sculptor. Hatty's first price was five hundred dollars, as she told Crow in answer to his question. Later, John Gibson convinced her to raise the asking price to eight hundred dollars in gold. It is possible that subsequently it commanded more.

Among the aristocratic purchasers were the Duke of Hamilton and the Earl of Portarlington, but the most celebrated royal acquisitor was the Prince of Wales, later Edward VII, Victoria's eldest son. In 1859, still a youth in his teens, he came to Rome, where he made the requisite rounds of the artists' studios squired by England's most revered sculptor, John Gibson. Proud to show the heir to the throne his young American pupil's work, Gibson steered the prince and his entourage to her atelier. A cartoon in *Harper's Weekly* captures the prince, affable and charming, talking to Harriet Hosmer. She is dressed in her studio

Oenone, by Harriet Hosmer, ca. 1855, marble, height 34". Collection, Washington University, St. Louis, Missouri, gift of Mr. Wayman Crow, Sr.

costume of gown and beret, somehow resembling a nineteenth-century Portia as she receives her royal visitor, neither the first nor the last of the European bluebloods to cross the threshold.[13] The prince bought *Puck* for his rooms at Oxford, apparently the scene for his own brand of puckish revelry.

Earlier in 1855, Cornelia and Lucien Carr had their first child, a girl christened Harriet Hosmer Carr. Hatty was overjoyed to have a namesake, and pride, tenderness, and spontaneous love spilled out in her letter to Cornelia and to the godchild. Many years later, Cornelia, editing Hatty's letters, apologized for the inclusion of a letter "almost too intimate for publication." Her purpose, she said, was to demonstrate "the warm, feminine side of the artist's nature" and to show "how keenly she longed for, and eagerly accepted, the ties of family life and love." Cornelia went on to explain that Hatty suffered from a deep

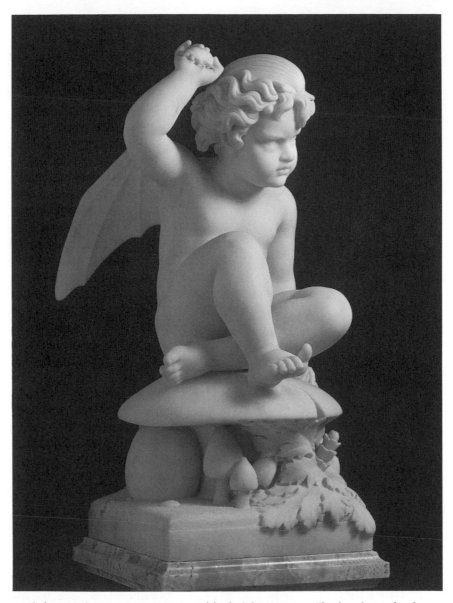

Puck, by Harriet Hosmer, 1855, marble, height 31". Inscribed on lower back "H. HOSMER/ROME." Collection of Richard York Gallery, New York City.

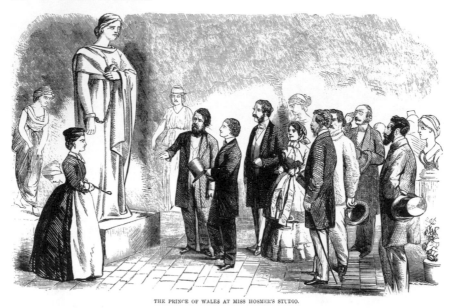

THE PRINCE OF WALES AT MISS HOSMER'S STUDIO.

"The Prince of Wales in Miss Hosmer's Studio," *Harper's Weekly* 3 (May 7, 1859): 293. Courtesy Kanawha County Public Library, Charleston, West Virginia.

loneliness in childhood, a reality not recognized by Hatty or her father. He had tried to make her life happy, Cornelia said in his behalf, "despite his own absorbing profession."[14]

Sharing his daughter's delight on the occasion of little Hatty's birth, Hiram Hosmer extended his formal congratulations to the child's father, Lucien Carr. His note provides at least a token recognition of the existence of Lucien Carr, who is very nearly nonexistent in Hatty's letters to Wayman Crow and Cornelia. But were Lucien Carr, an estimable man, to be regarded from the perspective of the Crow and Carr families, a well-defined image would materialize. He was a devoted husband and father, a man of many scholarly interests.[15] Dr. Hosmer's note to Lucien Carr is one of the instances in which we hear him speak for himself rather than through Hatty's often rebellious reflections of him. The note reveals that he remained a serious man of little levity, speaking with the voice of duty.

Hatty's doting letter shows quite clearly her abundant capacity for affection as well as the sensual character of her nature.

Rome, March, 1855

My darling little god-daughter:
Two days ago I received the announcement of your arrival in the world, which you must make beautiful by your smiles. How dearly I should love to see you with your soft, dimpled cheeks and your little lips that are getting to

be just round enough to kiss, though always sweet enough to love. I shall love you all over, very much for yourself, and twice over, for the sake of your dear mother, who was my best friend when we were girls together, and who is my best friend and sister, now that we have begun the world in earnest.[16]

She planned that the child would call her "Hatty" or "Aunt Hatty" and asked the infant rhetorically, "How would you like to come to Rome and work in my studio and make little boys and girls as beautiful as you are yourself?" She pointed out the importance of filling the mind and heart with beautiful and kindly thoughts from the very beginning. The images in the brain that would be translated into sculptural concepts had to reflect a beauty of character, for otherwise, "your marble children would be only the sculptured shadows of your soul, and if your soul is not pure and great, how can you expect your children to be so?" This was her creed, expressed in its purest idealism. Eager not to sound too stern, she told the baby that, were she there, she would take the little one on her knee, play with her, and tell her stories. "Now you must take a whole shower of kisses, my little one, from Your most loving God-Mamma," she concluded.

To Cornelia, she wrote that she could already see her godchild, "in my mind's eye, installed with a chisel, or a lump of clay, her little mobcap on her head, and calling her Aunt Hatty *'Maestra.'* I fondly expect that she will make equestrian statues of all the coming great men of the nation!" Although she firmly believed in the female destiny as artist, poet, or actress, she had no vision at that moment of women as political figures. Either she accepted women's place as society defined it, or content to distinguish herself in the field of her choice, she was willing to let the men have the rest. Writing many years later, Cornelia called Hatty's advice to her godchild "mature and wisely maternal, yet spinsteresque." Even with these closest friends, there was some conde-scension of the matron to the unmarried, drawn from the distinction that society made between the single and the married female.

When summer came, Hatty wrote Wayman Crow that she pictured the extended Crow family at Lenox, "even down to my dear little namesake." She wished that she could walk in on them, but she was all too conscious of the many miles of saltwater that lay between them. From "various quarters," she had heard that Cornelia's mother, Isabel, was once again pregnant. "Blooming" is her frequent euphemism to allude to a pregnancy in progress. Mrs. Crow, she had been told, "has never looked so blooming and so young as at present." She was so eager to see "my little Hatty," certain however that when that time rolled around, the child would be able to call her by name. Perhaps there

would be a little brother Wayman toddling around, a hint that Cornelia, too, might again be pregnant. Emma Crow, by then a volatile sixteen-year-old, was apparently undergoing adolescent unevenness. Hatty said, "I suppose she has been growing too fast but hope by this time she has learned to use her crescendo privileges in moderation." She hoped that the "Water Cure" had helped Emma.[17]

With Cornelia and her mother bearing children and most of her school friends being married, it is little wonder that Hatty was drawn to an assessment of her own single status. There is no question that, whatever a woman's other accomplishments might be, matrimony was the aim of her existence as society defined it. On the occasion of Bessie Sedgwick's marriage, Hatty wrote to Crow that "everybody is being married but myself." Written during the summer of 1855, the letter may reflect conclusions stemming from her friendship with Shakspere Wood.

> I am the only faithful worshipper of celibacy and her service becomes more fascinating the longer I remain in it—even if so inclined an artist has no business to be married—for a man it is all well enough, but for a woman on whom matrimonial duties and cares weigh more heavily, it is a great moral wrong, I think, for she must either neglect her profession or her family, becoming neither a good wife and mother or a good artist. My ambition is to become the latter so I wage eternal feud with the consolidating knot.[18]

This was the dilemma between the artist and the woman. She had clearly come to terms with her own ambition, a drive that could not be denied. Nonetheless, there was ambivalence and courage in her resolution to remain unmarried—more than is commonly recognized. Her innermost longings continued to be expressed to Wayman Crow in letters overflowing with affection. Cornelia Carr, who was not disposed to reveal her friend's most private feelings, deleted passages from these letters, not because they were improper but because they were personal.

Hatty seems at this time to have had no disinclination toward marital love or motherhood. All of her metaphors were conjugal, and the figures she made were her "children." Even more fatuously, they were, for a while, Crow's children, too; then, more circumspectly, his grandchildren. To Cornelia, in a moment of frustration, she confided: "I often think what a fool I am to have chosen to make my children in this way when if I had followed in the footsteps of another nature I should have had less to annoy me.—I suppose however I don't quite mean what I say. I think my profession one to be worshipped."[19]

Her view of marriage was romantic and ideal. The household that she knew best was the Crow family's, where Wayman Crow was head, adored by his children and his wife. Although Hatty was extremely fond

of Isabella Crow, she did not share Crow's pedestal in Hatty's estimation. In later years, Mrs. Crow became "the Mater" to match Crow's title "the Pater," but in this earlier time, Hatty refers to her with regard but not with intimacy.

By 1855, the charmed Sartoris circle had disbanded. Adelaide Sartoris had instigated a relocation of her household, first in Paris, then in England. Frederic Leighton, firmly attached to her, decided that he, too, had had enough of Rome. The entire ménage settled in Paris, where the Brownings were living in what Robert called "a horrible lodging . . . an apartment with no bottom (for carriages were under it) no top (for the roof tiles were over it) no back (for there was an end to the house with the wall of our room) and a front facing East." In December they moved to more attractive quarters, which "—not quite the Vatican in itself,—seems a great catch beside the other abomination." Suddenly, one evening, Adelaide Sartoris and Frederic Leighton appeared to "inaugurate our new rooms," Elizabeth wrote, "looking like a gorgeous St. Cecilia, with her green velvet dress and great singing eyes and brow." She talked as well as she sang, "or better some people might think."[20]

Of Frederic Leighton, Elizabeth was never quite as sure of her feelings. While she recognized him as "the successful painter of the English exhibition this year [1855] whose first picture the queen bought for six hundred pounds," she declared that she "always must doubt that there will be a development of the highest kind of genius, where there is so little humility." Robert Browning spoke of Leighton, too, in his letter to Hatty. His opinion differed sharply from that of his wife, either because he did not probe so deeply or because he understood Leighton's appearance of superiority for the reserve that it was.

> Leighton is a better fellow than ever,—very lovable, really: he is painting a very fine and original picture, life-size, of Orpheus playing Eurydice out of Hell, full of power & expression. He has a capital Pan enjoying himself in a dell—from a superb Italian model here,—the perfection of a man: a Venus, very clever too—and designs for perhaps a dozen delicious pagan figures,—a sudden taste that has possessed him.[21]

Robert said that he should really see Adelaide Sartoris "about every other day." Only laziness stood in his way, for she was as dear as before. "She sings and talks and looks and *is* just as of old,—and *so* good that is!" Hatty's "pet of a daguerrotype" lay on Adelaide's table, "and *I* know who gets hold of & keeps it and keeps it as long as he sits there!" There was already talk of a reunion of all in Rome the next winter. Adelaide spoke of going, but as quickly had changed her mind. Her

husband, Robert reported to Hatty, meant to settle in Paris—"for the next quarter of an hour, he means it."

While Browning deplored Hatty's absence from their midst, he must have made her envious: "Oh, Hatty, why were you not here,—in London first,—and you should have heard Alfred Tennyson read 'Maud' to us, and Mrs. Sartoris sing to Ruskin, & Carlyle talk, our three best remembrances." Dante Gabriel Rossetti, who was present, made a drawing of Tennyson as he read and gave the sketch to the Brownings, who placed it in the drawing room at Casa Guidi. Browning thought that no new friend of his would please Hatty more than Rosa Bonheur, "a glorious little creature, with a touch of Hatty about her that makes one start." The French artist, eight years older than Harriet Hosmer, had already emerged as a painter of distinction. Pictures of her reveal a candid face, round like Hatty's, and framed by short, curling hair. A likeness between them was noted by other observers as time went on. Bonheur's life-style, apart from the smothering embrace of the family, and her masculine kind of clothing probably contributed to the resemblance.

A few years later, Hatty wrote to her friend Anne Dundas: "If you have not already been pray go and see Rosa Bonheur and write me all about her. Mrs. Browning excepted, I do not know a woman for whom I have more respect and admiration than for her."[22] She tried to see Rosa Bonheur during a stay in Paris in 1861, but the painter was in the country, "and so of course I couldn't even catch a glimpse of her studio." Were she to come to Rome, Hatty thought, "the whole Campagna would be her studio, and she would see it in all its wonderful beauty. Fancy the picture she might make of those regal gray oxen and those dragons of fidelity, the Campagna dogs! Browning told me she had half an idea of coming, and it is the most friendly advice one could give her."

After the busy, productive summer of 1855, a short stint in the country served as a vacation. Professing herself to be rested and "strong as a Milo," Hatty promised Crow that she would be moving quickly into the winter's work without loss of time. She looked upon the letter awaiting her return as "God's providence," containing as it did assurance of the next stipend. Calling Crow "my dear, good, kind friend," she said that she was being "a good girl," as he had told her to be, drawing for only half the amount that he had made available. She believed that she would be "quite safe" financially, as "the little figure that I modeled this summer" was nearly finished.[23] This was surely *Puck,* the putto that had been ordered by a client who would pay when the marble figure was completed.

Most of all, she wished that she could see Wayman Crow in Rome.

Could he not plan a trip with the Sedgwicks, who often talked of coming? On the other hand, if she had something good to show, she might "run home and see all my good friends among whom there will be no one who has done so much for me as your own dear self . . . and that will always be the private and expressed opinion of your . . ." and here she signed with the drawing of a small hat.

11
Beatrice Cenci

Close on the heels of Hiram Hosmer's disclaimer for Hatty's livelihood had come a letter from a mysterious stranger. A certain Mr. Vinton had written to commission a full-length statue to be presented to the Mercantile Library in St. Louis, an institution formed to foster literature and the arts in the city. Hatty immediately supposed the donor to be Wayman Crow masquerading under another name. It was a likely assumption, another way in which her generous patron could help her. At the same time, he would be encouraging artistic endeavors in St. Louis.

A year before, the dynamic Crow had drafted a charter singlehandedly for a college of arts and sciences, presenting it to the Missouri legislature with the names of sixteen surprised incorporators. Originally named Eliot Seminary for the Unitarian minister William Greenleaf Eliot, in 1857 it officially became Washington University. Hatty congratulated Crow on his conception of an academic building planned to house the college, describing it as a "new hall which will certainly be a grand thing for the city—a sort of nucleus of art and learning sending forth rays of beauty and science and all sorts of good things." Reflecting on the city where she had spent nearly a year, she added, "I expect St. Louis will have advanced fifty years in taste and cultivation before I behold it again in less, I hope, than a tenth of that time."[1]

St. Louis did continue to advance in taste and cultivation. A few years later, Hatty told Crow that she was working on a fountain "that we want to see in Mr. Shaw's garden." Henry Shaw, a native of England, was a wealthy St. Louisan who had made his fortune in hardware and real estate and retired at age forty. He gave a large acreage from his country estate (now well within the boundaries of the city) to be used for botanical study and public enjoyment. When a portion of the land was set aside as a public park, Hatty announced to Crow that she could also see one of her fountains "out of the corner of my eye" in Tower Grove Park.[2]

Referring to the Vinton commission, Hatty called Crow "the prime

mover of all which is your generous self." Several months later, she was no less certain of his influence.

> Come now, dear Mr. Crow, confess Mr. Vinton a myth and yourself the liberal donor, for as yet it is nothing else, of the 1000 *scudi* [about the same amount in dollars]. I have entertained [illegible] suspicion of the truth for some time and now this generous proposition confirms the suspicion. Do I wrong Mr. Vinton—heaven forbid! Do I wrong you by supposing there *is* a Mr. Vinton in the case? Heaven forbid that too. I have an inward feeling that you will chuckle a little at the idea of my corresponding with *him* on the subject. Mind I do not doubt the existence of Mr. Vinton, I only suspect that you are inspiring him. I suppose time will prove all things.[3]

Vinton was apparently Alfred Vinton, chairman of the board of directors of the Mercantile Library. When Hatty was convinced, not only of his identity but of the independence of his action, she told Crow that if she received an order "from the poles, I should be persuaded that somehow or other you had a hand in it." How much urging came from Wayman Crow or who actually paid the bill has never been fully determined. Although she corresponded with Vinton, it was Crow in whom she confided. "Between ourselves," she told him, she was busy "composing something in my mind," a statue of "the Cenci" for Vinton, "whoever he proves to be."[4]

The Cenci that she referred to so familiarly was a young girl from sixteenth-century Roman history whose trial and subsequent execution was a dramatic incident in the era. The lovely Beatrice was the daughter of a Roman aristocrat, Count Francesco Cenci, a man of violence and perversion. Convicted of sodomy, he was also believed to have sexually assaulted his daughter Beatrice. From sexual relations of a father with his daughter, saints were born, the vile Cenci is said to have told her. In any case, he was known to have physically abused both Beatrice and her stepmother, Lucrezia Petroni, beating them both and keeping them confined in a cell-like room in a remote castle.[5]

At last, driven to the brink of insanity by his outrages, Beatrice, with the collusion of her stepmother and her young brother Giacomo, hired Olimpio Calvetti, who had been Beatrice's lover, and Marzio Catalano, a guitar teacher and tinker, to kill the wretched Cenci. According to one version, the count was drugged, but the two hirelings could not bring themselves to complete the deed. Beatrice, undone by the frustrating course of events, flew into a fit of anger whereupon Olimpio and Marzio drove spikes through Cenci's eyes into his throat. Without a twinge of regret, the two women wrapped his body in a sheet. While Count Cenci had been in constant trouble with the Roman authorities

for criminal charges and nonpayment of his debts, the case could scarce-
ly be ignored. Moreover, should the guilt of his heirs be proven, the
Cenci property would revert to the church hierarchy.

Meanwhile, a priest, Monsignore Mario Guerra, counseled the fam-
ily members to compound the *culpa* by doing away with the hired
killers. Olimpio was quickly dispatched, but the unfortunate Marzio,
picked up for another crime, confessed to the Cenci killing under the
duress of torture. Only the priest escaped, while the Cenci confederates
were taken and tried in the Sacred Rota, the high court of the church.
The pending case aroused morbid interest as well as cries for leniency.
The young Beatrice, whose charms beguiled even the lawyers who tried
to help her, became the central figure in the sensational case. Unwill-
ingly, Clement VIII provided her with one of Rome's great lawyers,
Prospero Farinaccio, who based his appeal for clemency on the premise
that the murder was motivated by an incestuous attack on Beatrice by
her father. In this classic case, Farinaccio argued diminished responsibil-
ity due to her youth, her intelligence—thought to be inferior, perhaps,
because she was a female—and her disturbed state of mind. A mitigating
aspect was the fact of a confession exacted by torture. Nonetheless, the
two women, Beatrice and Lucrezia, were beheaded, and Giacomo was
clubbed to death. A younger brother, Bernardo, thought to be retarded,
was imprisoned but later pardoned. The pope confiscated the Cenci
property.[6]

Five hundred mourners bearing torches saw the body of Beatrice
Cenci to her grave. Her tragic beauty at her execution was accentuated
by a wine-colored gown and delicate white slippers. Legends grew up
around her, and she was eventually looked upon as a saintly innocent
who had been violated. The Cenci palace took on a sinister mien.
Nearby in the Piazzetta Monte Cenci in the Chiesa di San Tomaso, a
mass is celebrated each year on September 11, the anniversary of the
execution, for the repose of Beatrice Cenci's soul.

The combination of incest, blood, intrigue, evil unadulterated, pur-
ity defiled, and wickedness in high places had a special appeal to nine-
teenth-century appetites. The story had been brought to public atten-
tion by the Genevan historian Jean-Charles Sismondi. In his work,
Histoire des républiques italiennes du moyen age, [*History of the Italian
Republics of the Middle Ages*], Sismondi cited the Cenci trial as one of
the many examples of injustice and corruption that the church had
promulgated. Published in 1840, the book supported the historian's
anticlerical position against the Roman Catholic hierarchy. The Cenci
story was well known to the Britons and Americans who lived in the
English Quarter. Many of them were eager to point the finger of accusa-

tion at the Roman church, albeit privately, as the focus of criticism sharpened in the revolutionary climate of those years.

Popular writers of the period squeezed every ounce of blood from the Cenci story. Pandering to the prevailing interest, Italian writer Francesco Domenico Guerrazzi, in 1851, wrote a sensational exposé entitled *Beatrice Cenci: Storia del Secolo XVI* with a frontispiece picturing Beatrice being pursued by her lusting father. Disregarding any historical evidence of Beatrice's guilt, Guerrazzi portrayed her as saintly and pure. It is probable that Hosmer may have been influenced by this idealistic portrayal.[7]

It was Percy Bysshe Shelley who saw in the Cenci incident the dimensions of tragedy in the highest sense. During his stay in Rome in the early part of the nineteenth century, he often visited the Cenci palace, a fortresslike bastion adjacent to the Jewish ghetto. Shelley did not perceive Beatrice Cenci as the titanic figure in a classical tragedy but rather as victim of an evil society and a corrupt church.[8] The result, *The Cenci,* was an intense drama in the Websterian mold. *The Cenci,* like Shelley, was not popular in Italy. The author, working in isolation, did not receive the accolades given to Lord Byron, and it was only in 1923 that *The Cenci* was produced as the stage vehicle that it was intended to be, appropriately mounted at the Teatro Argentina in Rome, its historical venue.[9] Nowhere in her attribution of the marble *Beatrice Cenci* does Harriet Hosmer ever mention Shelley. The irregularities of his personal life and his acknowledged atheism had alienated him during his lifetime and afterward. In Victorian society, becoming increasingly sensitive to moral issues, he had not been vindicated.

Nearly forgotten as a possible source of information and inspiration for Hosmer's *Beatrice Cenci* is Walter Savage Landor's series of tableaux, *Five Scenes,* written in 1851, in which both incest and murder are ignored. Hosmer undoubtedly knew the Landor work, as she knew Landor himself. It is highly probable that she studied the work, as well as Shelley's *Cenci,* to arrive at her concept. Her image of Beatrice Cenci reflects the final stage of the development of the character that Mary Shelley described after Shelley's death—"from vehement struggle, to horror, to deadly resolution, and lastly to the elevated dignity of calm suffering, joined to passionate tenderness and pathos."[10] But the odds favor a common ancestor for Hosmer's *Beatrice Cenci* and Shelley's *The Cenci,* rather than the latter work inspiring the former. Shelley, in pursuing the story, had been struck most forcibly by the portrait of *Beatrice Cenci* purported to have been painted by Guido Reni from life as the girl awaited trial in 1599. Harriet Hosmer, too, reported that her work was suggested by the Reni painting.

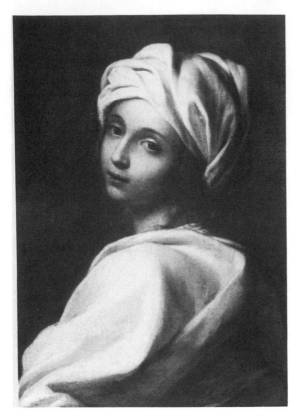

Portrait of Beatrice Cenci,
attributed to Guido Reni, oil
on canvas, 29.5″ × 20″.
Galleria nazionale d'Arte
Antica in the Palazzo Bar-
berini, Rome, from the
Barberini Collection.

Shelley had frequently gone to the Palazzo Colonna, where it was then hanging, to gaze at the enigmatic face of the subject. He even procured a copy of it from one of the myriad imitators who made their living that way. What was eerie and extraordinary was the subject's resemblance to Shelley himself. The costume was epicene and the turbaned head, with little of the fair hair showing, could have belonged to a young boy—the very image of the androgyny that attracted Shelley with its complexities. When Shelley's portrait was painted during the Roman sojourn, the artist, with conscious intention, emphasized some of the same characteristics of the Cenci face—the broad forehead catching the light, the finely etched eyebrows, the large eyes, nearly almond shaped, and the long, high-bridged aquiline nose.[11]

By the time the young Hosmer arrived in Rome, the portrait of *Beatrice Cenci* had been moved to the ground level gallery of the Palazzo Barberini. There it was almost as unprecedented a magnet for visitors as the classical models—an "art-idolatry" one critic called it, catching the public fancy much as the *Mona Lisa* did at a later period. Although

experts could not be sure that the portrait was painted by Reni, no amount of scholarly skepticism could erode the adulation of the cult of worshipers.[12]

That Robert Browning was keenly aware of Guido Reni is inherent in his poem "One Word More," written for "E.B.B." in London, 1855: "Guido Reni, like his own eye's / apple / Guarded long the treasure-book / and loved it." Hawthorne, too, during his extended stay in Rome, made regular pilgrimages to look at the painting before he climbed the staircase to the third *piano* to visit William Story and his family, who took permanent residence in the Palazzo Barberini in 1856. Hawthorne was mesmerized by the portrait, calling its spell "indefinable . . . more like magic than anything else." Realizing that most observers brought a prior knowledge of the Cenci story with them, Hawthorne wished that it were possible for "some spectator of deep sensibility" to view it without knowing the story. How would such a person interpret it? Hawthorne felt "as if the picture had a life and consciousness of its own." Reni could never have done such a work again, he thought, never questioning whether Reni had done it in the first place. While copyists might attempt to capture the expression from memory, forbidden as they were by Prince Barberini to set up easels, no one "can catch or ever will the vanishing charm of that sorrow."[13] He always left the painting reluctantly, unable to grasp its secret.

Reni's painting is the only source of inspiration or derivation that Hosmer ever credited. In the anonymous biographical sketch written during her lifetime and endorsed by the artist herself, the writer reported that Hosmer reproduced the headdress as it appears in the Reni portrait, rendering it as accurately in the marble "as the difference of material will permit." Years later, in an interview given in St. Louis, she attributed the sculpture to "a picture by Guido [Reni], now in the Barberini Palace in Rome."[14]

In September, 1856, Hatty wrote to her friend Anne Dundas. She said that she had "a famous block of marble for the Cenci, and she [the statue] is progressing in that material." She went on to say, "I made several changes in her after you went away, for instance gave her a vast quantity more hair, putting very sizable locks over the raised shoulder, made a cushion of the upper stone (which was a great improvement), and put on (I'm sure you will say, 'Oh horror!') a slipper!!!" Partaking of Gibson's contempt for contemporary clothing on sculptured figures, she argued that the slipper placed the subject "in costume" for the sixteenth century. "From the arrangement of drapery I was afraid it might look like an affectation of the antique unless I had something to modernize it a bit."[15]

The extended figure of *Beatrice Cenci* lies on a raised block that serves as couch in her prison cell. Although she will die on the following morning, her deep sleep is a natural one, her position relaxed but graceful. The head, supported by the cushion that Hosmer spoke of, rests on the right arm, the left falling lightly over the side, one hand fingering a rosary, symbol of the girl's prayers for divine mercy. The left leg is drawn up under the extended right, a pose that suggests the attitude of a child in sleep. The posture allows a variation in the folds of the drapery, the fabric going first one way and then another, creating a rhythm to the design without impairing the symmetry. The crown of hair, far more abundant than in the Reni portrait, gives the head a more plastic dimension. Instead of the cowl-necked garment that the androgynous painted image wears, diaphanous drapery drops away artfully to reveal one youthful, but unmistakably feminine breast, uncovered in the unconscious disarray of deep slumber. Beneath the seemingly pellucid marble "cloth," the lines of a beautiful body are clearly visible. The figure is sweetly sensual, a simple, refined statement of the subject's renowned loveliness and vulnerability.

Although it is a strange parallel, Canova's recumbent nude portrait of Pauline Bonaparte, the Princess Borghese, comes to mind as a model that Harriet Hosmer undoubtedly knew. In the neoclassical predecessor, close at hand in the Villa Borghese, the proud Paolina sits unabashedly holding the apple that identifies her as Venus. While American tourists found her nudity shocking, Harriet Hosmer would have looked at the recumbent figure intently to learn from the master Canova as John Gibson had before her. What the images of Pauline Borghese and Beatrice Cenci share is a prone position and a graceful, classical arrangement of drapery. Beatrice's couch is a narrow prisoner's ledge whereas Pauline's is luxurious, but each woman, so utterly disparate in life, has a pillow for her head. That the Canova work, freestanding with both horizontal and frontal axes, as is Hosmer's *Beatrice Cenci,* might have offered the young American some pointers seems credible.

Harriet Hosmer apparently convinced her client and friend Lady Adelaide Talbot to pose for at least a portion of the reclining figure. Having a model who was not an anonymous professional pose even in partial dishabille gave a "sculptress" the edge over her male colleagues, although Hiram Powers, with his reputation for unimpeachable rectitude, was known to have used a lovely young nonprofessional model for his celebrated *Greek Slave*. Fanny Kemble, always scornful of American prudishness, said that John Gibson, remarking on the lines of the Cenci back for which Adelaide Talbot modeled, opined, "And to think that the cursed prejudices of society prevented my seeing that beautiful

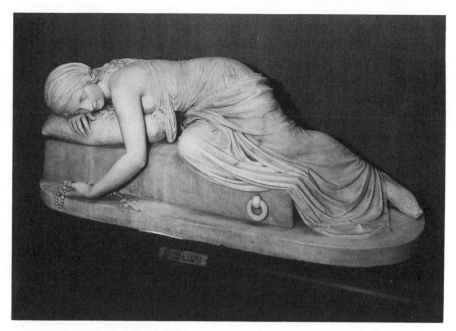

Beatrice Cenci, by Harriet Hosmer, 1856, marble, life-size. Courtesy St. Louis Mercantile Library Association.

back!" Fanny herself confessed quite freely that, as she observed the short skirts, low necks, and plunging décolletages of such beauties as Anne and Isabella Forrester, she wished that their gowns would slip off to reveal exquisite bosoms.[16]

The choice of Beatrice Cenci marks Harriet Hosmer's first departure from a classical subject. That she talked earnestly about it with John Gibson seems certain. That she was strongly influenced by the popular acclaim for the Reni portrait seems equally sure. No longer impervious to the potential for profit, she hoped for replicas in smaller size. More profound and subtle considerations moved her, however. For a young romantic, the story of the tragic heroine had a special appeal. Subliminally present are the motifs of male domination and sexual abuse. While the Cenci story was larger than life in Victorian society, women's actual condition was still contingent upon male authority. The spunky Hatty had broken with tradition to strike out on her own, but she was supported, encouraged, and sometimes kept afloat by male figures.

An incident recorded by French traveler and writer Louis Delatre illuminates the manner in which Hatty was perceived in Rome. Delatre entered Gibson's studio one day to discover a young woman zealously washing the clay model of a statue. He thought her to be eighteen or

nineteen—she was really in her mid-twenties. She was vivacious and laughing, her brown hair hung in loose curls, and her figure was slender. The visitor asked her name. "Enrichetta Hosmer," Gibson told him, adding that she was an American native of Boston who had "run away from home . . . against the will of her parents to devote herself to sculpture under my direction." Delatre may have misunderstood, for Gibson knew perfectly well that Hiram Hosmer was Hatty's only living parent. Delatre reported that Gibson spoke Italian, perhaps *sotto voce,* to prevent Hatty's understanding their remarks, another unlikely prospect unless Gibson was making sure that Hatty was enjoying his melodramatic account of her. Delatre relayed the information that her parents had "pardoned her disobedience and are proud to have her as a daughter."[17]

Back in Rome at this time was Matilda Hayes after an absence of three years. She wrote of Hatty's latest work to Cornelia Carr. "It has been a long time," she said, "since Rome has produced so beautiful a statue as the Cenci in conception and execution." Not to be ignored were improvements in Hatty's appearance.

> To begin, she has added an inch or so to her height, of which, between ourselves, she is very proud; and more than an inch considerably in circumference, though she has developed a charming little waist and figure. Her short hair, which you will find considerably darker in color, suits her admirably, and she is, in dress, neatness itself, her party wardrobe elegant and tasteful. So much for externals.

As for her social position, Matilda Hayes confirmed that she was "universally respected, and where known, loved," a hint that initial meeting with Hatty did not always produce a favorable impression. Recognizing Hatty's role as pioneer, Hayes said that "she has surmounted all the difficulties of her position as woman and artist nobly by the simple earnestness of her nature and life." She reassured Cornelia that the Hatty whom they both loved had not altered. "Better than all, she is the same frank, unaffected darling as in old times—her spirits more boisterous and sustained than ever; in fact, she is the happiest human being that I know and thinks herself so."[18]

Not everyone saw Hatty in that light. Her colleague Thomas Crawford was one of her detractors, although, from the tenor of his correspondence with his wife Louisa, gossipy little digs at friends and acquaintances seem to have been a shared part of their intimacy. Writing to his wife in America, he gave detailed accounts of the callers who came to see him and his sister at the Villa Negroni. Hatty had come, he related, "looking more like a 'Little pickle' than ever." He found her miniature

round straw hat with its "economical black feather" absurd, no match for the fashionable bonnets that the lovely Louisa must have worn. For a call on Crawford, Hatty was in the company of Mrs. Mozier, "who appears," said Crawford, "to have taken possession of Mr. Cass' [Lewis Cass, Jr., the American minister in Rome] carriage and him too for that matter." Even Emelyn Story came in for ridicule. She would be arriving in Rome soon, Crawford reported, unable to "resist the *enchanting* society of the snobs here and so comes out again to air her conceit."[19]

By autumn of 1856, Crawford was suffering from a brain tumor that manifested itself in a painful eye condition. He continued to work feverishly as he always had, but the disease was taking its toll to the genuine distress of all who knew him. So he is not to be faulted for irritability, for he was suffering terribly and bearing his predicament stoically and even optimistically.

Infinitely more exciting than a call on her ailing colleague must have been the nocturnal adventure that took Hatty to Florence, an episode that jumps tantalizingly from a letter to Anne Dundas. Written during a late summer's stay in the hill town of Albano, Hatty's words mirror her keen zest for the extraordinary.

> Nor have I been quiet either, while you have been on the wing but have ridden to Florence by moonlight at the rate of fifty miles a night. Nothing was ever so so fine as that journey. The entrance to Nepi, with its old towers and broken arches, the descent to the lakes of Thrasimene, the climbing of the hill to Perugia, and the arrival at five in the morning at Florence, are all things to be set down in one's golden book.[20]

It was Hatty's idea for the high-spirited party of friends to travel by moonlight, making the trip in three nights on horseback. According to a later account, they were nearly at their journey's end, when they lost their way and met a stranger who gave them directions. Following the bed of a stream that seemed to lead nowhere, they became increasingly nervous in the isolated countryside that was known to be rife with robbers. Hearing a low whistle, Hatty felt that they were all about to be massacred. "Who is there?" she called out, determined, she said later, "to die asking a question. It showed intelligence." The sound had come from a shepherd. Presently they were on their way again, reaching Florence with no further mishap.[21]

Unhappily, the names of her companions remain unknown. Her recollection of the event as told to Anne Dundas was poetic in its imagery with no reference to the excitement of losing the way, the part that she probably selected to make a good story later. Instead she described the scene.

The ground was covered with fresh young vines and bright red poppies sown by some friendly Morpheus, perhaps, to make her forget in a long summer sleep the wrongs she had endured, and over all, the great, quiet moon, like a loving and pitying mother, watched as tenderly and as patiently as she did ages and ages ago. Oh! my A(nnie), how enchanted you would have been. There never was a more silent journey, for it was too beautiful to talk about. We wanted all our forces to think and to look, but thinking and looking were done to perfection. We came back by riding early in the morning and late in the evening, having made the three hundred and sixty miles in seven and a half days.[22]

While in Albano, Hatty wrote to Cornelia only of domestic concerns. Her friend had just had her second child, a son named Wayman Crow Carr. Hatty reported on Matilda Hayes's observation of little Hatty, whom she had seen during a visit in America. She was said to resemble her godmother Hatty. Her "supernatural cleverness," also noted, could only have come from the fact "that she is my namesake. Hm!!!"[23]

Charles Sedgwick, the husband of their dear teacher, had died recently, a realization that saddened Hatty profoundly. Backing away from the fact of death as she was prone to do, she excused her vacillation. She simply could not write to Mrs. Sedgwick, she said, rationalizing that saying nothing was better than words. She told Cornelia that Fanny Kemble's presence at Lenox must have been comforting during Charles Sedgwick's last illness and thereafter. But the presence of Fanny Kemble's headstrong child, Sallie Butler, who seized on the sad occasion for a reunion with her mother, was "productive of so little happiness," Hatty remarked. Fanny had indulged her daughter in what Hatty called her "silly whims" at the expense of the Sedgwicks' convenience or sensibilities. In the diffident way in which she sometimes relayed negative gossip, she said, "I fear it is not the sunshine between the two and I fear it never will be."[24]

She always took Cornelia to task for not writing more frequently. Earlier, Hatty had opined that in three and a half years, Corny had written only three and a half letters. "There is not a day that you are not in my thoughts and in my heart of hearts, and I picture you to myself with that little Hatty of mine," she wrote. The contrast in their present life-styles, once so much the same, was now very obvious. Hatty liked to emphasize the difference from time to time, often condescendingly. This time she remarked on the physical endurance that her work demanded, forgetting perhaps that motherhood was not free from stress. "I doubt if your little body could be in an upright posture on your feet eight hours of the day, and I'm sure those soft little hands couldn't be dabbling in mud so long."

Writing in June 1856, Hatty had only to look out of her window to

Night Rises with the Stars, **by Harriet Hosmer, 1856, bas-relief in marble, diameter 16″. Photograph courtesy Watertown Free Public Library.**

see the illuminations of the dome of St. Peter's during the festival of St. Peter's Day. From one aspect she could see fireworks in the Piazza del Popolo, but more wonderful to her was the cupola etched in the dazzling display of lights that left the spectator breathless. Appreciating her vantage point, she wrote: "Last night the whole was illumined, and to-night too it has been very beautiful. I am thinking how many thousands of people would give their eyes if they could only be in my place for a few minutes." She was finishing two *bassi relievi,* "Night and the Rising of the Stars" and "Phosphor and Hesper," the stars of evening and morning in mythological metaphor. During the next winter, she said, she would model one of the popular pendants for the morning star relief.[25]

By the time of her fall holiday in Albano, Hatty was growing increasingly pessimistic about the recession in Europe. Feeling the pinch were all but the most experienced artists, Gibson, Pietro Tenerani, and Craw-

ford, "who have been through the mill" and "are always busy." She, along with others who were "struggling upwards," had no choice but to "grunt and groan, and they do grunt and groan pretty effectually." If fortune did not smile "more sweetly pretty soon than she has for the last year and a half," Hatty suspected that "nine tenths of the artists will open glove shops or tobacco stalls or something else, not for bread and butter, but for bread alone without the butter."

To Crow she confided: "In your ear in a very private way I grunt too but not aloud because Mr. Vinton was right in that respect, if in no other, that it is bad policy to complain to the world in general of want of patronage." Everything that she had made, she added, had been "disposed of," thanks to Crow. "But," she admitted in a rare tone of discouragement, "somehow or other it still seems up-hill work." She would never admit her low spirits to her father, never let him "into the secrets of my prison house," for he was a little too fond of dwelling upon the problems and even exaggerating them. She breathed into Crow's "paternal ear as a sort of *sfogo,* as the Italians say, which in English means letting off steam."

There was achievement to report. Her *Oenone* was well on its way to America. Perhaps Crow, vacationing in the East, would see the work when it arrived in Boston before it continued on to St. Louis. A *Puck* would be there, too, she said, ordered by a Mr. Hooper. Already looking forward to the exhibition of *Beatrice Cenci* the next year, she felt that it surpassed any of the works that she had previously done. An invitation to exhibit the *Cenci* at the Royal Academy in London the following spring had been issued to her by the academy's president, Sir Charles Eastlake, during his recent visit to Rome. He had promised "to do all in his power to have it well placed," she said. The position of a work in relation to other works often made the difference between critical acclaim, utter rejection, and ignominy. She would send the statue on ahead, appear at the exhibition in May, and then sail home for her first visit the following summer.

Beatrice Cenci was already receiving advance notices. John Gibson had taken with him to England a drawing of the work by the artist Guglielmi. Done from the cast, it was scheduled for publication in *Art Journal.* Hatty reported the triumph, "not from any feeling of vanity or self-satisfaction because I am intensely disgusted with myself," but rather to please Crow "that such a man as Sir Charles Eastlake finds something in my work of which to approve." Offering "one more proof" that she considered herself to be his "protegee in every sense of the word," she told him that she was about to draw on the other half of the two hundred pounds' credit that he had previously extended. Without this "godsend,"

she could not meet the bills coming due for the essential commodity, marble. Offhandedly, she told Crow that he could report her letter to her father if he liked, but, feeling that she had complained too much, she really preferred that he put it in the fire. To conclude, she affixed her mark from his "Affectionate" Hat.[26]

12
The Homecoming

In November, 1856, Hatty wrote to Wayman Crow with important news. She had received a commission for a tomb monument in the Church of Sant' Andrea delle Fratte. A certain Madame Falconnet, whose young daughter had recently died, had engaged Hosmer to do the sarcophagus sculpture.[1] For a Protestant and a woman, this was a singular assignment, the first instance of an American artist's work to be installed in a Roman church.

The church that would be the locus for the monument was only steps from the Piazza di Spagna. As Hatty was writing to Crow, an enormous classical column was being erected in the busy square. On top of it would be placed a figure of the Virgin, her head outlined in a crown of lights. The festive dedication of this new landmark would take place on December 8, 1856, two years to the day from Pope Pius IX's pronouncement of the Immaculate Conception of the Virgin Mary.

New England Protestants watched the preparations with curiosity and private condescension. It was said that convict laborers were preparing the giant pillar. Some argued that the pope had articulated the *ex cathedra* doctrine in 1854 only to have a reason for putting the magnificent marble, sitting unused in the Quirinal Palace, to some appropriate use. Pio Nono's reputation for having the *malocchio,* the evil eye, did not recommend his presence at events where anything was likely to go wrong. According to Charles Eliot Norton, the American traveler and man of letters, everything went off perfectly because the pope did not grace the event with his presence.[2]

Surely Hatty was a daily visitor to the nearby Church of Sant' Andrea delle Fratte during these days as she began her initial sketch, the *bozzetto,* for the tomb monument. Coincidental with her recent figure of *Beatrice Cenci,* the work would also be the image of a recumbent maiden. The girl, Judith de Palezieux Falconnet, Hatty said, "so much the better for me was most lovely." The figure of the adolescent girl would be placed on a sarcophagus with room for an arch over it. A

background of darker marble would set off the chaste white figure. Hatty told Crow that the light was "magnificent." Awed by the responsibility, she said, "I shall endeavor to exhaust myself on the work, only saving enough of my corporeal and mental strength to drag my bones to St. Louis next year to behold you once more."[3]

The Church of Sant' Andrea delle Fratte is an ancient one. The *Fratte* attached to the name distinguishes it from others in Rome sacred to Saint Andrew. The *fratte* were nettlelike plants that grew in the vicinity of the church in the twelfth century, when Rome was a medieval village. The street on which the church was built bears the name Capo le Case, the head of the houses, to indicate that it was the last outpost at the northeastern end of the small town that was Rome. Reconstructed in the seventeenth century, the present church has a campanile and a cupola designed by Francesco Borromini, at the time a bizarre departure from traditional forms. The curious octagonal dome was visible from lodgings on the hill above. The artist and traveler J. E. Freeman could look down on it to spot an occasional vulture along with the resident rooks, who wheeled and chattered around the belfry at sunset. During the Reformation and afterward, S. Andrea was the place of worship for Scottish Catholics. The patron, Saint Andrew, was also the protector of Scottish monarchs, an affiliation that was abandoned when the kings of Scotland became irrevocably Protestant.[4]

Only a decade or so before Harriet Hosmer's time, the church had been the scene of a miracle, one that the *padri minimi* who keep the church are still proud to describe. In 1842, Alfonso Ratisbonne, a Jew, had a supernatural vision of the Virgin Mary, so it was claimed. This phenomenon converted Ratisbonne to pious Catholicism and brought further honor and glory to the already historic church. In the midnineteenth century, S. Andrea had acquired enormous prestige as a place for weddings and funerals of expatriate Catholics living in Rome. J. E. Freeman told of the solemnity of an American lying in state in the nave, the rites accompanied by music that would have melted a heart of stone.[5]

Many elaborate tombs mark the sanctuary, including the sepulcher of the Swiss painter Angelica Kauffmann, a notable woman artist living and working in Rome in the late eighteenth century. Harriet Hosmer's sculptured figure of a young woman would be in splendid company. Within the basilica are two angels done by Gianlorenzo Bernini himself. The *Angel with the Crown of Thorns* and the *Angel with the Superscription* were originally planned as members of the group of figures for the Ponte Sant' Angelo, commissioned by Pope Clement IX. When the pontiff saw them in Bernini's studio, he said that they were too beautiful

IN MEMORIAM IUDITH DE PALEZIEUX FALCONNET MDCCCLVI

Tomb of Judith Falconnet, Church of Sant' Andrea delle Fratte, Rome, by Harriet Hosmer, 1857–1858, marble, life-size. Bibliotheca Hertziana (Max-Planck-Institut), Rome. Photograph by Soprintendenza di Roma.

to be outdoors. Copies of the two angels were then made for the bridge and the originals were kept in Bernini's house until his death, when they were moved to S. Andrea.[6]

"Of course you know all about poor Julie Falconnet's death," Hatty wrote to Anne Dundas. What the girl, who appeared to be about sixteen, died of is unknown. (A curious thickness in the set of the neck invites speculation about some disability or chronic ailment, as one views the finished work.) Hatty reported that a mask of the girl, taken after death, along with a portrait bust done in life, would permit her to get a good likeness. She described the work as she planned to execute it for the monument.

> It is to be a sleeping statue of her, and I have this day finished the sketch, though Madame Falconnet has not seen it. I have represented her lying on a couch, the little feet crossed and a chaplet in one hand while the other has

fallen by her side. The dress is modern, of course, but very simple, with long flowing sleeves which compose well; that is all of it, and the beauty of the thing must depend on the fidelity with which I render the delicacy and elegance of her figure.[7]

Death and dying were popular themes in nineteenth-century sculpture. Indeed, some of the first vanguard of American sculptors had apprenticed as gravestone carvers. As the century progressed, the marble creations were becoming increasingly sentimental. Children sweetly asleep, never to awaken, groups gathered around the couch of one about to expire, victims of a shipwreck, were subjects reiterated by successful practitioners. It is to Hosmer's credit that she rendered the solitary figure of Judith Falconnet with simplicity and dignity, stringently abstaining from excessive pathos.[8]

Although she was totally immersed in the design for the Falconnet monument, Hatty could still wish herself in St. Louis, where Fanny Kemble was performing her dramatic readings. The English actress was very much at home there. As one who respected Wayman Crow's business abilities, Mrs. Kemble was another who sought his help on investments. He represented her in a purchase agreement for real estate with Pierre Chouteau, Jr., a descendant of one of the city's founders, and his wife Emilie. But Hatty envied only the sociability that she was missing: "And yet unfortunately we can't be in two places at one time until we are little cherubs with wings and no places to sit down upon."[9]

In a letter to Crow written shortly afterward, Hatty spoke of the frustration of trying to put her feelings on paper: "Words are cold and formal things and one talks in letters very much as one talks by means of an interpreter, that is, without making the third party understand at all the true state of your feelings." But there was a "third party" who claimed to understand her feelings toward Crow better than Hatty herself did. Charlotte Cushman, back in Rome after several years' absence, was once again with Matilda Hayes. The relationship was deteriorating, but in this particular episode, they were firmly allied with Hatty as their quarry. Hatty told Crow that she had read aloud to Cushman and Hayes every word of his letter to her. The two women, noting that she savored his words, responded "with what seemed to them to be the perfect truth, 'Mr. Crow is your Father.'" Finding Hatty's devotion to Crow tiresome, they were actually trying to provoke her.

Hatty reported to Crow her response. It was completely direct with not a hint of the denial or defense that a more predictable soul might have offered. "No," she stated daringly, "if he had not been something more to me than my Father has been, I should not have been in Italy now,

and that is as much as saying I never should have been an artist. You are princely to me, dear Mr. Crow, in more ways than one, and not the least pleasing feature of the royal spirit you have toward me is your unbounded confidence which you are quite right in saying was rarely ever vouchsafed to me by the Dr."[10]

It seems unlikely that Crow would consciously compete with Hiram Hosmer. As Hatty herself had said, his position in her affections was unique. Many years later, in editing the letter, Cornelia Carr hurriedly scribbled over the words "than my Father has been." She apparently saw her own father's place in Hatty's heart as a threat only if it displaced Hiram Hosmer. "It is heart's blood to me," Hatty went on, "to hear you speak so undoubtingly of my future and inspires me with heart enough to contend with twice the quantity and quality of obstacles which beset Hercules, and so help me God, I would work off my fingers rather than disappoint the hopes you repose in me or that I should not manifest in a visible and actual way my appreciation of your great, great kindness." She didn't want to account for a lack of gratitude on "the day of 'general' reckoning," she said, for she already had too many sins to answer for. As for a show of appreciation to Crow, she would insist "on a day of 'particular' reckoning while I am in the flesh *fleshy*."[11]

An upswing in business made her recall the Yankee who said, "Statuary has riz," which pleased her "to the backbone." She looked forward to a busy, productive winter.

> First and foremost the monument [Falconnet], then an order from an English gentlemen for a bust; then an order from Mr. Clift of New York for a copy of Puck. Then another from Miss Cushman for another copy of the same. Then another order for two large bassi-relievi; then another for two portrait medallions of Lady Talbot and her daughter, Lady Constance, which I shall begin on Monday next, and I may have an order for a small copy of the Cenci.[12]

Hatty was beginning to think seriously of getting a studio of her own. As her works increased, the little garden room adjoining Gibson's atelier was becoming increasingly cramped. Previously, she had hinted to Gibson that it was time for her to expand, but it had remained "a forbidden subject," because he felt that she was not yet ready to work alone, "which certainly was very true." But now, he agreed that it was high time that his pupil consider hanging out her own shingle, as Hatty put it. What pleased her most about John Gibson's acquiescence was "the positive proof that my master thinks I am progressing." He would be no less her teacher, still giving her "the benefit of his advice and instruction." As long as she stayed under his roof, however, others would consider her a beginner. She had not said a word to her father,

"who I am afraid has some latent idea that I may settle down in America," a notion that she had resolved in her own mind long before.[13]

By February, 1857, *Beatrice Cenci* was already packed and waiting in Civitavecchia, where it would be shipped to Southampton. Gibson had written to remind Sir Charles Eastlake of his promise to secure a favorable position for the work. It was already being talked about "over the Channel," where Louisa Lady Waterford, "who is, it appears an oracle in London art, has written to Rome for a photograph of it." The marble maiden had set out "under favorable auspices. . . . I am not afraid to say it beats the *Oenone* which I wish was better for your sake." In response to her patron's question, she answered, "You ask what I get for the Puck—$500."[14]

In London for the exhibition at the Royal Academy, Hatty saw old friends and made new ones. Staying out most evenings until one or two in the morning at parties and receptions, she was feeling the effects of the "dissipation" but was nonetheless "getting fat on it." She preferred the simplicity of life in Rome, however, complaining to Wayman Crow that she was not herself at all. She had stayed with Adelaide Sartoris, "such a darling! so clever and so amusing." Her niche in Rome would never be filled, Hatty said. "I am now domiciled with Miss Cushman who is like a mother to me and who spoils me utterly," she went on.[15]

Hatty's praise of Charlotte Cushman was sporadic. In a letter to Cornelia, written from London in July, 1862, she was moved to say: "How good and thoughtful she [Charlotte Cushman] is. She thinks of everybody's pleasure and welfare, and manages to stretch out a handful of blessings to everyone she knows, sooner or later."[16] Much of the time Hatty took "the handful of blessings" for granted. But she did value Cushman's advice, although it was often given too freely. With *Beatrice Cenci* on its way to America and scheduled to arrive in Boston, Charlotte urged Hatty to exhibit the work in Boston without fail, counsel that Hatty intended to heed. "She [Charlotte Cushman] is pretty clever and knowing in these things," she observed to Wayman Crow.[17]

A sad note on the London scene was the deterioration in Thomas Crawford's condition. The Crawfords had gone to London for his treatment, but there was no hope of saving his life. "Poor Crawford," Hatty called him, telling Crow that the sight in one eye was quite destroyed, although the doctor thought that, were Crawford to gain strength, sight would be restored. He was suffering greatly and seeing no one, Hatty reported. "Mrs. Crawford is wonderfully calm," she continued, "but to me has changed immensely since she left Rome." Crawford died later that year.[18]

Hatty told Crow that she was nearly out of pocket due to the "merciless waves" that delayed expected monies. Unless she heard a message from "a prohibitory ghost," she would, within the next four days, add "another £ 100 to the long list which rises up in judgment against me," referring to her indebtedness. It was not that she lacked commissions; only the logistics were at fault. She also remarked that before she left Rome, she had found a perfect block of marble for a repetition of *Puck* for "Mr. McCreery," probably Crow's partner in the dry-goods business. It was equal to the marble used for *Oenone,* and nothing could be better. She was eager to hear about its progress in the marble, a task that she left to her skilled craftsmen.

Early in August, Hatty would sail from England, dreading the seasickness but anticipating her first trip back to her homeland. No hint of her exact arrival date would she give her father, for she wanted it to come as a surprise. But her rebelliousness was poorly concealed. "I like the idea of Father not listening to my going West [to St. Louis]—as if I should ask him! Nothing this side the grave will keep me from doing so if I go on foot. I am dying to see Corny and my little Hatty, not to mention all my kind friends in St. Louis." How she longed to get to Lenox, too, "and hug Mrs. Sedgwick." She would feel "antique," she said solemnly, observing that her own student days were over more than five years before. But she had not been lazy in her four and a half years in Rome and confided to Crow that she had "as much to show for my pains as most of the other girls, though there is no husband."[19]

The climax of Hatty's London stay was the evening of illuminations and festivity at the Royal Academy. The writer and historian George Ticknor called the surroundings and the company "brilliant." He particularly relished the triumph of his young countrywoman, which he told about in a letter home. "Miss Hosmer had stayed in order to be present to-night, and she had the benefit of it. She came rather late, and I had talked about her Cenci with Eastlake, Waegen, and other people whose word in such a matter is law here."[20] As volunteer docent, Ticknor had pointed out the statue of *Beatrice Cenci* to such dignitaries as the Bishop of London and Lord and Lady Palmerston. Given the good position that Eastlake had promised, the visitors could presumably walk around the figure to see the line of the back, the drapery gathered in a knot behind. So gauzy is the drapery over the well-rounded derriere that the cleavage is scarcely concealed, a wonder indeed that marble can give the illusion of such delicate transparency. Whether Lady Talbot modeled for the backside is unknown.

Ticknor continued his recital:

She [Hatty] was very neatly and simply dressed in pink, and looked uncommonly pretty. I found she knew a good many people, old Lady Morley, the Cardwells, and others, but I took her, and presented her to the Heads, the Bishop of London and Mrs. Tait, General Williams, the Laboucheres, Lord and Lady Palmerston, Sir William Holland, and sundry others I now forget. She pleased. Her statue was much praised. She was very happy, and I enjoyed it a great deal.

Lord and Lady Palmerston admired the *Cenci,* as did many others. Eastlake touched Ticknor's arm and whispered, "so they could hear it, 'Everybody says the same sort of things. It is really a beautiful work of art, and for one of her age quite wonderful.'" Presently, Ticknor left for home. It was quite time, he said, "nearly one o'clock. I was sorry to leave the little Hosmer, for I had to bid her good-by; she goes tomorrow, but I think she had enough of distinction to-night to make her glad she came to London."[21] Hatty had posed for two painted portraits of herself, or of her "ugly mug," as she put it, while in London. One of these was probably the image of her done by Sir William Boxall in which she wears the riding hat with dashing, drooping plume.

At last she arrived in Watertown, where her father and Miss Coolidge, the housekeeper who had mothered Hatty, greeted her. The returning young celebrity was the immediate object of attention. Callers at the house on Riverside Street included the poet Henry Wadsworth Longfellow and Mrs. Longfellow. Sara Jane Clarke, accompanied by her husband Leander Lippincott and their little girl, also came, and she and Hatty recalled the delights of their days in Rome together.[22]

Ellen Robbins was glad to see her childhood friend, the instigator of so much mischief. Now a nature painter of local distinction, Ellen rode with Hatty, driving her father's chaise, to the woods that they had once combed in search of wildflowers. On one such excursion, during this or a later visit, Ellen remembered that Hatty read aloud to her from Carlyle's *History of Frederick the Great* as she painted autumn leaves. And Hatty was quick to buy a book of wildflower paintings produced by Ellen Robbins for the sum of fifty dollars, a gesture that her father must have thought wildly extravagant.[23]

One of those most eager to see Hatty was Lydia Maria Child, still living at her farm home at Wayland. Hatty drove up in the chaise to salute her friend by raising her hat, the same one in which Sir William Boxall had painted her. The effect was not lost on Mrs. Child. When she commented on the becoming hat with its graceful plume, Hatty remarked casually that it was a lady's riding hat—she had not worn a bonnet in five years. She was dressed in the ample silk skirt that was once again popular, due to the influence of the Empress Eugénie of France. It

Harriet Hosmer, by Sir William Boxall, ca. 1857, oil, 35.5″ × 27″. Photograph courtesy Christie's, London.

had "a close fitting basque of black velvet, buttoned nearly to the throat, like a vest, and showed a shirt bosom and simple linen collar." Forgetting the elegance of her outfit from time to time, Hatty put her hands in her pockets "as boys are wont to do." She also had a boyish way of pushing her short, thick, brown curls off her forehead in an unconscious gesture.[24]

Maria Child was again strongly attracted to the young Hosmer, finding her totally unpretentious, "a trait by no means common with those who have received a great deal of attention in Europe." She wished that Hatty were her own daughter, Mrs. Child told her friend Sarah Shaw, saying that Hatty's "strong, fresh nature really put new life into my old veings [sic]." Mrs. Shaw had made a handkerchief for Hatty with a hat embroidered in the corner. "She keeps it stowed away in a box, because she don't want it ever to wear out," Maria Child reported.[25]

Maria Child apparently enjoyed the tidbits of gossip that Hatty brought from Italy. William Page, the portrait painter whose work was so greatly admired, was involved in a new courtship. His new love—he had shed two wives—was "a very shallow, pretensious woman, who gained influence over him solely through his vanity." In all probability, it was also during this period that Maria Child may have derived her opinion of Charlotte Cushman, one that later enabled her to say of the actress that she was "very kind-hearted . . . but she is a shrewd, experienced, managing woman of the world," an idea she may well have gleaned from confidential conversation with Hatty.[26]

Maria Child entered wholeheartedly into every opportunity to see Hatty. She went to Watertown to visit Hatty at the same time that *Beatrice Cenci* arrived, but Hatty hurried off to Boston, where the statue had just been taken from the ship. The "unshipping" of a work of marble was a tedious and cautious process. Hiram Powers carefully instructed his clients about the proper handling of their marble purchases. Often, he included a little sack of marble dust to remove finger marks and spots. Hatty used marble dust to clean the badly soiled *Beatrice,* a matter that detained her until four o'clock in the afternoon. Maria Child visited with Miss Coolidge until Hatty's return. She then "staid at the Doctor's all night, and in the morning went to Boston with Hatty to look at the statue."[27]

Maria Child had no trouble in deciding that *Beatrice Cenci* was "very far superior to anything she has done." Not long after, praise came from a source distinguished by artistic credentials. Rembrandt Peale, then over eighty, offered his compliments after coming from Philadelphia on two occasions to see *Beatrice Cenci* on exhibition in Boston.

I never presume to give a judgment on a work of art on the first visit. On a second visit to Miss Hosmer's Statue, accompanied by Mrs. Peale, I am better prepared to express our opinion of its beauty and excellence.

It is indeed a work most honorable to her taste and talents and meets with universal applause, as if it was the work of a great *Master;* but when it is regarded as the bold production of a *mistress* of the arts, the sentiment is greatly enhanced and felt in a lively manner by our Ladies of taste, who, although they will not dispense with crinolines, do not censure the Cenci for not having them but admire the graceful folds of her inner and outward garments almost as much as the beauty of her hands and arms and the perfection of her face.

Although somewhat patronizing, Peale, whose family included many female artists, was progressive in his assessment of the opinions of women. It is possible that he received some help in his evaluation from his wife. To underline his own expertise, he added:

Though there are some persons so ignorant of what belongs to statuary as to censure Miss Hosmer for giving her [Beatrice Cenci] so narrow a couch to repose on, *we* who know better commend her for it, as it enabled her to show so beautiful an arm falling over it, and gives such varied grace to the figure.[28]

While Hatty was at home in America, John Gibson wrote faithfully from London: "My dear little Hatty: I was very glad indeed to find that you are safe at Boston, and my rival is equally happy to hear that you are well, that is, you know, old Boxall." His friend and patron Mr. Sandbach had invited them both to visit him the following year, "but perhaps your father will keep you now safe where you are. He would relieve me of the trouble of keeping you out of the Devil's ways. . . . I dare say those horrid Republicans will want to keep you, bad as you are." He urged her to "be good; return soon; if you don't, I shall look out for another, but I do not expect to find such another clever fellow as you are."[29]

After receiving a letter from Hatty, Gibson wrote again. He softened his remarks about the "Republicans," applauding "their good taste and proper feeling towards you. They do themselves credit by encouraging you, fat as you are!" He enjoyed his student's success and the prospect of her besting his rivals: "I want to make a cat's-paw of you to annoy those money-making sculptors of London, to send to the exhibition your works regularly. I am sure you will surpass many of them, that is, if you can save yourself from the attraction of Love. I do not want to make you angry by saying, 'become an old maid,' No, no!" He signed himself "Affectionately, John Gibson, Sculptor and your slave."[30]

Hatty's stay in America was punctuated with small trips in the New England area, to Lenox and to Walpole, New Hampshire, where she had relatives. She spent a day at the seashore at Nahant with Fanny

Kemble and her daughter Sallie Butler. But in spite of her strongly expressed wish, she does not seem to have gone to St. Louis. Her letters, undated or partially dated, are characterized by the urgency of making arrangements to see her friends, of intense emotion at the thought of reunion, and dismay at plans that went awry.

One of the events that sadly changed the summer's course was the death of Cornelia Carr's second child, the year-old boy named Wayman Crow Carr, in Pike County, Missouri, where Cornelia and Lucien Carr lived for a while. Hatty did not know of the baby's death in July until she landed in America. She wrote Wayman Crow to say that she was deeply grieved. She wondered if Cornelia would come East where she would be sure to see her. Cornelia did come in September. She probably minimized her fresh sorrow, perhaps eased by the reunion with her dear friend and the pleasure of introducing little Hatty to her godmother. Hatty delighted in a curl that the child had cut from her own head and gave it to Miss Coolidge, who treasured it as a keepsake. Hatty, always in sympathy with childish behavior, told Cornelia, "Give our little Hatty a tender box on the ear and then put on a plaster of kisses—the first for her own rape of the lock, the second for her cunningness."[31]

Cornelia brought handmade gifts, cherished by Hatty: a shawl and headdress, a cushion that Hatty called *"capo d'opera"* in highest praise. There were mats for "Ellen," perhaps Ellen Robbins, and luminous pebbles to put in water. Slippers that Cornelia made would not be worn until Hatty obtained a new sanctum. She hoped somehow to see Cornelia's "sisterly face" in New York before she sailed back to Italy in late October.

More insistent was her need to see Crow, and why she did not remains a question. A serious economic depression in the United States in 1857 apparently threatened to be catastrophic to Crow's diverse interests. A railroad industry dangerously overexpanded and increasing tensions regarding the spread of slavery in the West were root causes that seemed to be affecting every level of an American commerce that had been bright and vigorous. Hatty's concern for Crow was infinitely more sensitive in this crisis than her attitude toward her father when his personal fortunes seemed to be foundering. She spoke of numerous failures in the Boston area among people "long accustomed to the ease and inactivity that wealth engenders." In spite of the recession, however, Charlotte Cushman, who had come home to America to perform, was playing to packed houses.

As Crow's need to alter plans for a vacation in the East developed, Hatty wrote to Cornelia: "I would go anywhere to meet your father but somewhere I *must* see him. I can't think of going away without it. Unless

he gave me his especial farewell and blessing, I should not expect to succeed in any undertaking." As she waited for the visit from Cornelia and little Hatty in Watertown, she urged Crow, "Write to me—there's a dear man and [illegible] me up regarding all your movements and better than all, come here and let me give you a kiss from Yr affectionate."[32] Crow seems to have been suffering from some minor physical ailment as well, for Hatty offered, "If you want a Nightingale, call on me for tho' I can't sing, I can nurse."

Crow's presence in New York might have coincided with Hatty's four-day stay there before she sailed, but it did not. One wonders if for some reason, the impassioned young woman was being fended off. She persisted in her optimism even against the odds: "Colburn would say there was no hope but a small creature called Cupid comes to console me and to assure me that if the worst comes to the worst he can at least manage to have a daguerrotype hung round my heart which he swears will be unchangeable and I believe him."[33]

She continued to write emotional letters to her patron, admitting that she knew nothing about business but was certain that no one better than Crow could successfully bring about a turn of events or, if need be, meet vicissitudes more cheerfully. Perhaps in response to his assessment of the crisis, she wrote, "Yes, it does seem vexatious that two such nice people as ourselves should ever be forced to think of ways and means and blessed be the Creator who has provided a place where we shall eventually live on credit and faith."[34] At last, she wrote from New York: "How grieved I am not to see you," adding that "we must try to believe that all that is is best." "On the assurance that the prayers of a righteous woman avail much," she counted heavily on seeing him in Rome the following winter "when you have outridden the commercial Helles-pont." She reiterated the classical metaphor several times.

Lydia Maria Child continued to keep track of Hatty's movements, explaining to her friend Marianne Silsbee that the busy visitor had wished to come to Salem to see her "pleasant countenance," had she not been in such a "desperate hurry." The Ticknors had lionized her, Mrs. Child reported, "giving her rings, bracelets, etc." In a rare show of pique, she added, "It made me think of the time when they used to follow me up with similar attentions; but I can't say I had the slightest wish for a return of their patronage."[35]

In New York during a frantic four days, Hatty was entertained by her cousin Dr. Henry Bellows and his wife and was able to visit with Catharine Sedgwick, who was optimistic about the turn for the better on the financial front. A plan to ride in the carriage of a rich American family who was going from Le Havre to Rome was scotched by the need

for the unidentified travelers to hurry home due to the "pecuniary crisis," as Maria Child put it. The necessity to travel alone would not bother Hatty, she added, the independent young woman "fully able to manage both horses and pistols."[36]

With the *Cenci* safely arrived and exhibited in Boston and with plans for a showing in the English Art Exhibition in New York, the next step would be its trip to New Orleans and then up the Mississippi to St. Louis and its "grandfather's arms." Meanwhile, Hatty needed to hurry back to Rome. Besides her father's anxiety about the increased perils of an ocean voyage in the late autumn season, she had to resume work on the Falconnet monument, which she had left modeled in clay. The work, which would give "great satisfaction to the parents of the deceased," Maria Child reported, would bring her the sum of twenty five hundred dollars.[37]

She sailed on October 24 on the new ship *Vanderbilt,* a vessel of five thousand tons that cost nearly a million dollars. Passengers were treated to fresh eggs laid by chickens who were signed on for the trip. To commemorate the particular hen who laid her breakfast egg, Hatty wrote an ode which began:

> Hail, laying bird, and thrice all hail!
> Thou'st raised an egg; my voice I'll raise.
> For will shall not, if flesh shall fail,
> To greet thy lays with other lays.[38]

Since she was able to compose seven stanzas of parody on Shelley while on the ocean voyage that she used to dread, her crossing on the *Vanderbilt* must have been relatively serene.

13
Interval in Florence

An interlude in Florence marked Hatty's progress toward Rome as she returned to her work. Robert Browning, eagerly anticipating her arrival in Tuscany, told her to be sure to apprise him of her schedule. "I shall count on your writing from Paris as you promise so as to be able to reckon days and nights, and keep my arms open to the proper width for the jump into them from the railway carriage, which I also count on." Continuing so exuberantly that Cornelia Carr later deleted the last portion of the note, he wrote: "Ah! Won't we have a time of it! It's too good to prove true, that's the word: but you're a darling [here Cornelia called a halt], and I shall soon K . . . gross thought. Rather shall soon exemplify the contraction and protrusion of the orbicularis oris—let me practice it now in bidding you Goodbye."[1]

Hosmer again stayed at the Villa Bricchiere, near the summit of the hill of Bellosguardo, with Isabella Blagden. Blagden, along with members of the Browning household, had battled the gastric fever that summer. She had also nursed Robert Bulwer-Lytton, the British envoy in Florence, during a particularly serious attack. The Brownings suspected that the kind woman with the dancing black eyes had perhaps become too fond of the attractive Lytton. Henry James, in his nostalgic look at a vanished society, described Isa Blagden as one who "befriended the lonely, cheered the exile and nursed the sick . . . in the good old days of casual tendance, before the dawn of the capped and cloaked, the now ubiquitous 'trained'!"[2]

Elizabeth Browning, increasingly frail, was approaching the zenith of her lifetime career after the publication of *Aurora Leigh* in 1856. When the book appeared, she sent Hatty a copy of the poem with the message that she hoped "it contained backbone," a reminder of Hatty's preference for "Aurora" over "Laura" for the principal character's name. The author need not have worried. *Aurora Leigh,* a strong feminist statement, was greeted by critics with extravagant praise and surpassed anything the poet had done before. In the lengthy work of ten thousand

lines, she spoke with the mature voice of sexual liberalism, shocking to many, perhaps even to Hosmer, for it was she who later referred to Mrs. Browning's "less delicate verse."[3]

Elizabeth, as well as Robert, looked forward to Hatty's stopping in Florence on her way back to Rome. In a letter to Fanny Haworth she said that Hatty had promised to arrive at the end of the month, when she would "sweep us all up into her apron," as she departed for Rome. "Nota bene—The figure is mine & too effeminate for the sculptress."[4] During her two weeks' stay, Hatty had breakfast and dinner with the Brownings nearly every other day, "a great favorite with both of us," Elizabeth said.[5]

The venerable art critic Anna Brownell Jameson was also in Florence during Hatty's visit. Jameson, the daughter of an Irish miniature painter, wrote copiously and gracefully on religious art. She was also a fine conversationalist, who lectured on her chosen subject in a beautifully modulated low voice, enthralling her listeners. For a time in 1837, while she was living in Canada, she visited in the United States, where she met Catharine Sedgwick and became one of the many pilgrims to the Berkshire area. Now old and stout, she was spending a year in Italy, revising her book, *Sacred and Legendary Art*. She had known Elizabeth before her marriage to Robert Browning and had helped the couple get a foothold in Italy.

Anna Jameson was staying in rooms on the floor above the Brownings in the Palazzo Guidi, where Hatty would breakfast with her. Or the two would join their friends in their dining room. The meal would be served by the house servants, with the food placed on a sideboard that the two poets had obtained from a convent in Urbino. Through windows curtained in a rich red, the fabric an imitation of damask, diners had a view of the tiny terrace, decorated with crepe myrtle and orange trees in tubs. Inside, the walls were hung with tapestries and medallions of Browning, Tennyson, and Carlyle. A fire was frequently built in the fireplace to modify the chill.[6]

In the evening, company would gather in the drawing room, filled with books from fellow authors. Along with the decorative tapestries were pictures of melancholy saints. A profile of Dante, a moulage of Keats's face taken in life, sketches of Tennyson and John Kenyon, and Penini Browning's little masterpieces were all part of the graceful disorder that Elizabeth cultivated. Guests were mindful not to stay too late, although comfortable chairs and sofas invited them to linger. But a reminder of work in progress was Elizabeth's small table cluttered with writing materials. Sometimes callers, like the Hawthornes, were treated to cake and strawberries passed by "little Penny," as Hawthorne called

him. The odd-looking child, "not yet emerged from his frock and drawers," would either chatter with the guests or lose himself in his own thoughts.[7] Two or three evenings a week, Robert Browning joined the company who gathered at the Villa Bricchiere. Younger than his wife by several years, he also had the abundant energy and vitality that she lacked. Women loved his company, threatening to spoil him with adulation. His attentions, never to be taken seriously, were flattering to them. Frances Power Cobbe, the Irish feminist who was a part of the Florentine circle, wrote that the woman to whom he was talking would often be pushed to the very edge of the sofa, in peril of falling off, so animated was his conversation.[8]

Over a period of some years, the gatherings at the Villa Bricchiere included Robert Bulwer-Lytton; Frederick Tennyson, the older brother of the poet; Fanny Haworth; the Trollopes; Walter Savage Landor; the attractive American journalist Kate Field; and Harriet Hosmer. Gossip, reports Edward McAleer, was always "heterosexual." When there was an intimate relationship between those of the same sex, it was viewed with detachment.[9] Frances Power Cobbe described Hatty Hosmer as "the most bewitching sprite that the world ever saw." Recalling the good times in Florence, she wrote: "Never have I laughed so helplessly as at the infinite fun of this bright Yankee girl. Even in later years when we perforce grew a little graver, she needed only to begin one of her descriptive stories to make us all young again. . . . Oh! what a gift,—beyond rubies are such spirits! and what fools . . . are those who damp them down in children possessed of them."[10]

Indeed, spirits of a different sort were all the rage in the English-American colony in Florence. One of the most interesting disciples of the occult was a weird old artist named Seymour Kirkup, called by Hawthorne "the old necromancer." The eccentric Kirkup, shabby, even filthy in appearance, reached back to a friendship with William Blake. He had attended the funeral services of Keats and Shelley. His paintings covered the walls of his messy apartment. At eighty-seven, he married a twenty-two-year-old Italian girl, and he died at ninety-two.[11] In spite of his preoccupation with spiritualism—he often spoke with Dante—Robert Browning liked him.

James Jackson Jarves, the expatriate critic and art collector, was also a true believer. Jarves's fervid interest in the occult may have been the reason that Elizabeth liked him and Robert did not. Spiritualism was one of the few subjects on which the two poets differed strongly. Penini's long curls and ridiculous clothes and Elizabeth's admiration for Louis-Napoleon were others. Jarves sponsored the presence of Daniel D. Home, the Scottish-American medium who had enjoyed and profited

from the patronage of Jarves's mother in Boston. Home's name was anathema to Robert Browning, who got his revenge in *Mr. Sludge, "the Medium"* but continued to bristle as Home held the company of literary folk and artists in his thrall.[12]

Even the quintessential Yankee, Hiram Powers, who had lived in Italy for thirty years without taking on any airs, had an avid interest in Home's rituals. Hawthorne, visiting at Powers's villa just outside the Porta Romana, told of a "great scratching" in the closet while Home was holding a seance. Mrs. Powers, who regularly had little afternoons of lemonade and cookies, "addressed the spirit, asking it not to disturb the company then . . . promising to confer with it on a future occasion." The following evening, during an interview with the spirit, those present learned that the violent noises issuing from the closet came from the ghosts of twenty-seven monks who had once inhabited the place as a monastery. Something "made free with Mrs. Powers's petticoats," lifting them "as high as her knees." On the breast of each of the group present around the table, a sign of the cross was made with the transverse drawn sharply "so as to leave a painful impression."[13]

What Hatty's part was in the evenings of table tipping, automatic writing and seances by this time in 1857 is not entirely clear. Earlier, in her eagerness to be a part of the Roman circle and its diversions, she had participated in the hocus-pocus, taking a turn at spirit writing. But her private opinion about the feverish fanaticism still going on is revealed in a letter to Cornelia Crow after hearing news of their former teacher Elizabeth Sedgwick.

> What you tell me of Mrs. Sedgwick seems to me the most extraordinary thing. *Fra noi* [between us] I really think she is insane and upon spiritualism. When a shiny head like that begins to ride a hobby, they often break down by the way when a weaker one would take the disease more mildly. . . . I think it is a monstrous pity for it cannot help prejudicing many against her and so affecting the school.

It is possible that during the interim in Florence she may have still enjoyed the eerie excitement while harboring reservations. Robert Browning remained a skeptic. Later he asked Isa Blagden, "Do you still sit around a table and see who will turn it least apparently?"[14]

The vogue for spiritualism in Victorian circles reached epic proportions, a climax of romantic and gothic preoccupation with the supernatural. Even Queen Victoria, after the death of her beloved Albert, was mesmerized by the hope of communicating with her dead husband. But the phenomenon of spirits talking in tiny, tinny voices through a medium was perceived as different from the more extraordinary sensitivity

that endowed certain gifted individuals with a special prescience. Harriet Hosmer herself and those close to her felt that she had that uncommon ability, a matter to wonder at rather than explain.

During the stay in America, Hatty had begun to gather material for her next work, a heroic statue of Zenobia, queen of Palmyra, a historical figure from the annals of the Roman Empire. As she had discussed it with her friends, Maria Child and Anna Ticknor, her "whole soul was filled with Zenobia," Child later recalled. Ticknor, eager to have a share in the creative process, offered a drawing that showed how, in her mind, Zenobia should look. Convers Francis opened his splendid library "for the benefit of Zenobia."[15] Probably, his books on the subject included a copy of the Reverend William Ware's romanticized story, *Zenobia: Queen of Palmyra,* as well as Edward Gibbon's history.

Hatty was meticulous in her concern for authenticity of costume. During her stopover in Florence, she talked about the problem with Anna Jameson, who had previously published *Memoirs of Celebrated Female Sovereigns,* a work that included an account of the historical Zenobia. Well qualified and resourceful as a researcher, Jameson offered to produce casts of antique coins that were contemporary with the period, the third century A.D.

Hosmer spent hours in the Pitti and other Florentine libraries, searching for the proper dress for her figure. Frustrated by her lack of success, she talked to Dr. Migliarini, director of the Uffizi, who sent her scurrying to the Church of San Marco. In the monastic sanctuary that had known the presence of Fra Angelico and Savonarola, she came upon the enormous mosaic, predominantly gold, of the Virgin Mary, or the "Madonna," as Protestants called her with polite discretion. This was exactly the image she sought, entirely appropriate for the period, "requiring little change, except a large mantle thrown over all." The ornaments were sumptuously Oriental, "with just such a girdle as is described in Vopiscus."[16]

Back in Rome, she wrote a long letter to Fanny Kemble, hailing her friend from "the land of the brave and the home of the flea!" Her only disappointment about the trip back, she said, was missing Adelaide Sartoris by a mere hour in Paris. But, in Florence, "the Brownings were more enchanting than ever, so utterly kind." She could not resist telling "of a little *sfogo* which the beloved Robert and I committed," one which, if revealed, would have been called outrageous. "You know all about the Certosa Convent, of course, and are aware of the fact that no one under immediate petticoat government can enter its hallowed and unhooped precincts. I had an imperious desire and particular reasons for wishing to see the monuments therein by Donatello, Orcagna and San Gallo."

She "arrayed" herself, "not like the lilies of the field but in something that *had been* spun," Browning's clothes. She went from the top to the bottom of the monastery, she said, "without exciting the least suspicion as was proved by my being ushered into the cells of the monks where either the occupants or I should have been relieved of our heads had the frailty of my corporeal vessel been discovered." She had seen many exquisite things, she said, "which every artist should see and which, having seen, he could never forget." Besides the aesthetic experience, the escapade may have resolved the urge to enter a forbidden cloister, perhaps the very one that she and the Brownings, in company with the Kinneys, had plotted to invade some years before.[17]

In the same letter, Hatty spoke of her need for a larger studio, "for the members of my family [her sculptures] are crying for more space." John Gibson did not seem inclined to let her go, so she was trying to acquire one or two rooms attached to Gibson's, if possible. Its size was the only limitation of her little room, her workplace since she had come to Rome. Nonetheless, Hatty reported to both Mrs. Kemble and to Wayman Crow that the Falconnet monument was coming along well. She was looking forward to beginning a model of *Zenobia,* and she was concocting a small model of a fountain from an idea that had been in her mind for a long time.

Reporting her "domestic concerns" to Crow, in the matrimonial metaphor that she often used, she wrote, "I have taken onto myself a wife in the form of Miss Stebbins, another *scultrice,* and we are very happy together."[18] (Worth noting is her use of the Italian feminine *scultrice,* although she studiously avoided "sculptress," which carried an inherent message of discrimination for her.) "Miss Stebbins" was Emma Stebbins, a member of a prosperous New York family, who came to Rome when she was nearly forty to study sculpture. She had been a painter, but, encouraged by her family, she decided to change to plastic art. She soon began to study with the sculptor Paul Akers. Lacking a place to live, she was hospitably taken in by Hatty Hosmer.

Hatty continued to ride the little pony that she had found earlier in the year in Albano, bought for the sum of fifty *scudi.* He was "a perfect little Puck," she told Anne Dundas, "whose only fault is in being too small, but strong as an elephant, full of wickedness, and . . . beginning to jump like a cat." She anticipated having a fine horse that winter, one that she could urge on with her whip "in the wholesome amusement of the chase." The horse was the generous gift or loan from Charlotte Cushman, a thoroughbred English horse, "full of spirit and good as gold," Hatty told Crow.[19]

Weather never daunted her. Maria Mitchell, the American astrono-

mer, told about a rainy day in Rome, where she was spending a leisurely six weeks. When the weather was pleasant, she climbed the Pincian Hill or the Capitoline or walked thoughtfully in the Forum. On rainy days, she said, "it is all Art." Along with the cathedrals and galleries, there were the studios of the artists, where Maria Mitchell estimated a thousand tourists gathered during the winter season. She wandered into the studio of the popular Paul Akers, where, as she looked at his work with interest, "the studio door opened and a pretty little girl, wearing a jaunty hat and a short jacket, in the pockets of which her hands were thrust, rushed into the room, and seemingly unconscious of the presence of a stranger, began a rattling, all-alive talk with Mr. Akers." Maria Mitchell overheard enough to know that a ride on the Campagna was planned, "as I heard Mr. Akers say, 'Oh, I won't ride with you—I'm afraid to,' after which he turned to me and introduced Harriet Hosmer."[20]

Maria Mitchell, who called herself a New England conservative, did not take to Hatty at first. Her "cricket like manners" bothered the woman who admitted to "old musty parchment ideas," and it took some weeks for her "to get over the impression of her madcap ways; they seemed childish." Later, she went to Hatty's studio to see *Puck,* "a statue all fun and frolic and I imagined all was fun to the core of her heart." Mitchell thought that, usually, to know people better is to uncover their weaknesses, a disappointment nearly inevitable in human relationships. But her experience with Hatty was contrary to expectation and her observation illuminating. "Harriet Hosmer parades her weaknesses, with the conscious power of one who knows her strength and who knows you will find her out, if you are worthy of her acquaintance. She makes poor jokes," the astronomer went on, "she's a little rude—a good deal eccentric—but she's always *true.*" Burning with enthusiasm for her conception of Zenobia when Maria Mitchell met her, Hatty represented the kind of determination and dedication that Maria Mitchell believed that women of ability had an obligation to nurture in themselves continuously throughout life.[21]

Hatty began to anticipate the arrival of *Beatrice Cenci* in St. Louis. She knew from Cornelia's reports that it had had "divers good notices and some that cut it up," adding that "the latter kind do an artist more good than the former and besides that, my professional feelings are not soft." She had not had a pedestal made for the Cenci, because she could not get what she wanted for it. She suggested that one could easily be made and covered with a cloth that matched the background. Maroon would be much better than crimson as an accent for the marble, red being "too powerful." Maroon was richer. Should the figure need clean-

ing when it arrived, it should be done with pure water and very fine marble dust, "then *dry* marble dust brushed over it but *no soap.*"[22]

Hatty's letter to Wayman Crow began "My beloved Mr. Crow, I write to send you a vow of love and that letter which was concocted in Watertown," presumably the letter that was to be presented to the Mercantile Library when the *Beatrice Cenci* arrived in St. Louis. She told Crow that she had not said "quite all I wanted to say but I feared you would object." Dated October 18, 1857, from Boston, the letter of presentation is as follows:

> Dear Mr. Crow:—
> Will you allow me, through you, to convey to the Mercantile Library Association the "Beatrice Cenci?" This statue is in execution of a commission I received three years ago from a friend of the Library, who requested me not only to make a piece of statuary for that Institution, but to present it in my own name. I have finished the work, but cannot offer it as my own gift, but of one who, with a liberal hand, has largely ministered to the growth of the Arts and Sciences in your beautiful city.

She had taken Vinton at his word but went him one better. Instead of giving the work in her own name, she offered it as a tribute to Wayman Crow. Her open letter to him is revealing:

> For your sake and mine, I would have made a better statue if I could. The will was not wanting, but the power; and such as it is, I rejoice sincerely that it is destined for St. Louis—a city I love, not only because it was there I first began my studies, but, because among many generous and indulgent friends who dwell therein, I number you most generous and indulgent of all, and whose increasing kindness I can only repay by striving to become more and more worthy of your friendship and confidence. And so
> I am ever affectionately and gratefully yours,
>
> Harriet G. Hosmer[23]

She was obeying Crow's wishes, Hatty told Crow in the private letter, in moderating her praise of him. One wonders what she might have said otherwise. But there would be further opportunity to express her indebtedness and affection, she cautioned. When that time came, he should not be surprised. She basked in the memories of her trip home, which had been richly rewarding. With genuine sweetness of nature and a message that begs the reassurance of his approval, she wrote: "I look back upon my visit home last summer with ever increasing pleasure—everything was sunshine—everybody so good to me, in fact, better than I deserve, sinner as I am, and in return for all that kindness and good feeling, I must try to do better, mustn't I?"[24]

14
Via Gregoriana:
"The Best Apartment in Rome"

While Hatty was working away in Rome, Charlotte Cushman was enjoying a successful tour of American cities. Wayman Crow and his family warmly welcomed her to St. Louis, where their comfortable house, about a mile from the Mississippi River, became her second home. Undoubtedly, the Crow family attended many of her performances, pleased to claim friendship with America's first actress.

Nineteen-year-old Emma Crow had only recently returned from her first trip to Europe, where Hatty, on her way back to Italy, had seen her and her chaperon briefly in Paris. A pretty, high-strung girl, Emma had gone through certain growing pains as a student at Lenox that Hatty, looking upon herself as an older sister, had remarked on from time to time. Now the glamour of the noted actress and the excitement of the theater combined to play strongly on Emma's emotions, making Charlotte Cushman the object of her adolescent adoration. By the time the actress left St. Louis for her next engagement in Memphis, it was clear that Emma Crow was the victim of an overwhelming crush on the forty-two-year-old Cushman, who acknowledged a parting gift from the girl as the riverboat *Baltic* steamed south in February, 1858.

> Who but the dearest "little love" in the world ever would have been so thoughtful for the comfort of her mistress—or the one who put up such a nice delicious lunch—that was brought to me Monday last. It comforted me marvelous much on my tedious journey to Cairo [Illinois]! Who ever would have done it half so daintily and in such a nice basket, such nice little towels and such a nice choice of provisions . . . and *on the top of it all* sent me such a pretty nice sweet loving clever note on the dear "little love" I have inspired in my "old age."[1]

Charlotte Cushman, "like all actors," Frances Power Cobbe noted, had acquired the habit "of giving vivid outward expression to every emotion." Nor was such fervid expression absent in her correspondence.

After a pause in Emma Crow's responses, Cushman inquired, "Did my note frighten you that you were making a monster which you could not subdue? No? Are you ill? I pray not so."[2]

Obviously smitten with Emma, Charlotte Cushman hoped to return to St. Louis after the southern portion of her tour was completed. "If anything should chance to prevent this, I shall hope to see you in some way before I leave the country at the end of June." Could not Emma and her sister Mary meet her in Chicago or Cincinnati, or perhaps later in New York? None of these projected reunions came off, and it can be safely assumed that Wayman Crow had a hand in preventing such an occasion. He did not take Emma to Cincinnati even though Miss Cushman had urged him to do so, saying that she wanted to see him on a matter of importance to their mutual protégée Harriet Hosmer. That there was considerable connivance between the actress and Emma Crow is suggested by Cushman's righteous insistence that it was "not wrong not to tell Papa. It would have wounded him. You were right to spare him."[3]

Letters, impassioned and seductive, continued during Cushman's American tour. An ambrotype of Emma made her look "a dark instead of a *fair* darling," but it would comfort Charlotte when she wished "to recall the features which seem to me now indelibly stamped upon my heart. I love you dearly, my own darling. Darling mine, the hard words must be said. They would have been softened to me had I been allowed to press them upon your lips. *I love you! I love you!* Goodbye, I kiss your pretty soft loving eyes and hands."[4]

In spite of the innocence of the era and the acceptability of romantic friendships between women, Wayman Crow must have thought it unwholesome for Emma to be so infatuated with an older woman of the world, as Charlotte Cushman surely was. The quality of Cushman's correspondence, whether he actually saw any of it, did not escape him as he saw its effect on the volatile Emma. A brief note from Cushman to Emma reads: "Darling, I want you to see this letter from your father to me. After you have read it, destroy it. I send you the earrings I promised made of my hair. God bless you and goodbye, my own darling."[5]

Her longing to see Emma unabated, she wrote of her acute disappointment. "I had such faith in your powers of persuasion and your father's love of indulging you that when a knock came at my door on Sunday morning at seven o'clock, I called to my maid to open the door for Miss Crow!" Chiding Emma, she declared that if Emma had persisted, "you would have been able to come away to your loving friend. You may make all your confessions frankly to me."[6]

At the time of this episode, Charlotte Cushman had already met

Emma Stebbins, who was to become her lifelong companion. Miss Stebbins, who took an exploratory trip to Italy in the winter of 1856–1857, recorded in her biography of Charlotte Cushman that, from that time on, "the current of their lives [hers and Cushman's as described in the third person] ran, with rare exceptions, side by side."[7] The ardent correspondence with Emma Crow must have been painful and threatening to Stebbins's emerging relationship with Charlotte Cushman. When Stebbins returned to Rome, this time to study sculpture, she moved in to share quarters with Hatty. Both women were corresponding with the absent Cushman, but Stebbins assumed the role of watchdog over the energetic, playful Hatty. It was the reportage from Stebbins that Charlotte Cushman relayed in her letters to Emma Crow. When Hatty was the subject, Cushman assumed the air of offended parent, eyebrows raised in disapproval at Hatty's behavior. Hatty was going to three parties "of a night," not returning home "until the small hours of the morning. This to a person who has to rise at seven to go to her work at which she stands for several hours." In the late afternoon, Hatty often rode "hard, hard" for two and a half hours. Cushman concluded that it was no wonder she had pains in her head and cold feet. "She is an immense favorite in society and cannot forego the charm and excitement it contains," she added, perhaps with some envy. When she would return to Rome, Cushman hoped "to keep her [Hatty] a little within bounds but *no human being has any control over her!*" How she wished that Wayman Crow would come to Rome and bring Emma, a hope that Hatty surely shared. Crow had "more positive influence with her than anyone else!"[8]

Hatty's letters to Cornelia Carr confirmed that she was indeed having a life of "social gayeties." She contrasted her life with that of her friend: "I do often think of you away in your quiet home and muse how different it is from mine with all the cares of work and the dissipations of a gay society, for let me do my best, I am tempted into them . . . but the difficulty is to draw the line between just enough and too much." If Charlotte Cushman was critical of Hatty's conduct, she continued to support and encourage her work. Excited about the concept of "Zenobia," she told Emma Crow, "If she carries it out as she conceived it, it will exceed anything she has done. Are you not glad of this?" Of Hatty's sale of repetitions of *Puck* to the Duke of Hamilton and Earl Fitzwilliam, she asked Emma, "This is getting into grand company, is it not?"[9]

The vigilant Emma Stebbins reported that Hatty, a victim of the common cold, was "taking a little care of herself." Hatty affirmed that there was a great deal of sickness in Rome but minimized any risk to

herself. She was, she thought, "too wicked for the Lord to want me and too good for the other old gentleman to take an interest in me." Unaware or indifferent to the accounts of her activities that Emma Stebbins was giving to Charlotte Cushman, she said only that she had heard from Cushman, "who seems to have left a large portion of her heart with certain members of your family." Hatty continued to write approvingly, perhaps recalling her own feelings of adulation when she had first met the compelling Cushman. She had come to jokingly call Miss Cushman "Ma" sometimes, but Charlotte Cushman was never equal to Wayman Crow in Hatty's affections, although she said to Crow: "I am pleased that you seen so much of her [Cushman] and know her so well because the more one knows her, the more one appreciates and loves her. She is a noble woman and as much of a mother to me as you are a Father."[10]

Some professed to see a physical resemblance between Hatty and Charlotte Cushman. "It is said I look uncommonly like her so I tell her her bad penny has come back to her in spite of herself." Continuing in a manner ingenuous but perhaps disturbing to Crow, she said, "I perceive that she [Cushman] and Emma are what we this side of the ocean call 'lovers'—but I am not jealous and only admire Emma for her taste."[11]

Meanwhile, in Watertown, Dr. Hosmer concerned himself with his daughter's business practices, convinced that she was still wildly profligate. In man-to-man fashion, he spelled out in a letter to Wayman Crow that "her outlays are only limited by her supplies present or prospective and nothing has checked profusion with her but want of means which has proved a real God send." The doctor went on: "But I do not regard the disease irradicated for it is bred in the bone—more than flesh deep. It would occasion relapses if medicine were suspended."[12]

Not long afterward, Dr. Hosmer was writing to Crow in a very different vein. Miss Coolidge, the housekeeper who had been his "stay and staff" for nearly twenty years, had died after a lingering illness, its signs and symptoms noticed by Hatty during the visit home. She had slipped into unconsciousness before she died, a circumstance that relieved Dr. Hosmer. Always fighting the mortal force that had devastated his family, he said of Miss Coolidge, "Peace to her ashes—she cheated death and the cold grave."[13] Grieving at the news, Hatty said that she had shed "more bitter tears than I have known since that chapter in our family which took place . . . fifteen years ago." (She appears to be speaking of the death of her sister Helen rather than the earlier death of her mother.) Miss Coolidge was the "only one in the world" who could make her father comfortable and had blessed her childhood "with the most tender and devoted affection."[14] One comforting aspect of her

father's loss was his first visit to the Crow family in St. Louis, where he showed up on their doorstep in one of his rare ventures away from his own hearth.

The American tour over, Charlotte Cushman returned to Rome, where she looked forward to moving into her own house at 38 Via Gregoriana. She had leased it well before she sailed to America, but there were extensive alterations to be completed before she could take possession. That Hatty was to have quarters in the house was a foregone conclusion. Much earlier, Hatty had been touched when she saw the projected designs with space on the third floor clearly designated as "Hatty's rooms." It soon became clear that Emma Stebbins would be sharing Charlotte's apartments, joining the family circle as the actress's intimate friend. The black servant, Sallie Mercer, was an indispensable member of the household. Enduring companion as well as personal maid to Cushman, she was one of the few people in whom Cushman had complete confidence and trust. No matter how disillusioning other associations might be, Sallie could be counted on. A note from Cushman bears this out: "Dear Sallie: July 18, 1855. Thanks for your consideration. There are few people in the world who care . . . whether I spend money or not. Yr affectionate Charlotte."[15]

Although the bond with Emma Stebbins was apparently sealed when Charlotte Cushman returned to Rome, the correspondence with Emma Crow continued, although probably with less ardor. Regarding the renovations of her house in the Via Gregoriana, Cushman said that Hatty's rooms were nearing completion, "commanding a lovely view and in fact the healthiest and best apartment in Rome. . . . This will be a satisfaction to you all who love her so much." Hatty was well and "as jolly as possible, full of fun and frolic."[16] Soon they would all be together at 38 Via Gregoriana.

The location was, and still is, superb—a ten-minute walk to the top of the Pincio to see the afternoon spectacle of the setting sun and only steps away from the beautiful Church of Santa Trinita dei Monti and the Piazza Santa Trinita, with the Spanish Steps rippling down to the Bernini fountain. More open then was the view from the windows at number 38, the vista stretching across the Tiber to St. Peter's dome, silhouetted against the changing sky. They could look right down into the Piazza di Spagna, Emma Stebbins recorded, to see the Madonna column, a recent addition to the old Roman street. Off to the left was the curious tower of Sant' Andrea delle Fratte, "where hosts of rooks gathered in the faithful with caws."[17] Charlotte Cushman spared no expense to make the house comfortable and beautiful. Deep chairs and sofas were upholstered in bright printed fabrics, and James Jackson

Jarves, an avid collector, helped her to acquire antiques and paintings as he relentlessly scouted monasteries and palaces.

As the year 1858 drew to a close, each of the women was eager to move into these lovely apartments. After at least one makeshift arrangement—sharing rooms with Hatty—Emma Stebbins could look forward to a more permanent Roman home in the company of the woman she had chosen to share her life with. As for the complex Cushman, who craved social recognition, she could at last command the role that she had sought and that had eluded her—patroness of the arts and chatelaine of her own castle. As for Harriet Hosmer, she looked forward with keen desire to these splendid accommodations, by far the grandest that she had enjoyed in her six years in Rome and apparently a gift from the generous Cushman.

At last they were installed in style. Cushman had her first reception on January 19, 1859, a prestigious event that gave Roman society much to talk about. Soon Cushman was giving little dinner parties at which a circle of friends that included John Gibson feasted on American oysters and wild boar with *agro-dolce* sauce. Luncheons and breakfasts sometimes included what Frances Power Cobbe called "woffles," eaten with molasses, sure to be "sudden death" but consumed heartily by the women guests.

Hatty expressed to Wayman Crow a confidential reason for wanting to be closer to Charlotte Cushman: "[After moving] I shall keep a sharper lookout on Miss Cushman and not allow her to go on in this serious manner with Emma [Crow]—it is really dreadful and I am really jealous—furthermore, it is a bad lookout for Emma, for, and you may tell her if you like, that unless she restrains her emotions, she will never get a husband. Tell her I speak from experience." She added an awkward parody of Shakespeare to describe her own situation: "How sharper than a serpent's tooth it is to have a thankless husband, but how infinitely worse it is to have none at all."[18]

What to make of this peculiar statement? In this private disclosure, Hosmer seemed to say that girls who spent their emotional energies on other females could end up single; many thought so. Did she regret being drawn in, even fenced in, by the circle of "emancipated women"? She certainly chafed at their efforts to control her. One thing seems clear—that she perceived herself as a marriageable female. As for the jealousy she speaks of, it seems little more than the pique of a child. That she understood the sexual preference of Charlotte Cushman appears unlikely. But she did indeed recognize the excessive emotion that was being generated by the correspondence. Emma Crow probably attended to little else, and Charlotte apparently wrote regularly. Emma

Stebbins must have been an unhappy accessory to the liaison. Referring to letters that may or may not have gone astray, Cushman said, "I daresay Miss Stebbins put them in her pocket and forgot to mail them so my darling little lover has been deprived of her rights."[19]

In her correspondence with Wayman Crow, Hatty's single status is a recurring theme, sometimes serious, sometimes comic. She wanted very much for Crow to see her as a womanly figure, as indeed she was. Looking at an ambrotype of her godchild, she told him that the picture rejuvenated her maternal instincts, a commodity that he might think she lacked. Jokingly, she claimed that she was waiting for him to find her a husband and promised not to marry until he did. But her approach to matrimony was taking on the authority of a stronger, rather than weaker, sex. "I have been searching vainly for Mr. Hosmer," she told Crow, but she had virtually decided that "I must leave it to sharper eyes than my own to find him."[20]

How much she felt the lack of a husband is open to speculation. While the stigma of spinsterhood in nineteenth-century society cannot be discounted, she obviously enjoyed the freedom of her life-style, with its mixture of sociability and solitude. Since these confidences were told only to Crow, is it possible that she was presenting a persona that did not mirror her true self? It would not appear so. Her words to Crow must be seen as reliable, or the credibility of her whole character is in question. Beyond the close relationship with him, there is the testimony of such observers as Maria Mitchell and Lydia Maria Child, women of great perception who vouched for the essential trueness of her nature. Nor can the "purity" of her emancipated life, as described by Elizabeth Barrett Browning, be forgotten.

Closely allied to her thoughts on marriage are Hosmer's ideas on feminism, very liberal for her time but still limited and conditioned by traditional social mores. Reporting a conversation with a certain Mr. May who visited her studio, she said, "He is a great women's rights man, I find, just as much so as it seems to me is *reasonable*—that is that every woman *should have the power of educating herself for any profession* and then practicing it for her benefit and the benefit of others." This was as far as she had gone with it. Like other liberated females, including the young Margaret Fuller in an earlier time, she was not particularly interested in women's suffrage.

> I don't approve of bloomerism and that view of women's rights, but every woman should have the opportunity of cultivating her talents to the fullest extent, for they were not given her for nothing, and the domestic circle would not suffer thereby, because in proportion to the few who would

prefer fighting their own way through the world, the number would be great who would choose a partner to fight it for [not "with"] them; but give those few a chance, say I. And those chances will be given first in America.[21]

She still thought that most women would prefer the protection of marriage. She viewed matrimony romantically with the male spouse "fighting" in the female's behalf. Those, like her, who chose to remain single out of personal conviction would not alter the structure of the family, whose fundamental importance in society she fully acknowledged. As for her indifference to women's suffrage, like many of her contemporaries, male and female, she would come round to a different point of view.

Surely one of the most interesting and notable observers of Harriet Hosmer was Nathaniel Hawthorne, who came to Rome in the spring of 1858 after serving as consul in Liverpool. The New England author, already widely acclaimed, and his wife, Sophia Peabody, were accompanied by their three children and a governess. Hawthorne's observations are among the most vivid of any Roman sojourner. He saw the city's eternal ambiguities—the sacred and the profane, the glorious and the decadent, and the chiaroscuro of light and shadow.

At first, Hawthorne was put off by the centuries of filth that enshrouded Rome, and his perfectionist nature stood in the way of his appreciation. He understood this quality in himself. During the carnival season, the Tiber teeming with yellow water and fragments of dismembered trees, celebrants in the Corso pelted observers with the customary confetti and played the boisterous game of snuffing out candles, often too roughly for the reserved New Englander. "Only the young ought to write descriptions of such scenes," he mused. "My cold criticism chills the life out of it."[22] But his natural curiosity drew him out into the streets and on walks in the Campagna, often with the artist C. G. Thompson as his cicerone. Many of the places he saw, like the Catacomb of St. Calixtus, the Tarpeian Rock, or the Capuchin church, he later used as sites for his romance *The Marble Faun.* The Hawthornes did the de rigueur tours of the artists' studios. While he missed the color and warmth that painters' ateliers offered, Hawthorne was nonetheless fascinated by sculpture. He dropped in on Joseph Mozier's studio, where he saw *Pochahontas* and the *Wept of the Wish-ton-Wish,* native American subjects that Mozier had turned to.

A few days later, the Hawthornes—Nathaniel, Sophia, and their daughter Rose—came to John Gibson's studio in the Via Fontanella, where Hawthorne took note of Gibson's *Tinted Venus* and *Cupid,* both colored to emulate the Greek polychromed sculpture. *Cupid* and *Venus,*

her golden hair held in a snood, her lips reddened, her outstretched hand holding a gleaming apple, were ongoing subjects of controversy. To Gibson his *Venus* was like a Galatea, but to Nathaniel Hawthorne and to others, even in the Roman artistic community, nudity in color was shocking, no matter how authentically Greek it might be. Like other Americans, he was offended by the unclothed body, the ghosts of his Puritan ancestors rising to haunt him in this as well as in other aspects of his psychic inheritance. Chaste, white marble somehow mitigated the shock of a bare body. Someone told Hawthorne that statues were sometimes stained with tobacco juice to give them a sepia tone. Thinking about Gibson's tinted works, Hawthorne wryly observed that, if Gibson were "to send a Cupid to America, he need not trouble himself to stain it beforehand."[23]

The Hawthornes moved through Gibson's domain into the studio of their young countrywoman. When he first saw Harriet Hosmer in her working costume, he thought that she was most "peculiar" in her velvet cap, shirtfront and cravat, but he gave his "full leave" for her to wear what suited her. As for her straightforward, brisk manner, unusual for females of the time, he felt she should "behave as her inner woman prompts." Such toleration, for this consummate New Englander, was a sign of growth. Before long, he came to the conclusion that the expatriate artists needed the Roman freedom. He voiced his opinion through the sculptor Kenyon in *The Marble Faun:* "Rome is not like one of our New England villages where we need the permission of each individual neighbor for every act that we do, every word that we utter, and every friend that we make or keep. In these particulars the papal despotism allows us freer breath than our native air."[24]

Not that Hawthorne didn't harbor some misgivings about Hatty Hosmer's inclination to do as she pleased and dress as she liked. How could she meet the later demands of "the decorum of age?" he asked himself. The costume that she wore was "pretty and excusable enough in a young woman" but scarcely suitable for an older one. It mattered little to the sculptor herself as she showed the distinguished visitors around the studio. Hawthorne was not impressed with the model of *Beatrice Cenci* that he saw in the studio; more to his liking was another for the Falconnet monument.[25]

The Hawthornes called frequently at Harriet Hosmer's studio, and examination of Hawthorne's complete *French and Italian Notebooks* as well as his pocket diary reveals that the Hawthorne family became very friendly with Hosmer. Besides studio calls, there were dinners together and social calls. Often they were mutual guests, most notably at the apartments of William Story and his family in the Palazzo Barberini.

Breakfasting at the Story apartment on May 23, along with other guests, including Harriet Hosmer, Hawthorne offered Hosmer his idea for a fountain, "a lady 'bursting into tears,' water gushing from a thousand pores in literal translation of the phrase." Hawthorne would call it "Niobe, all tears," and the gush of water "might be so arranged as to form a beautiful drapery about the figure, swaying and fluttering with every breath of wind, and re-arranging itself in the calm." He doubted that Hatty would adopt the idea, although he was certain that Bernini would have loved it. Again, Nathaniel Hawthorne described Hatty in his journal:

> Miss Hosmer, to-day, had on a neat little jacket, a man's shirt-bosom, and a cravat with a brooch in it; her hair is cut short, and curls jauntily round her bright and smart physiognomy; and sitting opposite me at table, I never should have imagined that she terminated in a petticoat, any more than in a fish's tale. However, I do not mean to speak disrespectfully of Miss Hosmer, of whom I think very favorably; but, it seems to me, her reform of the female dress commences with its least objectionable part, and there is no real improvement.[26]

Hatty was actually working on a fountain, one that told the myth of Hylas and the Water Nymphs. Hylas, the male figure, descended for water only to be set upon aggressively by a company of nymphs, who felt threatened by his presence. Poeticized in marble, Hylas became the figure at the apex of a pyramid while the nymphs twined around the base to drag Hylas down with their extended arms. Dolphins spouted jets of water, gratefully received by thirsty swans who supported the upper basin.[27]

Writing to Cornelia on November 12, 1858, Hatty described herself as sitting in Cushman's *salone,* "vis-a-vis to her." Stebbins sat on her left and "the invaluable Sallie [Mercer] on my right and this composes a family party." The following day the Falconnet monument would be placed in the Church of Sant' Andrea delle Fratte. It would be "a day of rejoicing." Shortly afterward, the Brownings, spending the winter in Rome, went to see the Falconnet monument. "I assure you, Isa, it is exquisite," Elizabeth wrote. "The pose,—the doubt between life & death,—the relaxation of the fingers . . . from between which the rosary (the last hope) has fallen—the simplicity & pathos altogether, make it most impressive. Not merely her best work, but a work far better than I, for one, ever expected from her." Robert was very pleased with the monument, Elizabeth continued. They had also paid a call at Hatty's studio. "We saw the Puck,—& the Will o' the Wisp which pleases me much less than the Puck." Zenobia, she said, was not "in seeing order,

but she means, she says, to be great in it." But the Brownings had not seen her since, for she was suffering "from a boil or two again—poor Hatty."[28]

The letter had begun with an account of Hatty's social life. Enumerating the visitors to their rooms in the Bocca di Leone, Elizabeth said "& Hatty & Gibson of course." She continued: "Hatty looked radiant when I saw her. She came in one evening after dining with Pantaleoni, with large sleeves, & lace, & everything pretty." To show that "she remains Hatty after all," Elizabeth went on.

> The night before she had been with Miss Cushman, & returning home at ten was encountered by a man who extended his arms & enquired why, she walked the streets of Rome at so late an hour—It was close to her own door, & she knocked before she spoke. Then turning round she said . . . "You ask my reason for walking so late. *This* is my reason—" And crash across his face she struck with an iron-pointed umbrella. He turned & fled like a man—I wont say as Miss Cushman did, like an Italian. So there's your Hatty for you.[29]

In her November letter to Cornelia, Hatty compared her *Will-o-the-Wisp,* the pendant for the popular *Puck,* and her newest creation, to Cornelia's expected baby. "You will have a little Wayman and I a little William ushered about the same time into this world of instability and plaster." Although Cornelia's previous child, Wayman Crow Carr, had died the previous year, it was not unusual to use the same family name again and again if the bearer did not survive. To think of any male child born to Cornelia as "a little Wayman," rather than a little Lucien, came very naturally to her. In January, however, she congratulated Cornelia on the birth of a son, Alfred Carr. She had thrown away two pieces of marble for *Will-o-the-Wisp,* but at last the little putto was nearing completion: "I am dying for you to see my young son also. Will and I will send you a photograph as soon as it is out of the Blocker-outs' hands."[30]

With all of the work in progress, there was still time for riding. Charlotte Cushman told Emma Crow about Hatty's new horse, "as safe and as quick as a kitten . . . a capital jumper." In spite of Dr. Hosmer's anxiety, Hatty would be as secure clearing fences as she had once been "on the back of the little horse her father bought her when she was first in Rome." The animal would pay for itself before Hatty was through with it, Cushman thought. If she entered him in the hurdle races, he would win the stakes.[31]

The year was winding down with a spate of dismal weather. The Campagna was inundated and, in the city, the Ripetta, the street running

Will o' the Wisp, by Harriet Hosmer, 1858, marble, height 31″. The Chrysler Museum, Norfolk, Virginia, gift of James H. Ricau and Museum Purchase (86.472).

Will o' the Wisp, a later version, by Harriet Hosmer, date unknown, marble, height 33.5″. The Chrysler Museum, Norfolk, Virginia, gift of James H. Ricau and Museum Purchase (86.473).

next to the river Tiber, was a veritable stream that had to be crossed by boat. As Hatty wrote to Crow on December 2, she speculated that, should the water reach the Corso, "the prospect is fair of having a fish race this year at Carnival, instead of the horses." The shepherds had taken to the hills after losing flocks and herds, "but with their slip-and-go-easy way console themselves after the manner of Noah's friend, that it is 'only a shower.'" She expressed her wish, as always, that Wayman Crow would come to Rome, and she ended with a prayer "out of the warmest corner of my heart—May He keep you all in the sunniest spot of the earth and may He preserve us all until we meet again."[32]

15
Gossip in the Caffè Greco

Beatrice Cenci was finally at rest in the Mercantile Library in St. Louis. The life-size marble sculpture had been exhibited in Boston, New York, and Philadelphia, as well as on the grand occasion at the Royal Academy in London. Harriet Hosmer hoped that the light was good in the spot where *Beatrice* had been placed and that the critics would deal leniently with her. "Beatrice has her good points, and she has her faults. Nobody knows it better than the parent who brought her forth, but I will leave it to others to find out what they are."[1]

James Jackson Jarves, writing as an art critic, one of his many roles, thought that "Miss Hosmer's *Beatrice Cenci* savors too much of a design by [Ary] Scheffer," whereas the writer of an article in the *Crayon* found any defects "trifling," and the statue "conspicuous for . . . originality; bold, firm, and independent treatment of the thought intended." There was "no evidence of copyism of any kind." Expressing the firm alliance between nationalism and art, the writer stated, "Miss Hosmer and the country have, in our opinion, every reason to be proud of it—and we do not 'lie' in saying so."[2]

After the turn of the century, when neoclassical sculpture came to be looked upon as sadly out of date, sculptor and art historian Lorado Taft wrote about the *Cenci*. Styles had changed, and Taft found the accessories—the pillow, the rosary, the "dainty slipper," and the ring in the stone—"too sharp and insistent for modern taste." But the statue itself had "much grace, and its beauty is of a very intelligible kind. The figure is as well modelled as it is composed, and the carving of the drapery is very refined." Although the statue evoked an era looked upon patronizingly, Taft conceded that "in the conception and, in the main, the execution, could hardly have been surpassed in the Roman colony of the fifties."[3]

Hatty wished that Cornelia could see the smaller copy of *Beatrice* in her studio. "You would call it 'cunning,'" she told her friend. (Presumably, this is the smaller repetition, approximately forty-two by seven-

teen and a half inches, now in the collection of the Art Gallery of New South Wales, Sydney.) Since her return from America, Hatty had been immersed in her conception of Zenobia. She described herself being "as deep in Palmyrene soil as the monks of the Cappucini are in the soil of Jerusalem." Her need for greater work space became urgent as the work progressed from maquette to *modello grande*. Charlotte Cushman told Emma Crow that she, Charlotte, had "set to work and found her a splendid room quite near which she seized on immediately."[4]

To Wayman Crow, Hatty wrote about the new studio at 5 Via Margutta. Her move put her only steps from Gibson, and the two continued to be close companions. "I wish you could raise your eyes from this paper to see what at this particular moment of writing I can see. It would be a huge, magnificent room, not in Mr. Gibson's studio but close by, with a monstrous lump of clay, which will be, as Combe would have said, 'when her system is sufficiently consolidated,' Zenobia." But she did not mention Cushman's hand in it. Either Charlotte Cushman had exaggerated her own part in the discovery or Hatty preferred to ignore her help. It was in this same letter that she expressed her intention to monitor Cushman's attentions to Emma Crow. Always wishing that Crow would come to Rome, she said, "The resources of my quondam studio being unequal to the demands made upon it this year, I have been forced to seek more spacious quarters, and here I am ready to receive you in regal style whenever you will favor me with a visit."[5]

Her ambition whetted by recent successes with *Beatrice Cenci* and *Puck,* Hatty was "dying for a chance at something big . . . dying to give, as Mr. Gibson would say 'some of these fellows a twist.'" This was the first indication that relationships with some of her fellow sculptors were not entirely amicable. Early in 1859, Hatty was honored with a membership in the Accademia de' Quiriti. Looking at the tangible evidence, a diploma in a handsome gold frame, she preened a little, telling Cornelia that she was "small minded enough to desire to make some of my artistic friends very bitter against me. I mean those who laughed at the idea of a woman becoming an artist at all. We will give them a twist yet."[6]

Most of her "brother sculptors" she regarded with respect. She set a high standard for herself as a professional colleague, but, occasionally she shared her private opinions about them with Wayman Crow. Even Hiram Powers came in for criticism when his *Daniel Webster* was inaugurated. Hatty called it "well criticized." When she had seen it some two years before in Powers's studio in Florence, she felt strongly that he was making a mistake in not throwing a cape around Webster "to take off from the poverty and meagreness" of modern dress. "He [the statue]

wants as Crawford used to say 'shaking up a bit.' Poor Crawford—he did and said clever things," she added.[7] Crawford was surely not forgotten in Rome. His uncompleted works were being completed by Randolph Rogers, and his studio remained open as his widow Louisa negotiated for repetitions of his sculpture.

Hard at work on her model of Zenobia, Hosmer had sought the opinion of Anna Jameson, the doyenne of art criticism, who responded from Brighton. The casts of antique coins were useless, Mrs. Jameson explained, valuable only to antiquarians. Then she addressed the personal issue: "the malignant sarcasm of your rivals at Rome, as to your having Mr. Gibson 'at your elbow' and all that." Rumors had been filtering through the cigar smoke at the Caffè Greco that John Gibson did Hosmer's work. Implicit in this gossip was the suggestion that there might be something improper in their relationship. Both Hosmer and Gibson were furious. Jameson, referring to the talk current in the Greco, said, "I should think lightly of your good sense and your moral courage, if such insinuations, irritating to your self-esteem and offensive to your self-dependence, could prevent your availing yourself of all the advantages you may derive from the kind counsel of your friend."[8]

Jameson told Hatty to place Gibson's criticism above hers. Gibson would take advice from Canova and Thorwaldsen, and Raphael, from "every gifted mind around him." She reminded Hatty that "the originality of a conception remains your own, with the stamp of your mind upon it, to give it oneness of effect as a whole. Impertinent and malicious insinuations die away, and your work and your fame remain, as I hope, for a long, long future." Advising Hatty to make her work "as perfect as you can," "to adopt any change of detail" without hesitation, Jameson reiterated her position that for the design of the figure, "the details of drapery and flow of lines," she should listen to Gibson: "This is between ourselves. I have embarked so much of pride and hope in you as an artist, that I should be in despair if you fall into the error of your countrymen and sacrifice what alone can be permanent in style and taste, to a vulgar ambition of self-sufficing, so-called originality."

Recognizing the difference between Gibson's expertise and her own, she continued: "You know that I can understand and feel in picturesque and romantic sculpture, and all that is good in the renaissance style which Mr. Gibson abhors, but in his own department of art, his taste is exquisite and sure." Because Hatty's "Zenobia is a classical heroine, to be classically treated," she must listen to Gibson. Since Hatty had moved from Gibson's studio and become independent—one way to dispel the chatter over the coffee cups at the Greco—she could afford to take Gibson's counsel. Examining the photographs of the clay model, Jame-

son did find the diadem resting too low on Zenobia's brow, detracting from the dignity and intellectualism of the face. She concluded the letter by saying, "Now do you want a stronger proof that I am *truly* yours, [signed] Anna Jameson."

Hatty, seldom prompt in answering letters, wrote from Lucerne ten months later. Traveling in Switzerland with John Gibson, she apologized for her lapse, explaining gracefully that perhaps she had been occupied "giving stronger proof of my sense of obligation to you by adopting your suggestions and profiting by your criticisms." She enclosed another photograph of the Zenobia model.[9] Whether they saw each other again is not known, but Anna Jameson's earlier counsel was, in a sense, a valediction, for she died in March, 1860, at her home at Ealing, of complications arising from bronchitis, and was greatly mourned by her many good friends. From time to time, several had tried to find ways to improve her stringent circumstances; John Gibson had a bequest to her in his will.

Spending the winter of 1859 at the Bocca di Leone apartment, Robert Browning continued to be concerned about Hatty. To Isa, he wrote: "Hatty is the old dearest little creature—she has been suffering from boils and last of all, from an abscess on the glands of the neck—which Pantaleoni [the Roman physician who treated many of the expatriates] had to operate on: it is vexing to see her with her poor neck tied up—but there is the old darling funny face." Soon Browning wrote of an improvement in her condition, "those horrible boils being subdued since I wrote last—I saw her in great spirits two evenings ago: her "Zenobia" is quite another thing now—not the plaster sketch which Mrs. Jameson admired so much,—and far better."[10]

Elizabeth added her thoughts about Hatty's sociability, saying that Paris was tranquil in comparison to lively, gay Rome: "Think of Hatty going out three times in one evening! She is quite other in this respect from what she used to be, when she vanished at ten, even if she appeared at all. And Hatty is not the stronger for these efforts, it seems to me." As for the painful abscesses, she cautioned Isa Blagden not to mention the subject "unless she speaks of it. Her own belief is that she injured herself by remaining through the summer at Rome, and she has made up her mind never to do it again." Expressing the fondness that had not changed, Elizabeth said, "Very dear she is and you should be kind, Isa, and come to Miss Cushman, and take her (Hatty) back with you to Tuscany,—for a summer at the villa [Bricchiere] would be good for her."[11]

When Nathaniel Hawthorne and his family returned to Rome after spending the warm months in Florence and the Tuscan countryside, the feeling of antipathy that he had harbored about Rome was replaced by

one of "quiet, gentle, comfortable pleasure, as if, after many wander-ings, I was drawing near home." Rome had claimed his heart, "as I think even London, or even little Concord itself, or old sleepy Salem, never did and never will." Calling on Hatty in her new studio, the Hawthornes found her "hopping about in her premises, with a bird-like sort of action," in the expansive room with skylight above. The studio was "pretty well warmed with a stove, and there was a small orange tree in a pot, with the oranges growing on it, and two or three flower-shrubs in bloom. She herself looked prettily, with her jaunty little velvet cap on the side of her head, whence came clustering out her short brown curls, her face full of pleasant life and quick expression; and though somewhat worn with thought and struggle, handsome and spirited." If you looked at her "as a woman," Hawthorne thought, her face was "worn with time, thought, and struggle"; but oddly enough, were it the face of a young man of twenty, the same face would appear "handsome and spirited." Not yet twenty-nine, Hatty told the Hawthornes that "her wig was growing 'as gray as a rat.'"[12]

There were few things in the lofty room, for she had obviously left most of her casts and models in John Gibson's studio. Hawthorne noticed "two or three plaster-busts, a headless cast of a plaster statue, and a cast of the Minerva Medica." This last Hawthorne felt she had used to help her design her Zenobia, for he saw a distinct resemblance between the two. Quixotic, often provincial, in his appreciation of art, Hawthorne was moved to describe the statue of Zenobia with infinite detail in the *Notebooks*. He mused about the statue, still in the clay. "I know not whether there is some magic in the present imperfect finish of the statue, or in the material of clay, as being a better medium of expression than even marble; but certainly I have seldom or never been more impressed by a piece of modern sculpture."[13] When Lorado Taft later pondered the depth of Hawthorne's feelings as the author viewed the statue, he claimed to have the answer.

> We begin to understand! The figure was still unfinished and in the clay—plastic, palpitant, and full of promise. . . . The artist's first thought was still there—a very noble and dignified thought, by the way, though not neces-sarily a sculptural one,—and the enthusiastic little woman was alongside to supplement the impression; to tell what she meant to say in the work.[14]

But, at the time, Hawthorne called the work "a very noble and remarkable statue indeed, full of dignity and beauty." He wondered how "so brisk a little woman could have achieved a work so quietly impres-sive." With photographs of *Puck* and *Will o' the Wisp* to compare, Hawthorne thought it showed "much variety of power, that *Zenobia*

Zenobia in Chains, by Harriet Hosmer, 1859, marble, height 84", location un-
known, probably destroyed. A smaller marble version, height 4', 1", is in the
collection of the Wadsworth Atheneum, Hartford, Connecticut; a marble bust
of *Zenobia,* height 17", is in the Harriet Goodhue Hosmer Collection of the
Watertown Free Public Library. Photograph courtesy the Schlesinger Library,
Radcliffe College.

should be the sister of these, which would seem the more natural off-spring of her quick and vivid character." He called the statue, eventually named *Zenobia in Chains,* "a high, heroic ode" and remembered it in the preface to *The Marble Faun,* along with the woman who created it. He explained his fictional treatment of works he had seen in the studios of Paul Akers and William Wetmore Story and said that "were he [the author] capable of stealing from a lady, he would certainly have made free with Miss Hosmer's admirable statue of Zenobia."[15]

As the Hawthornes were winding down their long sojourn in Italy in 1859, unification of Italy came nearer to realization. Count Cavour, minister to King Victor Emanuel II of Piedmont, became the builder of the new Italy, replacing the romantic theories of Mazzini with his own deft political skill. He succeeded in involving the French emperor Napoleon III in a joint venture to drive the Austrians out of the Italian provinces that they had held as imperial duchies for so long. The Franco-Piedmontese armies engaged the Austrians, soundly defeating them at the battles of Magenta and Solferino in northern Italy in the Lombard Lake region not far from Milan. The carnage was terrible, and Hatty, writing to Crow from Milan, which was filled with French soldiers, reported that "everything is as quiet as possible; it remains yet to be seen how much good resulted from those awful battles."[16]

While Napoleon III was helping to bring about the unification of Italy, French troops remained in Rome to protect the pope against any republican uprising, an ambiguous position to be sure. This evenhand-edness served to mollify the French clerical party and the devout Empress Eugénie. Then the emperor made a separate peace with Austria, an outcome that even the pragmatic Cavour had not counted on. The Austrians kept Venetia, but Lombardy became a part of the kingdom of Savoy, variously called Sardinia or Piedmont.

One compromise to emerge concerning the coming unification was the projected union of the existing Italian entities with the pope as the head. Neither Cavour and the victorious Sardinians nor fiery patriots like Giuseppe Garibaldi could possibly accept such a solution. In uprisings that sprang up in response to the new impetus, Tuscany, Modena, Parma, and Romagna, which was one of the Papal States, rejected their despotic rulers, holding plebiscites to determine their annexation to the parent constitutional government of Sardinia.[17]

In spite of the climate of unrest, Hatty left Rome that summer to go north to Switzerland with John Gibson. When he later complained that he had been henpecked, Hatty told him that never had he been pecked by so good a hen. She had been quite exhausted, she told Wayman Crow, feeling that she should never again "take up anything heavier than

a nail belonging to the north side of a coffin. . . . As Miss Cushman says, 'Death was no temptation.' I looked like an antique of a thousand, I ought to say, like a mummy of four thousand years old." She added: "If you could see me now, the bulk of the Great Eastern is nothing to mine, you would say. I live and move and have my being on the principle of the Dome of San Marco, which is famed for its breadth and not its height." She attributed it to the air, "in contra-distinction to the delicious malaria of the Campagna." A Roman summer, she decided, was enough "to break down the strongest constitution," in contrast to the salutary winters.[18]

In the fall of 1859, Emma and Mary Crow were coming to Rome, accompanied by the requisite chaperone, a Miss Whitwell. Hatty was ecstatic, for both girls were very dear to her. She told Wayman Crow that she had written to Hiram Hosmer, threatening to do something desperate to celebrate the event, "such as going to church." Charlotte Cushman was looking forward to their coming, too. Correspondence between her and Emma was still active, and she had urged Wayman Crow to let the two girls come, although he could not accompany them. To Crow, she wrote, "Miss Stebbins and myself are two spinsters of an age to be trusted and would take good care of them."[19]

Hatty and Charlotte, but certainly not Emma Stebbins, began to make elaborate plans for the girls' reception. Hatty advised them to arrive by way of Civitavecchia, the route she declared to be the shortest and least fatiguing. She would meet them there to expedite their move through the customs. As an old hand at it, she would see that their luggage went through unexamined and intact. The railroad had not yet come into the heart of Rome from the coast; so the eight-hour trip by carriage was much the same as it had been in 1852, when Hatty, at twenty-two, had made the trip for the first time.

Hatty or Charlotte had found an apartment for the visitors two doors from 38 Via Gregoriana. The only reservation was the ground floor entrance, "never quite safe perhaps in Rome." She and Cushman would look at it again before deciding. Charlotte Cushman had suggested that Hatty "look after their morals and she their creature comforts, but I [Hatty] mean to have a shy at their comforts too." There would be six horses available so that everyone could have a mount, including Miss Whitwell. "After that they are all under my thumb for I'se the feller which knows the Campagna and don't I lead Ma Cushman a dance!" They were still wearing summer clothes in Rome, but Hatty hoped that the girls would not come until November. As new arrivals, they would be especially sensitive to the sirocco, the stifling, unpleasant wind from the south, a less favorable alternative to the little west wind, the sweet, exhilarating *ponentino*.[20]

To Cornelia, Hatty wrote exuberantly that the girls had arrived but had remained only a few days before taking off, with plans to return for a much lengthier stay of several months. "They are just the nicest girls I ever saw," she said, "myself excepted." In the same letter, Hatty expressed her gratification at Cornelia's pleasure on receiving a crayon sketch that Emma Stebbins had made of Hatty. Hatty felt that Stebbins "had done herself credit." She was sitting for another and had also been immortalized in a little statuette "by the same fair hands." Hatty wondered which of them would "descend to posterity, she by my hands or I by hers." Later on, Stebbins missed an excellent chance to help her colleague "descend to posterity." In the biography that she wrote of Charlotte Cushman, she mentions Hatty's name only once, as one of the group that accompanied Cushman on the first trip to Rome in 1852. Her failure to include Hatty in the discussion of the years at 38 Via Gregoriana is clearly no accident.[21]

To reassure Cornelia, Hatty dismissed "the reports of war and bloodshed here." To be sure there were the continuing tensions. When Romagna declared its independence of the papal government, Pius IX excommunicated the leaders of the unification movement. Of the Roman situation, Hatty wrote, "Our heads are not off yet, and we don't mean they shall be." Regarding the coming sojourn of Cornelia's sisters, Hatty said that if they found the place "too hot to hold us, we shall make tracks with Emma and Mary." Minimizing the danger, she added, "So long as you see the star-spangled banner streaming from 38 Gregoriana, you may know all is serene." To Cornelia, the Crow daughter that Hatty would most like to see, she said, "No body on earth loves you better than your own Sis." On a little envelope that appears to have accompanied the letter, she added as an afterthought, "I commission you now to write my naughty biography and whenever you desire it, I will die to hasten its publication."[22]

By December, the girls were in Rome for a stay of several months, Hatty taking great delight in their presence. At Christmas, they made taffy and indulged in all kinds of schoolgirl high jinks, Hatty reverting more and more to the antics of her Lenox school days. Mary became her special pet, the one who nursed her devotedly through what Charlotte Cushman reported as "a bilious attack." Mary had taken to calling Hatty "her little husband." Hatty relayed Mary's role as "Nightingale" to Wayman Crow, "in the capacity of my little wife (our nuptials have already been solemnized)." Cushman, on what might have been another level, wrote to Emma Crow, off on a side trip, to tell Mary "that the tailor will not make her coat and trousers for Hattie so she will not be able to be married."[23]

Intrigue continued as Charlotte Cushman wrote to Emma: "I would not have Miss Whitwell think me other than a repressing influence upon you for the world. Therefore I am careful when we are in the presence of others and when we are alone, I am careful for you and for myself." She added righteously, "You should not condemn this prudence."[24] What to make of all this? Perhaps it is Charlotte Cushman's theatrical style that accentuates or exaggerates the whole affair. Was Emma Crow pouting because her idol was not paying her the attentions that she had hoped for? With Stebbins there as witness, her own life bound up with Cushman's, it is probable that there was electricity in the air. In any case, events took an odd turn toward a much more traditional plot. Ned Cushman, Charlotte's nephew and ward, appeared on the scene already primed for a flirtation with the lovely Emma, whose picture he had pirated from his Aunt Charlotte. Suddenly, Emma Crow was a young woman ready for a serious courtship in the usual manner. As for Charlotte Cushman, whatever her private reaction to this realignment, she was equal to any change of role. In the end, she may have welcomed this one. Emma Crow apparently moved into this new romantic phase with great ease and a new maturity, perhaps never completely aware in her innocence how unsettling her amorous friendship with Charlotte Cushman had been for those around her.

Rome, at last, had its winter, Hatty wrote, but that did not deter the little party from the last moments of sightseeing. "Today we knock off the Palace of the Caesars," she told Crow. The photographer had just brought in "your whole family of grandchildren." It was the first time Hatty had seen "the whole flock assembled." Missing only was the Falconnet monument, which had "foiled all attempts at photography." Paul Akers, "one of our band," she said, had just come back, "looking as if the climate of Columbia's happy land had been anything but happy for him." As for her colleague, William Barbee, she thought he would "flourish anywhere. He doesn't seem to me composed of [those] delicate fibres which are capable of being shattered by anything." She added her opinion of his current work, a coy maid entitled *Coquette*. If she had been jilted by such a young thing, "I should have thought myself in luck," she said. But this was said to Crow as only "between our own dear selves," for she was always careful to avoid any appearance of professional jealousy. If she were not to get a commission that was in the offing, it might "serve me right" for wickedly criticizing "Brother Barbee."[25]

From America, Maria Child wrote glowingly of an evening with Hiram Hosmer. He had shown the gallantry of "an old beau," she reported. Of the photographs of study models for *Zenobia* that Hatty

had sent to Maria Child, rather than to her father, Mrs. Child said that Dr. Hosmer had "such a longing for one of them that I sent him the front view." Reminding Hatty that her father and David Child, Maria's husband, had been "comrades in their bachelor days," she added that "the meeting made them both young again. Such peals of laughter I have not heard for many a day." She recounted the scene in the Watertown house: "All the inanimate fixtures in your studio remain as when you left them. Your father takes an affectionate pride in leaving them undisturbed."[26]

Hiram Hosmer's well-being was not to last. In the midst of the pleasant days in Florence, where Hatty had shown Emma and Mary the "nooks and crannies" that she knew so well, she received news of the utmost urgency. Hiram Hosmer was critically ill, and she was to come home at once. She had gone to Florence by the land route that she favored to meet the Crow girls, who had gone by sea. Whether word came to her in Florence or back in Rome, she hurried to catch "the Sunday boat" to Marseilles, where she immediately boarded the Cunard liner *Persia*. Commissioned in 1856, it was the fastest and most luxurious liner afloat.

Robert Browning, writing from a new address at 28 Via Tritone, told Isa Blagden that the news of her father's illness "drove all else out of her [Hatty's] head."[27] He had seen her for a few minutes on Saturday before she left with little knowledge of her father's condition. Hiram Hosmer had apparently had a stroke. Arriving home in what she reported to be sixteen days from Rome, she found her father sadly changed. She would need patience, never one of her strongest attributes, for the months ahead.

16
Tribulation and Triumph

Her father recognized her immediately, but Hatty, arriving home in early April, 1860, was certain that he had no idea how long she had been away. He spoke with great difficulty but insisted on going downstairs, she told Cornelia, adding that she was afraid to "cross him in any way." His memory was impaired, pathetic evidence of his disability. Instinctively, she reached out to Wayman Crow. "How many times he has attempted to recall your name!" Despairingly, she said, "How much I want to see you! Many things I have to say but pray with me—that is the next best thing." Recalling the recent good times with Emma and Mary, she added, "I left the girls so well in Florence. I little thought that I should be at home so much before them."[1]

When Hiram Hosmer was better able to communicate, the two discussed business matters. Her father's affairs were "by no means so ruinous as they have always been represented," she wrote, referring to her father's fear of penury, "but due to his nature, he will not be convinced." They had examined his papers together, even breaking the seal of a note that Crow already had a copy of. It was a brief letter stating simply that Hiram Hosmer had previously destroyed his will. The only direction to his daughter Harriet, his sole heir, was that she follow the advice of Wayman Crow "in all matters," an injunction scarcely needed. Hiram Hosmer stoically suggested disposing of two houses that he owned, along with another tract of land. Even the beloved house on Riverside Street, so full of memories, should go on the block, he thought, unless Hatty might want to keep it after his death for an investment.

In May, Hatty was still despondent. It seemed to her that her father was growing more and more feeble. "I fear summer will prove trying," she said.[2] Since the death of Miss Coolidge, Hatty's cousin Sarah Marsh had come into the household to look after Dr. Hosmer, but the strain on Hatty, unused to the onerous task of caring for an invalid, was plainly telling. Then news arrived that seemed to turn the whole course of

events around. Hatty received word from a jubilant Crow that she was assured the commission for the statue of Thomas Hart Benton, Missouri's first public sculpture. She acknowledged Crow's letter with elation and relief, admitting that she had "allowed my castles in the air to go up a little higher than usual before I had the reins absolutely in my clutches."[3] As for her father's response to the news, she reported, "I have not seen my poor dear Father look so pleased as when I read him your letter and came to that passage." It was an elixir to Dr. Hosmer, she said, and, indeed, he seemed to improve from that point. The commission had its genesis at least two years before. Hiram Hosmer had been in on it from the beginning, which may have been one of the reasons that he shared so completely in Hatty's happiness. Two years earlier, Hatty had written to Crow, "I have just had a letter from Father in which he let me in on a little secret (if secret it is), about a monument."[4]

During her stay in St. Louis, Charlotte Cushman had discussed the commission with Wayman Crow, who asked her if she thought the statue could be done in bronze for roughly ten thousand dollars. Cushman said that she believed it could, or should, "for I thought anything should be sacrificed to get you such a public work as that," she told Hatty, who promptly told Crow. Hatty judged the amount quite sufficient to pay for the modeling of the statue and the transportation of the cast to Munich, the location of the Royal Foundry headed by Ferdinand von Miller, in whom the expatriate sculptors had the highest confidence for the casting of bronze. The sum could well include a granite pedestal, Hatty thought, and perhaps the cost of shipping the work to America. Even at the earliest stage of the proceedings, Hatty dreamed of representing Benton in an image at least nine feet tall, since the outdoors diminished the human figure. She saw him standing "in a grand and simple attitude, wrapped in a large cloak (no coattails) which would open a field for fine drapery and give substance to what artists call *breadth* to the figure."[5]

Should there be any objection to Hatty's youth or to the fact of her being a woman, Gibson's "guarantee" of her work might reinforce her credentials. Because he was still "the first sculptor of Rome," his approval was important. The sculptor herself admitted that she did not know how to handle "the *accidental* circumstance of my being a woman," which could either "favor or injure my cause." She would leave that issue to Wayman Crow, promising to "justify your and his [Gibson's] confidence" in her, should she receive the commission. During the Crow girls' visit, and even while Dr. Pantaleoni was prescribing pills and advice, she had continued to think of the Benton statue. "I carry Benton's picture in my watch which gave rise to the remark that I was ever on the watch as I

am." Mary Crow, who was the only one "privy to my councils," gave her approval of plans secretly worked on, and Gibson, in his blue velvet cap, had concurred, "decidedly so," said Hatty, "like Jove shaking his ambrosial curls."[6]

With competition for commissions sharpening, Hatty reported that "more than one artist here is in a fury of jealousy to think I have a large work to do." Although she had been working on a proposed cemetery monument for Wayman Crow, the "large work" must have been the Benton commission monument, which she was favored to capture. "It is so pleasant to put these fellows in a rage!" she said, a further sign that she herself was enjoying parrying with certain male colleagues.

> They pick at me whenever they can so I cherish every opportunity of giving them a twist, and apropos to that, if by chance, I should get the Benton to immortalize, they would hear of the fact and have time only to expire. Shouldn't I like it though! Not only that they might have the pleasure of collapsing their flues but that I might have a chance of showing some folks on both sides [of] the water what I can do.[7]

One of her fiercest competitors for the work was "Stone," presumably Horatio Stone, a medical doctor who had given up his practice for sculpture. She ridiculed him as "poor Stone—he must feel rather small— rather on the pebbly order I think" when news that she had the commission arrived.[8] He had apparently gone so far as to make a model eight feet high of Benton. A certain "Headley" had written Hatty on behalf of Stone, saying that Dr. Stone had a good chance at the commission, except for Hatty. He asked her "(in a respectful manner if he might be so bold), what were my intentions in the matter." Headley actually hoped that Hatty would retreat from the competition, revealing a naive estimate of her character. She told him flatly that her purpose was "to get the commission if I can."[9]

Another competitor whom Hatty called "McDonald" appears to be James W. A. MacDonald, who had begun his career in St. Louis as a modeler. He, too, had a coterie of supporters to push his cause. After the announcement was made, Hatty considered a published riposte to her critics, thinking that it would be "an appropriate answer to the effusions of McDonald's party and will not be malapropos to the jealous spirits who don't like a woman to carry high hand in Rome." Later, still feisty, she told Cornelia to "just send word to MacDonald with my condolences that he can get out his coffin, and I have a bouquet for the Colonel [Brant, a member of the committee] that he can put in his buttonhole for the occasion."[10]

Maria Child was fully aware of all that was going on. Pleased at

Hatty's triumph, she took the occasion to write another "sketch" about her young friend. Drawing on Mrs. Child's literary skills, Hatty asked her to be "a Coptic of goodness" and contribute some ideas for "my exit speech" for "a winding up of Zenobia and the Benton monument." Should she be asking too much of her friend, she said, "pray say 'no— and be hanged to you' and I will immediately charter the clothesline." Of the "two disappointed aspirants to the Benton," Hatty reported that they were "letting off a little of their steam. But it is too late in the day for them to begin to croak." Hatty also told Mrs. Child that her brother, Convers Francis, and his wife had taken tea with the Hosmers on the previous day. Hiram Hosmer was feeling so much better that he was even considering riding out to Wayland on a cool day.[11]

It didn't take long for news of the Benton commission to circulate in Rome. Hatty's friend Shakspere Wood shared in the triumph. He immediately went "in the Pincio, expressly to retail my good news." Hatty passed on Wood's account to Wayman Crow:

> . . . and the first artist he met was a painter who responded "evidently feeling it himself" says he—"Won't your brethren of the chisel feel jealous!" He [Wood] continues, "There is only one thing that has diminished my complete satisfaction and that is that Mozier being away, I cannot *by accident* meet him in the street and accost him with "Oh! Mozier, I've got some news you'll be delighted to hear! and witness his horrid grin of anguish."

"You see Mozier is understood," Hatty told Crow conspiratorially, the first mention of her colleague Joseph Mozier that hints at her mounting distrust of him. Interestingly enough, later that summer, *The Crayon,* in addition to printing Harriet Hosmer's acceptance letter to the Benton committee, reported a social tidbit from Newport; the artist Mozier was visiting there as well as Emma Stebbins and Harriet Hosmer, the latter two as guests of Wayman Crow. Along with the Roman gossip, Shakspere Wood informed Hatty that *Zenobia,* in the hands of the marble workers, was "getting on apace and the marble turning out splendidly," a source of satisfaction to the absent sculptor.[12]

No commission was more coveted than the award of a piece of public sculpture. When such a work was delegated to a particular sculptor, he, or she, became the subject of intense interest and no little envy. Americans were beginning to memorialize their public figures in real earnest, as patriotic feelings crystallized and the need for local heroes burgeoned. Parks and town squares would soon be populated by statesmen and generals, orating with outstretched hand or sitting loftily on a favorite horse, silent testimony to the evolution of public taste in monumental sculpture and to the social and cultural history of America.

Realizing the element of pure luck in such things, Hatty had not allowed herself to be "very sanguine" about the possibility until she had the prize "in my clutches." She called such matters "slippery" but consoled herself with the thought that "when our dear Father [Crow] takes matters in hand, they are pretty sure to be successful. What a fine thing to have a public work!"[13]

The people of Missouri chose Thomas Hart Benton for their first public monument for good reasons. He had been a senator for over thirty years, a durable public figure strongly linked to the Jacksonian era of American politics. While in office he had played a key role in bringing about the Missouri Compromise in 1820, when the border state of Missouri was balanced against Maine, clearly a free state, in the dispute involving the containment of slavery or its spread to the West. Benton favored western expansion and the sale of new land at low prices to those who would settle in the new territories. Dedicated to gold and silver currency, he earned himself the nickname "Old Bullion" as he fought the establishment of a federal bank.

A controversial figure in the volatile events of the time, Benton lost his Senate seat but rose again to serve in the House of Representatives. His critics argued that he had given priority to local issues over the national welfare. One detractor claimed that no one did more to delay the extension of the Pacific Railroad than Thomas Hart Benton.[14] But if his public life was stormy, his personal life was said to be serene, although the fact of his daughter Jessie's elopement with Colonel John Charles Frémont caused strong family differences. Benton had died in 1858, which made him a likely candidate for a monument, a matter agreed upon by his friends and his foes.

The redoubtable Lydia Maria Child, who had monitored the political scene for many years, told Hatty that the commission was "a pretty tall feather in your cap, I think." She added her observations about Benton and the corruption that the politician is heir to: "Politics demoralized Benton, to a considerable degree, as they are *sure* to do, whenever a man enters deeply into the game." Then the woman who had given so much of herself to the cause of abolition added charitably: "But there was a streak of nobleness in him. I believe he was *really* opposed to slavery; and for *that* I am willing to forgive him much."[15]

The committee to choose the sculptor had been appointed by the Missouri legislature. Coincidentally, Wayman Crow was one of the triumvirate given the responsibility, along with J. B. Brant and M. L. Linton. In planning her letter of acceptance to this committee, Hatty told Crow privately that she had "dwelt a little upon the *feminine* element we have to deal with," almost as though her femaleness were an

unmentionable disease or handicap. Furthermore, she said, she would like to add "a few words I have long wanted to on that subject." Would Crow "tuck it into as many papers as will receive it?" It would answer not only MacDonald's supporters but the "jealous spirits" who resented her position in Rome. She worked hard on this auxiliary letter that she hoped to have published, trying it out on those in Watertown whose judgment she valued. Meanwhile, she was receiving congratulations on all sides, plaudits that she turned aside as she told her friends "modestly" to wait until they saw the statue. In her customary style, she told Crow that "between ourselves, I ain't a bit afraid, but I will give some of them a twist." As for her critics, the best compliment that they had paid her was to acknowledge her as Crow's protégée, she said. "I am glad others recognize the truth as clearly (if not as gratefully) as I do."[16]

Wayman Crow and his family were vacationing in the East, freeing themselves from the humid, hot St. Louis climate. They had stopped at Saratoga before going on to Lenox for an extended stay, possibly at the Curtis Hotel or one of the commodious "cottages" in the Berkshire region. After the family was settled in, Crow traveled on to Watertown alone to see Dr. Hosmer and Hatty. A meeting, personal and private, was so rare between the two friends that it must have been an event to cherish. Hatty wrote quickly to recall the day to Cornelia. "Well, I have seen the dear Pater—a short visit like an angel's and like an angel's in all respects. He looks uncommonly well to me though Father (perhaps a little perversely) thought him a little thinner than last summer. He came out on Friday evening from Boston and, of course, somewhat more than a *few* words were uttered that evening."

After staying the night, Crow left on the train Saturday morning to conduct some business in Boston. He and Hatty met at noon at the Parker House, already the hotel recognized as Boston's most elegant. They walked to the Statehouse to see Powers's *Daniel Webster,* dedicated the previous year by Edward Everett, America's foremost "occasional" orator. A statue of Benjamin Franklin was also on their list of things to see. They called on the Coolidges and Miss Whitwell, and then they returned to the Parker House, where they had "the cosiest of tete-a-tete dinners."[17] The rendezvous sounds curiously modern and was possible, perhaps, only for a woman like Hatty, an artist who was no longer subject to the restrictions of Boston's rigid society.

Together they went to the Athenaeum, the source of Hatty's first experiences in art, where the casts of the ancient works and the growing collection of contemporary ones, among the stacks of rare books and journals, testified to Boston's cultural primacy. Then she saw Crow off at the railway station. She hoped that he would return two weeks later,

when "I shall fly off with him to Newport for a little visit." Naturally, they talked of the Benton commission and the manner in which Hatty should respond to sniping remarks. While she had already made her formal response to the committee, she continued to revise the auxiliary statement that she wanted to release to newspapers. As was often the case in her relationship with Wayman Crow, as with no other, Hatty modified her original intention. Either in their personal encounter or in related correspondence, Crow had been successful in persuading Hatty to soft-pedal her fortissimo. Calling his advice "wise and prudent," she was convinced that "silence is not only most politic but most dignified." As to the disposition of the letter that she had sent Crow for publication, she added naughtily, "Ask Mrs. Crow to light her next cigarette with it."[18]

Her acceptance to the commission was graceful and articulate. Her statement, seen in the light of her own time, may clarify the situation as she viewed it.

> I have reason to be grateful to you for this distinction, because I am a young artist, and though I may have given some evidence of skill in those of my statues [*Daphne, Oenone, Beatrice Cenci*] which are now in your city, I could scarcely have hoped that their merit, whatever it may be, would have inspired the citizens of St. Louis to entrust me with a work whose chief characteristic must be the union of great intellectual power with manly strength.

Asking only to be treated as an artist, rather than a female artist, she continued:

> But I have also reason to be grateful to you, because I am a woman, and knowing what barriers must in the outset oppose all womanly efforts, I am indebted to the chivalry of the West, which has first overleaped them. I am not unmindful of the kind indulgence with which my works have been received, but I have sometimes thought that the critics might be more courteous than just, remembering from what hand they proceeded. Your kindness will now afford me opportunity of proving to what rank I am entitled as an artist, unsheltered by the broad wings of compassion for the sex; for this work must be, as we understand the term, a *manly* work, and hence its merit alone must be my defense against the attacks of those who stand ready to resist any encroachment upon their self-appropriated sphere.[19]

Was this merely rhetoric or did Hosmer's words reflect her true attitudes? Her sincerity in speaking of "the chivalry of the West" is unquestionable. By "the West," she meant St. Louis, where she was

offered her opportunity to study anatomy, where she had enjoyed social acceptance and privilege not easily forgotten, and where Wayman Crow and most of the Crow family resided.

She recognized that criticism of her work may have been tempered by the fact of her sex. Now, she stated candidly, she had the chance to prove herself as an artist, without deference or condescension to her as a woman. Was her acknowledgment that the Benton statue must be "a *manly* work" either acquiescence to the prevailing notion of male superiority or was it tongue-in-cheek? "As we understand the term" refers to the widely believed notion that a woman as artist did not have the capacity either for originality or strength for the conception of such a figure. Harriet Hosmer did not accept such limitations of her abilities, but she knew that the *Benton* would prove her mettle. The "barriers" that obstructed "womanly efforts" were very real indeed. Some of the attacks would surely come from those sculptors who resented a woman's successful competition in their ranks. However, Hosmer's swipe at those who would fight "encroachment" did not include all male artists. She had a very congenial relationship with Story, Powers, Paul Akers, and Shakspere Wood, to name only a few. Also, growing in number was the group of women sculptors in Rome, who looked to her as their leader and the prime example of acceptance and success.

What Harriet Hosmer might choose for Benton's costume became an immediate matter for speculation, especially in Missouri. Her antipathy for modern dress was well known, a legacy from neoclassicists like Thorwaldsen, who, upon finishing his statue of Lord Byron, was heard to say, "It is the last fellow I will ever model with his trousers on." One has only to see Alexander Doyle's effigy of Benton in the Capitol rotunda, his suit wrinkled and his waistcoat bulging with his girth, to see the merits of her stand. Although she had corrected the *St. Louis Post-Dispatch* writer who said that she had done only ideal sculpture, she denied that she had "scouted the idea of making a modern figure of Colonel Benton." He would be represented not as Apollo or Jove but in his everyday costume, the cloak that Hatty herself had seen him wear, for she had met him on several occasions. But she said emphatically that she had no notion "to present Benton as nobody ever saw him—bare throated—with sandals and toga."[20] She had not heard the last of it.

No better example of vicious assault toward her exists than the letter of a newspaperman, George Steadman, to William Torrey Harris, a prominent St. Louis educator. Steadman told Harris (and there is no indication that Harris agreed) that he had written a letter to a Kentucky paper in which he spoke "of Miss Hosmer's *Puck* and *Beatrice* in just such terms in which I think they should be spoken of—the first denial of

her high claims and first exposition of her pretentions to the title of artist ever made." Steadman bragged that he had been requested "on leaving Louisville to write a series of 'gossipy' letters and Miss Hosmer would form a good subject for the first one."[21] What reason he had for such animosity is moot.

While Hatty was in Watertown, Hawthorne's romance *The Marble Faun; or, The Romance of Monte Beni* was published in America with the title changed from the British version, *Transformation*. Hatty asked Cornelia if she had read it, without referring to Hawthorne's mention of herself and her work. Hatty called the book "a delicious one as a picture of Italy and Italian life!" Hawthorne's approval of her own work notwithstanding, she remarked, "*Fra noi* [between us] I don't think much of his art criticisms but that can't be helped." The plot, she thought, was unimportant, by the author's own design, but Donatello was "exquisite," and "for perfection of writing and beauty of thought and for the perfect combination of nature, art, and poetry," she had never seen its equal.[22]

Allusions to Harriet Hosmer as the prototype for Hilda, one of the female artists in the popular romance, were inevitable. Hatty, along with Louisa Lander, who had gone to Rome some years before, were the logical models for Hawthorne's emancipated characters. Lander had done a bust of Hawthorne, so he had had an opportunity to observe her independent life-style. He made several visits to Hatty's studio and knew her well socially.

Sir Henry Layard, archaeologist and politician, wrote to his friend Hatty to announce that he had just read Hawthorne's novel, "so you may easily fancy that you have been constantly in my thoughts. I, of course concluded that you were the heroine, but I cannot believe that you ever threw a gentleman over the Tarpeian Rock,—even after a picnic in the Coliseum." Layard was not the only one trying to identify Harriet Hosmer with one female character or the other. Was she the troubled and mysterious Miriam, whom Layard had speculated about? Miriam was engaged in carefully copying Guido Reni's *Beatrice Cenci,* an exercise filled with symbolism. Or was she the moralistic Hilda, who kept the light burning in the tower on the Via Portoghese? Layard, like others, saw no real parallel in either character. "Then as to the other lady [Hilda], I could not fancy you with doves and a pet Madonna—so I gave up all attempts at further identification."[23]

As Hatty prepared to return to Italy, an event of the greatest moment was the visit of the Prince of Wales to America. With anti-British sentiments still closely held in some quarters, there was apprehension about the treatment he might receive. In Boston, as in other cities, a grand ball was to be held to honor the young heir to the throne, one who would no

longer be young when he ascended to it. Queen Victoria, reluctant to entrust him with any duties, gave her son little to do. Later, when troubles between North and South came to a climax, Hatty observed that the prince might go to the southern states, as some had suggested, "to try his hand at a hierarchy till his mother dies—to get into the way of it." But he was the sovereign's best representative when it came to socializing, no matter where he happened to be. There was no thought that Hatty would not attend the ball. "Mr. Gibson would take my head off if I did not do the civil," she explained to Wayman Crow. It was only the year before that the prince had come to Rome, where he demonstrated his weakness for well-tailored suits and Italian gloves (he bought nine pairs) as well as the lure of tiddleywinks in the Caffè Greco and dinners among the artists at Lepre's.[24]

The ball, held at the Boston Academy of Music on October 18, is recalled in a splendid souvenir program, at once grand and gauche. A commentator reported that there were "not so many dazzling toilets as one expected to see," but the guests were "eager and well behaved," conduct toward the English visitor being a special concern of those who wanted fellow Americans to be on their best behavior. That they were "good-humored, tractable, and well dressed" was a considerable relief. There were quadrilles, waltzes, lancers, and a polka that concluded with a galop. Melodies by members of the Strauss family were the favorites. Longfellow was there, as well as the Lodges, Cabots, and Amorys. Arrangements were made for the prince to dance with many of the young ladies of suitable standing in Boston society. During the evening, the reporter recorded, "there was a world of flirtation. Hearts were not only touched, affected, stirred into accelerated pulsations, but positively smashed." At midnight, a buffet supper that boasted consommés, galantines, a variety of pâtés, sorbets, poulets, and crèmes was brought out as a climax to the festivities. At four in the morning, the prince was still dancing.[25]

No item went unpublished. More than 1,000 double tickets were sold at fifteen dollars each, and 525 "singles (for ladies)" went at five dollars. The total expenses were twenty-four thousand dollars, of which the decorations alone cost fifty-five hundred. The cost of the souvenir program was met in the time-honored American way. An advertisement for Burnett's Cocaine, a compound of cocoanut oil for the hair, very helpful for the treatment of dandruff, is featured, along with notices extolling the merits of Tilman's artificial flowers and exquisite bonnets. Chickering pianos were among the items advertised, too.

Hatty reported to Cornelia that "Mr. Everett," presumably Edward Everett, insisted that she make her presence known to the prince, who

recognized her immediately and gave her a cordial handshake. Afterward, when she was "prowling with Lord Lyons, he [the prince] came up to me and said how fond he was of my Puck, which is now in his rooms at Oxford. After supper, there was more prowling, and we got home at three o'clock A.M. So endeth the Ball."[26]

The news got around quickly in Rome. Robert Browning, seeing Hatty upon her return, found her looking well and "conducting herself pleasantly." He told Isabella Blagden about her encounter with the prince but added that "she told me none of this, of course."[27] Lord Lyons (Richard Bickerton Pemell, first Earl Lyons), with whom she did her "prowling," was an old comrade from the days of the picnics in the Campagna. He had succeeded his father to the peerage in 1858 and was appointed as British minister to Washington, a post he probably held at the time of the Crown Prince's visit. Although they saw each other rarely, he and Hatty remained devoted friends. Also in America that year were Charlotte Cushman, Emma Stebbins, and Ned Cushman. Ned apparently came to take some courses at Bowdoin College in Maine. Stebbins was using the time in the United States to promote her work. One of the commissions she hoped for was the statue of Horace Mann to stand at the front of the Boston Statehouse. Hatty, too, coveted this commission.

Some time after the Hawthornes left Rome, Hatty wrote to Sophia Hawthorne, whose sister Mary was the widow of Horace Mann. As one who had become a good friend, she commented on the Hawthornes' bad luck during their last months in Italy. Little Una had been critically ill from the fever, and at times there was little hope for her survival. The Piazza Poli, the Hawthornes' last address, Hatty called "the most unhealthy place in the city," only calling it so "now that you are safely out of it." She found it "little short of a miracle that Una is becoming the size of Daniel Lambert," a sideshow fat man whom Hatty frequently cited. Julian Hawthorne, she said, was probably "weaving a future President's chair out of the rattan he is getting at school," a joking allusion to his feeling the sting of the switch.[28]

But for all this introductory small talk she had a point to make, for she knew that both Nathaniel and Sophia Hawthorne admired her work. Word of the "monument to the memory of Horace Mann" had reached her through Wayman Crow, whose words she quoted to Mrs. Hawthorne: "I have said to one of the active men engaged in it if you [Harriet Hosmer] could have the commission I would subscribe handsomely toward it." Hatty hoped she wasn't "pushing" too much in her appeal to Mrs. Hawthorne, but perhaps the Hawthornes "could say a good word." She commended herself to them in the Italian way, *"distintamente"* with "best love to Mr. Hawthorne and the best wish I can

make is that you are still as fat as yours always . . ."[29] Competition was lively. Charles Sumner wanted the commission for his friend Story; Crow wanted it for his protégée Hatty, but in the end it was Emma Stebbins, new to the plastic art, who got the commission. Charlotte Cushman was firmly on her side.

While Cushman prepared for another series of engagements in America, her nephew Ned visited in Watertown several times. Some kind of wound in his hand was a great concern to Emma in St. Louis, although Hatty assured her, through Cornelia, that he was no longer suffering. At the same time, she responded to Cornelia's intimate questions about the progress of the romance between Emma and Ned that had begun in Italy. She was not "authorized," she wrote, to say that "anybody" was engaged. "Good friends, the best of friends they are," she affirmed, but she would venture nothing further. In return for what she called "valuable information," Hatty asked Cornelia how she would like "such an arrangement," meaning a marriage of Emma and Ned. Cornelia's opinion would "be strictly between ourselves."

Hatty spoke generously in Ned Cushman's behalf, giving him higher marks than members of his own family might have offered. In her affirmation of him, she also revealed her own criteria for the selection of a spouse. "As far as Ned's character is concerned, a better fellow could not be found and he would make any girl the kindest and tenderest of husbands—that much I can say for him."[30] The Crow family apparently had some misgivings and withheld their approval. Whether objections stemmed from reservations about Ned himself or about Emma, volatile in her affections, is not clear. Or perhaps they were not overjoyed at the prospect of Charlotte Cushman's influence and indulgence toward those whom she controlled being extended to their family circle.

While Hatty, quite naturally for her, took a sunny view of the possibility of the marriage, there were growing signs that she herself did not want Charlotte Cushman privy to all her plans. Undated notes, difficult to chronicle exactly, nonetheless have an unmistakable message. In postscripts, added as "N.B.," or *nota bene,* she cautioned Crow not to inform Cushman about her business transactions.[31] It was a language that she and Crow understood perfectly. Whatever the secret intrigue in the matter of Emma and Ned, love conquered, and the two were married in St. Louis, April 3, 1861, with a loving family and a doting Charlotte Cushman in attendance. The union gave Cushman a new sphere of influence as well as a new focus of attention, as she showered the young couple with gifts, property, and attention.

During Hatty's extended stay in America in 1860, Dr. Hosmer began at last to do some of the gardening and farming that he loved and to walk

and ride in his chaise once more. Hatty could then plan her trip to St. Louis, a prospect that delighted her. Not only could she confer with the Benton committee, but she could see Cornelia, Lucien, "little Hatty," now five, and the new baby, "Alfie."

Hatty and Cornelia apparently traveled back to the East together. They found themselves in Cleveland on the very day that their friend Fanny Kemble would be reading *Othello* in a public performance. They had planned no stop in Cleveland, but they "collared a brakeman, who collared the baggage master, who collared our trunks for us, and here we are," Hatty announced in a letter to Crow written just before going to the theater. When they reached Pittsfield, en route to Lenox, the two friends found a cattle fair going on. Drivers were asking an exorbitant six dollars for the six-mile trip to Lenox. But Hatty came upon a fellow working in the depot, a "darkey," she called him, who oddly enough had been in Rome as courier to the governor's son. He remembered her immediately from his stay in Rome. When she asked for his help, he promptly got them a "shandrydan," an old-fashioned chaise, and the fare was only a dollar each. Soon they were ensconced at Curtis's Hotel, happy to be back in the place that had meant so much to them. After visiting with Elizabeth Sedgwick and her daughter Bessie, they were taken to Pittsfield the following day by Mr. Curtis himself.[32]

Soon afterward, Hatty sailed on the *Africa*. She must have experienced a foreboding as she said good-bye to her father. Writing to him when she arrived in Rome, she said that she had "flitted 4000 miles as safely and comfortably as one who is encumbered with a fat body can." The Channel crossing was so smooth that she had slept through it. In Paris, she had stopped at the Meurice hotel before taking the train to Marseilles. After spending the day in "that most unpicturesque of towns," she prepared to sail on the *Vesuvio* for Civitavecchia. As the tender pulled away, the darkness was stygian, the rain relentless. Climbing the wet, slippery ladder, Hatty went aboard and hurried to stretch out in her berth, anxious for the ship to sail. But it did not budge until seven the next morning, and after going seventy miles, the ship again had to "lay to," reminding Hatty, perhaps, of her adventures on the Mississippi ten years before. Delayed two days, the ship went on through heavy seas to arrive in Civitavecchia more than two days late.

How good it was to be back in Rome. Only three weeks from the day that she had sailed from New York, she had slept "within sound of the bell of St. Peter's." John Gibson, she said, was pleased to see her. "He says I have grown tall, and I tell him he has grown handsome!" She was "heartily tired" of "meandering over the world" and looked forward to returning to her work.[33]

17

"Our Colonel" and the Loss of a Friend

After her six-month absence, Hatty wrote Wayman Crow that she had found her studio "tip-top, thanks to my dear Camillo," her most trusted assistant. She visited with John Gibson, who inquired solicitously about Emma and Mary Crow and wished that he might know Wayman Crow personally. She could hardly wait to begin the Benton statue. Almost immediately, she modeled several *bozzetti* of "our Colonel," as she called Benton. Each successive maquette she thought better than the previous design, flattering herself that they were "all cast into the shade by the last one with which his ghost [Benton's] has inspired me." Taking another shot at her rival for the commission, she went on, "I speak with the modesty of MacDonald himself."[1]

The cemetery monument for the Crow family, which she had given a good deal of attention before her hurried trip to America, seems to have dropped out of sight, never to reappear. Instead of the conception of Jesus raising the daughter of Jairus, which she had planned, an obelisk marks the plot in Bellefontaine Cemetery in St. Louis, where members of the Crow family are buried.

Before her trip home, Gibson had heard Hatty read one of Benton's most famous speeches. Encouraged by his approval, she took the theme— "There is the East. There is India"—for the statue. She posed the figure with a scroll-like map in his hand, hoping to capture a greater individuality in her treatment of Benton than "the rather hackneyed character of a senator." Indeed, the stereotypic image was a figure in the unimaginative costume of the period, string tie and ill-fitting vest, and with one hand extended in declamation. Gibson wouldn't hear of her "lumbering up the figure with boots and trousers." Their absence would be scarcely noticed, she argued; much of the form would be "concealed by drapery," for she planned to use the voluminous cloak that Benton had actually worn in life. At an early stage she had sent Crow a drawing, presumably the one said to be on a wooden roll, which went down on the *Hungarian*. Elizabeth Browning reported that although all on board

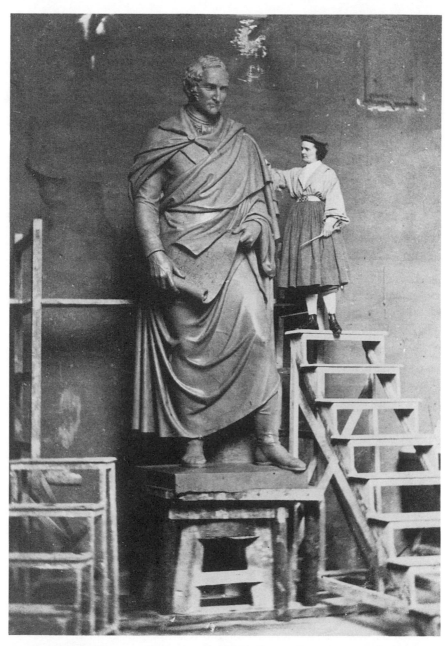

Harriet Hosmer at work on the clay model of *Thomas Hart Benton,* photograph by Marianecchi, Via Margutta 40, Rome, ca. 1862. The work in bronze stands in Lafayette Park, St. Louis, Missouri, where it was dedicated in the spring of 1868. Photograph courtesy Schlesinger Library, Radcliffe College.

had perished, the mail bag was recovered and, with it, Hatty's sketch. With no prescience of the coming disaster or her own luck, Hatty had begged Crow to examine the drawing carefully when it arrived, "unless the winds are capricious and the mail bags treacherous." In his dual capacity as her patron and a key member of the Benton committee, she hoped that he would "weigh well your deliberations, for if you do not smile assent, my only consolation will be the Tiber."[2]

Now that the commission was assured, she moved on to the model. "My mass of clay in its present humanized form is stunning and over-whelming. It certainly does make a larger piece of putty than I had anticipated but I am consoled and rejoiced. I mount a Zouave costume not intending to break my neck upon the scaffolding by remaining in petticoats."[3] Crow was quite right, Hatty agreed, in recognizing the figure's height from the ground "as the necessity for turning down the head—otherwise the face would be entirely lost." Benton was in "an attitude of thought," she explained, "which is naturally expressed by the slightly bowed head." But she resisted his disparaging remark about the hands, calling it "a *manly* criticism." The position of the hands in respect to the lens of the camera made them seem more prominent, she argued. That the outstretched leg seemed too far forward in its propor-tion was one of the "defects of photography" rather than the fault of the sculptor. The hands would not be given "a second thought," after Ben-ton had been "hoisted up into mid-air." She did think that the cloak could stand shortening, so she was "lightening" it a little.

Soon she would be receiving an initial payment of five hundred pounds. However much she resented Charlotte Cushman's prying into her affairs, Hatty was still disposed to borrow money from her. The five hundred pounds, she instructed Crow, should be placed "at Miss Cush-man's disposal," explaining that "Ma Cushman," as she still occasion-ally called Cushman, was giving her "a maternal lift out of the mire into which two or three awkward circumstances have thrown me—so much for that."[4]

Rome remained tranquil even after the kingdom of Naples and the Two Sicilies had been defeated by Garibaldi and his Red Shirts, as the troops of the charismatic, populist leader were called. Garibaldi had fully intended to push on to Rome, an enterprise scotched by Victor Emmanuel II and Count Cavour. Such a move would have been a colossal gaffe as well as an enormous embarrassment in the light of their alliance with the French monarch, one cemented by joint success in war against the Austrians and an arranged marriage between Clotilde de Savoie, daughter of Victor Emmanuel II, and Prince Jérome Napoleon, a cousin of the emperor's.

Pope Pius IX, in the thirteenth year of his reign, was still venerated as the supreme religious eminence, but, as secular sovereign, his days were numbered. Or perhaps one should say that his years were numbered, for the denouement did not come as soon as many anticipated. Harriet Hosmer was among those who saw a quick climax, surely by summer. "As to affairs here, they are marching on toward Victor Emmanuel," she said. The king of a nearly united Italy had already made a speech that she called "very fine" at the opening of Parliament at Turin. She had seen the banished monarch Francis II of Naples and his queen Maria Sophia after their kingdom toppled at the siege of Gaeta, where the queen, in a billowing military cape, had vainly tried to rally the fallen. Prophesying that Victor Emmanuel would enter Rome by the following summer (a miscalculation), Hatty told a visiting friend that she had better stay until then, when she would see "the grandest sight Italy has witnessed since the Pope's first toe was kissed."[5]

Soon, Italy's problems were eclipsed by the outbreak of war in America. Lincoln's election, foreseen as a signal for trouble, was the impetus for South Carolina's secession in December, 1860. Even before the Inauguration, six other states had followed. By April, 1861, Fort Sumter had been fired upon, sharply polarizing the lines between the Union and the emerging Confederacy. The United States was at war with itself.

Hatty wrote Crow that she was not prepared "for such a storm." She rationalized, as many others were doing, that it might be better for the crisis to come "than that the Union should drag on a wretched existence, being union in nothing but name." Nonetheless, she continued to hope that bloodshed could be averted. Opinion was divided in England as British mills and factories took over the profitable business of processing the cotton of the Confederacy. But Hatty, eager to vindicate her English friends and colleagues, claimed that they shared her anxiety. English newspapers and journals, she said, deplored "the state of things in our country, as if misfortune had fallen upon their own."[6]

Crow, she knew, was in the middle of Missouri's particular conflict. Its position as a border state with many citizens sympathetic toward the Confederacy was countered by a new constituency of Union supporters, strongly reinforced by the large number of German immigrants in the city of St. Louis. Crow himself, a member of the dying Whig party, hoped to avoid war and still preserve the Union, a prospect growing ever dimmer in the spring of 1861. Hatty comforted him, speaking of his "brave heart" and the empathy she felt when he was depressed. "In the meantime, dearest Father mine," she wrote to Crow, "do not bestow a single thought on me or my affairs." She asked him not to grieve so over

matters "beyond human control." The words she added are ominously prophetic: "Lincoln may be shot, Davis may be hung, but I pray to God to watch tenderly over you."[7]

Like scores of others, Hatty had come to see things differently since the day when she had rashly argued the question of slavery with Maria Child. During Hatty's recent stay in Watertown with her father, Child had recalled the occasion. Seeing Whittier, "an old anti-slavery friend," whose "flame [of genius] seems to burn brighter, as he grows older," she remembered that Hatty, fresh from St. Louis, had wanted to have Whittier "*hung,* alongside of me, and Frank Shaw, and Sarah Shaw, and George Russell, and Mrs. Russell, and James Russell Lowell, and Mrs. Lowell, and Ralph Waldo Emerson, and Wendell Phillips, so beautiful and eloquent, and so brave, and William Lloyd Garrison 'the noblest Roman of them all.'"

Mrs. Child continued with good-natured seriousness: "If you had had your will, 'Missouri Ruffian' that you are! and had exterminated the abolitionists, let me tell you, you would have destroyed the *wheat* of the country, and left nothing but the chaff. But you didn't know it; so I forgive you."

Reflecting on the rivalries for the Benton commission, Maria Child hoped that Hatty would not get into a fight "and settle the question with bowie knives and revolvers, Missouri fashion," although she herself could supply Hatty with a bowie knife if need be. The motto on the weapon might read "Death to Abolitionists," but the spunky woman concluded that bowie knives would not kill abolitionists, and indeed they had not. Instead, public sentiment had caught up with them.[8]

An addition to the Roman community that winter was Lady Marian Alford, a daughter of the second Marquess of Northampton and the widow of the Viscount Alford. Somewhat dubiously, Elizabeth Barrett Browning mentioned her presence as "a new acquaintance" who was "very eager about literature & art & Robert, for all which reasons I should care for her." But Hatty called her "divine." From the attention given her by this new friend, it is no wonder. "She knelt down before Hatty the other day & gave her, . . . placed on her finger, . . . the most splendid ring you can imagine—a ruby in the form of a heart, surrounded and crowned with diamonds."[9] Mrs. Browning continued, adding that Hatty was "frankly delighted & says so with all sorts of fantastical exaggerations."

Florence Compton (Lady Alwyne Compton), the sister-in-law of Lady Marian, recalled that, during the winter of 1860 in Rome, the family group saw Hatty nearly every day for rides in the Campagna or for visits. Lady Marian, she said, came to Rome "with her great love of

all that was beautiful and her overflowing sympathy, just when Hatty most wanted it, as you know." Speaking to Cornelia Carr, she added, "She [Hatty] might have become rather defiant and too eccentric among those who did not know and thoroughly understand her."[10] Was this observation merely a repetition of opinions previously expressed about Hatty's brusqueness, bad jokes, and the peculiarities that Maria Mitchell had noted (only to get beyond them and discover Hatty's true worth)? Or were there special considerations during the winter of 1860 that made the appearance of a new friend especially timely in the course of events? An allusion, almost an insinuation, "just when Hatty most wanted it, as you know," invites speculation but offers no certain conclusion.

In the social climate of the times, Hatty may have observed the new pairings recently come about. Louisa Ward Crawford, Thomas Crawford's widow, had married the reliable Luther Terry, one of the first artists whom Hatty had met and liked. Paul Akers had gone home, married, and would have a child before he died of tuberculosis, another comrade to leave the Roman circle. Whether Shakspere Wood had married at this time is a question. The state of her health may also be a key to her special need. During Emma and Mary Crow's visit, she suffered an ear abscess. In January, Robert Browning told Isa Blagden that he did not see much of Hatty, who "keeps the house, fears colds, and catches them all the same." Nor was she immune to emotional outbursts. Browning reported her absence from a party at 38 Via Gregoriana given by Charlotte Cushman. The rooms were "pleasantly filled, but Hatty not there!!" Elizabeth relayed Robert's account to Isa: "There had been a small emeute in the house, & Hatty had retired behind the barricades into her own bedroom." Elizabeth feared that Hatty's health was not robust and that her work had suffered that winter because of it.[11]

Keeping a distinct identity was no easy task for Hatty in light of Charlotte Cushman's imposing character. As chatelaine, Cushman was at last enjoying herself in Rome, taking a strong interest in promoting the work of female artists, with Emma Stebbins by her side. Hatty continued to do things independently, often to Charlotte's dismay. Hatty had obviously grown more assertive, and what was considered "defiant," as Lady Alwyne Compton had called it, was even more odious as a feminine characteristic than it had previously been. As the Victorian age moved along, attitudes toward feminine self-determination had deteriorated. The new fashions—wide, inhibiting crinolines and constricting corsets—were material symbols of social repression.

The association with Lady Marian Alford flourished, and Hatty was

Lady Marian Alford, by Richard Buckner, ca. late 1850s, oil on canvas, 82″ × 52″. With kind permission of the Most Honorable the Marquess of Northampton.

soon designing a fountain for her new client. Calling it "a charming commission," she was delighted that "my work will be seen by everybody worth having as spectators in England." She told Crow that she was "really in luck." Designed for the conservatory in Lady Marian's London house, the fountain represented "the song of the siren" and depicted a female figure seated high on a supporting shell as the playful *amorini,* little cupids in whimsical attitudes of attention, played on dolphins at the base of the piece. With water spilling over the vase, Hatty explained, the chubby infants would appear to be beneath the surface of the water. Elizabeth Browning said, after seeing the drawing, that "the imagination is unfolding its wings in Hatty." Hatty herself told Cornelia that Browning had called it "most poetic." She asked Cornelia, "Do you call it tragic, comic, or lyric poetry?" adding that "it ought only to play *eau sucree.*"[12]

Besides the patronage of artists and sculptors, Lady Marian distinguished herself by her support and sponsorship of artisans in needlework. She herself had a special interest in the needlecrafts and was later to write and publish a book on the subject. Her establishment of a school of art needlework at South Kensington places her among those

Fountain of the Siren, by Harriet Hosmer, 1861, marble, height ca. 7'. Photograph courtesy Watertown Free Public Library.

who helped to raise public consciousness and appreciation of such handiwork. The crafts movement in England was a force in maintaining cottage industry, rapidly shrinking in the exploding mechanization of the textile industry and crafts related to it. A woman of great warmth and generosity of spirit, Lady Marian took Hatty under her wing and brought her into the Compton family circle. She was at home in Lady Marian's house at Prince's Gate, as well as at Ashridge Castle. Along with the attention came a change in direction for Hatty that pointed her more and more toward England.

As new friendships flourished, others were bound to change. The Brownings continued to spend their winters in Rome, traveling down by *vettura* at a leisurely pace by way of Arezzo and Perugia, a trip that might take them seven days and six nights. In the winter of 1859 and 1860, they moved to a new apartment at 28 Via del Tritone after spending a few days at the Hotel d'Angleterre. Many of their old friends were there—Hatty, Charlotte Cushman, and the Storys. And there were visitors who called, like Harriet Beecher Stowe and Theodore Parker. Pen's pony, given to him by his father—"I am said to be the spoiler," said his mother—was sheltered in Charlotte Cushman's stable. Elizabeth hoped for "some small Italian princes and princesses to ride with him at Rome." She added that she objected to Hatty, "who has been thrown thirty times!" as a suitable riding companion for him—"not on account of bad riding, be it observed, but of daring and venturesome riding."[13]

During their last winter in Rome, the Brownings lived at 126 Via Felice. Elizabeth was increasingly weak, venturing out infrequently for rides in the carriage. On one occasion, however, she was said to be at the Caffè Greco when William Story brought Hans Christian Andersen over to kiss her hand. The lank, melancholy storyteller, always accepting with serious gratitude the fragments of tin soldiers that children offered him, went to Rome on numerous occasions. Hosmer reported that he visited her studio several times, his sad face mirroring "the hard struggles of his early life." She was present at a reading that he gave of *The Ugly Duckling*. The occasion may have been the rollicking children's party at the Palazzo Barberini when Andersen obliged those present with the story. Then Robert Browning followed with a reading of his poem, *The Pied Piper*, whereupon the versatile Story played his flute, leading a parade of children through the elegant rooms decorated with mythic figures and Barberini bees.[14]

In spite of pleasant intervals, the winter was difficult for the Brownings. Elizabeth's sister Henrietta had died of cancer, a devastating loss. In their more optimistic moments, Robert and Elizabeth still continued to hope for an apartment in the Palazzo Barberini. They had been "in

treaty" for space there for many years. While they waited, they dreamed and planned of ways to decorate the anticipated apartment.

Picking up their household for the annual migration to Florence, the Brownings arrived in June, 1861, to hear of the sudden death of Count Cavour at age fifty. It was news of the most tragic import to Elizabeth, who continued to hope for Italian unity. Coupled with the burden of grief for her sister, the word was shattering. In spite of Robert's urging, she could scarcely manage more than a few steps on the little terrace. One evening, when Robert had gone out, she sat where she could catch a breath of air from the open windows. When he returned, she had an incipient cold. Several days later, she developed an infection.

During the day, Robert Browning carried his wife to the drawing room from their bedroom with the turtle doves painted on the ceiling. Their old friend Robert Bulwer-Lytton called; so did Isa Blagden, still in the Villa Bricchiere. The devoted servant Wilson, who now had her own Florentine household, came to see the beloved mistress whom she had accompanied from England. It appeared to be only another interim of illness. At night, Elizabeth Browning seemed to hallucinate, imagining herself on a ship, a condition that Robert Browning attributed to an increase in her dosage of morphine. Early on June 29, she awakened and, with euphoric intensity, told her husband how much she loved him, kissing him, then the air and her hands. She dropped her head, as though she had fainted or fallen asleep. The servant Annunciata had to tell Robert that his wife was dead. Even so, it was some time before Robert and those nearest could be convinced that she was really gone.[15]

Searching for reasons for her rapid decline, Henry James later pointed to the death of Cavour. Her voice had become thinner and more high pitched, insistent at the expectation of Italy's coming unity. "Suspense for the lovers of Italy," James wrote, "rode her to death."[16] While the single, romantic reason is more appealing, it is probable that overwhelming physical problems were the cause of her demise.

Hatty had planned to go to Florence that summer, but for unknown reasons she went to the little mountain town of Antigniano, describing it as "a great place for those who cannot go far or fast." Near Leghorn, about fifteen hours from Rome, Antigniano was unknown to her, she told Cornelia, until the opportunity presented itself to join a party of friends intent on escaping Rome's torpor. Sending word of Elizabeth Barrett Browning's death to Cornelia, Hatty told her friend that no one would have better appreciated Mrs. Browning "for her most angelic character." Having this woman for her friend, "the most perfect human being I have ever known," she would always consider "one of the happiest events of my life."[17] There is no record of Hatty's having been at

the funeral of Elizabeth Browning. It is probable that she would not have gone had she been in Florence, for the trappings of death were repugnant to her, the reality very different from the conception of mortality in sculptural myth and legend. William Story complained that a "fat English parson, in a brutally careless way, treated her clay like any other."[18]

As for Robert Browning, he was cared for by the kindly Isa Blagden, who, with no regard for her own comfort and welfare, took him and Penini in hand for the first few months. The twelve-year-old boy was at last shorn of his curls and divested of his Lord Fauntleroy clothes, his father's first act of severance from the old ways. Browning had the painter George Mignaty do a painting of the drawing room; then, he packed up and left, never to return to the Casa Guidi, too filled with memories. From Paris, he sent Hatty a photograph of Elizabeth Browning with a note: "You will like to have what I send you, I know. It may be a long time before we meet again and you must remember me kindly. God bless you. Ever yours affectionately, Robert Browning."[19] There were meetings and letters still to come, but essentially, the charmed circle had been broken, the good times over.

Browning asked his friend Frederic Leighton to design the monument for Elizabeth's grave in the Protestant Cemetery. The following year, Browning, still grieving deeply, wrote to Isa: "Leighton wrote to me yesterday that the designs were completed—it is my own idea carried out—and beautifully, I think. I can't talk about it, and have not mentioned the thing to anybody (here), even Pen." He added that Hatty had seen the design, probably while she was in London in 1862, approving it, "as you will, I believe." Later, Browning wrote that Hatty had seen only the general sketch, one that had been altered and elaborated on by Leighton. Hatty found a single fault, a certain heaviness in the area of the sarcophagus that would be supported by classical pillars. "Leighton understands this," added Browning.[20] The resulting work, for all its classical influence, is a romantic concept, the stone monument held aloft by the pillars beneath.

At the same time that she wrote of Mrs. Browning's death, Hatty alluded to other matters in a sober and saddened way. Little Hatty had been very ill and in great pain, perhaps with the onset of the kidney disease that was to claim her at the age of twenty-five. Her godmother begged to be assured, "if only a line," that danger had passed. She was also concerned for Cornelia and for the health of young Wayman Crow, then about eight or nine—those "precious and dearly loved, in this most trying time of private and public calamity." Of illness and death and of the tragic course of the Civil War in America, she wrote with unac-

customed somberness, "Truly we must have committed some great sin to be forced to expiate in this manner."[21]

But, in spite of sad changes, life in Rome went on happily for her. She told her friend Anne Dundas about her horse, "a large, powerful fellow, but as free from vice as his mistress, and nothing more than that can be said!" Acknowledging the animal's well-earned reputation as unmanageable, she said that it would be "better to die with him than to live with any other, and better to be brought home (unlike the Spartans) on a riding whip, than to die an inglorious pedestrian death."[22] She had, in fact, slipped on the pavement in the Via Machelli, bruising herself and spraining her thumb, proof that all her injuries were not the fault of the horse.

Presently, she wrote to Anne Dundas when it seemed that her friend was returning to Rome for a visit. "Of course you come with equestrian intentions. We have never had a ride on the Campagna, a negligence we must atone for, without loss of time. I don't know that you are aware that my equine family now consists of two members, two very great darlings whose acquaintance you must consider indispensable for the sake of their mistress."[23]

All was quite the same, she told her friend. "The Studio Gibson, with the *capo d'opera* of a hole in the door is quite intact, as well as the master, who, being informed that you were shortly to arrive, said, "Oh! I am very glad of it, I am indeed!" Her friend, Hatty wrote, was not to imagine that Hatty had a pretentious studio in the Via Margutta. Except for its size, it was modest, and only temporary until she could get the "ground, garden and all, upon which I have fixed envious eyes for the last three years." She had hoped to send Anne Dundas her photograph, not just her head alone "(oh, no, for the fact is, when one has a nose like mine it is of no use trying), but on horseback, when naturally the face, and the impertinent s-center of it, becomes such an infinitesimal dose that it is not obtrusive nor *snub*-stantial."

They apparently joked about being spinsters. "By the way, I hear there is a letter waiting for me at the Poste Restante. Would it bore you too much to bring it along with you? It may be an offer of marriage for all I know, and those chances come far too seldom to neglect any!" She wished her Scottish friend "the happiest New Year in the world." It was December 28, 1861, and she had been in Rome for nine years.

18
A Place in the Crystal Palace and Repercussions

As the year 1862 arrived, the expatriate sculptors in Rome looked forward eagerly to the London International Exhibition. The event celebrated nineteenth-century industrial progress with a fervor almost religious. It also provided an international showcase for artists to display their works. The exhibition would take place at the Crystal Palace, the epitome of the new age. Designed by Joseph Paxton to house the great exhibition in 1851, it was made entirely of iron and glass put together from prefabricated parts.[1] While iron in architecture had been used in the previous century in France, the Crystal Palace was looked upon as the quintessential structure of the nineteenth century, representing what man had wrought in most dramatic fashion. But in its break with traditional architecture, it pointed ahead to the twentieth century in a way that few of the artists who would exhibit there could comprehend or emulate in their works.

The stately *Zenobia* was being shown in Rome at the Accademia de' Quiriti, but the queen would soon play to a wider audience. Six million visitors had seen the exhibition of 1851. Could not more be expected for this one? With the keenest anticipation and an appreciation of her good fortune, Hatty wrote to Crow, "You don't know what a grand place they have assigned me for Zenobia in the Great Exhibition, a square sort of temple I call it, for want of a better name, is to be erected with a niche on each of the four sides, into three of which go Mr. Gibson's colored statues and into the other, my statues." Designed by the eminent Owen Jones, the temple would be centrally placed in "an admirable light," essential for the viewing of sculpture. Much of this favored treatment was due to the influence of Hatty's friend, Sir Henry Layard, proving, as Charlotte Cushman had said, that "there is nothing like having friends at court." In addition to her *Zenobia,* which was being shipped from Rome, "the Prince of Wales will also send his *Puck* and Lady Marian Alford her bust of Medusa: so I shall be represented by three things."[2]

212

The expense of shipping large works of art was prohibitive for many sculptors. William Story, finding himself at a financial low point, despaired of sending two of his best works, but a benevolent Pio Nono paid for the cost of transporting the *Libyan Sibyl* and *Cleopatra* to London, on behalf of the Roman government.[3] They would be shown at the exhibition as works done in papal Rome under the aegis of a pontiff who patronized the arts.

Early in 1862, Hatty received word that her father had died. Knowing that his days were numbered, she was not shocked but deeply saddened, perhaps more so because they had had their disagreements. Sarah Marsh, the cousin who had stayed with him since the death of Miss Coolidge, had been "a treasure," Hatty wrote to Cornelia. "Whatever our little differences have been," she added, "he will always live in my memory as good and kind and excellent." The house on Riverside Street with all its memories, happy and sad, would soon pass into other hands.[4]

She said little else about her loss. The black-edged stationery was a sign of her state of mourning as society decreed it, but for the most part she grieved silently and went on with her work. She would shortly gain greater financial independence as her father's heir, and there was growing mention in her letters to Wayman Crow of stocks and shares. Talk of her "York" and "Cheshire" holdings were everyday items, and a new air of prosperity and confidence pervaded her letters. Crow continued to advise her, taking care of buying and selling as well as lending her money and forwarding checks to her as he had previously done. Transactions were carried on through Crow's New York bank, J. and J. Stuart. At the time, he was managing the finances or advising three of the era's best-known women—Harriet Hosmer, Charlotte Cushman, and Frances Anne Kemble.

More women were venturing into Rome to study sculpture. A new arrival in 1862 was Margaret Foley, who accompanied Charlotte Cushman to Rome on one of the actress's return trips. "Peggy" Foley, as she was known to her friends, had worked at a variety of jobs in her native New England, from factory work in Lowell, Massachusetts, to school-teaching. Well received in the Roman art colony as a skilled cameo worker and a pleasant associate, she hoped to go on to more creative sculpture, which, in time, she did. Hatty reported her as "pegging away cutting cameos" and turning out an excellent likeness of Emma Stebbins. A Mrs. Appleton was to be her next client.[5]

Louisa Lander, who, as a child, had modeled small heads in wax to amuse herself, had come to Rome about 1855. She lived independently with little of the social acceptance that Harriet Hosmer enjoyed. She began her work as a studio assistant in Thomas Crawford's studio. A

trip home to America in 1858 netted her some orders in addition to the portrait bust of Governor Gore that had been commissioned to her. When Nathaniel Hawthorne came to Rome in 1858, he sat for a portrait bust, marveling at Lander's free life-style, impossible for her to have enjoyed had she stayed in their mutual hometown, Salem. He pronounced her plaster model excellent. Then Louisa Lander left for America, and the Hawthornes for Florence, while the model was left for artisans to put into marble. As difficult as it is to believe, a self-styled critic, an American of some prestige, visited Lander's studio and took it upon himself to order the correction of some "errors" in the lower part of the face, taking responsibility for the act, as if that would somehow justify such outrageous gall. Julian Hawthorne later wrote that the portrait bust, instead of looking like its subject, resembled a combination of Daniel Webster and George Washington.[6]

The sculptor John Rogers, a cousin of Louisa Lander, however, thought the Hawthorne portrait very good, although he remarked that "Hawthorne does not notice her now and I don't know whether he will take it or not." The Hawthornes did pay for the work, but the bust was left in Lander's keeping for display at the Dusseldorf Gallery in New York in 1860. Later it was returned to the Hawthornes in Concord. The bust, depicting a bare-chested Hawthorne in the classic manner, is now in the Concord Free Public Library in Massachusetts.

The Hawthornes were decidedly cool to Louisa Lander when all of them reassembled in Rome in the fall of 1858, undoubtedly influenced by the gossip surrounding her conduct. For, about this time, fellow artists met in committee, led by William Story, to reprimand her for alleged indiscretions. According to John Rogers, she was said to have "lived on uncommonly good terms with some man here." Vain about her figure, he went on, she had "exposed herself as a model" before "respectable" people in a manner "that would astonish all modest Yankees." There seemed to be little doubt about the latter story, Rogers thought, but a series of stories of a scandalous nature and questionable origin had gone the rounds and were dying down only as he wrote his February letter. He did not like to be too closely connected with her, although shy and homesick, he continued to find the hospitality of Lander and her sister welcome. She had apparently refused to go before the American minister and swear that the rumors were untrue, and it is not difficult to understand her unwillingness to comply. Rogers, wishing that he had "a quarter of her pluck" in pursuing his career in Rome, said that had he suffered "such a loss of reputation, it would have killed me I believe, but she snaps her finger at all Rome and has not the least desire to leave."[7]

But, some time after, Louisa Lander departed. Continuing to work, she later opened a studio in Washington. When she left Rome, Harriet Hosmer reported to Wayman Crow that "Miss Lander" was about to be "transformed into a Nightingale" to nurse the wounded, adding that such a pursuit would be "between ourselves a more appropriate occupation for her than sculpture."[8] These enigmatic words give little clue to her feelings about Lander. It may be that she herself was ambivalent about her fellow sculptor. While they did not travel in the same society—John Rogers remarked upon Hatty's affluent life of keeping horse and servant—she was probably on good professional terms with her female colleague, as she tried to be with all her fellow artists, increasingly with the women. She was also becoming painfully aware of the venom of gossip, particularly as it was directed against women artists. But given the scrupulous code of Victorian highmindedness in which she was nurtured, it is impossible to second-guess her stand. Whether there is discreet innuendo in her remark to Crow or simply the implication that Lander lacked talent remains unresolved.

Women would continue to study in Rome for some time to come. It was still the only locale where they could enjoy the same advantages as their male counterparts, even though the mid-century in America marked a time when new opportunities were opening for women who wished to study art. The Philadelphia Academy of Art had groups of women attending painting classes by 1860, although they were still excluded from life classes. They responded by organizing their own classes, and some were daring enough to pose—although not in the nude. Paris was still lagging behind in the admission of women to the École des Beaux-Arts, and it would be another decade until artists, male or female, would be drawn to the French capital instead of to Italy. But such conservatism did not prevent women from painting or modeling as a fashionable hobby. One of the most notable amateur sculptors was the actress Sarah Bernhardt, whose work was widely praised. Even with these signs of change, women's attitudes about themselves, ingrained by society, along with male attitudes about "the second sex" were formidable obstacles to their progress.

In Boston, William Rimmer, sculptor and teacher, was attracting great attention. Rimmer was surely one of the most interesting artists of the period, so different were his works from those of his fellows. Born in poverty in Liverpool, he came to America, where he became a medical doctor licensed to practice in 1855. Hearing of him, Hatty told Crow that "there is a wonderful fellow called Dr. Rimmer in Boston who teaches art by a miracle and that even Miss Elizabeth Peabody hopes at the end of twelve lessons to be turned out an accomplished artist."

Although Rimmer's style, vigorous and original, was totally unlike the smooth, classical works coming from Italy, it was not this that Hatty objected to; it was the naive assumption that a mastery of the plastic art could be arrived at so easily. "Either the master or the pupil must be very sanguine and know very little about the length of that road," she said, "if they hope for such happy results in so short of time."[9]

One of Rimmer's students a decade later was Daniel Chester French. During the few months that French studied with Rimmer, the sculptor-instructor showed the class a copy of Houdon's *Skinned Man,* showing "just the way we'd look if our skins were removed—all the muscles fitting and overlapping in the most marvelous way," as French's daughter, Margaret Cresson, later put it.[10] If indeed this was the pattern of Rimmer's lectures and had Hatty been present, she might have found some similarity to her own study of anatomy with Dr. Joseph Nash McDowell.

What was going on in Boston was pale in importance compared to preparations for going to London. Hatty, Charlotte Cushman, Emma Stebbins, and John Gibson would travel together. The death of the prince consort, in December, 1861, would cast a shadow on the event, Hatty believed. To be sure, he had left a widow for whom life would never be the same again, but as it turned out, her subjects prepared to celebrate at the exhibition, perhaps remembering that it was Prince Albert, a patron and sponsor of the arts, who had helped to organize the event. Well ahead of the opening, Lady Marian Alford wrote that there was nothing to compare to "the whirl of London in view of the Exhibition."[11] Not only would the gala event buoy British spirits, but it would demonstrate the greatness of the empire, approaching its zenith in the latter half of the nineteenth century.

Only shortly before Hatty's departure, a visitor to her studio reported that the colossal figure of Thomas Hart Benton was waiting to be sent to Munich for casting, and the fountain for Lady Marian was nearly finished. *Zenobia,* about to be shipped to London, had been given "a rosy tint . . . and, much as I dislike colored statues, I cannot object to the delicate tinting of this." While Gibson's statues were frankly polychromed, Hosmer's were sometimes given a creamy coloration. One observer saw it as "catching the better part of Gibson's idea of tinting the marble."[12]

In London, Hatty was entertained by all her old friends, including Adelaide Sartoris. Leighton, ever devoted, had recently painted an enchanting portrait of Sartoris's daughter May for all to admire. Robert Browning, still gregarious, was in London devoting himself to Pen's education. In one of his chatty letters to Isabella Blagden, he reported

that he had seen Hatty the previous evening—"dined with her at Lady Marian Alford's and thought her much better in looks than some three weeks ago when she arrived there, worn and not well—but you saw her in your transit throu' London, she told me." Browning added that Hatty planned to visit Frances Power Cobbe in "about a fortnight."[13]

Press coverage of the exhibition was copious and prolix. It was hailed as "an epitome of the civilized world," extolling the progress of industry, mechanical skills, and "intellectual luxury," a grandiose term to describe the arts. But one critic saw "a want of taste and purpose," the same kind of censure that had been leveled at the previous exhibition of 1851 for the quality of its wares. Inevitably, there were kinks and snarls in the operation of such a giant circus. A large bell tolled either too much or too little, never just right, and the public became rowdy and overheated when lunchtime arrived and the warm, tired sandwiches did not measure up to expectations.[14]

In spite of their position in a dark corner, Story's statues were applauded for "independence in idea and execution" and sold at handsome prices shortly thereafter. Shakspere Wood got favorable mention for his *Elaine*. But John Gibson came in for critical dismemberment with the *Tinted Venus*. An American critic, noting that it had met with very little approval, later described it.

> Her heavy English limbs, stained, as was currently reported,—whether in jest or not, we cannot say,—with tobacco juice, to suggest the rosy-tinted Aphrodite; her hair, a pale straw-color; the pupils of her eyes, a light blue; golden earrings in her ears, and a golden collar about her neck; with a face of a common-place, house-keeping type, and an attitude devoid of character or intention—it was, to us, a work of unmitigated vulgarity.[15]

English analysts were less scathing in their remarks, although one writer, in speaking of the coloring of statues, thought that "the ideal character of sculpture is at once lost." Gibson stopped "halfway," the observer said, "but it would have been wiser had he never begun." The English critic, J. Beavington Atkinson, firmly defended Gibson as "the first of our English sculptors." The Greeks had indeed colored many of their statues, and Gibson quite naturally asked himself, "What would the Greeks have done?"[16] As for Gibson himself, he cared little for what critics had to say.

Atkinson called *Zenobia* "a noble figure of Queenlike dignity" but paid more attention to "Miss Hosmer's clever impersonation of mischief-making little Puck" as being "individual and real." Although Hatty was recognized as one of the foremost sculptors of the American exhibitors, *Zenobia* did not sell. When the young Prince of Wales had

seen it in her studio in 1859, he had asked that it be photographed for him, but no royal purchaser emerged. Reports that generous sums were offered for the figure appear unfounded. Harriet Hosmer was reported to have said that the statue must go to her native America, perhaps a ploy to stimulate interest. The advantageous spot and the recognition that Hosmer received at the London exhibition was attributed by one writer to "the slight modicum of respect that an Englishman feels bound to pay to a woman."[17] There were those among her colleagues who resented her success, and presently, the showing of her works, *Zenobia* in particular, at the Crystal Palace event became the instigating factor in a crisis that had been fomenting for a long time.

Anna Jameson's earlier letter to Hatty, in response to her queries about *Zenobia,* had addressed the malicious whispers that John Gibson was actually doing her work. Now, the rumors took a different direction and a more concrete form. The editors of *Art Journal* published an obituary of the English sculptor Alfred Gatley in which Gatley's life and career were reviewed in the usual manner. Abruptly and parenthetically, in an attempt to decry the lack of attention the estimable Gatley's work had received at the exhibition, the writer declared that it was too bad indeed that the late sculptor had been slighted in favor of other works. "The Zenobia, said to be by Miss Hosmer—but really executed by an Italian workman in Rome" was the offending statement, introduced absurdly in an effort to praise the deceased.[18]

It was not the first time that the statement had been made. A paragraph with the same accusations of fraudulent practices had appeared in the journal the *Queen.* The editor, a woman, was called by Beavington Atkinson "a pleasant person to meet in society, clever and bright," but "certainly on one point . . . rabid." Atkinson was not doing his duty, she had made clear, in not exposing "the Roman 'swindlers.'" Atkinson was understandably upset by what he considered to be a stupid blunder on the part of the editor of *Art Journal.* Since he had written for *Art Journal* before, a statement that he had made was inserted in the obituary of Alfred Gatley, who was Atkinson's friend. To many who read it, it might appear that he had written the entire piece, including the libelous portion about Hosmer. He explained to William Story, who supported Hatty, that he had no part in it. As for the offending statement, he attributed it to "carelessness and ignorance."[19]

Meanwhile, Hatty made ready for confrontation. She wrote to Crow: "I hope and trust I may soon be involved in a law suit. For seven years it has been whispered about that I do not do my own work but employ a man to do it for me. This scandal has now reached the point when I am accused of being a hypocrite and a humbug in the following manner . . ."

She then followed with the quotation from *Art Journal,* remarking, "pretty much to the point, isn't it?"[20]

Charlotte Cushman had urged Hatty more than once, she told Crow, "to take the matter up and set the question now and forever at rest. You have no idea how the report has been propagated abroad." John Gibson, too, was indignant, Hatty said, "and is ready to go into any Court of Law for me, and many others have I got to fight for me. So you see it will be no joke." Thanking Providence or whatever inspired the guilty person to libel, rather than verbally slander, she found it "Capital" that at last it was "actionable." The matter, she told Crow, was in the hands of a London lawyer.[21]

She spoke forthrightly and confidently in her own behalf. In a letter to the editors of *Art Journal,* she responded to the charges that she employed a professional modeler to do her work. While such a report was circulating privately, she said, she "treated it with the contempt and silence which I felt it deserved." But the publication of such a vicious lie incited her to action. In the letter, she outlined the process of sculpture as it had been practiced by the neoclassicists Canova, Thorwaldsen, Tenerani, and Gibson. A work began in concept as a small clay model or a progression of several of them. She explained that, once she had finished the model of *Zenobia,* four feet high, a framework was set up by her workmen who prepared the clay on the full-size model. Then she returned to work on it for a period of eight months with her own hands before it was put into the marble.[22]

Gibson, too, made a statement. Recalling that Harriet Hosmer had become his pupil as soon as she had arrived in Rome, he went on to say that he had found that she had "uncommon talent." She had studied under his eyes for seven years, "modeling from the antique and her own original works from living models." In answer to the accusations that *Zenobia* was his work, Gibson said that the only vestige of truth in such nonsense was the fact that it was "built up by my man from her own original small model, according to the practice of our profession." Reinforcing Hatty's review of the plastic process, he added that the "long study and finishing is by herself, like any other sculptor." He flatly declared, "If Miss Hosmer's works were the productions of other artists and not her own, there would be in my studio two imposters—Miss Hosmer and myself."[23]

William Story followed with a letter to the *Athenaeum.* He corroborated her account of the sculptural process, including the portion of manual labor done by studio workmen. Story named "Signor Nucci," employed by a number of sculptors, as the "Italian artist" referred to in the press. Nucci, Story said, was "greatly indignant," since such an

accusation reflected upon him as well as upon Harriet Hosmer, who would find "a common chorus of reprobation" in Rome in her behalf. Story called his female colleague "an amiable lady and an accomplished artist."[24]

In her own defense Hatty had written that less-successful practitioners of sculpture were continually jealous of those who were passing them, "but a *woman* artist who has been honoured by frequent commissions, is an object of peculiar odium." Then she hinted at the identity of a culprit. "I am not particularly popular with any of my brethren; and I may yet feel myself called upon to make public the name of one, in whom these reports first originated, and who, sheltered under an apparent personal friendship has never lost an opportunity of defaming my artistic reputation." While Charlotte Cushman urged Hatty on, and Story and Gibson lent their support, Robert Browning dismissed the matter as trivial. But he seemed to recognize the identity of the guilty party immediately. "You see Hatty's character [he told Isa Blagden] as given by Story in the Athenaeum. I don't think I should have troubled my head about such a charge in such a quarter, had I been she."[25]

To Hiram Powers, the dean of American sculptors in Italy, Hatty wrote a full account, promising to "unveil the whole secret to you and you will at once perceive that it is the battle of the Amazons to which I allude." Her metaphor gives the incident feminist dimensions.

> When the editor of *The Queen,* which was the paper containing the original article was called upon to make an apology, he [did she not know, as Atkinson did, that the editor was female?] did it in such an insolent manner that it made the matter worse, but when they saw I was really in earnest and laid damages at 1000 pounds, they began to sing a different song and offered if I would to suspend legal proceedings, to insert any apology which I would dictate, to give up the name of the writer and to pay all costs.

While she heard the chamade, she was not quite ready for a parley.

> That seemed all I could desire, but being curious to see what they could get up in defense, I at first refused to accept the terms and desired my lawyer to proceed. Reflecting afterwards that my motives might easily be misconstrued, and that I laid myself open to a charge of unreasonableness and probably to a desire of obtaining damages, which would have been still worse, I wish to say that I now accept his offer on condition that the apology should be inserted in The Times and the Galignani as well as in his own paper.[26]

"We need not mention many names before we come to the one who has been at the bottom of it all," Hatty told Powers. "The fact is, dear Mr. Powers," she continued, "it is indeed a monstrous thing for a man to be allowed to abuse his neighbors in this way with impunity. I have had

enough of it, and I am going to show up Mr. Mozier as he ought to have been shown up years ago." She had been a long time finding him out, she admitted, but she now knew that he was "the deepest hypocrite I ever encountered." No one knew this better than Hiram Powers, for Joseph Mozier had done little to commend himself to his colleagues while he was working in Florence. He had written at least three anonymous letters that denigrated Powers and his work. Powers turned some of the material over to Henry Tuckerman, the respected art historian, for verification. Slurs aimed at Powers were published in the *Republican* of Savannah, Georgia, as well as in other journals.[27]

Joseph Mozier seems to have had a compulsive need to denigrate others, possibly in an effort to bolster his own self-importance. Hawthorne saw him as lacking in polish but clever and shrewd, one who sought to entertain his listeners with gossip about his fellows. Horatio Greenough, Mozier told the Hawthornes, had no creative powers. Indeed, he claimed, the first of the Americans to study in Italy had copied his *Washington* at the Capitol from the Phidian Jupiter, and his celebrated *Chanting Cherubs* from Raphael. (Louisa Lander told Hawthorne that Mozier's *Prodigal Son* had been "stolen—adopted we will rather say—" from one done by a student in the French academy.) During the same evening with the Hawthornes, Mozier moved on to castigate Margaret Fuller Ossoli, another who thought him to be her friend and who could no longer defend herself. Belittling her, Mozier claimed that there was no "History of the Roman Revolution," that, in fact, she had lost all of her literary powers before she left Rome. Her handsome husband, Count Ossoli, he said, was boorish and stupid, and his family's aristocratic position amounted to nothing.[28]

Hatty had apparently been aware of Mozier's reputation for hypocrisy when she told Crow in 1860, "You see—Mozier is understood." Now she wrote Powers that she had prepared a statement that she planned to have "inserted in our principal papers." Mozier "got wind of what I intend to do and is in a great way about it," although he knew he had said it "over and over and does not deny it." She hoped to keep the statement confidential "until the gun is fired." Mozier was afraid, she said, that she "would go and publish some nasty article in the American papers." He would call it nasty when he read it, she vowed, "and I trust it will take away his appetite for a week." For Powers's eyes only, she copied what she called "the bombshell," entitled "A Word to the Public."

I had not been long in Rome before I was informed that an artist, with whom I was upon the most friendly terms, had engaged in spreading a report that the work which I claimed as my own was in reality the produc-

tion of a paid workman. In spite of the reliable nature of this information, I attached but little importance to it, thinking it impossible that one who had taken such kindly interest in my welfare could be capable of originating a statement that he knew must be so injurious to me in my profession.

Eventually she could not let the remarks pass unnoticed. Facing Mozier in an interview, she said that he "admitted that he had made these injurious statements and expressed his regret that he had done so." She was "willing to forget what had passed" until the calumnies appeared in print. She named Mozier as "the artist to whom I allude" for all to see in the article that she proposed.[29]

Her strong statement was modified and molded into an article called "The Process of Sculpture," a straightforward account of the plastic process from start to finish. Some of her colleagues, preferring not to publicize so openly the important role of the workers, may have been less than pleased at her candor. Saying that she had heard so much about artists' not doing their own work, she felt "disposed to raise the veil upon the mysteries of the studio." She would help those interested "to form a just conception of the amount of assistance to which a sculptor is fairly entitled, as well as to correct the false, but very general impression, that the artist, beginning with the crude block, and guided by his imagination only, hews out his statue with his own hands." Then she attacked the charges that women sculptors did not do their own modeling on the full-size clay models. She affirmed that such accusations were "utterly without foundation." She herself had never permitted a statue to leave her studio, "upon the clay model of which I had not worked during a period of four to eight months,—and further, that I should choose to refer all those desirous of ascertaining the truth to Mr. Nucci, who 'prepares' my clay for me, rather than to my brother-sculptor [Mozier], in the *Via Margutta,* who originated the report that I was an imposter." Even he, she added, had not yet accused her of "drawing upon other brains than my own."[30]

The episode and the accusation were certainly indicative of sexist discrimination, as Hosmer herself indicated. Other issues also present themselves. Irresponsible and inept journalism was a contributing factor, along with Mozier's protracted underhandedness. Hatty's statement to Hiram Powers that it was "a monstrous thing for a man to be allowed to abuse his neighbors in this way with impunity" went well beyond applications of gender, and Hosmer had kindred male victims to prove it. Years later, when Cornelia Carr edited "The Process of Sculpture" for the appendix of *Harriet Hosmer: Letters and Memories,* she deleted the portion in which Hosmer rebutted the charges that she and other wom-

en did not do their own work. Nor was there any mention of the "brother-sculptor." Carr felt, no doubt, that, with all parties dead, the recall of the incident was needless. She may also have felt that it would do Hatty no credit, but it now appears that Hosmer's handling of the affair was courageous and correct in a time when women were scarcely able to raise their voices against injustice.

Hatty was by nature resilient, and once the incident was resolved to her satisfaction, she did not let it simmer. But her youthful trust in her colleagues and in professional ethics had been eroded, and she became more wary and more aggressively competitive. At the same time, she had discovered that there were fellow sculptors who would support her and that she had the authority to demand restitution when injured. It was a singular triumph that would echo in America.

19
Zenobia, the Marble Queen

The Civil War in America continued its weary, agonizing course, the outcome still in doubt in the first half of 1863 before the decisive battles of Vicksburg and Gettysburg. Hatty, in her letters to Wayman Crow, claimed that Americans in Rome followed the events of the conflict with as much interest as though they were living in America. From time to time she commented on what appeared to be a Union victory; but, although Charlotte Cushman and Fanny Kemble were lending their talents to help the Union, she felt that she, as an artist, could not allow herself to become too caught up in the daily episodes of the war.

She took a lively interest in the affairs of the stock market. Her "Cheshire" stock had moved to an incredible new high, and she watched for "the magic number," anticipating a slide before it reached for another higher figure whereupon she would sell some shares.[1] She continued to hope for a favorable exchange rate, for soon she would be paying Herr von Miller of the Royal Foundry for casting the bronze *Benton.*

Mary, the third Crow daughter, had recently married Robert Emmons. "Mrs. Emmons," as a term of address for Mary, little more than a schoolgirl when she had visited Italy in 1860, sounded very strange to Hatty. Mary had said in a letter to Hatty that her husband Robert had decided that his bride was stronger than he, "which looks well for her," Hatty joked to Crow.[2]

There were recurring thoughts of Watertown. Her cousin Dr. Alfred Hosmer, whom she still called "Alfie," was living in the house on Riverside Street, which he seems to have bought from her after her father's death. Of Hiram Hosmer's grave site in Mount Auburn Cemetery, she admitted that she did not like the lot even though her father had selected it. Although she thought it "too low and too shady," she would presently erect a monument. Rambling on to Crow, she recalled nostalgically that her father used to say that her memory was "a total wreck. The reflection of how long ago that was makes me feel that I am becoming a fat denizen of the Vatican where antiques hold sway."[3]

Charlotte Cushman had left Rome, and Hatty called herself "a forlorn old maid once more." She regretted having to sell two shares of her "York" stock, vowing to "make them up some day. If all my property yielded the same [as York, presumably], I could afford the luxury of a husband instead of leading the life of *economical* celibacy." With a more certain income, she was at last planning the studio that she had dreamed of for so long. Crow would think that she was "rather clever" when she told him that she had persuaded the owner to "build it himself after my design." The rate of exchange for monies coming to Italy from America was so unfavorable to her, she told the proprietor, that it was impossible for her to undertake a construction project on her own. The owner agreed to draw up a contract and to sign and deliver it. Hatty would send the plan to Crow for his inspection.[4]

In the summer of 1864, Hatty made good on her promise to take *Zenobia* to America, where she looked forward to the possibility of a quick sale. Accordingly, she set out for Liverpool, taking an opportunity to visit her friends in Britain. From Edinburgh, she told Crow that she had spent all of her "pin money" in an effort to "restore pulled out hair from loss by exchange." He was not to send her any money, she said, that is, not "till I ask for it." Her coming to England had been a stroke of luck, she said, for she had picked up work amounting to fifteen thousand dollars. She hoped to have as much to show for her trip to America.[5]

From Edinburgh, she would return to England to stay with friends for a week before sailing on the *Scotia.* Soon she would have to find her "sea legs." She wished that she could say "sea stomach. How I abhor the voyage. It is only for the pleasure beyond that makes me pluck up and go." Before sailing, she went to see the banker J. Pierpont Morgan, who told her that the *Scotia* was "the easiest sailing vessel in the world," welcome news on the eve of her departure. She would head for the Fifth Avenue Hotel in New York and for the Revere House in Boston, from "thence migrate and meander."[6]

A pilgrimage to Lenox was a priority on her agenda. Elizabeth Sedgwick was seriously ill, and there were last words to be said. In Watertown, where Hatty was attending to family affairs, she received a note from Mrs. Sedgwick, written after their visit together. The message began, "One more goodbye and God bless you." Success had not spoiled Hatty but improved her, Elizabeth Sedgwick said. "You are progressive," she declared. "Be a good Christian and remain a good, bright American." Nor had Mrs. Sedgwick lost her hope for the soul's transcendency. "When I get my spirit wings, I shall surely come to you, though I may not be able to render you conscious of my presence."[7]

A saddened Hatty wrote to Cornelia, "Honey, make much of Mrs. Sedgwick, for I fear she will not stay here long nor indeed can we desire that she should." The somberness was tempered by happy thoughts. Emma and Ned Cushman had become the parents of a son who Hatty guessed would be "ground to pieces with affection." But, she went on, "Don't you think Emma will be disappointed it can't be a little Charlotte?" Emma had spent the summer in England, a stay arranged by her father. With the baby born, Hatty predicted that Ned, Emma, and "Master C." would soon "walk to Italy. See if I am a true prophet."[8]

She did not wish to renew all old acquaintances. To Cornelia, she wrote that she had gone to the opera the previous evening and "Who do you think I saw—Virginia Vaughan," who had been one of the original group to go to Rome. "She didn't see me, I hope, and when I discovered who she was, I turned my Grecian profile the other way as I was not particularly desirous of an interview." This did not prevent Hatty from scrutinizing her. "She was decently enough dressed but with a queer looking party." Sizing up Ginny Vaughan's figure, she added, "She looks as if the world went comfortably with her, far as the adipose tissue is concerned."[9]

Zenobia was sold to Almon Griswold, a rich New Yorker, for an undisclosed amount. Hatty's figure of "12,000 francs," told to Crow, was about $2,500, which must have been the net sum that she received after the cost of freight and other expenses were paid. Griswold, eager to be a collector of art, talked of building a gallery for his new acquisition after it came to rest following showings in New York, Boston, and perhaps Chicago. Griswold also encouraged Hatty to submit a design for gilded bronze doors for the new Academy of Design in New York. If a different style of architecture was decided upon, he conceded that there could be problems in her getting the commission. Nonetheless, he would use his influence, he told her as she dined with him and his wife, and he even offered to contribute a thousand dollars to the cause.[10]

George Hillard, a literary figure of the period, saw one of Hatty's concepts for the doors, apparently during her brief visit to Boston in 1864. Using her favorite myths as metaphor for the hours of the day and night, Hosmer produced designs that Hillard called "graceful, animated, with the best spirit of Greek art." Yet they were original, "no tame imitation of existing types." Existing *bassi relievi* that appear to have been extracted from the panels of a portal confirm Hillard's opinion, for the figures are fluid and undulating, soaring with a movement both strong and delicate.

Two years later she sent Cornelia a photograph of one of the gates for the commission for the Academy of Design, apparently still pending

and a realization that she still hoped for. She described the design. "The two central figures are, as you perceive, figures of two young artists— one a painter, the other a sculptor—one with the world in his hand, the other with a book to signify that artists should be students not only of letters but human nature." The central figures were surrounded by the Muses, "as they should be" Hatty further explained. Thalia, the Muse of Comedy and Mirth, was balanced in the opposite corner by Erato, the Muse of Love. In the same relationship were Melpomene, the Muse of Tragedy, and Urania, of heavenly things. The four "ages of art" were linked to the four ages of man—youth, love, strength, and age. She had dispatched the drawing to Almon Griswold, whose promised influence never materialized.[11]

Included on her American itinerary was a trip to St. Louis to see the Crow family. Writing to Wayman Crow after her return, she told him that her article "The Process of Sculpture" would appear in *Atlantic Monthly*'s issue for December, an appropriate moment in view of *Zenobia*'s appearances in New York and Boston. Even before the issue was on the stands, tear sheets of the article were being handed out at the exhibitions. Referring to the pointed remark about her "brother-sculptor in the Via Margutta, who originated the report that I was an imposter," she said triumphantly to Crow, "I have had my poke at Mozier if I flatter myself rather nicely."[12]

She could not resist one more "Parthian arrow," as she sometimes called her *coups de main*. Entitled "The Doleful Ditty of the Roman Caffe Greco," it was a satiric verse of many stanzas, set in the Greco where male artists gathered to discuss the threat to their supremacy. Whether the ditty, good humored and clever but filled with the classical characters so familiar to Hatty, could be understood by any but the *cognoscenti* seems doubtful. But Hatty was her own best press agent. Everything she did, said, or wrote made news. The remarks of the British press in the previous year came to the surface again, this time with a political cast. An unnamed English offender "could not have understood her any more than the mad Monarch understood his American colonies," one writer asserted, commenting on her spunky handling of the affair. She was "a real little American institution and not to be trampled upon" was the patriotic conclusion.[13] The "Doleful Ditty" was carried in the *New York Evening Post* and the *Boston Transcript* in the summer of 1864.

Zenobia was to have her introduction to American society in New York, which had forged ahead of Boston as the leading seaport and business capital of America. In the autumn of 1864, in spite of the Civil War, New York was a vigorous, roistering city. A page in the *New York*

Times "Classified" offered a cross section of entertainments for the variety of tastes in Victorian Gotham. For several days before the opening of the exhibit, the following advertisement caught the eye:[14]

ZENOBIA
QUEEN OF PALMYRA
THIS MAGNIFICENT STATUE
BY
HARRIET HOSMER
will be on exhibition on and after Monday, Nov. 14 at the
FINE ART INSTITUTE
DERBY GALLERIES
No. 625 Broadway
From 9 A.M. until 10 P.M.
Single admission 25 cents
Package tickets for One dollar

Also advertised was a theatrical offering entitled "A Bull in a China Shop"; a second grand concert given by "Mrs. O'Neill, the brilliant Irish soprano, at the popular Niblo's Saloon"; skating at a gymnasium; a long list of sights to be seen at Barnum's American Museum; and an exhibition of "Laughing Gas" at a special matinee for ladies and children. "Heller's Salle Diabolique" featured "The Mystic Scarlet Spirit," which Heller "riddles . . . with a rapier . . . and amputates its limbs." Animals, too, were a beguiling attraction in the Manhattan of 1864, presaging the American enthusiasm for zoos. "The Giraffe would be receiving his friends at Van Amburgh's Menagerie" and a whimsical notice announced:

The POLAR BEAR MAY BE SEEN FELIC-
itating himself upon the approach
of winter, at the Menagerie today.

How the discriminating connoisseur chose from this tantalizing variety cannot be determined, but *Zenobia* drew heavily. The phenomenon of a work of art competing with carnival attractions would be reenacted a hundred years hence when Michelangelo's *Pietà* would draw millions to gaze on its marble perfection at the New York World's Fair.

The first showing of *Zenobia* in America took place at the Derby Gallery in New York at a gala private reception attended by a gathering of distinguished artists, politicians, and socially prominent figures. Fellow artists Albert Bierstadt, John Kensett, Eastman Johnson, Frederic Church, and Sanford Gifford were among those present, as was the art

historian Henry Tuckerman. Harriet Beecher Stowe, Henry Ward Beecher, and Hatty's old friend the writer Catharine Sedgwick were there, too. William Cullen Bryant, recently honored by a splendid seventieth birthday celebration, also paid his respects to the American sculptor, who had gone to his party a few days before. Bryant, a dynamic civic leader, was instrumental in establishing two of New York's most distinctive institutions, not yet created—the Metropolitan Museum of Art and Central Park.

The "Society News" of the *New York Home Journal* reported that the gallery was festively draped in green for this splendid occasion, a backdrop for the sculpture and the artist, who was described as playing the "seneschal" as she moved among the guests. An ingratiating presence, Hatty was called "fine looking and healthful," which should have laid to rest rumors that *Zenobia* had exhausted her. But the observer who called her "tall and dignified" must have been very short or myopic, for her height of five feet, two inches, shy of the classical ideal, was always a joke between her and John Gibson. If Harriet Hosmer stood tall that evening, it is not surprising. Recognition from such a roster of guests points to the event as the pinnacle of her career, a triumphant homecoming with her creation *Zenobia.* Praise was often fulsome, focusing on the young artist herself rather than on her work: "Standing warm and life-like before us, she was lovelier than she had molded the marble Queen to be—and so she may live to be told, by the survey of any sculptor's appreciative eye, should she sit for her own bust thereafter."[15]

Immediately after the New York opening, Hatty planned to sail for Rome. Always the object of much social attention, she had been in the United States for several months visiting her friends. Luck had followed her all the way. Even as *Zenobia* awaited her New York debut, the building next to the Derby Gallery was completely destroyed by fire, "within fifty feet of her majesty," Hatty had reported to Wayman Crow. Hoping for an uneventful and smooth crossing, she booked passage on the *Persia,* the Cunard liner whose cabins were handsomely outfitted in exotic Oriental style. With its iron hull, paddlewheels turned by steam, and the added aid of sails, the *Persia* is listed in the *New York Times* shipping news for departure on November 16, 1864, from New York to Liverpool, with first-class passage at $132, payable in gold.

When Hosmer left, *Zenobia* was on her own. In January, 1865, the queen opened in Boston at Childs and Jenks Gallery on Tremont Street. Even without the appearance of the sculptor whose presence added the thrill of seeing a real, live celebrity, Bostonians came in droves to see the work of their young countrywoman from Watertown. Interest in a work

of art from Italy in the city that was called "the Athens of America" might well be expected, but the number of would-be lookers, lined up along the street outside, exceeded reasonable expectations. It is possible that Bostonians were challenged by the records their rival New Yorkers had set in welcoming the marble queen. Besides the old-time New Englanders, brought up in the shadow of the Athenaeum, there were country people eager to see a piece of genuine marble statuary and first-generation Irish, many working as domestics in grand houses on Beacon Hill. Lydia Maria Child, Hatty's perennial press agent and loyal friend, wrote to the *Boston Transcript,* "This is the third week of the exhibition, and nearly fifteen thousand people have paid homage to the Queen while the gallery continues to be crowded daily."[16]

Mrs. George Ticknor and her daughter Anna took turns writing to Hatty about the attendance. "The janitor tells me that on Saturday night . . . it had reached 17,385," wrote Anna Ticknor. By February 18, the *Boston Commonwealth* announced that over fifteen thousand had seen the statue. Viewers were advised to see *Zenobia* by sunlight and gaslight to fully appreciate all of the subtleties of light and shadow. To make this possible, the enterprising Jenks had the gallery open each Saturday until "9^1/$_2$ o'clock" to satisfy more than twelve thousand requests, according to publicity that was perhaps overblown. A morning opening at eight o'clock made it possible for diurnal Bostonians to have an early advantage.[17]

Noted writers were often asked to record their thoughts about great sculpture. The beloved poet John Greenleaf Whittier had the good sense to disclaim any credentials as critic, but he paid his homage in a way that accentuates the close comradeship between American ideas of patriotism and sculpture. "I only know . . . that it very fully expresses my conception of what historical sculpture should be. . . . In looking at it I felt that the artist had been as truly serving her country [in the Civil War], while working out her magnificent design abroad, as our soldiers in the field, and our public officers in their departments."[18]

But if the poet Whittier did not feel competent to judge sculpture, there were others eager to sustain the symbolism that poetry could express for art. One of the simpler efforts was George Hillard's lines "To Harriet Hosmer."

> Black upon white—*my* art no higher goes
> No better skill my pen prosaic knows.
> *You* need not stain the virgin page, who write
> So fine a hand in lines of purest white.

The clever Hillard was brief, but others, known or anonymous, wrote tributes that amounted to many stanzas. One example, attributed to Anna Ticknor, entitled "Zenobia, Queen of Palmyra," concludes:

> O pale mute marble! most serenely still
> Yet eloquent with more than voiceful thought.
> Thus stand forever, holding through all time
> The passing record of a passing hour:
> And, with the seal of silence on thy lips,
> Yet speak the lessons of a vanished past![19]

As later generations would learn more about the Civil War from the novelist Margaret Mitchell than from the historian David Saville Muzzey, so popular perceptions about the Palmyran queen were shaped by a historical novel. The Reverend William Ware, a Unitarian minister and writer, was the author of *Zenobia: Queen of Palmyra,* a work carefully researched but nonetheless romanticized. Although Hatty had never mentioned the book as a source, others, including the poet Whittier, linked her marble image to Ware's heroine.[20]

Some, like Hosmer herself, had read the classical sources, including Gibbon's *History of the Decline and Fall of the Roman Empire.* There was another side to the antique story, quite different from the poetic tributes or the almost perfect picture presented in Ware's novel. One commentator observed that Zenobia—"her complexion was a brunette"—may have been involved in the conspiracy that resulted in the death of her husband Odenathus, whom she succeeded as ruler over vast territories in Asia Minor. While she and her late husband had enjoyed Roman favor and held the honorary titles of "Augusta" and "Augustus," Zenobia, as reigning monarch, began to challenge the supremacy of Rome in the area. Far more ambitious than her spouse, she defied the emperor Aurelian and led her troops in battle against his. After a desperate siege of the city of Palmyra, the defeated Zenobia was taken as Aurelian's captive to Rome, where she did indeed walk in the procession just as Harriet Hosmer represented her. Aurelian, impressed by her intelligence, dignity, and beauty, quickly extended amnesty to her and installed her in a villa in the Campagna town of Tibur, not far from the villa that had been Hadrian's. She later married a Roman senator, and her daughters made alliances in aristocratic Roman families, their descendants traceable for five generations.[21]

Gibbon had devoted most of a chapter to Zenobia and the fall of Palmyra in spite of a bias that admitted few women to the ranks of history. He pointed out her illustrious heritage as a descendant of the Ptolemies. He testified that her beauty rivaled that of her ancestor

Cleopatra, although he judged that Zenobia's "chastity and valor" far surpassed Cleopatra's. Besides "dark, sparkling eyes," fine white teeth, and a voice that was "strong and harmonious," she was gifted with "manly understanding." Gibbon acknowledged that Zenobia was "perhaps the only female whose superior genius broke through the servile indolence imposed on her sex by the climate and manners of Asia." Writing some years before Victoria came to the throne, he observed that "instead of the little passions that so frequently perplex a female reign," Zenobia's reign was "judicious."[22]

Close to Zenobia as adviser and friend was the noble philosopher Cassius Longinus, her mentor in classical languages and learning. It was he who wrote the letter of defiance to Aurelian at her behest. But when Longinus was apprehended as a war criminal, Zenobia, according to Gibbon, abandoned him. Confronted with her own guilt, Zenobia's courage failed her. "But as female fortitude is commonly artificial," he wrote patronizingly, "so it is seldom steady or consistent." When Zenobia was captured and taken to Rome, the distinguished scholar Longinus was executed.[23]

Harriet Hosmer rejected the historical Zenobia as Gibbon represented her. During the showing of the statue in America, Lydia Maria Child recalled that when Hatty visited in 1857, "her whole soul was filled with Zenobia." She had scouted every source, "whether historic or romantic," some of which were found right next door in the library of Mrs. Child's brother Convers Francis. Hatty was, however, "so in love with her subject that she rejected as unworthy of belief the idea, expressed both in Gibbon and Ware, that the fortitude of Zenobia was ever shaken by her misfortunes." Her queen was resolute and courageous. Seeing the marble effigy more as a literal image than as sculptural conception, some wondered if *Zenobia* should not have reflected the sorrow that she must have felt in behalf of Cassius Longinus instead of the "expression of pure crystal thought."[24]

The figure drew tentative criticism, spoken softly, unsurely, or innocently. One viewer expressed the opinion that "the weight is not distributed correctly," that there was "a sensation of weakness and want of poise and firmness." An "anonymous friend from New York" allowed that "the artist has been successful in rendering the expression" but that there was "a want of harmony between the body and the freedom of action of the lower limbs. Can any person walking preserve so stiff an attitude in the neck and throat as Zenobia does in the statue?" The eagle-eyed observer pronounced the left side the better but saw "still one or two sharp angles on that side in the forefinger and the chin and throat that marred the effect."[25]

Another writer found a "lack of womanly fullness at the lips" and a "cramped little toe of the left foot, not natural to a sandal wearing race," but probably reproduced accurately from the flesh-and-blood foot of Hosmer's Italian model.[26] With no guidance for aesthetic judgment, every onlooker exercised the option to criticize. No doubt Harriet Hosmer, who had used the marble goddesses of antiquity as her models, was amused at the grass-roots analyses. She liked to relate anecdotes exposing the ignorance of "incompetent critics," who would visit John Gibson's studio. Not knowing tibia from fibula, they would presume to tell Gibson how a leg should look.

Even professional art critics little understood the canons of sculpture, but some were sensitive to the shifting social climate and the effect that it would have on sculptural subjects. An unnamed writer, recalling *Zenobia*'s appearance in the London exhibition, observed that the classical themes were moribund. Harriet Hosmer had failed, he said, not because she was a woman, but because she had followed the examples of males who clung to outworn ideas for their themes. New subjects for portrait sculpture cried out for attention, the writer claimed, urging "Miss Hosmer" in "very frank, but very friendly words" to look for a woman to model who had something to say to the modern world, rather than an obscure character from ancient history. Harriet Beecher Stowe was the writer's choice, to be depicted at her work with complete realism of costume and feature.[27] While there is no record of her reaction, Hatty must have scoffed at the suggestion. Buttons, bows, and the hoopskirts that were the current fashion, as well as their counterparts in masculine dress, were anathema to her as a true disciple of John Gibson.

James Jackson Jarves, whose instincts were sometimes prophetic, echoed the need for American subject matter that was relevant to an emerging native idiom, foretelling that "American sculpture is destined like its painting to partake of the new strong life that is fast coming upon us,—a life equally of ideas and action." The opening of the West and the almost religious reverence for the American landscape had indeed influenced painting. Only those sculptors locked into ideal Greek themes would find their efforts becoming obsolete as sculptural themes became inspired by native ideals, rendered with greater naturalism and vigor.

Jarves observed, not correctly, that Harriet Hosmer was "an example of a self-made sculptor, by force of indomitable industry and will." While he admired *Puck* for its humor and spirit, he found *Zenobia* "materialistic" in the sculptor's treatment of accessories and queenly costume, details that "overpower the real woman. Indeed, Miss Hosmer's strength and taste lie chiefly in that direction," he continued, not

without ambiguity. Her works were "of a robust, masculine character, even in details." Continuing his assessment of her, he added, "She has not creative power [the old shibboleth], but has acquired no small degree of executive skill and force."[28]

But an analyst writing in the *Atlantic Monthly* found the ornaments, so essential to "the majesty of the still unconquered queenly nature," properly subordinated. Nor was the chain that manacled the hands "an element in the tragic poetry of the subject," too conspicuous. As for Zenobia's robes, however much later observers might wish for a disheveling wrinkle, the writer found their perfect symmetry of the rippling folds "almost faultless." Hosmer had evidently made a careful study of drapery (as indeed every sculptor did), for "every fold seems to have a meaning."[29]

After the peripatetic *Zenobia* had finished its tour in 1865, Hatty, gratified by the whole experience, could say that she felt "fully compensated" by the statue's reception in America and satisfied that she had refused all purchase offers abroad. The trouble and expense of transporting it to the United States had been justified even though the fifteen thousand dollars that Almon Griswold was reported to have paid for it, perhaps inclusive of expenses, was considerably less than the artist could have realized in Europe. While this was exaggeration, typical of the journalistic extravagance of the time, there was some truth in the statement that the Carrara marble "in the rough" would have cost, by one estimate, six thousand dollars in New York.[30] What Americans lacked as connoisseurs of art, they made up in mercantile acumen.

Hatty was prepared to market her wares in a new way. Jenks had convinced her to send models of her works to him in Boston, where they would be promptly sold. To Crow she posted a list of the pieces and the prices that they should bring:

Zenobia (small)	$1,200
Zenobia (bust and pedestal)	1,000
Puck	800
Will o' the Wisp	800

"I have written to Jenks," she added, "that I must get the above prices or the idea of speculation is a poor one." Remuneration should be in gold and all expenses paid. This was a private matter, she told Crow, and not to be repeated.[31]

In November, 1864, Hatty wrote to Crow from London, relieved not to have lost too much of her "inside furniture" while crossing. She did not hate the Atlantic as much as she thought. Each time she crossed the ocean, "I feel my life is prolonged ten years." In London, she found

Charlotte Cushman in a highly emotional state. In the actress's new character as matriarch of an expanding family, she was tense about the welfare of Emma, Ned, and their baby, Wayman Crow Cushman. To Crow, the child's maternal grandfather, Hatty said, "For which anxiety I trust you have long since discovered there was no just cause, and I philosophically remarked to her that now she sees what it is to have babies."[32]

Charlotte Cushman was undoubtedly not amused at Hatty's insouciance. She had been intimately involved in the drama of delivery, with every aspect of Emma's travail etched on her memory. Emma had had a severe labor, the pain eased somewhat by the use of chloroform. Her doctor, judging incorrectly that the birth was not imminent, had gone to see another patient in the neighborhood. With a nurse in attendance, Emma's labor accelerated. As Charlotte Cushman told Cornelia Carr:

> Ned and I, who were anxiously listening, heard a double cry of mother and baby—the latter screamed out as soon as his head was born in the most lusty way. I could only weep tears of joy, and when I was called into the room and baby deposited in my arms, I assure you I could scarcely see my way across the room to sit down by the fire with baby rolled in a blanket until such time as the nurse should be ready to take him! I was too thankful to feel that she was through the hour of labour and had ceased moaning to care whether the baby was a boy or girl.[33]

While Charlotte wrote the letter to Cornelia, Ned sat by Emma's bedside. Her nephew and ward she described as being "in a perfect state of twitter—he moves about like a bird, roosting first on one bough then on another." He was very anxious, fearing that something would happen to the baby, his worry apparently stemming from the loss of their first child. Ned, in his concern for his wife, was "indignant" if anything interrupted her sleep. For what seemed excessive interference on the part of a father, the doctor had to "scold" him for being "in such a state."[34] To the woman who called herself "Granny" the arrival of Emma and Ned's baby was a stellar event. For all her inordinate possessiveness, which threatened to smother those close to her, she could be counted on for complete devotion.

Back in Rome, Hatty was ready to go to work, "tooth and nail." Her rivals were "tearing their hair to see me back again," their choler stimulated by the publication of "The Doleful Ditty of the Roman Caffe Greco." However arcane it might have been to the unenlightened reader, the satire was easily understood by the expatriate crowd in Rome. Hatty was purring with contentment at having had a "poke at those vinegar cruets in the shape of sculptors in Rome. How different

they are—the whole set—from the artists in New York who are gentle-men."[35] Her American tour had been an unqualified success.

The statue of *Zenobia* marked a progression in the sculptural images of Harriet Hosmer. Her previously wrought female figures had all been young women who were the victims of male aggression—*Daphne, Medusa, Oenone,* and *Beatrice Cenci*—helpless and impotent. Her choice of a woman of power and wealth was perhaps a maturing projection of her own fantasies as she neared the age of thirty with a greater recognition and appreciation of her own ability to compete in a male-domi-nated society. Zenobia's qualities of the mind and spirit, her athletic prowess, her unflinching courage and dignity in humiliating circum-stances, as well as her fabled beauty, made her an ideal of womanhood both romantic and realistic—one with which Hosmer could readily identify.

There was a growing consciousness of the feminine potential in areas hitherto unperceived. Whittier saw Harriet Hosmer and her statue *Zenobia* in terms of the feminist challenge: "I am gratified, too, that she [Hosmer] has lent an additional argument to those of us who believe in the natural equality of the sexes, and that in the highest art, as in the Christian arcana, 'there is neither male nor female.'"[36]

As *Zenobia* may have reflected Hosmer's subliminal self, so was the queenly figure in direct apposition to the cultural context of the period in which a storybook heroine, properly historical, appealed strongly to current tastes. Beauty and chastity in the same woman were qualities much admired. Aloof, regal beauties whose dignity never failed them were the prevailing ideal. Power and riches were also attractive attrib-utes in the materialistic climate of the nineteenth century. And there existed a modern-day woman who, though lacking in ideal beauty, wielded her scepter over a vast empire. It was Queen Victoria herself, the symbol of the era.

20
Her Own Hearth in Rome and Success in Dublin

Back in Rome, Harriet Hosmer was delighted with the progress of her new studio at 116 Via Margutta. "I go for a prowl about the domain and feel myself quite a Roman proprietor," she wrote to Wayman Crow. She felt "the greatest satisfaction in looking upon the spot where everything is to be and nothing is, as Mrs. Kemble said of Washington." When finished, "no studio in Rome will hold a candle to it," she said confidently. "I have already warned my friends of the airs and graces which I intend to assume when it is really completed."[1] Later she would extend the space by having a wall knocked out into what had once been James Henry Haseltine's atelier. Stables, too, were a part of the grand plan.

The business of sculpture was not without its headaches. Hatty was finding certain aspects of her new affiliation with Jenks, her American representative, troublesome. Crates containing her marble works were often lost sight of for weeks as they were transported to America. Although she tried to be philosophical about the problems in the enterprise—"we learn a little in this world by being bitten a little"—she complained that it was nearly impossible to sell sculpture from her studio without a piece to show. Wishing that she had a *Zenobia* in her studio, she worried that "it may be at the bottom of the sea for all I know."[2]

The shipping of statuary from Italy was a constant concern for sculptors. When, on one occasion, Hatty was relieved to learn that cases of her works had appeared after wandering somewhere between Liverpool and Leghorn, Story told her that she was lucky. His *Cleopatra,* he pointed out, went to the bottom "and was fished up after a year and a half." Not to be forgotten was the voyage of the ship *Elizabeth* that went down off Fire Island in July, 1850, taking Margaret Fuller Ossoli, her husband, and their child to their deaths. The hold was freighted with marble works including the statue of *Calhoun* by Hiram Powers, which lay for weeks buried in the sand before it was retrieved.[3]

Ancient treasures were still being unearthed in the heart of Rome.

Just as Hawthorne and William Story had marveled at the excavation of the *Venus* a few years before, Hatty found the "grand bronze-gilt" figure of Hercules, newly resurrected, "really sublime."

> Much as I had heard of it, I had no conception of its great beauty—and then we saw the hole forty feet deep in which it has lain hidden for 1800 years. Is it not wonderful that at last, by the merest chance, it has been permitted to see the light? It is, as perhaps you know, a colossal statue of the young Hercules with the lion's skin in one hand and something, which perhaps might be the apples of Hesperides in the other.[4]

At last Hatty would be moving into her own apartment. She had found the perfect place at 26 Via delle Quattro Fontane, the street that begins at the Piazza Barberini to move up a hill past the Palazzo Barberini to the intersection of the Four Fountains, each an elaborate sculpture group marking the quadrant where the Via del Quirinale and the Via Pia are on either side. It was the choicest of locations, hard to come by even for one who had been in Rome as long as Hatty had. Best of all, just adjacent to her "lares and penates" was the Palazzo Barberini, so close she could look down into the courtyard. In fact, her building was called the "Palazzetto," the little Palazzo Barberini. It rented, unfurnished, for the modest sum of twenty-eight *scudi* a month, about the same amount in dollars.

If Hatty's move from 38 Via Gregoriana came as a surprise to Charlotte Cushman, she lost no time in renovating Hatty's rooms for new occupants. Hatty wrote to Crow on May 5 that she was moving into her new quarters the following week. "My old ones are already pulled to pieces for Emma and the Consul." Cushman, intent on having Ned, Emma, and baby "Nino" with her in Rome, had been successful in getting her nephew appointed to the office of American consul. The monetary rewards were minimal, restricted to small fees for transacting business, so an independent income was a requisite. In 1867, Congress passed a law that entitled the consul to a salary of fifteen hundred dollars a year.[5] But the position carried prestige, and it seemed made to order for the dashing Edwin Cushman, a splendid horseman for the hunt and a gentleman with good connections.

William Stillman had been the previous consul, a man zealous in apprehending secessionists and Southern agents, who were indeed lurking in Rome. Charlotte Cushman, in spite of her ardent patriotism, took umbrage at his strong measures and complained to her friend, Secretary of State William Henry Seward, who understood her ambitions for her nephew. When Stillman was transferred to Crete upon his own request, after a confrontation with J. C. Hooker, resident secretary of the legation and a partner in the bank bearing his name, the way was open for Ned.[6]

Charlotte Cushman expended a great deal of energy in the politics of the American colony, activity never missed by the observant William Story. He had previously written to his friend Charles Eliot Norton, commenting, "Miss Cushman is mouthing it as usual and has her little satellites revolving around her." He was experiencing a certain malaise with regard to "the permanent American society," which he called "very low, eaten up by jealousy and given shockingly to cabal and scandal." The legation, he said, "is no Legation at all," and the "tongue" spoken was "solely American." In the midst of this atmosphere, "the great Cushman patronises them [American officials], and Mrs. [name deleted but presumably the wife of the Minister] nestles under her wing."[7]

In the same Roman spring, Hosmer's figure *The Sleeping Faun* was completed. It was her first rendering of the adult male form. In it a beautiful, sleeping youth, momentarily quiet but filled with life and energy, is stretched out against a tree trunk. One shapely leg is crossed over the other, and the torso is artfully draped with a tiger skin so that the genitalia are not revealed, a device often used by American sculptors of the nineteenth century to avoid full nudity of the male.[8] Another figure in the Hosmer work is a small satyr with furry limbs and cloven hoofs, who crouches behind the tree. While the faun slumbers, the little fellow ties him to the stump with the end of the tiger-skin drapery. For Hatty, it was probably sheer pleasure to invent such a situation, the kind of mischief that she called a "caper."

Rome had its share of Greek and Roman satyrs and fauns. Harriet Hosmer undoubtedly knew the *Barberini Faun,* a Roman copy of a Hellenistic piece. Sleeping in much the same pose, it is a more vigorous, muscular *Faun,* baroque rather than classical in style, and has the same tiger skin and accessories to identify him. But the antique *Faun* is explicitly nude. The break in what appeared to be a logical and consistent progression of female figures, from *Daphne, Medusa, Oenone,* and *Beatrice Cenci,* helpless victims, to the defeated but still powerful *Zenobia,* may have been purely arbitrary. Or, the faun may have spoken for the androgynous creature within her who still acted out childish rites and relationships and regarded the fanciful creatures of mythology as her familiars.

Another *Faun* very much in the popular spotlight was the figure known as the *Faun of Praxiteles,* or the *Campidoglio Faun,* an attraction in the museum at the top of the Capitoline Hill. It was this merry, fun-loving faun that was the motif in Hawthorne's novel, *The Marble Faun.* Published in 1860, it was an enormous success in Europe and America, generating increased interest in American artists in Italy among travelers and sightseers.

Just as some noticed the inspiration of the *Barberini Faun,* in Hos-

mer's "modern" sculpture, others saw a correspondence with Hawthorne's description of the *Faun of Praxiteles*. Hatty had loved the fictional Donatello, the young Tuscan youth who resembled the *Campidoglio Faun*. One might imagine, if Donatello had been real, that it was he who posed for her sleeping youth. Moreover, Hawthorne's observations about the ancient *Faun* seem more apt for Hatty's creation, for he saw "less of heroic muscle than the old sculptors were wont to assign to their types of masculine beauty." Hosmer's male model was strong, yet smooth and lithe in an almost hermaphroditic sense. Sensual but far less sexual than either of the two Hellenistic fauns, it is perhaps more evocative of Praxiteles' lesser-known *Hermes* than of the voluptuous figure in the Campidoglio.[9] It was natural for a neoclassicist working in Rome to be influenced by classical models, whether consciously or not, just as younger sculptors were impressed by their elder colleagues. *The Awakening of Endymion*, Daniel Chester French's only neoclassic work, must have been inspired as he viewed *The Sleeping Faun* in Hosmer's studio in 1875 during his stay in Italy.[10]

As soon as Hatty's faun emerged from an especially beautiful piece of marble, she had it given a fleshlike tint, just as Praxiteles had done, leaving the delicate coloration to the encaustic painter Nicias.[11] It took its place among the most admired works at the Dublin Exhibition in 1865, including a colossal statue of Pope Pius IX and a Lear-like figure of *Saul* by William Story. The art event attracted much critical attention even before the public opening. Soon, Hatty wrote excitedly to Wayman Crow to tell him the tangled "sequence of my Faun's tale."

She had told the chairman of the exhibition committee in the beginning that her faun was not for sale—it was going to America. Such a stand seemed to be the very impetus to whet the appetite for a purchaser. At a preview, the Irish aristocrat Sir Benjamin Guinness saw the piece, and the day after the opening, Hatty received a "Telegraphic Dispatch," informing her that the committee was prepared to sell the *Faun* to Guinness for a thousand pounds. "Don't conclude with America," the dispatch said. She awaited a fuller explanation.[12]

Hatty confided to Crow that her first price for the *Faun* had been eight hundred pounds, a figure soon topped in the marketplace. But still the amount was not firm. The committee officials told Guinness that the sculptor had an offer of fifteen hundred pounds in America, whereupon the eager Guinness increased his tender. At last it was agreed that the *Faun* would go to Guinness for the thousand pound figure. Hatty wrote to Cornelia that "the Faun went the opening day of the Dublin Exhibition for a thousand pounds—that beats Mr. Griswold [the purchaser of *Zenobia*], doesn't it?[13]

Hatty explained the complicated story of the sale of *The Sleeping Faun* more fully in a later letter to Crow. It is easy to see how art trading was hindered by a lack of instant communication. She revealed to Crow that the committee's notion that she had a fifteen hundred pound offer in America was a mistake. She had only told them vaguely that she wished the piece to go to America. "Isn't it very pleasant to have your works squabbled for," she asked Crow rhetorically.[14]

She then copied an article from the *Dublin Evening Mail* that told the whole chain of misunderstanding involving the sculptor, the committee, and the purchaser. The writer applauded the success of the exhibitors in getting good prices for their works, and especially thanked Hosmer for sending "one of the chief attractions of the Exhibition." Hatty asked Crow, "It cannot but be satisfactory, can it?" She could say all this to him, she added, "without its seeming too monstrous conceited as when I sit down to have a chat with you, I tell you all I know." In view of the *Faun*'s great success, she was already modeling a pendant, a *Waking Faun* that had John Gibson's hearty approval. "I declare," she said, "my children are getting to be as numerous as Brigham Young's wives. I only hope they get along as swimmingly as my babies."[15]

Hatty suspected that Sir Benjamin Guinness would present the statue to the city of Dublin as a public gift, which he did. The site of the exhibition building extended directly into the back gardens of Iveagh House, Guinness's Dublin mansion, so it was easy to move *The Sleeping Faun* to the newly created entrance hall at the mansion (now the Department of Foreign Affairs).[16]

Following the stunning success of the Dublin Exhibition was a moment long anticipated, the coming arrival of Wayman Crow and his wife Isabella. Mrs. Crow had been in Rome several years before, when Wayman Crow, Jr., and the youngest child, Isabel, who traveled with her, were little more than tots. But "the Pater," always occupied with the demands of his various businesses, would be coming for the first time. As Hatty wrote, Mrs. Crow and the children were already on the ocean, with Crow scheduled to follow later as head of the family. Since he would disembark at Queenstown, he could see her *Faun* in Dublin before coming on to reunite with the family, including Cornelia, at Versailles. Hatty would join them there also, and she already had plans for the summer. "I am projecting a little twist in Switzerland," she told Crow, "if you will say 'ay.'"[17]

In October, Hatty returned to Rome and her work while the Crows continued to travel. In November, she reflected somewhat sadly on the Crows' thirty-sixth wedding anniversary. "The cause of my melancholy is that it does not seem ever probable that I shall be enabled to enjoy the

THE SLEEPING FAUN

The Sleeping Faun, by Harriet Hosmer, 1865, marble, height 49″. With kind permission of the Most Honorable the Marquess of Northampton.

like anniversary. A shorter period even would content me and I stake my all (I don't mind telling you) on the very next Leap Year." When, at last, the Crows were coming to Rome, Hatty was ecstatic. They would travel from Florence to Leghorn, where they would take a ship to Civitavecchia. Orlandi's Hotel Sovero was the only place for travelers "where the fleas perform on their own hook," she said. She knew "every brick and stone in it and its foundations."[18] She and Emma had the same intention, of meeting them in the "Marine City," happy, no doubt, that the trip could now be made on the railroad. Before too long, there would be a railway station in the heart of Rome on the site of Crawford's Villa Negroni, razed to make room for progress.

Charlotte Cushman and Emma and Ned hoped to have the visitors stay at 38 Via Gregoriana, Hatty reported. But for the winter she had arranged for rooms at the Hotel Europa, where she thought her friends would be most comfortable. Hatty had matured in her feelings for Wayman Crow. She no longer sent him impassioned expressions of emotion, but her devotion to him remained constant. His presence in her very neighborhood and the occasion to show him all the sights of her beloved Rome would give her the keenest pleasure.

Harriet Hosmer, ca. 1867. Photograph by Granfield, 115 Grafton Street, Dublin. Schlesinger Library, Radcliffe College.

21
Monumental Matters

General William Tecumseh Sherman's brutal, unrelenting march to the sea proved to be the decisive factor in bringing the Civil War to an end. With the subsequent fall of Savannah and the collapse of Southern defenses, surrender came in April at Appomattox Courthouse. Only days afterward, President Lincoln was assassinated. When the word reached Rome, the expatriate Americans assembled solemnly at the legation in rooms attached to Hooker and Pakenham's Bank at 25 Piazza di Spagna to hold a memorial service for the dead president. In chambers draped in mourning crepe, many came with black bands on their sleeves. Some would wear them for the six months of mourning decreed by Congress.[1] Pope Pius IX, who had been steadfast in his support of the Union, along with other dignitaries, offered sympathy and condolences to the American community.

The shot that killed Abraham Lincoln resounded sharply in the Italian studios of the sculptors. Remote though they were from their homeland, they reacted in various ways to the tragedy. The American sculptor Thomas Ball, after hearing the word in Munich, took to his studio in the Palazzo Guidi in Florence and impulsively modeled the figure of a black man accepting his freedom from the martyred president, the artist using his own white body reflected in two mirrors as the model for the kneeling slave.[2]

After bitter quarreling and chaos among the members of the Lincoln family and government officials, the body of Abraham Lincoln was at last buried on May 4, 1865, in Oak Ridge Cemetery, Springfield, Illinois, in response to an unremitting order from Secretary of War Edwin M. Stanton. With the long agony and accompanying drama of the funeral train now past, plans for a permanent memorial monument at Springfield began to take shape at once: Governor Richard J. Oglesby was named president of a group incorporated as The Lincoln National Monument Association, made up of Illinois politicians and nationally prominent figures, some of whom were close friends and followers of

Lincoln. Their immediate need was money, and they hoped to raise a sum of two hundred thousand dollars, an unprecedented amount for any public monument. Reading about the plans for the Springfield monument and the large amount of money, Hosmer wrote bluntly, "The sum they aim at in Springfield is princely—what a haul it would be."[3] But several years would pass before the Illinois memorial was defined. Meanwhile, other endeavors were gaining momentum.

On the very day of Lincoln's death, a former slave named Charlotte Scott delivered a five-dollar bill, freely earned, to her employer, Dr. William Rucker, to be used as seed money for a monument to the Great Emancipator. A letter describing the gift of the freedwoman was published in the *Missouri Democrat,* resulting in contributions amounting to seventeen thousand dollars in cash; an additional six thousand was subscribed, including a substantial amount contributed by black soldiers. A commission was appointed to carry out the plan for a monument to be placed on the Capitol grounds in Washington, D.C. The money was placed in the capable hands of James E. Yeatman of St. Louis, a close friend of Wayman Crow's; Harriet Hosmer knew him also.[4]

Yeatman had worked tirelessly as president of the Western Sanitary Commission, an important unit of the wartime organization, with responsibility for the establishment of hospitals, the recruitment of nurses, and fund-raising. The commission was also charged with educating and training former slaves. Yeatman established the headquarters for the Western Sanitary Commission in his own bank, where he literally slept and ate while he scrupulously managed over four million dollars. Coincidentally, the head of the United States Sanitary Commission in the East was the Unitarian minister Dr. Henry Whitney Bellows, a cousin of Harriet Hosmer's whom she had seen during visits in America and would visit with frequently in Rome.

Although Yeatman had declined Abraham Lincoln's invitation to head the newly established Freedmen's Bureau, in the name of the Western Sanitary Commission he took charge of the emancipated people's drive to raise money for a fitting memorial to their benefactor. When the whole project became stalemated by President Andrew Johnson's conflict with Congress, the monies were deposited at interest to be resurrected at a later date.[5] Although plans for monuments were springing up on every side, Hatty quickly reached a conclusion: "I have always had an inkling in my bones that the [monument in] Washington being Mr. Yeatman's was the most politic to strike for; however," she told Crow, "it will be for you to be the umpire. I will make the design and then you shall dispose of it." She was not one to minimize personal

influence, and she knew, both from her successes and her failures to win commissions, how valuable it was to have friends in high places.

The Crows had not yet reached Rome in their European travels, but Hatty joined them for a trip to Switzerland, where she apparently began designing a monument or at least came up with a concept. Back in her studio, she told Crow that if he could look into her private room, he would see a monument in embryo. She had it all together and was "not at all displeased with it." She planned a "Council of War" with an architect, and she hoped to have "considerable" to show Crow by the time he arrived in Rome.[6]

Her neoclassical conception featured "a Temple of Fame," based on what she believed to be Lincoln's greatest achievements—the emancipation of the slaves and the preservation of the Union. She was guided by these themes rather than the military motifs that would be increasingly popular for such monuments. Columns, statues, and bas-relief sculpture were all features of the work, but the central focus would be directed toward a sarcophagus figure of the dead Lincoln guarded by four "mourning Victories, with trumpets reversed," to show their profound sorrow.[7]

During his lifetime, Abraham Lincoln would not have been an appealing subject for Hatty. In his rumpled, ill-fitting clothes, he had scarcely represented the Greek ideal of nature at its most beautiful. Other sculptors agreed that an image of such a homely man held little prospect. John Quincy Adams Ward, although he became more and more inclined toward naturalism, is said to have refused a commission to do the living Lincoln, unable to conceive of him as a model for sculpture.[8] One wonders what Rodin, forging his way to modernism with the tactile honesty of his rough-hewn surfaces, would have made of him.

Another expatriate artist, Larkin Mead of Vermont, was already showing his design for a monument to visitors. Judging only from photographs, the editor of the *New York Daily Times,* James W. Simonton, had already recommended Mead's work to Illinois Governor Oglesby, predicting that Mead would compete strongly, if not successfully, for the Springfield commission. Goaded by Mead's favorable publicity, however premature, Hatty, hotly competitive in the monument race, told Crow, "And now that Mr. Mead has hit upon the original idea of a Corinthian column I see my chances are not to be trifled with."[9]

Hatty wished that she could join the Crows for their sojourn in Florence, but she could not leave the monument. "My daily presence is of imperious necessity." She felt that Crow would agree with her decision. The Crows would undoubtedly visit the studio of Hiram Powers,

Hatty noted, and she sent her love to the dean of American sculptors in Italy, adding, "I daresay you will see Mead's [model] in his studio as he hangs out in Florence." She called Mead's conception "wondrous base" and told Crow, "between ourselves," that it contained no idea "but that of warfare" with nothing at all to suggest Lincoln's great acts.[10]

The Crows' arrival in Rome was the grand climax for Hatty. Accompanied by their youngest child, Isabel, and a governess, they frequently dined with her at 26 Via delle Quattro Fontane in the apartment that she was taking the greatest pleasure in furnishing. But for all her anticipation, Hatty complained that she was nearly too busy with the monument and other works to spend much time with them. Given a high place on the schedule of excursions was an early visit to meet John Gibson so that these dear friends could "form a personal acquaintance" with the man whom they knew only through Hatty. Gibson had been ailing throughout the previous summer, suffering several fainting spells. Only a few weeks after the Crows must have met him, he had a stroke that paralyzed him while he was working to complete a group centering on Theseus. Less than a month later, in the early hours of January 27, Hatty was called to his room, along with Mary Lloyd, who had nursed him. While Lloyd stayed with Gibson until he died, Hatty "left a kiss on his forehead and came away," walking home sadly under the cold stars of the Roman morning sky. Later she saw her "beloved master" in death, looking "grand and calm and beautiful." Feeling the loss of this dear friend profoundly, she "left Rome for a time," reluctant perhaps to face the reality.[11]

John Gibson's many friends and colleagues gathered to bury him in the Protestant Cemetery, since 1803 the last resting place of many expatriates and their children who died in Rome. On the day of Gibson's burial, J. E. Freeman recorded, artists and dignitaries came from everywhere to pay tribute to the modest Welshman who had lived and worked in Rome for over forty-eight years. The professors from St. Luke's Academy came in a body, and the French Legion d'Honneur sent a contingent who were resident in Rome. According to military ritual, each man fired his gun into the open grave, causing a street urchin sitting on a nearby wall to ask, "How is that? He is dead and they are killing him again?"[12] It was a logic that Gibson would have understood.

In a codicil to his will written in 1855, Gibson bequeathed most of his estate, estimated at thirty-two thousand pounds, to the Royal Academy. His marbles that were not sold, casts, and *gesso* models were to form a part of a collection given to the academy in his name. Relatives and friends, including Mary Lloyd, were remembered with modest gifts of money. The late Anna Jameson, her name not removed from the will,

was one of those named. Hatty had known previously that Gibson wished the Royal Academy, of which he was a member, to have his works. Robert Browning, in a letter to Isabella Blagden, said, "How often have I heard that Hatty was sure of it!" But Browning thought it too bad that Gibson had not left her a keepsake. "I am sorry about the death of poor Gibson—a simple good man with great talent and little genius enough, *secondo me* [according to me]; I don't like—nor was prepared for—his not leaving Hatty—so far as I hear—a ring or an old set of modeling tools. She has quite enough of her own, but there is too abrupt a descent from the high expectations."[13]

Whether Hatty had harbored such expectations is ambiguous, but her later mention of the sculptor Benjamin Spence, who, in the following year, died in Leghorn, as "the grasping executor" gives some hint that she resented Spence's being left Gibson's books and mementos.[14] Browning was apparently wrong or premature in his judgment, for visitors to Hatty's studio and her home saw Gibson's works, probably casts, and witnessed her reverence for them. It is likely that she and Gibson felt that their relationship as teacher and pupil represented more than any token. That Hosmer epitomized a living legacy of artistic inheritance from neoclassicists Francis Chantrey, John Flaxman, Canova, and Thorwaldsen was not overlooked as Gibson was eulogized.

The Crows had no more than departed when Hatty began making arrangements for Cornelia to take an apartment the following winter. Rents were high compared to her modest twenty-eight *scudi,* with larger furnished apartments as much as a hundred a month. She found one for Cornelia that was nearby, owned by the sculptor Tenerani. In a sketch that she enclosed of the floor plan, she marked the four bedrooms needed for Cornelia, the children and servants; anteroom; *salone;* dining room; and kitchen; another undesignated space she called "Room to raise the devil generally and in which the windows are to be opened."[15] Cornelia's apartment seems to have been just opposite Hatty's in the Quattro Fontane. When certain windows were opened, they could almost signal to each other.

Lucien Carr does not seem to have been a part of this extended stay in Rome. What he was engaged in is unclear, but he may have been on an expedition in America collecting the Indian artifacts that he studied. There is some indication that Cornelia's health was not robust during this interim, a factor that may have dictated a hiatus in their conjugal life. For affluent Victorians such separations between spouses were not unusual. For the wife to spend several months abroad with the children and a retinue of nursemaids was the opposite of another pattern, as European immigrants—husbands, fathers, and brothers—went to Amer-

ica without their womenfolk. When the men had earned enough to send for them, the women joined them.

Writing to Wayman Crow, who was now back in St. Louis, Hatty told him how much she missed having him in Rome. Although she was not yet "in the spirit land," she was inclined to give "a good rap at a door somewhere in the region of Olive Street," the Crows' address in St. Louis. As for Cornelia, Hatty said that she was settling in happily, taking a few days "to scratch around and make a comfortable hole to brood in." So quickly was Cornelia taking to Rome, she would soon be using "the Italian subjunctive with propriety and grace."[16]

The Waking Faun, Hatty told Crow, was turning out well after "a near squeak," when a crack in the marble "came so near to interfering with the figure itself that my poor blocker-out didn't sleep for a week." Nor was that all. A row of braziers had been placed around the *cavaletto*—the trestle holding the model—in order to make the plaster dry faster. But fire burns wood, said Hatty, "although the Italians don't think so." Down came the wooden sawhorse and with it the model, breaking into "I don't know how many pieces." Although it was put back so cleverly that the cracks could scarcely be seen, there was no excuse for "the stupidity of the first management." Had it been marble, the result would have been far worse.[17]

While Cornelia was staying in Rome, Hatty had another of the clairvoyant experiences that she was known for among her friends. While she was taking "forty winks" on the sofa after Cornelia had dined with her, she was "moved to say, 'I have such a feeling of a carriage accident.'" Cornelia dismissed it as a dream, but Hatty insisted that she had not been asleep. "Now let's see what comes of it," Hatty said. Ten minutes later, after she had really dozed off, the two women heard "a tremendous crash under my windows, in the *Cortile* of the Barberini Palace," startling both of them. "Up I flew to the nearest window and there was the Princess Orsini's carriage, upside down, on a pile of bricks, which in true Italian fashion had been left right in the driveway, with no lantern." The princess was cut and her shoulders bruised, but it was "a mercy" that she and others were not killed, said Hatty. "It was quite theatrical," she went on, "to see the servants of the Barberini gather about in their gay liverie, torches in hand to watch the rescue of the Princess and her companion, as they were carefully drawn through the window on the upper side of the carriage." Wearing a ball gown, the princess was on her way to an evening party at the Palazzo Barberini. Summarizing the incident, Hatty said, "So you see what a witch I am!"[18]

An earlier psychic phenomenon continued to interest her contempo-

raries who engaged in the current vogue for the supernatural. During the period that Hatty boarded with the French landlady, she had a personal maid named Rosa, who developed tuberculosis. Forced to retire, the young woman remained at home, where Hatty visited her frequently when she rode in the afternoon. On one occasion, Rosa "expressed a desire for a certain kind of wine," which Hatty promised to bring the very next day. The following morning, after sleeping well, Hatty awoke at the stroke of five, distinctly conscious of another presence in her room, although it was kept securely locked while she slept. Only Rosa had another key. Asking if anyone was there, she saw Rosa come out from behind the screen in the room, just as she had been accustomed to do in the days before she became ill. Firmly and clearly, her former maid spoke: *"Adesso sono contento, adesso sono felice"*— Now I am content, now I am happy. Then she was gone. Her French landlady ridiculed her, Hatty said, surprised that a dream would impress "a young lady so free of superstition as you are." But Hatty felt strongly that Rosa had died. Sending to inquire, she found that her servant had indeed succumbed at five o'clock.[19]

Lydia Maria Child asked her permission to write about the incident, and later Hatty discussed the experience with William Gladstone, the distinguished English statesman. Gladstone was highly interested, she said, until she told him that the apparition had spoken to her. "He said he firmly believed in a magnetic current, action of one mind upon another, or whatever you choose to call it, but could not believe ghosts had yet the power of speech." Nonetheless, Hatty clung to the occurrence, calling it "as much of a reality as any experience of my life."[20]

At the end of the year 1866, she was still going to Crow for help, in spite of brisk business and new prosperity due to her inheritance. "Ere this," she wrote, "a thunder bolt will have reached you from Freeborn [a banking house at 11 Via Condotti] in the shape of eighty pounds which I was compelled to draw, for never was there a white woman with such magnificent prospects so plaguing hard up as I am at this moment though every day I am expecting a windfall." "But," she concluded, "my two Fauns in the meantime must eat."[21]

In the summer of 1866, Hatty worked "by the sweat of her brow," she told Crow, which was easier when there were few visitors in Rome. She made the final preparations to send the plaster model for the freedmen's monument to America for the commission to see. The cases containing the dismantled structure would be shipped from Ripa Grande, one of the ports along the Tiber. It would be a longer route, Hatty thought, but safer, for otherwise, the ship might be delayed by quarantine, the bane of travelers or those sending goods abroad. Meanwhile, Hatty wrote, "I

close my eyes and open them to temples and cornices but hooray—it goes off satisfactorily."[22]

With Cornelia in Rome in October, Hatty had someone in whom she could confide. She had dreamed that the model had arrived in America and was much admired, she told Cornelia. Then she added the old adage, that dreams are contrary to reality, "but Cornelia said, 'It is bound to come true.'" What her competitors might be doing was always a matter of interest. Hatty relayed to Crow what Randolph Rogers "has been about all this time—a model to be submitted in Rhode Island." Satisfied that he was "safely diverged into another channel," she thought there would be less competition for the Lincoln commission with Rogers "disposed of."[23]

Writing to Crow one evening, "before putting on my night cap," she said that she was encouraged by a letter from James Yeatman, although he seems to have made it clear that he was not going to award the commission to her without "obtaining a more public verdict in its favor." That was "wise," she said, for it would "withdraw any charge of favoritism." But she was not deflated, for she confidently said she had no fear of "public criticism." William Greenleaf Eliot had criticized the length of the recumbent Lincoln, which Hatty promised to address, although she again pointed out that, seen by the camera, the figure would suffer from some distortion.[24]

The freedmen's committee had apparently offered her five hundred dollars as reimbursement for the shipment of the model—an amount she called "very handsome." Her expectations soaring, she asked Crow, "Do you think it premature to get the duplicate going? I should like it in the studio when the grand announcement is made that I am the happy individual, for many will come to see it." If it arrived safely, she would bet "all I owe on the result." Elated at her prospects, as she viewed them, she reported that she and Cornelia had dined together. "We immediately went off on an innocent bender."[25]

Attempts on the part of artists to keep their plans secret were futile. In the parochial atmosphere of the artists' colony, inhabitants entertained themselves with rumormongering. It had been "pretty well spread around Rome," Hatty said, that the monument was to be hers. "Doctors will be in great requisition among the artists when the report is confirmed." Hatty's female informant said that the word had come from the sculptor William Rinehart, who was in America and who had "got hold of it and written his newly acquired knowledge to Rome." Rumors persisted, which, Hatty said gleefully, had "given a good many the stomach ache." She could not count how many bronze foundries had applied to her for the job. Others thought the monument was to be in

marble, "and I will undertake to say fifty workmen have pronounced themselves ready to assist." Even her studio assistant Camillo had been congratulated. Her workmen, she said, read the Florentine journal *Nazione*, which was said to have published an announcement "that the great Lincoln monument is given to me." Her head was in the clouds, but from time to time, she had a sobering thought, "If counter currents set in, it will collapse my flue."[26]

Concerned about the portions of the monument to be fabricated in bronze, Hatty urged Crow to use his influence: "Pray hold out against the casting being done in America: instance—the Bowditch statue [Nathaniel Bowditch, naval oceanographer] in Mt. Auburn with cracks as big as a crater and the Franklin statue in Boston as black as your hat." She recognized the *"patriotic* sentiment" in support of the burgeoning bronze casting industry in America, but it was "a ticklish business," too important for experimentation. Ferdinand von Miller at the Royal Foundry was said to know secrets of casting unrevealed to others. The deposed King Ludwig was evincing an interest in the monument, recognizing that a commission for the Royal Foundry was good business for Bavaria. As more and more premature predictions were made in English journals and reprinted in the *Galignani,* Hatty was scarcely to be blamed if she believed her own publicity. "Many congratulations I have had though truth compels me to acknowledge not many from my brother sculptors of our nation."[27]

The design for the monument was well received in St. Louis. Only "Mr. Blow" had criticized it. Blow (probably Henry T. Blow), Hatty said, was "of little account." In the small world of sculpture she had heard that her colleague Chauncey Ives had had a bad experience with the same Blow, a tidbit that she recalled hearing at dinner at the Griswolds. "Altogether I don't know how things could be more favorable," she said to Crow. As for any criticism that might be heard in St. Louis, no critic could have been "more merciless" than she and her assistant Purini on the day that the model was taken apart and packed.[28]

As she wrote to Wayman Crow at midnight, December 31, 1866, Hatty contemplated the enormity of the task. Speculating that she would need six years to complete such a work, she urged Crow to "tell them five if it frightens them. Of course I would bind myself to use all reasonable speed but it is obvious that the work is enormous and I must work conscientiously." Even in her new, commodious studio, she wondered whether she had the space required for such a giant undertaking. Then, as she prodded Crow about the money, she changed tone abruptly, "If you can, screw them to $100,000." Only gold should be the medium of exchange, she observed shrewdly. "Gold is always safe,

greenbacks vary." She would rely totally on his "sound judgment" in all matters pertaining to the monument, which she knew he would "exercise according to circumstances."[29]

The statement issued by James E. Yeatman is puzzling. Dated December 1, 1866, St. Louis, it reviewed a statement by T. C. H. Smith, outlining the beginnings of the fund for a freedmen's monument. Next Yeatman told of the initial money raising and the stalemate brought about by President Johnson's veto of the Freedmen's Bureau bill. Then Yeatman wrote:

> In the mean time Harriet Hosmer, the talented daughter of New England, an artist whose genius has conferred honor on her country, hearing that a "Memorial to Freedom" was proposed to be erected, and at the suggestion of some friends, went to work to design a monument. It was in the mountains of Switzerland—free Switzerland—that this lover of freedom conceived and designed a monument, which she has since modeled in clay, and a plaster cast of which she has sent to this country. The same was shipped to Boston, and is now in that city.[30]

The commission was so well satisfied with her design that they had "adopted" it, giving the citizens of Boston "an opportunity of passing judgment on what they [the commissioners] deem the greatest achievement of modern art." The commission believed that "every lover of freedom, everyone who loves his country, everyone who honors Abraham Lincoln, every lover of art," would aid in completing this great work, one which especially commended itself to women since the artist was a woman. Proposing that the monument should be on the Capitol grounds—"height, sixty feet; base, sixty feet square; the architectural work of New England Granite, and the figures, bas-reliefs, and ornaments of Bronze," James E. Yeatman signed the statement in behalf of the commission.[31]

The published statement surely concludes that Harriet Hosmer would be the sculptor of the monument; so Hosmer is not to be faulted for her confidence. The affair would drag on for several more years before it took an entirely different turn.

22
A New and Intimate Friend

Carnival had come again. In the crowded streets the Romans vented their high spirits before the lean days of Lent began. It was no place for the fainthearted as many, bent on mischief, pelted the passing carriages with confetti, fragments of lime molded over large seeds. The carnival had not changed for generations—certainly not since Sara Jane Clarke, as "Grace Greenwood," had described the party of New Englanders watching it from a borrowed balcony because their own windows in the Corso were too high above the street. That year, 1853, the horses had raced down the Corso, reenacting the ancient Roman rite on "a sheet of yellow mud." The animals were brutally caparisoned with "spiked balls dangling at their sides," the contest over when they fell mortally wounded at the finish. It was a spectacle watched mostly by the rabble of Rome and curious foreigners.[1]

Americans who lived in Rome grew weary of the annual foolishness, growing a little more jaded with each passing year. William Story called a recent celebration "very dull," blaming it on the civil authorities who had asked the Italians to stay out of the Corso, the very center of the merriment. Even with Cornelia and the children in Rome during the carnival of 1867, Hatty called the occasion "no great shakes." But her godchild "little Hatty," Alfred, and Lucien "enjoyed it mightily as well they might for it is merest child's play."[2]

With the carnival's conclusion, the distance between the native population and the Americans, preponderantly New England Protestants, widened again. The church intensified its pieties during the Quaresima, the forty days of Lent, which climaxed with Holy Week, when once again the ancient ceremonies were reenacted in St. Peter's. Shortly after he had gone to Rome, William Story called the solemn rites "senseless and superstitious, with a penny worth of religion to a ton of form." He had little taste or tolerance for the custom of Maundy Thursday, when Pio Nono washed "the feet of twelve fellows in white foolscaps." However, when he heard Allegri's *Miserere* in the Sistine Chapel, "with the

awful and mighty figures of Michel Angelo looking down on one from the ceiling," he called it a "solemnly beautiful experience."[3] To dramatize the glory of Easter, the traditional illuminations lighted up the sky. One brilliant variation was the "diamond tiara" of the pope, glittering over St. Peter's dome, a symbol of his dual role as pontiff of the church and sovereign of the Roman realm. Hatty told Crow that 150,000 *scudi* had been spent "for the gratification of one single evening." Even with half of the amount donated by the Zouaves, Hatty thought the expenditure profligate.[4]

Relations between the Vatican and the American diplomatic officials were especially congenial during this period. Pope Pius IX had ingratiated himself with the federal government by using his power over the American bishops of the North and South to keep communications open between the two factions. He had even subtly suggested that he was the person to try to mediate differences between the Union and the Confederacy, since the situation called for a neutral nation or principality without army or navy. The Vatican state fit that description, Pius IX thought, for his battalions of soldiers had been disbanded and he had only one ship, a corvette curiously named the *Immaculate Conception*. Occasionally, American ships came into the port of Civitavecchia from the Mediterranean. In the spring of 1867, when an iron ship paid a visit, it was an event of great interest to the American expatriates. Hatty told Crow that she, Cornelia, Consul Cushman, and the Carr children were all preparing to go.[5]

Cornelia's Roman sojourn gave Hatty the opportunity to see her namesake almost daily. Little Hatty, at twelve, was not modeling in a mobcap, as her godmother had playfully predicted for her at her birth, but she was an accomplished pianist. Hatty said that the child's talent went "with the name." With her agreeable, good-humored "Aunt Hatty" nearby, Hatty Carr roamed the neighborhood with the trusted servant John by her side. Hatty Hosmer told Wayman Crow how pleasant it was to meet them by chance, "scouring the [Via] Babuino," the busy little street between the Piazza di Spagna and the Piazza del Popolo where American artists and their families had lived for years. Thomas Buchanan Read, his wife Hattie, and Read's mother-in-law, Caroline Hyde Butler Laing, a writer of books and articles, lived at 107 Via Babuino. John Gibson had dined there, and Harriet Hosmer had also. On one occasion, when she had a previous invitation for dinner, she promised the Reads that she would appear afterward. Another time, she wrote to say that she always accepted "kind invitations for Mondays and Thursdays with a margin, for those are hunting days." If it rained, she added, "and there are no Foxes which require my attention, I should be delighted to come."[6]

Hatty's apartment at 26 Via delle Quattro Fontane gave her the opportunity to entertain friends and visitors. (While she had lived at 38 Via Gregoriana, it is probable that all social events were given in the name of Charlotte Cushman, known for her hospitality.) When she greeted arriving guests, Hatty extended a small hand and looked them directly in the eye. She still wore her hair in natural curls tossed back from her high, broad forehead, a coiffure shorter and more casually arranged than the prevailing fashion. No photograph or sketch, one woman visitor thought, did justice to Hatty's animated face, its expression changing from frankness and vivacity to warm sympathy and concern for a guest. Her speech had become more continental, influenced no doubt by the splendid voices and diction of her friends in the theater as well as the educated accents of some of her English comrades. Still, her manner seemed natural as she laughed spontaneously. She was the same witty woman whom the caller remembered from previous years, with no inclination to be clever at another's expense.[7]

A reception hall, or anteroom, was filled with plants and flowers. This opened directly into the library, a room filled with books from floor to ceiling. Along the walls were casts of Gibson's works carefully arranged by his devoted student. Guests passed through an exquisitely furnished bedroom and the dining room to a *salone* beyond, a drawing room that Hatty furnished with Italian antique furniture, rich draperies, and carpets. Fine paneling, painted frescoes, and handsome bronzes gave the room an exotic character, totally different from anything familiar to an American caller. A fire was lighted on the hearth in the dining room when dinner was served. Venetian mirrors covered much of the wall, and there were pieces of antique porcelain around the room.[8]

Six guests, including the English sculptor John Bell, were present on a particular evening. They sat down to a table set with fine silver, satiny linens, and sparkling crystal. Fruits, wines, and cheeses were on the table. The entrée was a popular Roman dish, *cinghiale*—wild boar accompanied by a sweet and sour sauce. The finest wines accompanied the dinner, so the guest judged, perhaps a Chianti Classico from Tuscany or a Frascati from the Roman Campagna, brought to the city in a wooden cart drawn by great, white oxen. As the host, Hatty was quick to catch shyness or reticence on the part of her guests. Encouraged by her sensitive perception, they heard themselves become brighter—even brilliant—as the conversation went on.[9] While the wine may have loosened tongues, especially those on leave from a more abstemious American society, there seems little doubt that Hatty was taking her place as a serious contender among other hostesses and managing it with the same aplomb that she took the fences in the Campagna.

Studio visiting was still a social charade in the 1860s. John Murray's guide, *A Handbook of Rome and Its Environs,* continued to update the names and addresses of the painters and sculptors as well as their current works and the hours when they received visitors. "Hosmer, Miss (American)" could be found in her studio at 116 Via Margutta, called "a bijou of arrangement and decoration, quite unique in its kind at Rome or elsewhere, and is open at all times to the public, the talented artist herself receiving visitors generally from 1 to 2 o'clock." A caller at her studio in 1866 reported that a visit to see this American "celebrity" was not to be missed. Unlike her friend William Story, Hatty greeted her guests in person. "It was pleasant to find a bright, piquant woman instead of the Amazon, bustling with weapons offensive, which our fancy had conjured from the shadowy realm of gossip," the visitor said. With a manner that was crisp rather than brusque, the sculptor patiently explained her work over and over to successive callers. Anecdotes about the visitors' ritual were rife among the expatriates. One story was told about Randolph Rogers, who was showing his statue, *Nydia, the Blind Girl of Pompeii,* to a caller who was deaf.

"What did you say her name was?" Rogers was asked.

"*Nydia,* Bulwer's *Nydia.*"

"You don't say! Why she looks quite intelligent for an *idiot.*"[10]

The courtyard of Hatty's studio, an island of tranquillity and beauty just as Gibson's *cortile* in the Via Fontanella had been, was filled with flowering trees and shrubs. The *Fountain of the Siren,* a replica of the one created for Lady Marian Alford, stood in the center. It was on this spot that the sculptor posed with her sizable work force of distinguished-looking, bearded assistants and marble carvers, who wore the traditional hats made of white paper to keep the fine powdery dust from their hair. Hatty stands in the center of the picture, looking very much "the boss." The photograph, "Hosmer and her men," as she called it, was taken "by way of a joke," but it had been a "great success."[11] She wears a velvet beret, perhaps the same one that Hawthorne saw her wearing nearly a decade before.

A stream of visitors came through the doors of her atelier in those years. One was Mark Twain, who arrived in a company of journalists, some with the naive attitude of "innocents abroad." As Mark Twain examined one of the works in Hosmer's studio, he was heard to observe to a woman nearby, "I have never had the opportunity of seeing near at hand the work of a thoroughly trained sculptor before. Now, in the statues I have generally seen, the artist always had a particular point from which he wanted you to look at his work, and, from that point, it looked well. But this, I observe, looks well from all points."[12] Like other

Harriet Hosmer with her studio artisans, 1867. Photograph courtesy Watertown Free Public Library.

American visitors, he soon found his way to the Caffè Greco, where he is memorialized in bronze.

In the years after the Civil War, the coterie of women sculptors continued to grow and thrive. While Louisa Lander had left under what appears to have been a cloud of parochial prejudice, others, particularly Harriet Hosmer, were pointed to as singular examples of success. One of the most interesting of the group of female sculptors was Edmonia Lewis, who came in 1865 or 1866. Her mother was a Cherokee Indian, her father black. She grew up among the Cherokees and later attended Oberlin College, the first institution to admit women of minority groups. There, she was accused of poisoning two white women classmates. Defended by the black lawyer John Mercer Langston, she was exonerated. She relocated in Boston, where she studied modeling with sculptor Edward Brackett.

While her first works were done in the prevailing neoclassical style, she moved toward a more naturalistic expression of the oppression that black people and Indians had suffered. In Rome, her studio was listed in Murray's *Handbook* at number 8 Piazza di San Nicola di Tolentino, not far from William Story's splendid studio. She was said to have an abrasive personality, though perhaps she was perceived that way because

she showed an independence of spirit and action that was not expected from one who was black. Visitors to the studios saw her as an exotic curiosity, her dark skin in sharp contrast to the white marble that surrounded her. That she was said to have emerged from an Indian wigwam added to the interest.

Although Harriet Hosmer does not mention Edmonia Lewis in her correspondence, she was cordial and friendly to the newly arrived artist. Lydia Maria Child, on the other hand, was closely in touch with the young Lewis's progress. Child, who had risked her reputation for the cause of abolition, was deeply involved in the plight of black people. She was, she wrote Theodore Tilton, editor of the *Independent,* more surprised each day at the intelligence of Negroes who had not been "allowed to cultivate their minds or own their bodies."[13] Of Lewis's recent reception in the Roman colony, Maria Child said that "the colored sculptor" had found "several artists disposed to be kind to her, both in Florence and Rome." But it was Harriet Hosmer who represented the acme of achievement. Not only was she successfully competing in the field of sculpture as a woman, but she was also rich and famous. Maria Child quoted a portion of a letter that she had received from Edmonia Lewis: "A Boston lady took me to Miss Hosmer's studio. It would have done your heart good to see what a welcome I received. She took my hand cordially, and said, 'Oh, Miss Lewis, I am glad to see you here!' and then, while she still held my hand, there flowed such a neat little speech from her true lips!"[14]

Edmonia Lewis added that "Miss Hosmer has since called on me, and we often meet." Pictures of the black sculptor show her in a costume startlingly like Hosmer's tailored shirt, ornamented with a handsome pin on a neat tie at the neck. While this may have reflected the style for emancipated women, it may have been a conscious imitation of the woman who was, for many other women artists, a model.

The sensible Mrs. Child was not sentimental in her appraisal of Edmonia Lewis and the financial problems that beset her, and she told her friend Harriet Winslow Sewall that she had been forced to write a frank letter to her young black friend about money matters. "The fact is," she told Mrs. Sewall, "I should rather have given fifty dollars than have done it. But I have observed that she has no calculation about money; what is *received* with facility is *expended* with facility." Hiram Hosmer had said almost the same thing about his daughter, who argued that she had been denied the experience of dealing with business affairs. But, with a rare wisdom, Child understood Edmonia's inability to handle money. "How could it be otherwise, when her childhood was spent with poor Negroes, and her youth with wild Indians? People who

live in 'a jumpetty-scratch way,' (as a slave described his 'poor white' neighbors) cannot possibly acquire habits of balancing income and outgo."[15]

Maria Child felt that if those helping Lewis continued to pay all her bills for freight and marble, "without expostulation from any quarter," she would continue to send statues without counting the cost or without a customer on the other side. When Lewis asked Child about modeling a *Pocahontas,* Child advised her to wait until her models were good enough to be "*ordered* in marble." A "mediocre statue" was worse than a painting of poor quality, Child stated, for the reason of size and bulk; "it is so conspicuous, and takes up so much room that no one knows what to do with it."[16]

It has been said that Edmonia Lewis studied with Harriet Hosmer, but there seems little support for such a belief, although Hosmer may have offered criticism in an informal way. Nor does the notion that Lewis lived with Charlotte Cushman seem reliable. The very size of the household at 38 Via Gregoriana, with the young Cushmans and their growing family, Emma Stebbins, and Sallie Mercer, seems to preclude that hypothesis. However, the word that Charlotte Cushman, well known for her beneficence, was helping the black sculptor was current and probably had some basis. Maria Child was relieved to hear the account of her given by "a lady from Rome," but she presumed that "it was only *partially* true. . . . I don't believe that Charlotte Cushman has taken Edmonia Lewis 'under her protection,' for, if she had, she would never have allowed her to run in debt for marble on the mere supposition that Mr. Garrison's friends would raise money to pay for it." Child's assessment of Charlotte Cushman was undoubtedly influenced by intimate conversations with Harriet Hosmer. "Miss Cushman is very kind-hearted, and if Edmonia was in great trouble, she would relieve her, but she is a shrewd, experienced, managing woman of the world."[17]

The practical Maria Child told Edmonia Lewis that she must learn to do something that would earn her a living. Only a portion of her time should be devoted to "perfecting herself as a sculptor which would take years of patient labor." Lewis, she thought, would take music lessons and hire horses while the money lasted. With affluent artists all about her—for example, William Story, living like royalty in the Palazzo Barberini, and Harriet Hosmer, riding to hounds in the Roman Campagna—it is not surprising that she hoped to emulate them.

Other friends and associates of Hosmer's were Margaret Foley and Florence Freeman. "Florry" Freeman, who had come in company with Charlotte Cushman in 1861, on one of the actress's return trips, was a particular favorite with whom she regularly exchanged professional

news and gossip. Once, when a bad storm had struck Boston, Hatty told Florry Freeman that she was accustomed to a Boston that "gave herself airs, but I never knew before that she treated herself to hurry-canes." "Peggy" Foley had begun as a cameo cutter, as Hatty had indicated in a letter to Wayman Crow. She went on to specialize in portrait medallions with considerable success. She was well liked by her colleagues, including Harriet Hosmer. Unfortunately, hard work and the Roman climate took their toll, and she died at the age of fifty-seven in 1877.[18]

Anne Whitney was another who came to Rome after the Civil War. What appears to be the name "Miss Whitney" is mentioned in a letter to Wayman Crow written in 1868. Responding to notions that she would take the sculptor into her studio, Hatty said, "As for taking her as a pupil—perhaps I might when I have studied about twenty years more." But she would be glad to help the newcomer who, she thought, had talent. Anne Whitney was, coincidentally, also from Watertown. Nine years older than Hatty, she had studied with William Rimmer in Boston. Moving away from neoclassicism, she focused on themes of social activism and injustice. Her life was very different from that of Harriet Hosmer, for she cared little for publicity or society.[19]

Harriet Hosmer, younger than nearly all of her female colleagues, was their acknowledged example of what could come about for a woman. Although she was friendly and helpful to her fellow artists, she is probably credited with more assistance than she was able or inclined to give in those busy years. Her studio at 116 Via Margutta had nine rooms, constantly in use either by her or her assistants for modeling, casting, and cutting marble. It is entirely possible that, from time to time, she was willing to share some of the space.

In the spring of 1867, a visitor found Hosmer working to perfect *The Waking Faun,* the pendant to *The Sleeping Faun* that she had sold in Dublin. As she played upon the clay model with a hose to keep it wet, she said, "You see he takes it coolly." She had been at work on the statue longer than she cared to tell. But she told the caller what John Gibson had said when she had spent so much time on the *Medusa:* "Nobody asks you how long you have been on a thing but fools, and you don't care what they think."[20]

The modeling of *The Waking Faun* had plagued her from the beginning. The same young male image, with short curling hair and graceful, relaxed physique, had awakened to catch the same little satyr working his mischief. Holding the little fellow by the hair, the faun tries to look stern, difficult for a creature known for his sunny, carefree nature. Hatty had hoped to exhibit both *Faun*s as companion pieces in the Paris

The Waking Faun, by Harriet Hosmer, 1866–1867, plaster or marble, life-size, current location unknown. Photograph courtesy Watertown Free Public Library.

Exhibition of 1867, but at last she told Wayman Crow, in the strictest confidence, that she had had to give up the plan. She had not wanted to speak openly of it, hoping that the shortcomings would be "rectified," but now she stated her case simply: "It is this: it fell too far short of the other and I never could make it go—it was no good—it was in no manner, style, modelling, sentiment nor anything else, the worthy companion of the other."[21]

Now, with the exhibition only weeks away, there was not enough time to give the second piece the kind of high finish that had distinguished the first, putting an even greater distance between the two in quality. With regret, she told Crow: "If you only knew the pulls and twinges I have had regarding that statue. I should have suppressed it long since without any hesitation, had it not been for the undeniable fact that I did not want to disappoint you and I knew how you had your good heart set upon its going to the Exhibition." She knew all too well "that one poor statue does an artist more harm than a dozen good ones can do him good," which was, she said, "the spiteful nature of the world."

She could not risk it, for if she herself knew that the second was inferior to the first, others would quickly come to the same conclusion. Nonetheless, she had had "a dreadful tussle" with herself and gave in only "when the light dawned." She was working on another, smaller model— "in plain English, I am going to have another shy at it." Cornelia, who had seen the progress of the work, said that Hatty would be "well repaid."[22]

Hatty had refused the offer made by the Vatican to pay for the shipping of her sculpture to Paris, where it would then be shown in the Roman section. Story, Powers, and Rinehart had accepted the pope's offer. Only Hatty preferred to exhibit in the American collection in spite of the high cost of shipping and freight. While her move was heralded as a patriotic one, it is possible that she thought it prudent to identify herself with American art at a time when war memorials, particularly those to Abraham Lincoln, were being competed for. *The Sleeping Faun* was given a good place at the Paris exhibition, thanks to the director's care of her, Hatty reported. Had she been there to install it, she told Crow, she could not have done better than Monsieur Beckwith.

The exhibition, which began in the spirit of festivity and the celebration of the achievements of the Second Empire, was greatly diminished by the death of Maximilian, Napoleon III's protégé emperor in Mexico. The news of the execution, when it was announced, "plunged the Court into mourning," Hatty told Crow, and stopped all festivities. Louis-Napoleon had received the information just as he was preparing to award medals, she reported. "What a sad knowledge for him—worse too, to keep it to himself all day." She observed that he might well "date his downfall from this news, and they say his face in the procession was the saddest ever seen."[23]

Well might his demeanor have been sad, for the whole Western world held him responsible for the catastrophe. In Maine, the *Portland Transcript* observed, "If anybody deserves to be shot, it is Louis Napoleon. He is the chief criminal in this great national crime." The "archdupe" some had called Maximilian, who was the younger brother of the Austrian emperor Franz Joseph. Led by the promise of power and supported by the French emperor with money and troops, Maximilian and his wife Carlotta, or Charlotte, daughter of the king of Belgium, had gone to Mexico under the flimsiest of pretexts. After Maximilian and Carlotta had been crowned as monarchs of Mexico by Napoleon III, they had come to Rome to receive the blessing of Pope Pius IX. The Vatican gave them a glittering reception to which all diplomatic emissaries were invited. Sensing the ambiguity of a European ruler in the Western hemisphere, Rufus King, the American minister, was in a quan-

dary. Lacking instructions from Washington, he felt it best to attend. He was speedily rebuked by Secretary of State Seward.[24]

The French, bearing the expense of the Mexican misalliance, became increasingly hostile to Louis-Napoleon's support of Maximilian. Also, the guerrilla forces fighting in behalf of Benito Juarez, who was actually president of the Mexican republic, refused to be defeated by the French invaders. Along with these factors was a stronger pressure from the United States government, hitherto occupied with the Civil War.[25] Then Napoleon III withdrew. Harriet Hosmer had little love for the French and cared nothing for Paris, but as she witnessed the climax of the Mexican fiasco, she felt some sympathy for Louis-Napoleon. As for the predictions of the debacle ahead for the Second Empire, they were not long in coming to pass.

Hatty traveled in Britain for the remainder of the summer of 1867 and well into autumn, a period that prefigures the direction of her life in years to come. London was her base, and from there she visited in Ireland, Scotland, and Wales. Showing her the Welsh countryside was Mary Lloyd, who had tried her hand at sculpture in John Gibson's studio and whose sweet singing voice and pleasant personality made her a favorite. Eventually she shared her home in London with Frances Power Cobbe, who had become badly crippled. As news of Hatty's presence in Britain reached her friends, she received a letter from Adelaide Sartoris that began "My dearest Hat." Would she come to the Sartoris home, Warsash in Titchfield, where they would "go over the days in our beloved land and make the old jokes and try to laugh the old laughs?" Sartoris had also written to Lord Lyons to urge him to join the house party. Fanny Kemble would not be there, for she had hurried off to America when she had heard of the death of her former husband Pierce Butler, perhaps to comfort her daughters, especially Frances, who had remained loyal to her father and, with him, to the Confederacy.[26]

Hatty did not make the proposed reunion because, as Adelaide Sartoris said, she had given her "wretched skull a knock against a chimney piece" while visiting at Lady Marian's house, Ashridge. "You can't think how disappointed Lord Lyons was" at not seeing his friend, as he watched one train after another arrive "with no Hatty." Soon after, however, Hatty was writing Cornelia from Warsash, saying, "How oddly things come round in this world." Nostalgically, she spoke of "Aunt Totty," their girlhood name for Adelaide, who "sings all the old Roman songs." Annie Thackeray was there, too, and all the others had gone yachting at Cowes. "Needless to say," Hatty told Cornelia, "I prefer terra firma."[27]

Urged to stay in England while affairs were so uncertain in Rome,

Hatty moved from one country house or castle to another. Cornelia, in Paris for a time, had some differences of opinion about Hatty's protracted visits at the great houses of English friends. Answering Cornelia, who must have asked if Hatty's schedule was subject to the whim for which she was known, Hatty replied, "No, malicious Miss, I make my visits just the reverse of what I intended." When she had finished castle hopping, she would return to Rome by way of Paris, "back to your arms unless I grow too fat for anything which is very likely." Pleased with herself, she later boasted that she was the richest woman in England, "for I have only to say 'I am coming' and all is ready."[28]

In company with her German maid, Kuhl, she continued her peregrinations: to Castle Ashby, the home of the Marquess of Northampton; to Raby, the seat of the Duke of Cleveland; back to Ashridge and Lady Marian Alford; to Wotton House, Aylesbury, and the Duchess of Buckingham; and then on to Melchet Court to visit a new friend, Louisa Lady Ashburton. Hatty had met Lady Ashburton early in 1867 when the handsome Scottish woman had appeared in her studio with a letter of introduction from a mutual friend. Recalling the day as one of special meaning, Hatty took delight in telling how she became transfixed at the sight of Louisa, then at the zenith of her statuesque beauty. Hatty, thinking that she may have been spending too much time in her studio, saw the visitor as the Ludovisi goddess, the magnificent Juno that she and Anna Jameson had once admired together, appearing before her in the flesh. "There were the same square-cut and grandiose features, whose classic beauty was humanized by a pair of keen, dark eyes," a radiant smile, and a rich, vibrant voice.[29] Hatty was immediately smitten.

Louisa was an imperious presence, too formidable for some. She could be grace and kindness itself or the personification of tyranny, a woman quite unpredictable in her relationships. Lady (Walburga) Paget, a highborn Prussian whose husband was the British ambassador in Rome, described her.

> Generous, violent, rash and impulsive, ever swayed by the impression of the moment, she was necessarily under the thumb of somebody. Bevies of impecunious artists hovered around her like locusts, tradespeople made fortunes out of her and adventurers found her an easy prey. . . . Though she was not infrequently offended, she always and graciously retracted, and her smile, with the light in her dark eyes, under the straight brows, put me in mind of lightning amongst the thunderclouds.[30]

As Louisa Stewart-Mackenzie, member of a Scottish family of some distinction, she had become the wife of the second Lord Ashburton

Louisa Lady Ashburton and Her Daughter, Maysie, by Sir Edwin Landseer, 1862, oil on canvas, 35" × 28". With kind permission of the Most Honorable the Marquess of Northampton.

eighteen months after the death of his first wife Harriet Montagu, the beloved of Thomas Carlyle and the bane of his wife Jane. Lord and Lady Ashburton had one child, born in 1860, who was named Mary Florence (for Florence Nightingale) and known thereafter as Maysie. When Lord Ashburton died in 1864, Louisa was thirty-seven. Soon she was immersed in completing and decorating Melchet Court at Romsey, in Hampshire, spending extravagantly as she collected art and artists.

While Hatty was enjoying her extended visit in England in 1867, a new impetus to take over Rome was developing. Although Hosmer and other American and British expatriates were satisfied with the pope's secular rule and the status quo, there was ample evidence of support for the Piedmont monarchy. Foreign visitors, oblivious to the continuing suppression of revolutionary ideas, were innocently surprised to see as graffiti the name of the composer Verdi, unaware that it was not his name but an acronym that signified Vittorio Emanuele, Re d'Italia.[31]

Writing from Ashridge, the home of Lady Marian Alford, while "all the good folks have gone to church," Hatty said that she was glad for any excuse to stay away from Rome. Irregular troops of the popular Garibaldi were skirmishing with the pope's protectors in an effort to force capitulation. After such an episode, Ercole, her studio assistant, had

written that studio and stable were intact, "nothing taken possession of except in fleas which the Garibaldians are welcome to." Another of her men, a "blocker-out," had been injured by an exploding bomb, necessitating the removal of his finger. Another terrorist incident involved her servant, "my valiant John," who was attacked by two men as he was on the way home "and robbed and stabbed, though fortunately the dagger went through his coats only."[32]

Hatty hoped "to mercy" that the French protectors of the pope would stay. Hearing that Garibaldi was going to America, she said, "and I hope to God he will go somewhere and not turn up again in my life time—he is getting to be a regular nuisance." As for Pius IX, "satisfaction was never so strong as now." While it had been fashionable to ridicule the papal troops, "they have shown themselves to be valiant soldiers." Consul Edwin Cushman, in his eagerness to observe and report on the guerrilla raids to his government, found himself participating too wholeheartedly. Attempting to help an injured papal Zouave, Cushman was wounded. Fired at twice by a Garibaldi attacker, he picked up a gun and drove off his assailant. But his behavior, however courageous it may have appeared to his comrades, was severely reprimanded by Secretary Seward on behalf of President Andrew Johnson.[33]

Back in Rome after the English sojourn, Hatty found all tranquil again, with all of the Garibaldians "gobbled up." While the French appeared to be leaving, she thought that they would go no farther than Civitavecchia. Her optimism about papal Rome's survival was still intact. With new zest, Hatty planned to fill up her studio, making up for the last two years, she told Crow, when she had not been very prolific. Her new client, Lady Ashburton, would keep her busy. The association, begun early in 1867, had already yielded bountifully. Before Hatty went to Britain, she told Wayman Crow that Louisa had ordered a *Sleeping Faun.* When its pendant, *The Waking Faun,* would be finished to Hosmer's satisfaction, that, too, would be added to the growing collection at Melchet Court.

A *Puck,* a *Will o' the Wisp,* two charming putti playing on the backs of dolphins, and four yellow alabaster pedestals were sitting in Hosmer's studio at the end of 1867, awaiting Louisa's disposition of them. Were Hatty to break her neck in the Campagna, she realized that Louisa would have no proof of ownership; so, in a written statement, she listed the works and pedestals as the property of Lady Ashburton, from whom, she stated, she had received the sum of seven hundred pounds. One of the few papers from her hand so exactly dated, December 23, 1867, it is signed H. G. Hosmer. She was also at work on a chimneypiece for Melchet Court based on a myth and entitled *The Death of*

The Mermaid's Cradle, by Harriet Hosmer, 1893, bronze, height 7', installed in 1894 in Fountain Square, Larchmont, Westchester County, New York. The fountain is apparently a replication of one designed for Lady Ashburton at Melchet Court. Photograph courtesy Marlene Park.

Putti upon Dolphin, by Harriet Hosmer, ca. 1861, marble, height 33″. With kind permission of the Most Honorable the Marquess of Northampton.

the Dryads. In a lighthearted letter to Cornelia, Hatty retold the tale of the tree nymphs who perished when "little lads" cut down their trees, leaving them "nothing to do but die which they are accordingly prepared to do."[34]

Two fountains, *The Dolphin* and *The Mermaid's Cradle,* were executed from Hatty's models and placed in the Italian gardens at Melchet Court. A second chimneypiece was also contemplated. It would feature mythic figures personifying day and night, a theme that had fascinated Hatty since her youthful rendering of *Hesper.* Hatty studied the well-known frieze in the Palazzo Barberini, which had inspired Thorwaldsen's use of the motifs of day and night. Although she drew preliminary sketches in a letter to Louisa, there is no further evidence of a completed design. Mentioned in Hatty's letters to Louisa are a *Psyche* and a *Hermes.* Whether these were completed and later lost or destroyed is not clear. Nor is the identity of a bust, which Hatty promised Louisa would "look quite a different thing," known. She added that the drapery of the piece was "a little present from Lady Marian," who may have presented the fabric to Hatty or even posed with the cloth around her. A *Mars* may well have been a copy of an antique piece, replicated in Hosmer's studio

by the artisan Camillo, who thanked Lady Ashburton for the opportunity to execute the "*bel lavoro.*"[35]

A large, freestanding *Amazon* was almost completed when Hatty told Louisa that she was nearly bankrupt. A great deal of money had been spent on the piece, and facing Hatty each Saturday was the fact of paying her workmen. If she were to ask eight hundred pounds for the *Amazon,* Hatty said, it would be four hundred less than Louisa would have had to pay Gibson in his lifetime for "exactly the same work, because when Camillo finished his [Gibson's] marbles, he never touched them himself." Later, Hatty reminded Louisa that one hundred pounds remained due on the *Amazon,* and only half of the cost of "the other Faun," presumably the *Waking Faun,* had been paid. If Louisa would not be pleased with the *Amazon,* "you will never be pleased again."[36]

Early in the friendship with Louisa, Hatty declared herself in league "with the confraternity of furniture dealers" in Louisa's behalf. Sixteen "of the loveliest chairs ever looked upon" were on sale privately. From a cardinal's estate, they were gold and red velvet, but not garish, and only worn to just the right degree. Emelyn Story had taken four as Hatty herself had done. Eight remained, for which Hatty had secured first refusal for Louisa. The *padrona* would not sell half, but Lady Marian would gladly take four off Louisa's hands if she wished. A vase in the Vatican was another item that Hatty urged Louisa to buy for her newest venture, Kent House in London. Louisa should make up her mind promptly so that Hatty could secure for her the fine *rosso di levanti* marble. Pedestals for statues of Lady Ashburton's St. Bernard dogs, modeled by Hatty, as well as for the "antique Faun" and *Amazon* were giving Hatty trouble, since Louisa wanted them as "pendants."[37]

The finances of the two women became very much intermingled, and they shared a mutual extravagance. Lady Ashburton paid in installments that often fell into arrears; also, Hatty borrowed from Louisa. If the business relationship between the two women was calculated, their personal liaison was clearly spontaneous, adding a new dimension to Hatty's life that had hitherto been lacking. There had been the flirtations, reported flippantly to Cornelia: "My dear, I haven't nary a lover this year—the truth is I have been and am now too busy to flirt with anybody." Never counsel her not to work too hard, she admonished, for if she did not work, she flirted, "and that is much the worst of the two." Another time she announced that "the pleasantest time after all is when lovers are howling for you," but she was quick to deny any "flirtatious friendship with Sarah [Freeman] Clarke," an old friend from New England.[38]

If flirting among the women in Roman society was a popular pas-

time, it did not rule out Hatty's option to be the coquette with the venerable Sir William Boxall, as reported to Wayman Crow. "Boxall, my early love and my late one too, was here for nearly a month, and of course I flirted a deal with him. He is as delightful as ever and quite as matrimonial. In fact, I was plighted to him before a justice of the peace, and I told him positively I never found myself in such a plight before." But the amorous correspondence with Louisa Lady Ashburton, was distinctively different. Hatty's attachment to her was enduring, beginning with infatuation and romantic intensity, then mellowing into a friendship that was close and familial. Sometime she professed to be a "hubbie" to Louisa, whom she called "my *sposa,*" and sometimes she referred to herself as Louisa's "wedded wife." When the restless Louisa traveled, Hatty's letters followed her. Often separated from Louisa for a year or more, Hatty would artfully introduce a conjugal term to remind Louisa, perhaps, of their bond.[39]

Louisa, generous to a fault, sent gifts. Photographs of the Elgin marbles particularly pleased Hatty, and she thanked Louisa profusely for having her ring reset. Telegrams were a new and exciting way to communicate quickly, and Louisa frequently used them. Letters, on Hatty's side, at least, were loving, even passionate, leaving one to wonder if much of the ardor was not expended in the letter writing. A great deal of energy went into the making of elaborate travel plans, usually aborted, in an effort to be together.

Louisa's health was a constant concern to Hatty. After she discussed Louisa's symptoms with Emelyn Story, who suffered from similar disorders, Hatty passed on palliatives. Admonitions to her beloved to stay out of drafts were delivered repeatedly. Urging Louisa to come to Italy, she importuned, "You are never afraid of coughs when I am with you." Hatty reported on her own state of health—"no throat," as she called laryngitis. Along with the chronic falls from her horses, she was also prey to the hazards of her profession. At work in her studio, she cut off the end of one of her fingers, in the "worst way imaginable, screwed it in a pair of calipers!" Calling it "mercilessly ingenious" on her part, she said that although she nearly fainted, she recalled that "it must be clopped on directly," a method that seems to have worked, for the quickly repaired wound was "beginning to sprout" and would soon be well.[40]

Only rarely was there a darker side to the relationship. With unaccustomed seriousness, Hatty, in responding to Louisa, asked that her friend never "fancy estrangement—it will be quite time enough to think about it if it ever does come; at present let us be happy in knowing what sweet dear love we have for each other." Once, she dreamed that she had arrived in England to find herself replaced by another woman, shadowy

and faceless, conveying "no intelligible idea to my mind except past clandestine flirtations," of which Louisa seems to have had her share. Accusingly, she felt that the dream was "founded on fact, for you never take any notice of me now—anymore than if I wasn't your wedded wife." Still, she emphatically denied that she had ever suffered from jealousy and did not now. She was not above dangling a rival's name before Louisa. The Countess Wittgenstein, prominent in Roman society, was paying her attentions; Louisa could just ask Lady Marian Alford.[41]

To spend the winter together in Rome, Hatty and Louisa had even discussed buying number 18 Piazza Santa Trinita, at the top of the Spanish Steps. Each of them, along with Lady Marian Alford, could contribute two thousand pounds to share the cost. When that could not be realized, and with Rome filled chockablock with visitors during the 1872–1873 season, Hatty informed Wayman Crow that she was making some changes in the living arrangements of her apartment in the Via delle Quattro Fontane so that she could take Lady Ashburton and thirteen-year-old Maysie into her "nest" for a stay of several months. To Cornelia, Hatty gave the news a more sensational slant, although her words were surely not intended to say what twentieth-century readers might infer: "I am about to prepare for an increase in family. You will be startled at that piece of news, which must be unexpected to all my friends: however, there are various constructions to be placed upon these words."[42]

Louisa and Maysie spent the better part of four months with Hatty, and Louisa reported that they had the most agreeable time with their host, "the sweetest of sisters." But it was to Maysie that Hatty turned, calling herself "your little fat sister." She called Maysie "Twinniekins," and Louisa became "the mother" or "the dear mother" in this perplexing array of kinships, reflecting once more Hosmer's deep need to belong to someone. That this might have been an adjustment on the part of Hatty and Louisa to the presence of an adolescent girl seems unlikely, for the analysis of sexuality had not yet entered the intellectual realm of the pre-Freudians. What does seem credible is that Hosmer, subconsciously more comfortable with maternal and sisterly relationships, returned to that safe harbor.

Later, anticipating a reunion with Lady Ashburton, who had been traveling in Egypt in 1875, Hatty delayed a planned departure of her own, which would, she told Louisa, "enable us [all] to do Laocoön once more." Continuing the metaphor, antic or erotic, she went on to say that she would "fancy when you get this note, we have already begun Laocooning and will fold my arms round you." Letters from Hatty to "My

Beloved," "My Truly Beloved," or simply "Beloved" were signed merely "Thine." In the Victorian manner, enclosures might be verbena, clover, with a play on the word "lover," a sprig of May from the Campagna, or "a geranium with a kiss on every leaf, which you must transfer to your own lips."[43]

The fervid phrases in certain of Harriet Hosmer's letters to Louisa Ashburton seem oddly fatuous and patently sexual today. Given the commonality of loving, even sensual, correspondence between women in the nineteenth century, including Hosmer's early letters to Cornelia, these expressions from a woman mature in years are infinitely more intense and private than her unselfconscious recitals of flirtatious friendships. Had her sexual orientation changed at some time previous to the episode with Louisa Ashburton? This question may never be answered, for knowledge is incomplete. It is enough to say that Hosmer's correspondence with Lady Ashburton speaks eloquently of her capacity for love and her need to be close to another human being in an intimate sense. In the social and cultural climate that prevailed, it is not surprising that the object of her love should be a woman.

23
The Benton Bronze: "Safe on His Pins"

As the year 1868 began, Hosmer was still closely identified with the freedmen's monument. An engraving of her design and an accompanying article were published in the English *Art Journal* on January 1. With regard to Harriet Hosmer as designer and sculptor for the monument, the article said, "Of her power to fulfill the trust reposed in her there can be no doubt; her genius is of the highest order and she has proved her capacity by producing some of the greatest works in sculpture of our age."[1] The edifice would cost about fifty thousand pounds and was destined to be placed on the grounds of the Capitol at Washington, D.C.

In Rome, Hatty had entertained St. Louis guests over the Christmas holiday. The Partridges, presumably George Partridge, prominent in the Western Sanitary Commission, and his wife, had "pecked" at her table. Hatty's hospitality was curtailed by her servant Antonia's "taking to her bed with a sort of rheumatic fever." Partridge had become what Hatty called "a good *monumental* ally," talking with her long into the evening concerning her design for the freedmen's monument. Seeing it in a photograph, he seemed to like it, she said, and they both agreed confidentially that the monument could be built at a price lower than the projected cost.[2]

The funds for the monument, still wanting, were held at interest, watched over by the scrupulous Yeatman. Hosmer had nursed the idea that helping to raise money for the monument would undoubtedly crystallize her securing the commission. Crow may have been tactfully discouraging her when he told her that it was not "a happy moment for making the move," as she paraphrased his words. With President Andrew Johnson engaged in an imbroglio with Congress, everything was "too blue." Nor was she "much encouraged by the report of the darkey monument. However when I see that *six millions* have been gathered together the past year for *religious purposes,* I can't [but] think that the sum we want might be hammered out by persistence."[3]

A drawing of Harriet Hosmer's proposed design for the freedmen's monument to Abraham Lincoln, *Art Journal,* January 1, 1868. From the Resource Collections of the Getty Center for the History of Art and the Humanities.

In English circles, it is not surprising that Hosmer was thought to have the freedmen's monument in her pocket. Robert Browning wrote to Isabella Blagden to comment on what appeared to be a foregone conclusion: "I am glad Hatty is going to have so great a chance: she is an intrepid creature to accept it. Six and thirty figures here, four there, three everywhere—all on the strength of Puck and Zenobia and the Faun best of all."[4]

Browning had no doubt seen the *Art Journal,* and what Hosmer called "the second edition" of her design for the monument. The figure of Abraham Lincoln was no longer recumbent but was instead standing erect in the "Temple of Fame," holding the broken chains of slavery in one hand and the Emancipation Proclamation in the other. During the previous summer in England, Hosmer had shown her designs to her friends William Gladstone and Sir Henry Layard. Each had written a letter to her, offering intelligent, benign criticism, words that she carefully weighed. Her confidence in the judgment of these two Englishmen,

however distinguished, for a project so wholly American indicates a growing alienation from her roots in America, where a more vivid, less ideal, style was emerging. The place to show her drawings was London, she told Crow. They should be hung where they could be seen and endorsed by men of distinction like Browning, Gladstone, and Layard.

Wayman Crow had previously suggested to Hatty that she design a monument that would be appropriate for either the freedmen's monument or the Springfield tomb of Abraham Lincoln. Pleased with her conception for the first, she argued that any alteration to make it also appropriate for a tomb would affect the integrity of it. Each part related so harmoniously to the other that she hesitated to withdraw any existing motifs or introduce new ones. To divide the focus would be "to make two imperfect halves rather than one perfect whole." Rather than tamper with the design, wrought specifically for the freedmen's monument, she had said, "Let's trust to luck, keep the plaster dry, and go in for Washington and *Win!*"[5]

In February, 1868, Hatty's exclusive preoccupation with the freedmen's monument changed. The National Lincoln Monument Association in Springfield, Illinois, announced a competition to artists, offering a thousand dollars for the best design for the tomb of Abraham Lincoln. At last a plan of action had been formulated for this most important memorial. Hatty heard the news at a Roman social gathering that she called a "tea fight." Thinking at first that her informant was talking about the freedmen's monument, she then realized that he was referring to a circular put out by the association in Springfield. That no one had yet been selected she knew, although she had acknowledged that Larkin Mead and his friends had been "angling" for the commission since shortly after Lincoln's death and subsequent burial in Springfield. Now the matter would be decided through competition. With $130,000 in hand, the sum that Hatty believed to be realized, the committee was launching the contest. But the fulfillment of the enterprise was contingent upon raising $200,000 or more, and the times were hardly congenial.[6]

Mulling over the complexity of these considerations, Hatty came up with an idea. If Crow considered it feasible, he could submit it to James Yeatman. "Why not unite the two associations—the funds [run] short in both and so between the two make up a handsome sum. But as far as we are concerned, there would be a slight proviso and that is that they give the commission[s] to the same artist, name unmentioned but which we know." What did Crow think of this plan as a possibility, she asked, adding expansively, "I'll subscribe $10,000 for myself." Writing at a later hour of the same day, Hatty had thought more deeply about the

Springfield endeavor. Nothing would please her more, she said, than to have her design accepted for Springfield, which, as Crow had pointed out, would someday be the center of the country. She would prefer that her work be located in the West rather than the East. "It is more my home. I began my studies there, and they appreciate whatever there is in me a thousand fold more." Indeed, it would be "something to have the monument placed over the bones of the great man it honors."[7]

Responding to the news of the competition, both Wayman Crow and Yeatman wrote quickly to encourage Hatty to participate. As Crow said, Hatty must return to her first conception of the recumbent figure of Lincoln as its central focus. She had given it up reluctantly in favor of the standing image, for she had believed from the first that Lincoln should be presented lying in state, "a historical fact familiar to everyone." Now, her idea "of expressing him dead," which she had said she would "advocate to the last," had come round again. It was now "more a *mortuary* monument," she said, although this time she would modify the temple, making it more spacious "to fully contain the sarcophagus," an element that was faulty in the first. She wondered: "Who are the concurrents? Are there many designs sent in? Would it be of any use if I were on the spot myself?" She would come running at once although she surely could not have "two better lawyers" than Crow and Yeatman, who, she felt, would do all that they could to procure the Springfield commission for her.[8]

Her appetite whetted at the thought of the contest, she thought that she, Crow, and Yeatman "must bring great force to bear upon the attack at Springfield." What she really believed would wield the most influence was "the promise of making up the deficiency in hard cash by the Freedmen's Monument Society." She had observed that "what has the greatest weight in this world is generally the base but useful metal."[9] That any attempt to manage the monies subscribed by those freed from slavery was high-handed, not to mention unethical, seems to have occurred to her only dimly. Even in that time of laissez faire, it was a misbegotten idea.

Wayman Crow promptly told Hatty that James Yeatman was not interested in such a proposal. Whether Crow presented Hatty's plan to Yeatman with any degree of seriousness is not known, but she answered when she heard the news, "I am sorry Mr. Yeatman won't angle at Springfield if there is any chance of a bite. A bird in the hand is worth two in the bush even if that bush is the Capitol in Washington." She did not let go of the idea easily. Even so, she recognized a risk: "Of course we don't want the experiment tried unless there is a pretty good chance of their being amenable, but if I had my say, I would have them *manipulated*. If we *miss* this chance and *lose* the other, what then?"[10]

Manipulation seems to have become more than a word in her lex-

icon, for, during this same period, she was successfully manipulating Lady Ashburton to make all manner of purchases, her sculptures as well as other art objects. With Crow, at least, it was all talk, and she quickly put aside the conspiratorial role to turn to other topics. In her March letter to Crow, for example, she gave an account of Admiral David Farragut's visit to Rome and congratulated Crow on turning sixty, an age that she now looked upon "as about ten years this side of the prime of life." At Easter Hatty expressed her pleasure at the postponement of the Springfield competition until September, giving them time for "the Generals to plan their campaign." James Yeatman, in a message to Hatty through Wayman Crow, had told her not to abandon the Washington enterprise yet. This she interpreted as a word of caution, that the Springfield prize might not go to her; but, on further deliberation, she was again optimistic about her chances.[11]

She prepared to let Crow in "on a little secret." She was "*coming home with Corny,*" who had spent the winter in Paris, where Hatty Carr could study at the *conservatoire.* Hatty reasoned that she might as well be "on the spot," in case any "emergency" arose in regard to the Lincoln contest. She had planned to come home the following year anyway, and this change gave her less time to anticipate seasickness. She could do little harm, she thought, even if she did no good. "And if by chance I should get the commission," she argued, "I shall have a quantity of material to collect which would call me home anyway. Unless you absolutely countermand me on the ground that it would do more harm than good, I shall risk my fortunes with Corny whenever she sails."[12]

To Cornelia, she wrote, "Tell it not in Gath, whisper it not in Babylon and don't babble on the subject anywhere." She told Cornelia to include her when she went to engage passage. "Hooray! Won't we have fun when I am the sickest. . . . Don't breathe this—that I am going home—I charge you. Half the artists who compete" would follow suit, and that might hurt her chances. One of the reasons for her trip home was her anxiety about Wayman Crow's health. Vague word that he was not well preyed on her mind, creating an insistent need to see him. He was feeling the effects of a series of boils. Hatty recalled that she had once had thirty of them, "not much in themselves except the pain while they last, but they leave one so weak that other ailments may follow in their train." For the whole winter of her plague of them, "I had something or other all the time, and a wretched winter I had of it." With the prevailing belief that such "ungentle benefactors" cleared the system, she said, "But in the end I was better for them." She told Cornelia that they two should do all they could to cheer up "the Pater." "His chicks must devote themselves to him," she vowed.[13]

Meanwhile the romantic friendship with Lady Ashburton was flourishing. "Dearie," Hatty told Cornelia, "I have been off flirting—went to Perugia with Lady Ashburton for a few days and a heavenly little *giro* I had of it." Playfully, she went on, "But oh, how your jealous soul has been avenged, for I came back with a worse cold than I ever remember to have had and wretched have I been for a week—positively wretched—in bed half the time and sick unto death the other half." It was only that day, after dosing herself with medicine the previous night, "that I feel any ways equal to anything." Cornelia may not have been jealous, but as time went on, she seems to have become increasingly uncertain that Louisa was the best influence on Hatty. When, in a letter, Hatty mentioned Louisa as her "better half," she added, "As you say, my 'worser half.'" As for the trip, Charlotte Cushman reported it to Cornelia, with whom she had taken up correspondence. Hatty had gone off "for eight days with Lady Ashburton, who has carried off not only her heart but her voice, for she has returned without one, being unable to speak aloud, but she will be all right shortly."[14]

Henry Whitney Bellows was another whom Hatty considered to be a valuable ally. She had "skewered" her cousin, "the Reverend Doctor," as he arrived from Egypt, giving him "a sketch of the campaign we are planning with a view to 'taking Springfield.'" She told him that they wanted him "on our side—whereat he rubbed his hands and said, 'with all my heart.'" She would send Bellows a list of the committee members to see if he knew any of them personally. Meanwhile Bellows suggested that he write one of his travel letters, which were being published in America, with the monument as its subject. Hatty could let no opportunity go unexploited. Moving to other things, she blamed the high incidence of illness on "the prolonged eruption of Vesuvius." Although the volcano was many miles south, it was popularly believed, perhaps with good reason, "that uncanny gases have escaped, which have poisoned the air." Except for the nasty cold from which she was suffering after her jaunt to Perugia, Hatty could say, "Providence has certainly blessed me with health." Soon she would be seeing Cornelia, whose name had been "appearing in print as one of the high in American society in Paris."[15]

Hatty had been forced to do something, she told Wayman Crow, "which was like pulling out eye teeth, and that was I drew upon you for $1500 exchange and all." That she could pay it back in America that summer was a consolation. She would be sending several things home for which she would be paid, "but it nips me a little at this particular moment." Turning "several times over" in her brain the design of the monument as it had to be altered for the Springfield submission, Hos-

mer came to a conclusion. The first of her conceptions was better in as much as the sculpture was concerned, but the architecture of the second was far superior, with the temple simplified by the removal of "festoons and Eagles." She thought she might have a drawing done to illustrate it. "The enemy most to be dreaded," she continued to think, was a simple architectural monument, obelisk or column, for "surely a story can be but poorly illustrated by architecture alone."[16]

Besides sending a photograph to Wayman Crow, Hatty thought it wise to send pictures to Henry Bellows, "who enters upon the matter with enthusiasm." If Crow could think of any way in which Bellows could be useful, in addition to his writing, "he is the man to be relied on." Would it be any good if Bellows wrote to Governor Oglesby? "He only wishes to be told," Hatty assured Crow, but she was afraid to make suggestions "without consulting you for fear of doing more harm than good." What luck it was, she continued, that a certain Judge Davis, who seemed to be "a weighty man in the Springfield Council," was a friend of Crow's. Accordingly he would be able to be "the better manipulated."[17]

Responding to Crow's request for estimated costs, Hatty said that she could tell him "exactly what it will be on this side of the Atlantic," with the exception of "one or two items." The sculptured figures would be "11½ or 12 ft high, probably the latter," she began.

The studio expenses for modelling, casting and extra moulds—	$10,000
Sending to Verona—at which point Muller [sic] becomes responsible and expenses from there are included in price of casting	2500
Muller for price of casting and delivery at sea port	$47,425
	$59,925

"Say $60,000," she said, rounding out the figure. George Partridge had estimated the cost of the granite, based on the price that he was paying for new granite, at perhaps $30,000. A granite cutter, Hatty thought, could easily give an estimate just by looking at the photograph, "calculating the height at 60 feet." As for working and putting up the monument, "suppose we say $50,000," she concluded. That could readily include the cost of transportation to Springfield, adding up to a sum of nearly $100,000.[18]

Crow would have to calculate the cost of sending the monument from Bremen to Springfield from his experience with the Benton statue, only recently arrived in St. Louis. Hatty did not doubt that the expenses

would come to $150,000, "so I should not consider that I was paid very handsomely unless I had $200,000." This was an outside figure, she judged, and it might amount to less. Thomas Crawford, she said, had received only $80,000 for the Richmond monument—"he just paid expenses but he was glad enough to do it even on those terms." She would leave it to Crow's judgment to determine how much gold would be needed for payments in Europe and how much paper currency in America. She preferred to contract for the entire project, "placing the monument and all," she said; "then I can have my say in all ways."[19]

Again she returned to the idea of "a very handsome subscription" to be offered "*conditionally*," which would be "of vast weight." Instead of the $30,000 that she had previously proposed, her sights soared. "I would say $50,000—it sounds magnificent and you and Mr. Yeatman and I could arrange about the lacking 20." It would be enough for the Springfield committee to know, she concluded, "that the Freedmen's Association would be responsible for that sum and they may arrange with the artist as she herself can suggest—the artist hopping [*sic*] to be behind the scenes." In a postscript Hatty, now more partner than protégée, observed that the Springfield committee had raised its estimate of the monument's cost to $250,000. The $100,000 that they had in hand left what she called "a handsome deficit in the Springfield treasury." If funds did not materialize by the first of September, "they will have a considerable sum to rely upon from *somewhere*. All this confirms me in the opinion that the larger the sum offered by the Freedmen's Association, the greater the chance is for us." Did Crow agree with her? "I see it resolves itself solely into a question of pecuniosus [*sic*] and private influence."[20]

Most propitiously, the statue of Thomas Hart Benton was at last due for its inauguration in St. Louis. "Old Bullion comes in the nick of time," Hatty said. She recognized, nonetheless, that it would be criticized, probably most of all by those who were disgruntled at her getting the commission. "All public statues have been uniformly picked to pieces by disappointed aspirants," she said, "who, at one period, had wished a hand in the matter themselves." But she was sanguine.

> One thing can be said—they can't be more bitter in their criticism than they were on the Everett [William Story, Sculptor], and perhaps I may add the Mann statue [presumably that of Emma Stebbins]. We must be prepared for some pokes in the ribs. Apropos of the Everett, it is said that all those squibs have been written by William Everett himself [Everett's son] as I believe he did not want Story to have the work.[21]

It had been eight years since Hosmer had done the Benton model, and she felt that the added years of experience had enabled her "to do

better now." If they needed any support against detractors, Crow was prepared to bring out the late John Gibson's endorsement of his female pupil, to which Wayman Crow said he would add, "Lay on, Macduff." On the twenty-seventh of May, the great bronze statue of Thomas Hart Benton was unveiled in Lafayette Park, compared in its beauty to the Parc Monceau in Paris. Wayman Crow began his account of the long-anticipated event with boyish exuberance. "Hip! hip! hurrah! 'Old Bullion' is on his feet at last, and he stands magnificent. Yesterday was a proud day for St. Louis, a proud day for you, and I need hardly say it was a proud day for me."22

It was a fine spring day in St. Louis, proclaimed as a holiday throughout the city to mark the inauguration of the state's first public monument. Flags flew on public buildings as well as on the handsome private residences on the four sides of the park. At two o'clock, Wayman Crow, riding in his carriage, arrived to take Jessie Benton Frémont, Thomas Hart Benton's daughter, to the ceremony. She was accompanied by her husband, John Charles Frémont, himself a celebrity who had earned the name "the Pathfinder" when he explored the American West. In the presidential election of 1856, he had been the unsuccessful Republican candidate, losing to James Buchanan.

The crowd in Lafayette Park was said to number as many as forty thousand people, including three thousand schoolchildren, who were dressed in white and carried bouquets of roses. Seated on the platform was Benton's old Negro manservant. After the firing of a rocket and an opening prayer, Crow escorted Jessie Frémont to the base of the monument, where she pulled a silken cord that released the drapery to reveal the statue. Witnesses said that tears were in her eyes when she saw her father's image, the cloaked figure of the man holding a map in his hands. The band played "Hail to the Chief," an anthem not yet reserved for presidents, while a cannon "gave thirty salutes in honor of Benton's thirty years in the United States Senate." With the sun gleaming on the bronze, Jessie Frémont walked around the statue, looking at it intently from every angle as guards held back the surging crowd.23

To Crow, Benton's daughter said, "I was prepared to like Miss Hosmer's work, but this surpasses all I had expected." The sculptor had caught her father's "very expression and attitude," she said, and he had worn his cloak very much as Hosmer had arranged it. When he was asked for his opinion, General Frémont, who had eloped with Benton's daughter, said that the statue was the best work of art that he had seen in America. What he thought of the man that it represented is not recorded. When Crow's carriage returned to pick up the party at six o'clock, they again circled the monument. As they drove away, Jessie

Benton Frémont blew a kiss to her father's effigy. Then bowing to those who had gathered at the gala event, Jessie and John Charles Frémont left the scene.[24]

With his letter before her, Hatty responded to Wayman Crow with the same delight, "Hip! Hip! hurrah!! Indeed it is a long time since I have been so happy as I am this day." She recalled nostalgically that he had used the old Yankee salute when she had first received the commission in 1860. She had laughed as she read his letter, walking back to her father's house from the post office. She recognized that the number of people who had turned out could be credited to her friend Crow, who had planned it all. Beyond all doubt, having Jessie Benton Frémont present to unveil the statue was "the master stroke," the "circumstance [that] enhanced the ceremony immensely."[25]

Even as she wrote, Hatty thought of another ceremony taking place in St. Louis. She little imagined, she had told William Greenleaf Eliot, the president of Washington University, that she would ever "enter into a conspiracy with anyone against Mr. Crow." But with the connivance of William Eliot and James Yeatman, a bust of Wayman Crow, modeled in Rome by Hatty and put into marble, was brought to the June 18, 1868, commencement exercises of Washington University, the school that Crow had founded almost single-handedly. The surprise gift was concealed in an alcove and revealed at precisely the right moment. On the base of the work and on both sides are carved:

WAYMAN CROW
Rome M.D.C.C.C.LXV—Tribute of Gratitude.
Harriet Hosmer, Sculpt.

The image of a bearded Wayman Crow wore "a calm and noble expression, a look full of meaning, an indescribable something which shows the work to be no less the language of the artist's heart, than a faithful likeness of her friend."[26]

James Yeatman wrote to tell Hatty of the success of their secret undertaking. (He was noncommittal about the Springfield competition.) Crow was greatly pleased and gratified at Hatty's recognition, although she said to him, "All I can say is that the Bust ought to be a statue and that statue of gold to repay you for all the trouble and care you have taken for and of me. You—my best friend—where should I have been without you?" Gold, the precious metal unalloyed, could not have been far from Hatty's thoughts. Affixed at the top of one of her letters to Crow was a small clipping: "Miss Hosmer received $10,000 in gold for her statue of Benton.—*Cincinnati Journal of Commerce*."[27]

The Benton statue was given the local and national attention appro-

Portrait bust of Wayman Crow, Sr., by Harriet Hosmer, 1865, marble, height 24″. A plaster casting of the portrait bust is in the Harriet Goodhue Hosmer Collection, Watertown Free Public Library. Washington University Gallery of Art, St. Louis, Missouri, gift of the heirs of Wayman Crow, Sr.

priate to a public monument, although those of Republican persuasion were cooler toward immortalizing the Democrat Benton. The most caustic criticism was recorded in the diary of Judge William B. Napton, who wrote that the image looked more like Wayman Crow than Thomas Hart Benton, "and no two persons could be more unlike." But Hatty was satisfied with the initial response to the Benton statue, writing Crow that "portrait statues are ticklish things, particularly when the artist is bold enough to present a modern without trousers." That the Missouri statesman at last stood "safe on his pins and *so do we*" gave Hatty leave to turn her attention to the coming competition. "You are right in saying that I should feel very flat if Springfield didn't go," she had told Crow, although she continued to deny that the contest was her real reason for coming home.[28]

The death of Governor Oglesby's wife had prevented Wayman Crow from making a trip to Springfield, probably for the purpose of lobbying in Hatty's behalf. Dr. Bellows, she said, was only waiting for instructions before writing to Oglesby. She had also "got the scoop announcing that Mr. [Leonard] Volk had made a design for the monument. We don't care how many make designs so that only one gets it—provided that *one* is the *right* one."[29]

She and Cornelia had changed their minds about sailing on the *Palmyra,* "as I have no respect for emigrants—except at a distance." They were going instead on the *Ville de Paris,* on July 30. Besides the pleasure of crossing with Cornelia, Hatty's instincts about the trip were positive. One of the encouraging aspects was sailing with a potential client who was "nibbling" at a fountain, an interest she might foster with a "little wholesome conversation." She contemplated her financial situation, thinking that it might be "good policy" to sell her Cheshire stocks, an "egg" she had "held on to . . . more as recollection than anything else." With her stable, house, and studio finished, she ought to lay up something for the future. With the great outlay of money demanded for sculpture, she said, instead of "shooting invariably over the mark," she ought to "quit sculpture and go to whittling."[30]

As the time for her departure approached, her correspondence to Crow gained momentum. She had had an encouraging letter from James Yeatman, saying that those who had seen her design were "favorably impressed" with it. If a photograph was effective, she thought, a plaster model would be even more persuasive. The committee seemed to have no deliberate plan of action, Hatty reported from Yeatman. What she had most feared, she said, "was that they were all bigots—on the architecture scheme—having no decided plans, they will be easier of manipulation."[31]

She had made a third design which she said she could not "beat as a composition—the third is always the lucky number." On this one she could "gaze complacently." She had shown it to several artists and architects. A very clever one had said that it was "'*a capo d'opera*.' It certainly beats the other two to nowhere." She had put eight columns at the temple, "thereby removing the appearance of *portico*—now the figure is enclosed within it." She had also "transposed the Victories and the Negroes for two reasons": to put the Negroes in a position of greater prominence, which many had recommended, and more important for the design, she thought, to improve the outline of the monument, disposing of the "unsatisfactory effect of four standing figures around four standing columns." Yeatman, known for his courtesy and graciousness, had told Hatty that he hoped she would present her design in person, but she had replied that she "would never entertain such a thought." She knew too well, she said, "on which side my bread was buttered not to leave it in the hands of those who would do far better than I can do for myself—that in America or Liberia I can confide my fate with perfect tranquillity to you [Crow] and to him." She intended to remain "perfectly passive," she had told Yeatman, although she might have added, "Till I get the commission and then I will fly around like a parched pea."[32]

Arriving in Paris, Hatty read her letters from Wayman Crow before washing her face, "having collected all the smoke and dust between here and Turin without once seeing soap." She had climbed Mount Cenis by train, an experience that she would relate to him when she saw him. Cornelia was well and Hatty Carr "remarkably well." Even without having slept in her bed "like a Christian" for three nights, she sat down to have "a little chat" with Crow. She was carrying the newest rendering of the design, which she wanted to present along with a model that was on its way. She felt that her chances were good due to "the personal influence we have." What appears to be a resolution of her previous schemes is a mention of "the weight of the 25,000 in which we shall come off fairly anyway." She told Crow that she wanted "to keep the iron hot, and if we can keep it burning and scorching up to the first of September, we can afford to let it cool afterwards." Most of all, she wanted "to hear the good news from your own lips." She said that she hoped to see him in eighteen days as she wrote from Addiscombe, a property of the Baring family.[33]

Allusions to Hatty's stay in America are vague and arcane. Because she spent much of her time in the company of Wayman Crow and the Crow family, there was no need for correspondence. It is probable also that Crow thought it prudent to keep Hatty's visit private in view of the

Springfield competition, set to begin in early September. It can be assumed that she should not have expressed herself, either directly or by innuendo, on the subject of fund-raising for the Springfield monument. Her attempt to manage the freedmen's monument funds had undoubtedly been scotched. To mollify her and to gain an advantage in Springfield, the twenty-five thousand figure had probably been discussed as a contribution from Hosmer, were she to be selected to do the sculpture. For the high cost of erecting public sculpture, now being contemplated in epidemic proportions in America, public monies and contributions solicited from private sources were all cheerfully accepted. That a successful artist would be a donor to a commission given to himself or herself would not be improper.

Hatty and Wayman Crow bathed in the surf during that summer visit and sunned themselves on the rocks at Rockland, Massachusetts, where they talked to their hearts' content, days that she looked back upon longingly the following year. During the sparsely documented visit, however, a new side of Harriet Hosmer emerged, rising in response to the events that had been taking place in the United States as issues of women's rights began to come to the surface again after the end of the Civil War. This time women in greater numbers strove to define their situations and elevate the position of women through organizations and clubs aimed at intellectual and social development. One of the earliest of these groups was Sorosis, formed largely by women who were writers and journalists. Among them was a woman named Phebe Hanaford, a Universalist minister, whom Harriet Hosmer heard preach during that summer at Rockland. Her letter of approval and encouragement to a woman who dared to enter still another profession considered to be exclusively male was included in a book by Hanaford entitled *Women of the Century*. While Hatty acknowledged the struggles of women artists, she said with firm conviction,

> . . . but what a country mine is for women! Here every woman has a chance, if she is bold enough to avail herself of it; and I am proud of every woman who is bold enough. I honor every woman who has strength enough to stand up and be laughed at, if necessary. That is a bitter pill we must all swallow in the beginning, but I regard these pills as tonics quite essential.[34]

Thinking back to the time when her "brother artists" had started the rumor that she did not do her own work, Hatty felt that she must have "made some progress in my art; otherwise they would not have been so ready to attribute that work to one of their own sex." No one could accuse Phebe Hanaford of not preaching her own sermons, Hatty said, and in a few years, it would not be at all remarkable for women to be

preachers, sculptors, or whatever they wished to be. Writing to Wayman Crow from the Astor Hotel in New York, Hatty said that she had gone "to the *Revolution* office where I subscribed for a paper." There she was enthusiastically welcomed by Susan B. Anthony herself, who later recalled the occasion: "How well I remember you as you tripped into *The Revolution* Office in New York twenty years ago and subscribed for the Revolution to go to *Rome*—before I dreamed who you were."[35]

Harriet Hosmer's concern with feminine injustice began chiefly as a personal, rather than a social, concern. But as she realized the strength of her own example, always with some surprise, she achieved the stature of her public image. She was the prototype for a growing number of women who wished to enter untraditional professions, and she began to lend her name and support to the feminist issues that were relevant to her own experience. Hers was not a voice of the people; she led a privileged, even charmed, life. She was an elitist and remained politically conservative. But as a woman, the first to achieve international acclaim in American sculpture, she was the paradigm to whom feminists pointed.

Three years later, in 1871, the controversy that swirled around the young sculptor Vinnie Ream gave Hosmer the opportunity to express herself clearly on the subject of women artists and the continuing accusations that they did not do their own work or leaned more heavily on their studio assistants than was legitimate in the process of sculpture. Vinnie Ream had competed successfully for the statue of Abraham Lincoln commissioned by Congress, although she was beleaguered by bitter criticism. After the statue was unveiled in the Capitol rotunda, she was again beset by cruel critics, both male and female. In the top margin of a long letter from Malvern, England, Hatty wrote to Wayman Crow, "You were exercised to know why I had defended Vinnie Ream. Whenever I hear such things said about any woman, you may be sure I will always write immediately to something or somebody."[36]

Undoubtedly, Hatty was referring to her letter to the *New York Tribune,* reprinted in the *Daily Chronicle* under the heading "Vinnie Vindicated—A Card from Miss Harriet G. Hosmer." In it, she stated forthrightly that she could not remain silent "while such an attack is made upon any woman or her works." Writing from Rome, Hatty could identify most closely with the accusations that Vinnie Ream had "flitted about Rome receiving the attentions of cardinals and other dignitaries" while studio artisans were doing her work for her. There was nothing new or novel about such charges, Hosmer said. As a resident of Rome for many years, she also made it clear that cardinals were not inclined "to flit about with young ladies." She knew Vinnie Ream personally, she

said, and believed the young American to be conscientious and hard-working, "as much entitled to the credit of her work as any artist I know." If Miss Ream were to face her attackers squarely, forcing them to prove their charges or face legal consequences, the accusers would disappear quite quickly, as had those responsible for the published calumnies about Harriet Hosmer nearly a decade before. Who were these "vague and mysterious beings" who helped the female sculptors with their works? With irony, Hatty invited them to come forth so that the world could see "individuals of whom one has heard so much and seen so little." Until proof of their existence could be provided, she regarded "all such accusations as unjust, ungenerous, and contemptible."[37]

Others besides Wayman Crow may have been surprised to read Hatty's defense of Vinnie Ream. Critics of the young midwesterner seemed to emerge chiefly from the eastern establishment, an elite coterie in which Harriet Hosmer was at home. Moreover, the young Vinnie Ream's success in capturing the congressional plum could have aroused Hosmer's envy rather than approbation, although she did not compete for the commission. But her sense of fairness was outraged, and she had not forgotten her own recent past.

During Hatty's visit to America in 1868, the contest for the Springfield monument began. Thirty-seven designs were submitted from thirty-one artists. Leonard Volk, who had done the life mask of Lincoln and a cast of his left hand, offered two designs for the monument, as did five other sculptors.[38]

Hosmer's statement to the Springfield committee explained her "Temple of Fame" conception. Four statues of black men showed "the progressive stages of Liberation," as she described it. One slave appeared "exposed in chains for sale"; a second was depicted working on a plantation; a third guided and assisted Union troops; and a fourth served as a soldier in the Union army. These free-standing figures stood at the outer corners of the lower base of the monument.[39]

Around the central base were four bas-relief sculptures illustrating scenes from the life of Lincoln, from his birth and early occupations as "builder of log-cabins, rail splitter, flat-boatman and farmer" to his career as a lawyer in Illinois and his subsequent inauguration as president. A third panel showed the events of the war and a fourth was a glyptic rendering of the assassination scenes, the melancholy funeral procession, and the interment at Oak Ridge Cemetery.

Above these relief sculptures, Hosmer designed an octagonal plinth to form the base of the temple that had been a constant element in her designs. An inscription appeared on the base of the temple at the same

level as four mourning allegorical figures of the Victories, "stricken down at the moment of declaring their triumph":

Abraham Lincoln
Martyr President of the United States
Emancipator of four millions of men
Preserver of the American Union.

At a higher elevation another relief would show thirty-six maidens on a circular column, representing the states of the Union. Eight columns arose from the base to form the temple, and within it lay the recumbent figure of the president on a sarcophagus. Upon an architrave that surmounted the temple were the last words of the Emancipation Proclamation: "And upon this, sincerely believed to be an act of justice, I invoke the considerate judgment of mankind and the gracious favor of Almighty God."

Records of the procedure indicate that members of the committee who were judging the entries looked for mention of a vault. Whether those answering the call for designs were fully cognizant of this prime consideration is not known, but, wherever there was provision in the design for an actual underground tomb to protect Abraham Lincoln's mortal remains, a special stamp was put on the portfolio. While this was prior to any attempt to steal Lincoln's body, those responsible were looking ahead to a tomb that would be virtually inviolable. Few of the sculptors who submitted plans provided for an underground vault. Several, like Harriet Hosmer, planned a sarcophagus above the ground.

Five ballots were taken before a final decision was made by the fifteen voting members. Initially, more than one vote could be cast in order to register preference for several. Hosmer is said to have had three votes on the first ballot, only to be eliminated on the second. In the end, it was Larkin Mead who won the commission. He had submitted his design early. He took his prize money and returned to Italy, where he married a Venetian and never again worked in America.[40]

It was December before it was publicly announced that the commission had been given to Larkin Mead although Hatty must have known earlier that she had not been chosen. In spite of what could only have been keen disappointment, she wrote graciously to Crow, "I am sure if our monument has not been built, it has not been for the want of two good heads and hearts—and even at the last you have been good enough to go rescue it [the model] at Springfield."[41] She planned to write a letter of appreciation to James Yeatman also, feeling, no doubt, that he had done all that he could reasonably do in her behalf.

The hurt was not gone in a day. During a morning call at Henry

Bellows's Roman dwelling, she heard the eminent Dr. Samuel Osgood, clergyman and writer, call Mead's design "a vulgar thing," she told Crow ruefully. She could repeat Osgood's remark to him and to Yeatman, she said, "but it would look like spite if I said it to anybody else." As for Mead himself, she passed on Osgood's opinion of him as "a little squirt." In justice to Mead, she said, she was forced to add that "all those who have met him say he's very modest—peace to his ashes." She fired a last salvo, "I hope he can't furnish the required Security!!!"[42]

She had stopped in Florence on her way home from America, dropping in to see Hiram Powers at his studio as she always did when she had time. Mead would have "occasion to regret getting the commission," Powers thought, for "there will be some hitch sooner or later," as Hatty put it. Quoting Powers, who was known to be disenchanted with government commissions, Hatty wrote, "I have had my experience of public committees and the thorns are thicker than the roses." She could not suppress a wry but probably accurate comment. The committee could not count on raising another fifty thousand dollars easily, she said, "for we don't care or stand for art in our country collectively (individually perhaps we do) and now that the first enthusiasm has passed, it will take a good while to heat the iron again."[43]

The matter of the freedmen's monument was still open, but in the following year, William Greenleaf Eliot visited the Florentine studio of the American sculptor Thomas Ball. There he saw the model of Lincoln and the suppliant slave accepting his freedom, wrought by Ball just after the president's assassination. This was the sculpture group ultimately selected for the freedmen's monument, which was unveiled April 14, 1876, the eleventh anniversary of the assassination, in Lincoln Park, Washington, D.C. An inscription identifies the monument as the one erected by the Western Sanitary Commission of St. Louis with funds given solely by emancipated citizens. The former slave Charlotte Scott is named as the first contributor.[44]

Harriet Hosmer's scheme to manipulate the freedmen's fund, which, fortunately for her, came to nothing, was an egregious misjudgment in light of a professional life governed by high principles. While the competition to secure commissions was already highly politicized and the rules not clearly defined, her zeal to obtain the commission that she wanted very badly carried her to extremes. In the commentary for *Harriet Hosmer: Letters and Memories,* Cornelia Carr mentioned Hosmer's involvement in the Springfield monument commission only briefly. In what she considered her friend's best interests, she gave little indication of the strong determination to win or of the pain of losing. Why she did not reveal more of the story can best be understood

in terms of the biographical traditions of the time and the strength of her loyalty to Harriet Hosmer. However, Hatty's failure to win a contest into which she had invested so much of herself is an essential part of her life's narrative, shaping her attitudes and directions in the years ahead.

24
The Causes of a Quarrel

The winter season of 1869 was especially festive. Hatty reported herself "thoroughly dissipated for a fortnight" after a succession of dinner parties. She stayed with her "tipple" of Bordeaux and water, but she had given up coffee after dinner and felt better for it. Mr. and Mrs. George Childs of Philadelphia had entertained sumptuously at the Hotel Europa. Hatty, in turn, had invited them to dinner to meet the poet Henry Wadsworth Longfellow and his wife, the "Healeys" (presumably the painter G. P. A. Healy), and the Amorys of Boston. Those present "christened" the *salone* that she had taken such pride in furnishing.[1]

One of the last details to be added to the room was the chandelier that Hatty had bought in Paris. After being presumed lost, it had "turned up," she wrote Wayman Crow. Not only that but it had "remained up forty-eight hours in my *salone*" after being hung. In the handsomely decorated room, the fixture that she called "the sweetest thing in the way of a glim" lighted the faces of a distinguished company.[2]

In the midst of the pleasant life in Rome, word of the Springfield monument came intermittently to tease Hatty. Visiting at 38 Via Gregoriana, Hatty had a conversation with Charlotte Cushman. "'Have you seen the Post?'" Miss Cushman asked. "'No post,' says I," Hatty told Crow, "'but the bed post.'" According to Cushman, an article in the *New York Post* had "bowled over all the artists," as Hatty paraphrased it, with the information that the Springfield committee had paid Larkin Mead for his design but had decided instead to erect Hatty's. Hatty's reaction was cautious. "'A very pretty story,' say I, 'as far as it sounds' and then I thought to myself, 'and far too pretty to be true.'"[3] She had not seen it herself, but it was reported to be published in New York. There was, of course, no truth to the tale. What was evident, however, was a cautious parrying between Hatty and Charlotte Cushman, moving to the climax of a quarrel in the weeks ahead.

Meanwhile, Hatty was hard at work on a full-length statue of Maria Sophia, the former queen of the kingdom of Naples and the Two Sici-

lies. She and her husband, Francis II, who had inherited the throne from his father Ferdinand II, the contemptible "King Bomba" of the earlier insurrections, had taken refuge in Rome in 1861 after the fall of their capital, Gaeta. It was an opportunity for Pope Pius IX to return the favor, for he had sought asylum at the court of Ferdinand II when he fled from Rome in 1849 during the Roman revolution. The arrival of the royal family, guests of the pope in the Quirinal Palace, had elicited a counterdemonstration on behalf of the unification movement as nationalists seized the occasion to celebrate the fall of Gaeta, one more step in the progress of unity. The Corso shone with the brilliant red and green of the Italian flag while the cry of "Viva l'Italia!" resounded throughout the night.[4]

The royal couple took up residence in the Palazzo Farnese, and soon Roman inhabitants became accustomed to seeing them, often on horseback, as they rode about the streets and into the Campagna for the hunt. Maria Sophia was the daughter of Duke Maximilian Joseph, head of the ducal line of the Wittelsbach house, and his wife Ludovica. Cousins of the rulers of Bavaria, they lived in the Alps near Munich at Lake Starnberg in the Castle of Possenhofen. In the family of four girls and three boys, the daughters were tomboys, riding to hounds at an early age and surrounded by a bevy of dogs and horses. Following in the footsteps of her elder sister Elizabeth, who had married the young emperor of Austria when she was sixteen, Maria Sophia was also wed by proxy, at eighteen, to Crown Prince Francis of Naples, cementing an alliance with the house of Bourbon-Parma in the complicated web of European royal politics.

Hatty's enthusiasm for Maria Sophia, looked upon in elite circles in Rome as an unfortunate exile, is readily understood. In their love of equestrian sports, they had much in common. But beyond that, Maria Sophia represented a flesh-and-blood heroine, for she had stood beside her husband on the battlements at Gaeta during the final siege that brought down the kingdom. Wrapped in a voluminous cape, she became the symbol of resistance, urging on the defenders of Gaeta in their last battle to sustain the kingdom of Naples and the Two Sicilies against republican forces fighting for a united Italy.

It was coincidental that Maria Sophia came to Rome as an exile in 1861 when Harriet Hosmer was exhibiting her statue of *Zenobia,* the vanquished queen of antiquity. In spite of all that Hosmer could do to resuscitate her, *Zenobia* was far removed from contemporary struggles. But when Maria Sophia came to her studio, years later, dressed just as she was at Gaeta, in cape and spurs, here was an actual, modern-day heroine, beautiful and courageous, a tragic figure irretrievably stripped

of power. Small wonder that Hatty was enchanted with her subject. She told Wayman Crow that she thought he might have seen a photograph of Maria Sophia "with a cloak wrapped around her—called the Gaeta costume."[5]

There were all sorts of photographs of the queen. The Italian writer Silvio Negro tells of the proliferation of a series described as "filthy" in a scandalous ruse that may have been one of the first of its kind in the unfolding annals of photography. A disreputable couple who lived by their wits conceived of a scheme whereby they obtained pictures of Maria Sophia from one of Rome's most reputable family of photographers. Then they cleverly substituted the body of a hired model to produce the obscene versions. Even after this calumny was resolved with the arrest of the culprits, Maria Sophia was besieged with requests to use her picture. She did not know how to refuse, and she quickly lost control over the situation. She was portrayed as Venus or Eve, as sailor or Zouave, Amazon, "borghese" or "signora." She appeared on foot or on horseback, carrying gun, riding whip, fan, or crucifix. Most remarkable was her picture as the queen in *Venere del Tiziano,* surrounded by cardinals and other dignitaries of the church who paid homage to her as Venus. The pope could be seen giving a benediction to all.[6]

Harriet Hosmer worked on the life-size statue of Maria Sophia for two years, and it was seen and admired in her studio. An unidentified writer called it "a noble work of art." Since Maria Sophia had sat for the sculptor herself, it had the "value of perfect resemblance." One aspect of the queen's appearance was her luxuriant dark hair, so long that, had she wished, she could have draped herself "like Godiva." On the image, the hair was worn thickly braided to form "a natural crown more beautiful than goldsmith's skill could supply."[7]

Maria Sophia posed in the same costume that she had worn on the historic occasion of the downfall of Gaeta. A riding habit, which showed only at the neck and hem, was obscured by an enveloping cape. The folds of the garment suited the purposes of the sculptor "quite as well as any ancient drapery," the writer said. Even the "modern" boot that the subject wore, one with braids and lacings, appeared to be an ancient sandal. Although Hosmer called the costume "perfectly classic," she was credited with giving "grace and elegance to a modern dress." The writer noted a defiant expression on the model's face, one of slight disdain in the face of danger. Standing erect, her right hand lay on the folds of the cape where it extended across the breast and over the shoulder. The other hand pointed downward to indicate a cannonball at her feet.[8]

Since not even a photograph of the statue remains, there is room for speculation about the work. Is it possible that Hosmer created a con-

temporary work that was less ideal and more dynamic? While she frequently reaffirmed her belief in the perfection of the Greek style, she was known to infuse her works with her own spirit. Here was the perfect vehicle, a modern queen in a current crisis. Given the drama of the pose, including the "nervous foot" that the writer described, the body of the queen might have been tense and the drapery of the cape turbulent. Had the statue endured, it might have been seen as a move toward a fresher and more naturalistic style.

Some years before, a group of enthusiasts for fox hunting had organized a hunt. Hatty, one of the ringleaders, had contributed fifty pounds out of her own pocket to equip a professional huntsman to manage the meets. A cosmopolitan collection of Englishmen, Roman aristocrats, and Americans rode over the grassy plain of the Campagna, past the remnants of an ancient civilization, oblivious to the reactions of the natives, feeling themselves to be "monarchs of all we survey," as Hatty put it. The English, born and bred to the kingly sport, were strong riders mounted on horses that had no equal for endurance and speed. Their shabby, soiled scarlet coats were a badge of honor, worn with the proper indifference. Their fellow huntsmen, the Italians, were quite the opposite—poor riders but probably dressed impeccably for this new adventure. The Americans, cocky and daring in the exuberance of their young society, were ready for anything. Hatty, in proper hunting dress, topped by a silk hat, rode sidesaddle on her horse Gallant. Mocking the danger, she told Crow, "On Monday, we shall make our first appearance in the hunting field so any time from now on you may expect to hear of cracked bones and gelatinous flesh." Reporting a good run "of some six or eight miles," she added that "no less than fourteen individuals upset." There were, Hatty admitted, "rather a run of accidents, there being already two dislocated shoulders, one broken arm, a broken wrist, and a cracked leg besides bruises and sprains too numerous to mention—such a life."[9]

The quarrel with Charlotte Cushman seems to have rested squarely on "the brush," the tail of the fox—surely a cause so trivial that there must have been deeper reasons. Hatty herself called it a series of small things—"the world is made up of small things"—which had been fomenting for a long time.[10] For nearly five years, the hunt had been Roman society's exclusive event. During the winter season, Italian aristocrats and both English and American enthusiasts rode to hounds across the Campagna, taking their stirrup cups at the tomb of Cecilia Metella.

In spite of full participation and financial support from the Americans, none of them was ever awarded the brush. At last, tired of second-class treatment, Hatty made a stand. In total agreement was Consul Ned

Harriet Hosmer on her favorite hunter, June 4, 1867, photograph by Michele Mang & Co., Piazza di Spagna 9, pianterreno, Rome. Schlesinger Library, Radcliffe College.

Cushman, who stated his own displeasure forthrightly. Hatty wrote a letter that was published in America, explaining her resignation from the hunt. Her "authorship," she said, gave her the opportunity to support Ned and "to air my own grievances a bit—that the brush is invariably given to Italians who are much the worst riders in the field and Ned justly resisted the practice." Since Ned "represents the stars and stripes, of course all patriotic Americans were bound to stand by." In an article that quoted from Hosmer's letter, Americans who were intending to visit Rome were advised of this discrimination against their countrymen, should they be asked to subscribe to the hunt.[11]

With exquisite courtesy, the master of the Roman foxhounds, Prince (Sigismondo) Bandini, came to see Hatty to express his regrets "that any cause of discontent" had arisen. The prince "said everything that a gentleman could," and at the same time he urged her to return to the hunt. "When somebody boxes you in the ears and then says he is sorry," Hatty said to Cornelia, "what more can you ask?" Neither the apology nor the invitation to return included Ned however. When Hatty said flatly, "Well, if I go back, my friends must go back with me," the prince said that he hoped that "it will all come right in time," an evasion that was not lost on Hatty.[12]

Apparently, Ned was believed to have been the writer of some anonymous letters on the subject of the hunt. Certain that he would never stoop to such a device, Hatty "made a point of putting Ned on his guard regarding the same letters which was more than some of his other friends, who had known of their existence long before I had, had done." She had "battled with them all" in the consul's behalf, Hatty claimed, but she had yet to hear "one good word of Ned in connection with the hunting difficulty." In spite of her having said "nothing but what was just and honorable and generous," she was receiving "nothing but abuse at the Gregoriana." When she encountered Ned on the street, there was time and inclination for only a cool, polite bow.[13]

With her customary frankness, Hatty had told Charlotte Cushman the whole story of her interview with Prince Bandini. When Cushman, who could be a tiger in behalf of her own cubs, heard that Bandini wanted Hatty back but not Ned, she was furious, calling the incident "a contrived plot" and accusing Hatty of wanting "to be made a good deal of." Furthermore, she supposed that if anybody could ride like Hatty, "it was natural to like to show off in the hunting field." Hatty, referring sarcastically to Cushman's "friendly observations," told Cornelia, "You may be sure if it had been anybody but Miss Cushman who uttered them, I should have given vent to my feelings by boxing the offender's ears."[14]

"Where the shoe pinched," Hatty had told Crow somewhat less pugnaciously, "was that Bandini (the Master) should have come to me and invited me back and nobody else—that story isn't worth writing in all its ins and outs—suffice it to say I did what I thought was just and handsome in the matter as regards Ned." While Hatty recognized that Charlotte Cushman's resentment went deeper than the incident called for, that did not temper her own anger. "There was a dreadful sore point somewhere to which I said in surveying the situation, 'Go to Grass,' 'it will feel better when it is done aching' and other ejaculations in the same strain and that is all I care about it."[15]

Preparing to invite Charlotte Cushman to her party for the Longfellows, Hatty went to 38 Via Gregoriana, where she promptly became the object of "twits" and "unnecessary remarks" that completely suspended the purpose of her errand. She withheld the coveted invitation, telling Cornelia, "You may depend, I didn't invite her to meet Longfellow or anybody else." To Wayman Crow, she wrote: "You suspect rightly that 38 Gregoriana was not at the frolic [for Longfellow]—the best reason perhaps was they were not invited. 38 and I haven't been very thick lately, not since the makeup with the hunting society." They had not "split," she said, but they were not exactly "hand and glove." During the months that followed, Hatty claimed that she had continued to call but finally wearied of making all of the overtures. "They" could just as well seek her out, she decided, whereupon all communication ceased.[16]

It was during this time that Charlotte Cushman's worst fears were confirmed. She had breast cancer, a horrifying revelation to her and to those who loved her. In spite of what was considered to be a delicate matter, the word spread. Hatty knew it, she confessed, but she felt powerless to act. With genuine sorrow she wrote to Wayman Crow saying that it was "quite true that her fears are confirmed and I am so grieved to hear it." She was not supposed to know anything about it, she said, so she was telling it to Crow in confidence. "She is going to have an operation performed in London—and that very soon. We know how little there is to hope from that—it is quite dreadful."[17] When an aunt had died some years before, she had said that she had "no faith in cancer cures," adding in a letter to Cornelia, "It is my one horror in life."

Cornelia, always dutiful and kind, wrote to Hatty in her role as keeper of her friend's conscience. Her gentle but firm reproof was implicit in Hatty's response. "You say you know I 'make a point of doing what I can for the sick and suffering if it only be sympathy.'" She then poured out her heart to Cornelia.

> God knows how I grieve over this calamity. I think of it by day and I dream of it by night, but beyond its being a deep deep heartsore to me, I can do nothing. I am as powerless to offer even a word of sympathy as if I were an utter stranger—not because the sympathy and sorrow are wanting but because it is not for me to write the first word.

Hatty wished that she could sit down with Cornelia for a talk. Although she considered most of what had happened "too paltry to fill up a letter," she reviewed the whole affair leading up to the rupture. While she was putting it down in "a disjointed manner as to style," she felt that the facts were solid. She left it for Cornelia to determine whether she had been treated "in a fair or friendly manner.[18]

Hatty spoke of old obligations:

> There is just one person living from whom I would take as much as from Miss Cushman and that is the Pater. I owe very few as much as I do to Miss Cushman. I am always ready and willing to acknowledge my great indebtedness to her as more than one can testify and that gratitude is bound in her goodness to me during my earlier days in Rome.

Then she spoke of the changes that had taken place in their relationship:

> You and I have had all this over more than once and you know what I feel on that point before I write it. In those days her loyalty to me was staunch. She spoke of me the same to my face or behind my back. I knew exactly where to find her. Now I never know. She would very likely say it was my own fault and my reply would be "Quite as much yours as mine."[19]

Because she was not supposed to know the nature of Charlotte Cushman's illness, she excused herself from making any overtures. Bound by the rules and a measure of stubbornness, she could not muster the magnanimity to try to set things right. Still, she was deeply hurt when Charlotte Cushman and those around her left Rome: "They all made a point of going away without so much as a good bye or any word—written or spoken. I took that, as I presume it was intended I should, as a cut direct, and rule myself and shall continue to rule myself accordingly." Hatty was sorry, she said, that she could remember "anything but what has been nice and pleasant" at the time of "this great sorrow." It was surely "not the moment to gather up old grievances—let them lie down and be forgotten." She only wished that she could lighten the sadness, "but I wait to be sent for. I stand where I have been placed and that is outside—if they ever want me inside, they must come and fetch me."[20]

Although Charlotte Cushman had stopped speaking to Hatty, she shared the story of her ordeal with Cornelia in letters of unusual candor about physical matters. Thanking Cornelia for her "sweet, kind, womanly interest" in her and her troubles, Cushman said that she had been warned that it was "more than likely that the trouble in my breast" had been aggravated by the act of writing as her flesh rubbed against "the bones of my corsets." Even so, she was loathe to give up correspondence with those who had expressed such warm concern for her.[21]

In addition to the surgical procedures that she endured, there were attendant disorders of the blood diagnosed as "erysipelas," which was like a "collar around my chest and shoulder and lifted the skin almost half an inch thick." Then abscesses developed which had to be operated upon, and after that she had an attack of pneumonia accompanied by a

"racking cough" and irritation in the lungs that kept her bedridden for forty-one days. When she was lifted out of bed, she was so weak that she had no control of her legs. "Legs, did I say—there are none—all has dwindled to shanks—sticks—shin bones upon which, as I told your father, you could sharpen a knife." She was still crawling about wearing a dressing gown, her long hair in braids. The wound was not yet closed.[22]

Charlotte Cushman had been nearer "the Gates" than anyone except her doctors knew, she told Cornelia. During a period of reflection, one of her "larger regrets," she said, was that she had "suffered my sensitiveness at Hattie's *neglect* of me (as in my health and strength I had allowed myself to consider it) to initiate me to any expression with regard to her—expressions which always somehow get repeated with or without intention to do mischief." She had written Hatty a penciled note, she said, happy that she had done so before the receipt of Cornelia's recent letter.[23]

Hatty acknowledged to Wayman Crow that she had received "a sweet little note" from Charlotte Cushman. Although Hatty commented with genuine gratification, and probably relief, on Cushman's "resurrection," the reconciliation was not complete. At least on Hatty's part, the relationship no longer rested on mutual love and trust. For her, it was an uneasy truce. In spite of the appearance of Charlotte Cushman's recovery, the "evil was not eradicated," as Emma Stebbins later wrote in her account of her friend's life. Eventually, they, along with Sallie Mercer, returned to America, where Cushman moved restlessly from the "Villa Cushman" at Newport to another house at Hyde Park and still a third at Lenox. She continued to give readings to enthusiastic audiences.

Later, acknowledging that the actress was again "poorly," Hatty said that it was only "heroism" that had kept her alive so long. Referring to a "farewell speech" that the actress had made in her native Boston, Hatty said carefully that it was fine, "but I can't help thinking, without saying anything derogatory to her dignity, but she ought not to have appeared anywhere after her farewell in New York. When a Roman general obtained a triumph in Rome, he never descended to Monte Cavo." Hatty and Cornelia continued to correspond with confidentiality about Charlotte Cushman, whose relationship to the Crow family through the marriage of ·Emma and Ned called for circumspection. On one occasion, Hatty told Cornelia that she had destroyed all portions of Cornelia's recent letter that related to Cushman. Hatty had not regained any confidence in Cushman's sincerity. With irony, she wrote, "If Mr. Booth wanted anybody to support Miss Cushman, he better write over and get me, for a better piece of acting there never was!"[24]

In 1874, an expatriate named Stephen Weston Healy stirred up a new controversy about the authenticity of artworks coming from Italy, accusing many of the neoclassicists of what amounted to fraud. Reverting back to the brouhaha of the previous decade, Healy reported that Hatty and Charlotte Cushman had confronted the American sculptor William Rinehart at that time to ask him if he had said "upon a certain occasion that Miss Hosmer employed men to model for her." Rinehart had reportedly replied, "I didn't say so, but I haven't the least doubt that it is true." Hatty urged Cornelia, then living in Cambridge, to "try to get out of" Cushman what she recalled of an interview between "herself, myself, Nucci [the studio artisan who was said to be doing Hosmer's modeling], and Rinehart, in Rinehart's studio." Hatty gave Cornelia a correction of Healy's version, saying that Rinehart, confronted by the sculptor herself and the honorable Nucci, who found the unwanted attention onerous, had actually said, "Until now I have always believed it to be true."[25]

What Hatty was asking of Cornelia was indeed difficult. Cornelia apparently did approach Charlotte Cushman, who made a response of sorts. "I am immensely amused at Miss Cushman," Hatty wrote in answer to Cornelia's report, "though sorry you have had anything disagreeable to contend with. Rely upon my making no use of anything connected with her." She wanted it only for her "own satisfaction." "My only surprise is that she said so much in my favor *if she did*."[26]

When Charlotte Cushman died in 1876, Hatty put aside all unworthy thoughts to speak nothing but good of the dead. Perhaps she was recalling only the early days in Rome when she wrote: "I had a letter from Ellen telling me of dear Ma's death—dear sweet soul she was. It is a real sorrow to feel that I shall never see her again. She was always one of my staunchest truest friends, and her love for me and mine for her dates back to my earliest recollections." Concluding that there were "few like her" and that "her sweet presence will be missed," Hatty came to the end of that chapter in her life.[27]

When Emma Stebbins's biography of Charlotte Cushman appeared in 1879, Hosmer was mentioned only once and then merely as one of the group who came to Rome together in 1852. For all her close association with Charlotte Cushman and her presence in the household at 38 Via Gregoriana for more than six years, there is only this glaring omission. Nor did Emma Stebbins personify Emma Crow Cushman with any other identity than that of Edwin Cushman's wife and the mother of the children whom Charlotte Cushman adored. Both Hosmer and certainly Emma Cushman must have been threats to the exclusive devotion that

Emma Stebbins desired of her idol. By ignoring them, she was vindicated.

Defying all of the old notions about *mal'aria,* Hatty remained in Rome during the summer of 1869. She liked the absence of "forestieri," as she always called visitors from abroad. America was "poorly represented" at the moment, "the Yankees being reduced to about half a dozen in number, Florry Freeman being one of them." A new friend was her neighbor, the wife of sculptor Franklin Simmons, who had settled in Rome that year. In very poor health and spirits, Mrs. Simmons came to Hatty for comfort. Believing herself to be "a bit of a doctor," Hatty prescribed some medicines that "answered the purpose," with Mrs. Simmons looking "more like a human being and less like a snowball.[28]

Thomas Ball's equestrian statue of *Washington* had recently been unveiled in Boston's public gardens. The event was "on a small scale as compared with the inauguration of Benton," Hatty remarked, but then "it was Boston—that made the difference." She would have liked to have seen the finished work, for she had only "inspected a small bit of the plaster cast once on a time in Ball's studio." Ball was clever, she thought, and "likewise a gentleman which cannot be said of all our brother sculptors and I wish him success in everything."[29]

In America, Hatty's business representatives, Hovey and Hoffman, were putting some of her works into terra-cotta. Apparently, *Zenobia* was returning to clay to attract buyers, and *Puck* would presently be available. While she objected strenuously to the exploitation of her marble works as reproductions, she found no fault with the small replicas in terra-cotta, "*if they are not too good,*" she told Crow emphatically. She recalled that it was a year ago when she was preparing to sail from Paris "for the Rockland House," where they had met for a reunion. A good letter from Wayman Crow was a treat, but given a choice between the written word and "a gossip on those rocks which we frequented last year," she would take the rocks "and the viva voce." What she would not give for a dip in the ocean, but those luxuries could not be enjoyed every year. "The only way is to make as much of them as we can while we enjoy their possession and to live as long on their memory as we can when they are passed."[30]

For all her resolve to remain in the city in the summer and leave it to the visitors in the winter season, Hatty may have felt a certain envy when she received what she called "Browning's last unpublished poem," which was actually the joint effort of a group of her friends who were Lady Ashburton's guests at a prolonged house party at Loch Luichart,

the Mackenzie ancestral home in Scotland. Many stanzas of unremarkable doggerel concluded with a postscript:

> Do wash your hands, or leave the dirt on,
> But leave the tool as Gammer Gurton
> Her needle lost,—Lady Ashburton
> Thus ends this letter—ease my sick heart,
> And come to my divine Loch Luichart!

If the poetry was undistinguished, the cast of characters was not:

> W. W. Story, his mark X
> Emelyn Story
> Edith Marion Story
> M. Alford

And then "Signatures of In order of infraposition":

> I am, Roderick Murchison
> Sarianna Browning
> Robert Browning
> L. Ashburton[31]

To her "eight beloved friends" Hatty wrote a response in similar vein, regretting that she could not be with them. The last stanza read:

> I may not be—may not—alas
> Is the refrain I sing,
> Yet comforts me this fling at thee,
> This little Highland fling.[32]

Robert Browning had grown a little peevish with the passage of time. Whether deliberately or not, Hatty had ceased to inform him of her presence in London when she came. Or at least Browning thought so. He would have liked to see Hatty and Charlotte Cushman, he wrote to Isabella Blagden, but they did not "signify their presence" to him. With a tone of ennui, he added, "It don't much matter." Since Elizabeth's death, Robert had become highly successful. Not only were his works well received, but he was also devastatingly attractive to women. Many felt that he had become spoiled with all of the adulation. But his attitude toward Harriet Hosmer, the companion of happier days, was changing when he wrote to Isabella Blagden in 1867. Hatty was no longer "the old dearest little creature" of the Roman days but "just the old Hatty—less interesting which is the way with all such pretty things after a time; the 'not niceness' of her conduct is the old story."[33]

Hatty's behavior, Browning thought, was an "unfailing characteristic of talent," as distinct from genius. Hatty would invariably adopt some-

one as "'dearest friend'" only to drop him or her "at a minute's notice or without it, for some defect or fault." These caprices were the limitations of talent, to cleverly use people who could help her and then cleverly shake them off when she found that such were not "the *best* and truest." Having got this off his mind, Browning continued to Isa Blagden, "Just so I feel for Hatty's little self—not mistaking her, but liking her considerably in her way." Browning had turned down an invitation from Lady Ashburton, in 1868, to join Hatty and Lady Marian Alford, who were her guests at Loch Luichart. He was not inclined toward sociability— possibly, as William Whitla suggests, because he was immersed in correcting the proofs for *The Ring and the Book*.[34] But in the summer of 1869, he decided to join his sister Sarianna and William and Emelyn Story and their daughter Edith in accepting Lady Ashburton's invitation to come to her house at the Scottish lake. (Pen Browning had just failed again at Oxford, a matter of keen disappointment to Robert.)

When her guests arrived, Lady Ashburton was nowhere to be found, so they had to put up at a miserable little inn until their hostess appeared. Her reputation for unreliability and peculiar hospitality was described by Lady Paget: "At her home she varied between untold kindness and unmitigated tyranny. When she asked friends to her country house she had either no room for them or she made hay of their rooms, whilst they were staying there." Waiting to be received, the group at the inn picnicked as in the old Roman days in the Campagna, with Browning reading from his *Rob Roy* with gusto. His ebullience had only increased with the years, and he wore it less becomingly. Mary Gladstone, who saw him at another house party a few years afterward, complained that "he talked so loud and breathed into one's face and grasped one's arm," conduct that provoked her, though she had once admired him. She had to agree with some Americans who remarked that Browning had "dinnered himself away."[35]

Browning was apparently at his most charming at the Loch Luichart gathering, and Louisa Ashburton had a decided weakness for poets and artists. There were many who thought that he proposed to her, a version that she undoubtedly advanced and continued to nurture. In 1872, at the house party where Mary Gladstone was provoked by Browning's behavior, she noted: "We all supposed he was proposing to Lady Ashburton (she was there too), at least she let it be thought so."[36] It is more plausible in light of unfolding events to conclude that Lady Ashburton may have been the proposer—or at least that she may have made it clear that she was open to courtship. Browning persistently denied any intention to remarry; nor, in his private correspondence with Isabella Blagden, did he suggest that he had any such venture on his mind.

After the Loch Luichart meeting, Lady Ashburton continued to issue invitations to Browning, "cajoleries and pathetic appeals, for two years together," he later called them. She asserted that it was he who was trying to renew "a relation of even ordinary acquaintance." At last she succeeded in getting Browning to pay her a visit again, an occasion she used to insult him openly, so Browning wrote to Edith Story. She then tried to make amends by sending a servant with still another invitation. Furious and vindictive, her pride wounded at being spurned, as she saw her situation, she wrote to Browning, or "bespattered" him, as he described it.

> . . . yet the worst she charged me with was,—having said that my heart was buried in Florence, and the attractiveness of a marriage with her lay in its advantage to Pen—two simple facts,—as I told her,—which I had never left her in ignorance about, for a moment, though that I ever paraded this in a gross form to anybody is simply false.[37]

It was inevitable that Hatty would participate in all this, although she probably had no knowledge of what had gone on between Louisa and Robert Browning, except from Louisa's highly charged version. Although Hatty had not been present at Loch Luichart, she apparently took up Louisa's cause, castigating Browning in letters about his ungentlemanly conduct at Loch Luichart and in the events that followed. Hatty was influenced not only by what Louisa had said or insinuated but also by the gossip of others in their circle, including Adelaide Sartoris.

Armed with a letter from Browning to Louisa, left in her keeping together with a letter from Louisa herself, Hatty went to the Storys. Louisa had said that she preferred that Hatty not take this step, because it seemed "so like revenge." "Having set that alright," said Hatty, "it shifted the act upon my own shoulders." She put Browning's letter into William Story's hands and asked him to read the letter aloud, which Story did. Both he and his wife "admitted that they could not have supposed Mr. B. capable of writing it." Emelyn Story said indignantly and with strong emphasis, "Well, I never." Story, too, thought it "a most improper letter to have written." He requested a copy of the letter, and Hatty replied that she must ask Louisa. Assured by the Storys that she had done the right thing in showing the letter, she said, "if it does not serve to open their eyes a little now, I am mistaken." Recalling Elizabeth, still the very image of perfection, Hatty told Louisa: "Oh he is a miserable nature—I mean B. *She* was the one who made him spread his wings and soar above himself. When she left him he began to sink and sink and now he is *very* near the earth."[38]

Instead of the indignation that she exhibited at Browning's supposed bad treatment of Louisa, Hatty was probably jealous, but jealous of

whom and what poses a dilemma. She feared, perhaps, that if she didn't dispose of Browning, she might lose her hold over Louisa. Another side of her may well have remembered the intimacy she had enjoyed with Browning in the happy days before Elizabeth's death. He was the comrade with whom she shared fun and adventure. There was no place for her in this realignment, and she resented it. She meddled in the most self-righteous way, a sorry attempt to wield influence in what was none of her affair.

Browning was angry and bitter that Hatty would drop him as a friend, with only the gossip of others as evidence. He asked, "What business" had Hatty "with my behaviour to Ly A. in Ly A's house?" Browning scoffed at Hatty's devotion to Louisa, "begetting this chivalrous ardour in her,— Lady A. has got plenty of friends quite as intimate, who never fancied for a moment that they were called on to fight her battles."

> So, now, I have done with Hatty, for once and always. Had I believed stories about *her,* many a long year ago, and ordered her away from people's houses on the strength of them, I should have lost a friendship I used to value highly: but I have gained some pleasant memories by being less ready than she to believe slanderous gossip,—and,—as she has elected to know me only through the reports of others, though I would have shown what they were worth in a minute, had she given me the opportunity,—so shall our relation be, and no otherwise, to the end of time.[39]

Nor was the conflict resolved, although Browning said that he was not going to mention it again. He kept Louisa's vituperative letters, even sending copies of them to the Storys to vindicate himself. In 1875 Lady Ashburton attempted to mend the bad feelings, not only with Robert but with the Storys, writing first to William Story, who told his absent wife Emelyn that he had just received "a fathom-deep burial of the hatchet" and that he would respond with a personal call on Louisa Ashburton. Only a hint of the ongoing imbroglio is apparent, albeit inconclusively, in a letter to Cornelia. "Do write me," she instructed Cornelia, "and make a note of this, how you found out that Lady Ashburton caused any part of it."[40]

The differences between Hatty and Robert Browning were never resolved, although she moved to repair the relationship in 1887 with a note to introduce her friend John Shortall of Chicago, an overture that failed utterly.

> Churchside
> Denmark Hill
> March 31, [1887]
>
> *My dear Friend,*
> Here comes a very affectionate ghost from the Past. This ghost, however, has very often been with you in spirit though absent in shadow, and it was

glad you had not forgotten her,—as Lady Marian assured her not long since, your enquiries proved. Now she is coming in the flesh to explain its long seclusion. In the meantime, pray smile kindly upon my friend Mr. Shortall who presents you this, and believe that I am as always

Affectionately yours
Hatty Hosmer

Browning enclosed Hatty's note in a letter to the Storys, justifying his disclosure by saying that it was "due to you"—"to show how far impudence can go." John Shortall had been received cordially by Browning, who called him "a pleasant kindly person" who had "no need of anybody's intervention on his behalf."[41]

There is no mention of the break with Robert Browning in Hatty's public utterances. When she wrote of Browning in later years, she spoke cautiously, suggesting that, while his photograph revealed a face "of great intellectual power," he also appeared to be "the comfortable man of the world, tinged, perhaps, with a certain sense of success." Sometime after the death of Robert Browning, the writer Lilian Whiting recalled seeing Hatty at the home of a friend in Chicago (possibly John Shortall). Hatty's lap was filled with letters from the Brownings, which she was about to share with those present. Suddenly, she was overwhelmed with emotion. Weeping uncontrollably, she "gathered them [the letters] up in the folds of her dress" and went upstairs.[42]

A page in Harriet Hosmer's handwriting appears among her letters and papers:

> Elizabeth Barrett Browning
> buried in Florence June 1861.
> Robert Browning
> buried in Westminster Abbey December 1889.

> "Parted by death," we say—they, in that land
> Where suns spring, blossom and decay,
> Crowned with the halo of a new content,
> Our little planet in the firmament
> All lost to view, smile at our words,
> And hand in hand wend their eternal way.
> Harriet Hosmer

25
Farewell to Pio Nono

The year 1870 was a watershed. While Queen Victoria still reigned supreme over the British Empire, significant events were taking place on the Continent that would greatly alter the balance of power in Europe as well as in the world. From the defeat of Napoleon III and the Prussian triumph in the Franco-Prussian War, the German Empire would emerge as a world power. More directly related to the Roman life of Harriet Hosmer was the unification of Italy, completed with the accession of Rome, a turn of events that would bring about many changes in the city where Hatty had lived so many years and, eventually, upon her life and her work.

By 1870, a few American artists were studying in Paris at the École des Beaux-Arts, absorbing what was to become an important influence in American sculpture. More would soon find their way to Paris, ending Rome's supremacy as the place to study art. In America, a strong native style in sculpture was evolving among those who had stayed at home or studied only briefly abroad. The drama of the Civil War had sharpened the national consciousness, turning styles and tastes from the ideal to the real. Artist and art historian Lorado Taft wrote of the change as an awakening from dreams, "aroused . . . by the drama in which they lived. Classic themes gradually receded into pale obscurity." Even in Italy the expatriate sculptors put aside their characters from ancient history and mythology. No longer were they content to "do Greek," as they called it; they turned instead to workaday themes, romanticizing the mundane and the ordinary. The last American sculptors to represent the neoclassical school, Taft writes, were Harriet Hosmer and William Rinehart.[1]

Harriet Hosmer remained with the Greek ideal until the end, deploring what she called the "bronze photographs" of famous men that peopled every park. She would continue to rail against the modern costume, "so utterly ungracious and ungrateful." After all schools of sculpture had "completed their little cycles," she said, "lovers of all that

is beautiful and true in nature" would seek inspiration "from the profounder and serener depths of classic art."[2]

Why was her position, however valid, so immutable? Surely the primary reason was her thorough grounding in neoclassicism under the guidance of John Gibson, an opportunity she recognized from the beginning as the greatest stroke of good luck, a chance to be seized and cherished. Like a disciple schooled in the tenets of the true religion, she never wavered. A less exalted explanation may have been her disinclination to quarrel with success. She had risen from obscurity to international acclaim. She hobnobbed with royalty, and English aristocrats were her patrons. In the 1870s, the Prince of Wales purchased her *Sleeping Faun* to add to his private collection, in which Hosmer's *Puck* had resided since 1859.[3]

Lady Ashburton continued to be Hatty's patron and best client during most of the seventies. Not only did she commission works, but she apparently set Hatty up in a London studio. Of the works actually delivered to Lady Ashburton, few remain. Some, like *Puck,* were well known in America, but the two *Putti upon Dolphins,* inspired by the figures in the *Siren* fountain, remained in England in the collection of the successive marquesses of Northampton. The generosity and patronage of Lady Marian Alford was carried on by her son Lord Brownlow, who commissioned a design for gates decorated with sculptured panels for a reported sum of twenty-five thousand dollars. Doors that Hosmer had designed for the National Academy of Design in New York never materialized, and the Venetian palace built in 1866 to house the academy had no sign of Hosmer's work. But the desire to fashion palatial portals remained with her. She used the classical themes of earth, air, and water in her conception for the seventeen-foot-high "Golden Gates," which were to be cast in bronze and gilded to look like gold. With the growing influence of the beaux arts movement in architecture, the embellishment of bas-relief motifs and freestanding sculpture was growing. For Harriet Hosmer, carved fountains, fireplaces, and splendid gates were a natural expression for her style and taste and readily marketable to her aristocratic clientele. The opulence of an age that came to be known as "gilded" provided a new opportunity for sculpture in the decorative arts.[4]

Later, when Hosmer, still America's foremost woman sculptor, was asked to exhibit at the Philadelphia centennial, she told Crow excitedly that she planned to send a plaster model of the gates that she had done for Lord Brownlow, "gilded to look like the original." She predicted to Wayman Crow that the glittering gates would indeed "make a show." But, in 1876, when she prepared to ship the golden gates on which she

had worked the entire winter, the central portion was too tall to fit into the hold of the ship. With the deadline at hand, there was little she could do. She sent only a small plaster figure, probably one of the relief sculptures from the gates, complete with extra gold paint to repair the piece if it should arrive damaged.[5]

In August, 1878, Hatty arrived in London from Rome with her plaster model of the *Pompeiian Sentinel,* one of the few of her original works after 1870 to attract notice. The piece was almost certainly inspired by Edward Bulwer-Lytton's enduringly popular book *The Last Days of Pompeii,* just as the character of the blind girl Nydia had offered to her colleague Randolph Rogers a literary theme that was rendered over a hundred times for eager buyers. Perhaps this is what Hosmer hoped for.

The *Pompeiian Sentinel* was exhibited in Colnaghi's Gallery in the Haymarket, where the owner himself took down a part of the entrance to the gallery in order to accommodate the arrival of the colossal figure of the soldier who died at his post. But the exhibition was at the height of summer, when the beau monde, who might have had a serious interest in the work, had deserted London for the country. Hatty, undaunted and pleased with herself and the model, called the right leg of the *Sentinel* the best thing she had ever done. Although the work was hailed as another of those contemporary pieces so authentically antique that it might have been found by archeologists in a dig, such themes appear to have been clearly moribund. Hatty took the model back to Rome, but the union of marble and the male figure was never consummated.[6]

In modeling the piece, she had used a new method. After modeling roughly in plaster of Paris, she then coated the maquette with wax. The most intricate touches of her modeling knife, Hatty said, made their marks upon the pliant wax, which retained shape and form more exactly than the temperamental clay. Related to her experiments with wax were efforts to convert limestone into a product very like marble. Previous attempts at this metamorphosis, realized by Italian inventors, had produced scagliola, a simulated marble used in friezes and cornices. Now Hatty told Wayman Crow that she had developed a material under compression that could scarcely be told from marble, so strong and hard was the new product. An added bonus was its potential for taking on permanent colors, applied while the stone was still in the vat.[7]

During the latter half of the seventies, pondering the popular fascination with perpetual motion, Hatty developed a machine that was powered by magnets to prove the principle. As she had done with the synthetic marble process, she had this invention patented in England

and America. Reports of her plan for manufacture were glowingly reported in the press, both in England and America. That women could be inventors was another proof that females could be creative, not merely imitators of men.[8]

None of Hatty's inventions or processes ever came to full fruition. She worked with patent lawyers, and for a brief time her reports were enthusiastic, only to turn sour as those in whom she put her trust failed to live up to her expectations. Whether the lawyers did not fully believe in the potential of her products or whether she was served by incompetent men is not clear. Her own propensity for total involvement, followed by ennui and disenchantment, may have contributed to the outcome. The sheer difficulty of manufacturing and marketing a product, and the accompanying red tape, may also have been a realistic deterrent.

In spite of her disappointment about the loss of the Lincoln commission, Hatty continued to enter competitions from time to time. Shortly after the resolution of the Springfield contest, she spoke of submitting a design for a military monument at Rockford, Illinois. Sending a drawing or model took "24 hours and 30 dollars," she said, which she considered to be a modest expenditure in time and money even if it came to nothing.[9]

A later opportunity to enter a contest came with the call for designs to honor the late Charles Sumner. Hatty wrote to Cornelia, on whom she was relying increasingly to act for her, that a design was on the way. If the model, done in "imitation bronze" was broken in any way, Cornelia should have it mended by the *formatore* Garibaldi in Boston. Some green paint should be applied before the plaster dried, and a little gold dust, which Cornelia would find tucked away in a paper inside the case, should be blown on.[10]

Although she boasted—"And as mine is the best, of course it will be selected!!!!!!!"—she showed no deep disappointment when she heard the results. "I see that Anne Whitney and Ball and Milmore have won the three prizes for the Sumner statue," she said. She had heard the rumor that the committee had changed their collective minds, from a seated Sumner to a standing one, although she did not think they could be "so mean." It was said that none of the three finalists would be chosen. The three that she named—Anne Whitney, Thomas Ball, and Martin Milmore—had, in fact, been named as the best of twenty-six applicants. When it was discovered that the sculptor Whitney was a woman, there was surprise and dismay. All of the finalists were awarded prizes of five hundred dollars, but Thomas Ball was given the commission and the stipend of twelve thousand dollars. Hatty told Cornelia that she was not certain that what she had heard of the whole affair was not

"all talk," but she instructed Cornelia to take her model "and crack it because it isn't worth packing."[11]

Another of Hosmer's original works was the *African Sibyl,* which had its genesis in the sixties, with emancipation as its theme. The work depicted a black female figure with a small Negro boy at her feet. The prophetess was said to be foretelling the freedom of her race. While other works, like her concept for the freedmen's monument and the Springfield tomb monument, had taken precedence over the *African Sibyl,* Hatty told Crow early in the seventies that she had turned down an offer of two thousand pounds for "my Sibyl with pedestal." She had hoped to exhibit it in her gallery in London, used primarily for exhibition, and then send it to America. It was another work using what she called "a new process of sculpture," a wax method that she had described to Crow when she last visited America in 1868. More than a decade later, she elaborated on the group to submit it to the Crerar competition for a Lincoln monument in Chicago. Hosmer carried on a lengthy correspondence with the donor John Crerar, but eventually the commission went to Augustus Saint-Gaudens.[12]

Writing to Crow early in 1870, Hatty was pleased that William and Sydney Everett and their sister Charlotte Wise, children of Edward Everett, had talked to her about a monument to be erected in Mount Auburn Cemetery to honor their father, who had died in 1865. "A handsome order," she called the commission, which was to be executed in bronze and the red freestone that she especially liked. She was surprised and flattered, since the Everett family had always favored Hiram Powers. Nonetheless she was cautious, aware that there could be "slips about monuments."[13]

During a trip to Munich, she talked to Herr von Miller about the casting of such a piece, and in 1873, she instructed Cornelia, "Tell Mr. Everett [one of the sons] no time is being lost on the statue for the monument." She wished that Everett and his sister would put aside their impatience and simply send her a drawing of the lot at Mount Auburn, along with its dimensions. Later, when she heard that everything in Boston was "frozen up," she told Crow that she wanted to get "the underpinning down for the Everett statue, but I hear stone is soft compared to our native soil at this juncture." What happened to the Everett monument commission is not known.[14]

During this same interim, Josiah Letchworth of Buffalo commissioned a recumbent sarcophagus figure and pedestal, similar in design to a much-admired tomb effigy of Queen Louise done by Christian Rauch at Charlottenburg Palace in Berlin. Letchworth had erected an elaborate mausoleum at Forest Lawn Cemetery in Buffalo, New York, to

hold the piece, intended as a memorial to his wife.[15] Like the Everett piece, this, too, seems to have been aborted at some stage. There were indeed "slips about monuments," an unfortunate turn of events, since these works completed would have given continuity to Harriet Hosmer's career in America.

As the decisive year 1870 began, Hatty had no notion of the changes taking shape for her life and for history itself, as she acknowledged Cornelia's Christmas gifts with cheerful exuberance. "When I saw those red stockings, I said to myself, 'Well, of all my lovers, my dearest little Sis is the most faithful, the most utterly unforgetting.'" There had been neither time nor place "to replenish my wardrobe in the stocking line, and I was dreadfully out at heel." Some time before, Cornelia had had a baby daughter, christened Isabel after her grandmother and aunt. Hatty had teased Cornelia about her brood, calling her "Cornelia, Mother of the Gracchi and everybody else." She was amused by Cornelia's description of her offspring as "ballast to keep you stationary." She herself was, she said, "a musty old Aunty in a moldy old catacomb (no reflection on my salone which is lovely.)"[16]

For all her poking fun at herself, Hatty was confident and content. Business was brisk, and she was quick to buy marble when the opportunity appeared, still leaning on Wayman Crow for financial lifts. Her York stocks were doing well, as she wrote to Crow early in 1870. "God bless York," she said. "May she (or he for I haven't learned the gender of factories) go on prospering to the crack of doom, for it is a crack article." She continued to joke about her unmarried state. In a society where the single woman—no matter what else she had accomplished— was not considered to have fulfilled her ultimate destiny, it was better to joke than not. One time, she announced at a party that she was engaged to the old pope but was waiting for him to make the proper disclosure. She wrote Cornelia, "By the way, Edie Story is going to be married [to an Italian aristocrat]; I ain't. They are not here [in Rome]. I am." And a year later, when Cornelia wrote of her youngest sister Isabel's engagement, Hatty responded with mock indignation, "I can only say that if you think I should be content with being a bridesmaid at my time of life, you can't think how much mistaken you are, even to one of my sisters. It's a Bride I want to be."[17] Again, Hosmer's humor gets in the way of serious analysis. Although she may have felt a twinge at time's passing as those she had known in their infancy began to marry, it is safe to say that her own single state was no longer a source of regret.

Returning to Rome, Hatty told Cornelia, was the popular Mary Lloyd, who would be occupying an apartment near the one that Cornelia had rented during her Roman sojourn. It was close enough for

Hatty "to chuck beans at her of a morning." Other friends were staying at the Hotel Costanzi, where Hatty reported herself a constant visitor. Fanny Kemble, always clever and witty, was there, too, firing up all of Hatty's old "Lenox enthusiasm." Wearing her old gowns, which she rotated artfully, Kemble was even more outspoken than in her youth. When Anne Thackeray Ritchie asked where she might drive Mrs. Kemble, the actress answered, "*Andate al diavolo* [go to the devil]—go where you will—only go to the Campagna."[18]

At work on the statue of Maria Sophia, Hatty had come to know the exiled queen quite intimately. She was not above teasing Louisa about her royal friend with the beautiful eyes. As minion answering the royal bidding, she once wrote James Yeatman, champion of freed black people, to ask if he could locate a young girl to work as a maid for Maria Sophia. She told Crow that Yeatman had "fished me out a little darkey from the depths of the Black Sea and sent me a very pretty photo of her which I have forwarded to the Queen and now we will see if she is pretty enough."[19]

After the birth of a daughter in 1868, whom Hatty called "a dear little thing" albeit "the wrong sex," Maria Sophia was more handsome than ever. Present in Rome for her accouchement was her sister Elizabeth, the empress of Austria. "Fascinating," Hatty described her to Louisa, and accompanied by three of the most "superb creatures," her staghounds. She rode in the hunt, and some in Rome prostrated themselves before her. Hatty modeled the imperial dogs, and the empress invited her to see her fine horses and lovely art objects, but the two never met again. Maria Sophia and her husband Francis II left Rome before the Italian forces entered the city, never returning to claim the statue in Hatty's studio. However, Hatty's friendship with them continued. She escorted them to the great houses of her friends in England and visited in Bavaria at their estate at Garatshausen on several occasions, playing chess with Francis and riding with Maria—one time wearing her hostess's riding clothes when she had forgotten her own.[20]

In spite of an atmosphere of superficial calm in Rome, it was becoming increasingly apparent that the pope's secular powers would soon be suspended. With an instinct for consolidating his assets, Pius IX called for a Vatican Council, embracing all arms of the far-flung Roman Catholic Church. In the last month of 1869, Hatty had written that Rome was "black" with "priests and prelates," as representatives arrived from all over the world. The purpose and agenda of the conference were not clear, Hatty said, "even to the Pope himself."[21]

What emerged from this council, known as Vatican I, was the dogma of papal infallibility. The pope, speaking *ex cathedra* on matters of faith

and doctrine, was the indubitable voice of authority for Roman Catholics. "The old Pope has stuffed his infallibility pill down the world's throat," Hatty told Crow. Since bishops were "dying off about one every twenty four hours (great heat)," she supposed that the pope felt that "if he did not expedite matters, there would not be one left for a majority." Not much about the council was understood in Rome, for the Vatican newspaper, *Osservatore,* was "three quarters full of Latin that nobody can read." With the public attention diverted by the war declared between France and Prussia, the pope was "left to gloat . . . pretty much to himself." To Louisa, Hatty announced that, unless her absent friend remained in "a conjugal frame of mind," she would marry one of "the fathers," who were in Rome seven hundred strong.[22]

The eyes of the world were in fact on the brief but bloody 1870 conflict known to history as the Franco-Prussian War. The forces of nationalism had been at work in the German states as they had been in Italy. Under Bismarck's leadership, Prussia had assumed the responsibility to work toward a united Germany. Meanwhile, Napoléon III's faltering regime was becoming increasingly impotent and isolated as a new Italy arose on France's borders. Louis-Napoleon, ill-advised, believed that a war, successfully waged against Prussia, would restore public confidence in the sagging empire.[23]

France's paranoia escalated when Prince Leopold, a Hohenzollern, was offered the Spanish throne after a coup had overthrown the reigning queen. It was not the first time that the crown had been extended to him. This time he accepted it, but under pressure from the French, he withdrew. A volatile exchange of rhetoric ensued, misunderstood and altered in the press and inflaming the national pride of both Prussians and French. Many who were prudent saw the confrontation as stupidity, but cool heads did not prevail. Napoleon III declared war on Prussia, July 15, 1870.[24]

"Hot work on the Rhine," Hatty called the war to the north. She did not see how she could travel in peace from Paris to Munich as she had planned to do that summer. But the war would soon be over, she correctly predicted, "if the other powers do not intervene which at present does not seem likely." She sympathized with Prussia, because France seemed to be the aggressor. "and besides that, France is so cocky," she said, "a good thrashing will do her good." The powers at war were "so equally matched that it is difficult to foresee what the ending will be."[25]

With France involved in her own struggle with Prussia, Victor Emmanuel II saw his chance to take Rome. Although the pope's days were numbered, Pio Nono continued the papal business as usual, appearing

in the street dressed in simple white, his red cap on his head. In the home of the artist Thomas Read, Read's mother-in-law, Caroline Laing, reported in her journal that her daughter Hattie Read and a visitor, "Miss Brewster," had seen the old pontiff riding in his carriage on the Pincian Hill. Miss Brewster fell to her knees like the good Catholic she was. Mrs. Read remained standing, but she said that the pope "looked her pleasantly in the face and gave her his benediction." "Miss Brewster" was Annie Brewster, a correspondent for the *Philadelphia Bulletin* and the *Newark Advertiser*. Besides being present frequently at the Reads (not always to their liking), she also became friendly with Hatty Hosmer. When Hatty took the visitor to Albano for a few days, Tu-Tu, Miss Brewster's dog, was left to languish with the Reads.[26]

In anticipation of the takeover by the Republicans, which would be welcomed by many but abhorred by the elite Romans, visitors were urged to leave the city. Annie Brewster and Hatty stayed—Hatty undoubtedly because she did not want to miss the event and Brewster to get her story. In the final days, when the "Sardinians," as Hatty persisted in calling Victor Emmanuel's armies, were about to enter Rome, the two women attended a solemn high mass at St. Peter's. The mass was the occasion for the deepest mourning. Everyone who loved Rome—Catholic or Protestant, native Roman or expatriate, nuns, priests, and the hierarchy of the church—came in sober black. When the pope, the lone figure in white, entered the basilica, "a universal wail echoed through the Church," as Harriet Hosmer told it. As the pontiff passed before her, she could see tears streaming down his face. His clerics, too, were weeping. Hatty sobbed along with everyone else at this moment of profound sadness.[27]

Although the people had been told that there would be no bombardment, Hatty awoke on the morning of Tuesday, September 20, to the sound of cannons. Following the instructions, she had hung an American flag from her apartment windows, a symbol that would draw sympathy from the invaders. But on this morning, shells rained around her house in the Quattro Fontane. One struck a nearby church, carrying away a large fragment. At about ten o'clock, believing that the firing had subsided, Hatty "sallied out," as she put it, venturing up to the four fountains. She was accompanied by a servant, Pietro, and the two got as far as the Via Pia, the street whose name would shortly be changed to Venti Settembre to commemorate the date. Someone shouted "*Indietro, indietro,*" a command to the crowd to move back as the troops penetrated the wall of the Porta Pia and prepared to enter Rome. Hatty was caught in the mob and pushed back. When she again reached the four

fountains, she looked back to see a man—someone she recognized—covered with blood. Horrified, she asked him what had happened. Didn't the signorina know that a shell had burst close behind her? The man appeared to have lost several fingers. Hatty took him into her house, gave him wine, and bound up his hand as best she could before he went off to find a doctor.

Later she went to the loggia of a house high behind the Capuchin church, where "a musket ball grazed my face, and others were playing around us." She and her companion, presumably Annie Brewster, decided that they had better come down to shelter. A walk to the Porta Pia brought them to the scene of greatest carnage. A beautiful old building had been riddled by bullets. Six dead Zouaves, the last of the pope's protectors, lay dead in the courtyard of the Villa Napoleone. Nearby the stone heads of Saints Peter and Paul, knocked from their pedestals, lay in absurd disarray near the dead. In the late afternoon, Hatty watched the conquerors march in. Catholics to a man, they showed little pleasure at their ambiguous mission and its success. Pope Pius IX shut himself up in the Vatican, a voluntary prisoner. He had lost a kingdom. As the spiritual leader of all Roman Catholics, he would gain greater authenticity.

Hatty went to England in the early fall. There she visited with Mary and Robert Emmons, as well as with her English friends. Mary, the third of the Crow daughters, was a favorite of Hatty's, and she found the spa town of Leamington, where the Emmonses lived, charming in every way. She had put her will in the hands of J. Pierpont Morgan, the American-born banker with the firm of George Peabody in London. She had promised to bestow her dog Bruno upon Morgan, who had "fallen in love" with the animal.[28] Stopping in to see him on trips to London was one of her pastimes. The two exchanged news, and his safe was available to her when needed.

In December, 1870, King Victor Emmanuel II at last arrived in Rome, slipping in unannounced and unnoticed. The catastrophe of a terrible flooding of the Tiber gave him "an excuse," as Hatty reported, "to bodkin himself through these holy walls." He drove through the Corso and up into the Pincio to survey his new domain from the height. The deluge worsened, and the Corso, Ripetta, and Babuino had to be traversed in boats. Merchants lost thousands of dollars as the water inundated their shops. Hatty wrote to Crow that she was cut off from her usual access to her studio in the Via Margutta, entering it instead through the Hotel Terny. But with the luck that she thought traveled with her, the water came up just to her stable door, a level somewhat lower than that of her studio.[29]

Meanwhile, in France, the government of Napoleon III had been

overthrown and the emperor taken prisoner by the Prussians after the ignominious defeat of his armies at Sedan. When the government toppled, a new republic was proclaimed in France. That did not end the war, however, and Paris was under siege until the surrender. At Versailles, a triumphant Bismarck proclaimed the German Empire. "Poor France is squelched," Hatty wrote to Wayman Crow, "and I am sorry for her and should have infinitely more compassion if I did not feel that she was unpardonably aggressive in the beginning. Prussia is now cock of the walk, the arbiter of Europe, the great German Empire."[30]

In Rome, the new government took over, attempting to run the city and cope with the problem of old loyalties as the Romans showed their resentment of new administration. In Roman society, no one knew whether or not to speak with the newly arrived prince and princess of Piedmont, scions of the ruling house, a delicate situation that called for *savoir-faire*. As for Hatty Hosmer, she said that she remained loyal to Maria Sophia, her "violet-eyed heroine of Gaeta." In some quarters, the republican way of doing things took hold quickly. Soon after the transition, Hatty reported a strike of Roman coachmen—forerunners of the taxi drivers—who staged a spontaneous *sciopero,* or short strike. There was not a carriage in the piazza, Hatty told Crow. One of "the Liberals of last year" had told her, "'If we ventured to speak our minds, we should say now Viva, il Papa. Our *libertà* has cost us too dear.'"[31]

Not long afterward, Hatty spoke of the changes that were coming about. "Rome," she lamented, "is slicking up a little." The expatriates were not happy about it. "In time, it will become like every other city in the universe, clean, tidy, and hatefully *progressive*. We want it just as it was—with all its dirt and all its charms, and we fervently pray that something may come in the way to upset it all and restore it to its former delightful condition." She also believed that "the old Pope will have his own again." The rise in taxes that was inevitable would "do more for the Holy Father than a whole French army." The "liberated Romans" were already "beginning to groan," and they had not yet learned "what Victor Emmanuel is capable of."[32]

Streets and their numbers underwent change, including Hatty's own Quattro Fontane, where her number 26 was changed to number 14. Presently she spoke of "commonplace streets by the yard." During a Roman stay in later years, she observed, "No one, who did not know the 'has been' can believe how the sights of Rome of our former days have dwindled away. All is now vulgarity and tinsel; the calm majesty of the Rome of our former winters is gone forever."[33]

While Hatty continued to call Rome her home for many more years, the year 1870 marks the beginning of a change in her attitudes about the

city and subsequently about her work. "Life is too short," she would soon say, "to be always performing your duties."[34] Her evolving dissatisfaction with the place that had been her home for eighteen years may have reflected a deeper malaise and nostalgia for beloved faces and a society that was rapidly vanishing. She may also have heard the knell for neoclassicism.

The Italians say "buona sera" very early in the afternoon. No sooner does the sun cross the meridian of midday than one greets another with "good evening," although there is a long afternoon and twilight before "buona notte" signals the time to retire. There is perhaps a parallel in the course of Harriet Hosmer's life and this Italian way of arriving at an early evening. At the pivotal year 1870, she was barely forty, and her career was at its height, although, as it turned out, she had done all of her most important and enduring works. Although she had many satisfying and productive years ahead that would span a long, pleasant interval before the end of her life, it was past high noon.

Epilogue

Changes in Roman life were at first imperceptible. The hunt group continued to meet regularly, come king or pope, with the same spills, bumps, and bruises. Tourists crowded the city during the season, and the ritual of studio visiting went on. That Hatty was still dining out regularly, as she always had, is implicit in Henry James's observation of her at a dinner party at the Storys' Barberini apartment early in 1873. She struck the supercilious young American as "a remarkably ugly little grey-haired boy, adorned with a diamond necklace." More to his taste were Sarah Butler Wister and her mother Fanny Kemble; each became a special friend. He did allow that Hatty, on that first meeting, was "both 'vivacious' and discreet." As the woman whose studio Hawthorne had visited fifteen years before and whom he had immortalized in *The Marble Faun,* she was an object of particular interest to James.[1]

Only days before, James had written home to say that as yet he had seen nothing of the artist society in Rome. "As far as it is American, I doubt that it amounts to much." So it was not without bias that he judged "the extraordinary little person known as Hattie Hosmer" as "better, I imagine, than her statues." Later, in his biography of William Wetmore Story, James named Hatty as the leader of the women sculptors in Rome, "the white marmorean flock," he called them poetically, if patronizingly, a name that has clung for want of a better one.[2]

In 1878, the two pivotal figures in contemporary Roman history died. In January, throngs, including many tourists, walked through the Quirinal Palace gardens into the grand salon, where the body of King Victor Emmanuel II, the first king of a united Italy, was seated on a throne, fully dressed in ceremonial regalia. On February 10, Pope Pius IX, whose reign was the longest in papal chronicles, succumbed. On the high altar at St. Peter's, his body lay in state with his feet pressed hard against a metal screen so that they could be kissed by faithful followers.[3]

Far more personal a loss that year for Harriet Hosmer was the death of young Wayman Crow at twenty-five. After studying and traveling abroad, he was apparently stricken with a hemorrhage at his sister Mary Emmons's home. Whether the cause of death was the result of an

accident or from a congenital disorder is not known. Hatty wrote to the Crows of "the saddest news from Leamington . . . a great sorrow and trial." Nor was the Crow family to be spared further grief. In 1880, Harriet Hosmer Carr, Cornelia's oldest child and Hatty's godchild, died of Bright's disease, a lingering kidney ailment. She was twenty-five.

Later, in a letter to Cornelia, Hatty spoke approvingly of Crow's gift of an art gallery to St. Louis and to Washington University as "a most excellent and happy one, definitely more useful than a monument in the ordinary sense." On May 10, 1881, Crow gave William Greenleaf Eliot the deed to the St. Louis School and Museum of Fine Arts, built as a memorial to Wayman Crow, Jr. The two-story Italianate structure at Nineteenth and Locust streets held several hundred casts and mechanical reproductions of famous monuments. Upstairs was Hosmer's *Oenone*.[4]

Disenchanted with a changing Rome, Hosmer spent extended time at Kent House, Lady Ashburton's London home, and, as before, at Melchet Court, where her sculptures were in the company of a collection that included works by Raphael, Rubens, and Titian. A fire at Melchet Court in 1872 elicited her greatest concern, not only on behalf of Lady Ashburton, but for the possible loss of the house's treasures. Fortunately, the fire was contained and the art saved.

Equally accessible were the townhouses and country places of Lady Marian Alford, a member of the aristocratic Compton family. Castle Ashby, the seat of the Marquess of Northampton, as well as Compton Wynyates, the manor house dating its origin to the sixteenth century, were places that she knew well. It is probable that the lure of society and the beauty of great houses, surrounded by splendid forests and exquisite gardens, absorbed some of Hosmer's desire to compete for commissions. The British connection promised her new opportunities in the area of the decorative arts, a felicitous development for neoclassic sculptors. At one point, she told Cornelia that she was tempted "to become a Britisher," because Lord Northampton promised to build her the finest studio in London if she would do so, and Lord Brownlow offered her a house and estate as a part of the package. Whether these were serious tenders to entice her toward British citizenship is uncertain, but she was obviously very much at home in the English setting.

For a time she had a studio, apparently furnished to her by Lady Ashburton. Hatty had resisted Louisa's prior efforts to install her in a London atelier, not wishing Louisa to have to worry about "four more walls" in addition to the responsibilities of her several properties. Hatty indicated also, in letters to Louisa, that she was not entirely satisfied with the proposed locations. But later she was pleased to have, in

addition to her Roman studio, London space that she used more for an exhibition hall than for a workplace. The arrangements, like other entanglements with Louisa, were complex. Writing in 1876, she reminded Louisa that she had given her a certain bas-relief sculpture to "cut off . . . one half my indebtedness to you for the studio."[5] Unlike other letters, the tone was cool and there was no salutation.

Hatty continued to depend on Wayman Crow for loans and financial advice, counsel that she may not have followed. Her unchanging loyalty to the Crow family, however, was evident in a letter to Wayman Crow in 1872. "Having had the sniffles and having been stared in the face by death and a pocket handkerchief," she had written a holographic will, apparently an action that she was moved to take from time to time. After the payment of her just debts, she said, everything that she possessed she left to her "two dear friends Mrs. Lucien Carr and her godchild Harriet Hosmer Carr." Should one outlive the other, the survivor should inherit her entire estate. All models and casts found in her studio in plaster should be destroyed and her body buried in the family plot in Mount Auburn Cemetery.

Cornelia Carr, writing of the death of her father Wayman Crow in 1885, spoke of his passing as Hatty's "greatest loss," underscoring, perhaps, that no one, man or woman, had superseded Wayman Crow in Hatty's affections. As time had robbed him of vigor and his eyesight had diminished, Hatty had spoken sadly of "the dear Pater." With his death, she lost inspiration and the impetus to create, and her movements became even more unpredictable, Cornelia recorded.

During the seventies, when Hatty began work on her perpetual-motion machine powered by a magnet, many thought that she had retired from her work as a sculptor to devote herself to her inventions. Some, like Frances Cobbe, felt that she was losing valuable years that could have been given to sculpture.[6] Hosmer seems to have had an adversary in "young Linton Chapman," presumably the artist John Linton Chapman, who charged that she had falsified her claim as inventor of a motor run by a permanent magnet. Whatever court heard the case, mentioned only in a fragment in the Hosmer papers, ruled in Hatty's favor. Chapman's subsequent charge, that she had stolen her process for making artificial marble from an Italian, was equally unsubstantial. A man called Dr. Ciccaglia, referred to as the "real" inventor of the process, gave the *New York Post* a letter confirming Hosmer's claim, since she had altered his earlier process significantly.

Hatty wrote sadly of the death of Isabel Conn Crow, Cornelia's mother, in 1892. There would no longer be a reason to visit St. Louis with both Wayman Crow and his wife gone, she told Cornelia. By that

time, Chicago, a burgeoning city with a pioneer museum and the Chicago Art Institute, had assumed an importance in Hatty's life. The World's Columbian Exposition, planned for 1893, would be opulent beyond all expectations. Hatty frequently stayed at the home of John Shortall at 1600 Prairie Avenue in Chicago for extended periods. Shortall even arranged a studio for her use on the third floor of his house, where she spent her days working, still busy, as she told Cornelia, on a new idea for sculptured gates. In return for Shortall's hospitality, she apparently was his entree into cosmopolitan circles in Rome and in England.

In Chicago, invigorated, no doubt, by the city's energy, Hatty shone for a new circle, eager to know her. That neoclassical sculpture was no longer in vogue was an academic matter; Harriet Hosmer was still perceived as the foremost woman in her profession and an inspiration to all females who aspired to achieve. Moving with the times, she began to speak out on feminism. In a talk to the Women's Club of Chicago in 1890, she recalled that Sarah Freeman Clarke, who had to appear in a Roman court, "learned that the evidence of three women was necessary to balance that of one man." Italy had regressed since the Renaissance, Hatty said, when many women were learned, some of them professors in the universities. As for suffrage, it mattered little, she said, whether England or America gave the vote to women first, although she hoped that it would be her own country that removed "the political disabilities of women, that stigma of civilization of the nineteenth century."

Vivacious and youthful-looking well into her sixties, she often dressed in flowing Greek gowns, probably to avoid the necessity for the corsets that were harnessing the figures of women. On one occasion, she removed the net, or snood, that restrained her hair, to appear at a speaking engagement in all her "primeval beauty," so she told Cornelia. She was also observed in fashionable suits and elegantly plumed hats. She loved finery—embroidered, monogrammed handkerchiefs, silver-framed handbags, and, especially, jewelry, which she took the liberty of depositing in J. P. Morgan's safe when she was traveling in England.

Over the years of her prominence, members of European royalty had honored her with decorations. The grandest of these tributes was a sash from the dowager empress of Russia, who had arrived at her Roman studio in a sedan chair borne by two burly cossacks. Ludwig I bestowed on her a triangle of steel brilliants, a Bavarian medal of honor that he himself pinned on. While she was recognized as one who had hobnobbed with the aristocracy and royalty in Europe, in her native America she began to be looked upon as the symbol of women's struggle for equality in the professions. Susan B. Anthony, who had become a towering

figure in behalf of women's rights, notably suffrage, wrote to Hatty on several occasions. Recalling her appearance at the *Revolution* office in New York in 1868 to subscribe to the paper, Anthony urged Hatty to participate in the organization of women artists. Later, she invited her to the fiftieth anniversary celebration of the National American Woman Suffrage Association in Washington, D.C. "With love and admiration" was the closing of one letter; another expressed the hope that "your *well of joy* and enjoyment is deep and has a never failing supply!!"[7]

The World's Columbian Exposition scheduled for 1893 in Chicago opened the last act for Hosmer as sculptor. Well ahead of the event, the Daughters of Isabella, a Chicago suffragist group, commissioned her to do the figure of their patron, Isabella of Castille. In the tide of growing feminism, the Spanish queen was seen as an equal partner in the achievements and the glory of Columbus. Hatty's concept was a heroic figure of Isabella, swathed in drapery, offering her jewels to Columbus.

It was, perhaps, a curious anachronism that Harriet Hosmer was chosen to model the statue of Queen Isabella for the Columbian exhibition. One factor was surely her eminence among women sculptors, expressed in a citation from the Women's Press Association, in March, 1891: "To Harriet Hosmer whose noble life work has helped to lift the women of the century to a higher level." Another reason was her current identification with women's rights. Not least was her popularity in Chicago, where, as a visiting celebrity, she had made herself at home. She continued to visit John Shortall as the preparations for the exposition progressed, even having her favorite Chianti shipped from Italy to his address. Her notes to a certain Mrs. Coonley, presumably the suffragist who entertained Susan B. Anthony, indicate that she also stayed at the Coonley residence. Another of her addresses was the clubhouse of the Queen Isabella organization, located at Sixty-first and Oglesby streets. If Hatty was not working, she was being entertained at bridge parties and receptions.

Internecine squabbles characterized the Isabella proceedings. The suffragist Isabellas were at odds with Mrs. Potter Palmer, head of the Board of Lady Managers. Owner of a Hosmer *Zenobia,* Mrs. Palmer had a pet project in the creation of a women's pavilion for the coming exhibition. But Susan B. Anthony expressed her displeasure at the segregation of women's art. Although Hatty had once endorsed the idea of a national monument to women in art, she took a stand with Anthony to oppose the placement of her *Queen* in a women's pavilion. The eventual location of the statue outside the California pavilion resolved the episode.[8]

The *Queen* was modeled in a plasterlike substance, probably akin to

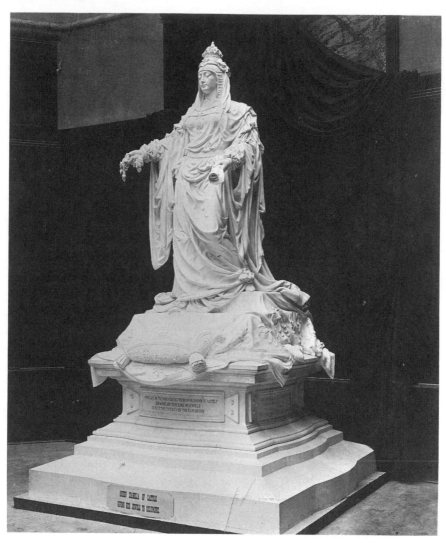

Queen Isabella of Castile, 1893, plaster model, probably larger than life-size. *Queen Isabella of Castile* was exhibited at the World's Columbian Exposition, Chicago, 1893, and another model was exhibited the year after in San Francisco. Schlesinger Library, Radcliffe College.

staff, the material that built entire shining cities for international exhibitions, with splendid buildings that stood for a season or two and were then dismantled. The statue was intended to be cast in bronze, but funds for the venture were never realized. Of the sculptors who showed their works at the exposition, Hatty singled out Daniel Chester French. Publicly she praised French's Millmore memorial monument, the *Angel of Death and the Sculptor,* as a modern work that presented "not only historic truth, but beauty of form and sentiment, pathos and outlines of harmony and grace." It was, she said, a poetic rendering, not a "betrousered obituary."[9]

As a result of the Chicago showing, *Queen Isabella* was again unveiled, this time in San Francisco at an event called the Winter Fair. California sources felt bound to point out that the figure they were seeing was not the same that had been shown in Chicago; this *Isabella* had come directly from Hatty's studio in Rome. To reinforce this fact, Hatty told an appealing story, embellished in all probability by her sense of drama, of the workmen in her studio bidding formal good-bye to the statue. Each doffed his hat and addressed the effigy as though it were a living personage, with wishes for a safe journey and return to Rome.[10] With Hatty present for the unveiling of the statue, there were again gala attendant festivities. Some said that the colossal statue of *Queen Isabella* ought to be placed as a beacon in the San Francisco harbor. The statue stayed in California, and it later disappeared from sight, possibly a casualty of the earthquake in 1906.

Frederic Leighton, president of the Royal Academy and knighted by the queen, continued to correspond with Hatty. Recently he had written to tell her of his pleasure at the reception of his bronze figure *Sloth,* which had received an award for excellence. When he again wrote from Algiers, not long before his final illness, he had been ordered by his doctors to rest, suffering as he was from heart disease. "You who know me so well," he wrote, "can understand how irksome to me is this enforced idleness."[11]

Anne Dundas, seeing him in Venice on the Grand Canal, as their gondolas passed each other, remarked to Hatty that Leighton had looked ill, although "one would not, as the Celtics seers say, have seen the shroud already waist high about him."[12] Preceded in death by Adelaide Sartoris, in 1879, his beloved to the end of her life, Leighton died in 1896. He was buried in St. Paul's, where a full-length sarcophagus image marks his tomb. When, after his death, the modesty of his estate was viewed patronizingly, Hatty defended him: "Before fortune had in any way smiled upon him," she remembered, "his name was synonomous with helpfulness and kindness to those less fortunate than himself."[13]

The intensity of the affection between Hatty and Louisa mitigated with the passage of time to a devoted friendship. Received as a member of the family circle, Hatty took great pleasure in watching Maysie, the Honorable Miss Baring, after a proper debut, marry Lord William Compton, the nephew of Lady Marian and later Marquess of Northampton. As for Louisa, she gained a reputation as a philanthropist. The Mission to Seamen, in Victoria Dock Road, captured her attention and energies more than any other social concern, perhaps because of her love of the sea.[14] Maysie became the mother of three children. After the youngest, Spencer, was born, she sustained a crippling disease that progressed over the years to paralysis and complete invalidism.[15] Present during the last phases of Maysie's illness before she died in 1902, Hatty read to her and tried to make her laugh, continuing in the role of entertainer that was natural to her. To Cornelia, Hatty confided that she was far more worried about "the dear mother," for Louisa by then was suffering from breast cancer.

Her daughter's death was a devastating blow to Louisa. Attended by a nurse, she continued courageously, and seated in a wheelchair, with Hatty by her side, they watched the coronation parade of Edward VII, at last the monarch. While it has been assumed that Hatty remained with Louisa until the latter's death in February, 1903, there is some indication that she went back to Watertown for a visit. From her old home on Riverside Street, she wrote a note to Cornelia, thanking her for forwarding Lady Ashburton's letter. Louisa had written, "Your presence *really did* her [Maysie] more good than I can tell."

Florence Compton, the wife of Alwyne Compton, bishop of Ely and the brother of Lady Marian, was another friend of those days, and it is she, writing to Cornelia after Hatty's death, who said that Hatty had been with Lady Ashburton when Maysie died and had remained with her until Lady Ashburton's own demise. When Hatty returned to America at last, she took up residence in her native Watertown, her presence not perceived except by those close to her.

At first, she seems to have stayed at her old family home, now inhabited by the widow of her cousin Alfred Hosmer. It is probable that her prolonged visit may not have been mutually agreeable, and presently she told Cornelia, who was living at 163 Brattle Street in nearby Cambridge, that she had moved in with the local jeweler, Charles E. Gray, and his wife. She was seeking more room, she explained, and with Gray's mechanical skills in watchmaking, he could help her in constructing her machine, the magnet-powered creation that still occupied her.

In the summer of 1907, Hatty took off with the Grays for a farm at

Bolton. She had two rooms at her disposal, one an attic room where she retired to tinker on her invention, still working indefatigably although she was nearly seventy-seven. She imperiously imposed her schedule on the household, demanding breakfast at half past six, on Sunday as well as every other day. Then she drew plans until noon, sometimes making models of different parts of her machine in platinum. At noon, she appeared promptly for the midday meal. After a short interval to read the paper, she was back at work.[16] In the evenings, she and Gray talked about the machine. To Mrs. Gray and her sister she told stories of the days in Rome. Occasionally they would listen to a concert on the player piano.

Always interested in technology and the new wonders of the world, she had once written of the patience that creative endeavor took. Alexander Graham Bell had worked on his telephone for ten years, and everyone knew how long Samuel Morse had "tugged away" at his telegraph. Hearing the rumor that Thomas Edison had abandoned his experiments on the electric light, she had written incredulously, "I do not believe it." She looked forward to the day of the airship, when it would be possible to breakfast in America on Monday morning and lunch in England early the next day. Meanwhile, the maiden voyage of the *Lusitania* had to suffice, although, she wrote to Cornelia, "she did not perform wonders, did she?" But it was hardly fair to judge her performance by a first trip—"she will go better by and bye." She had once written, "What fun it would be to come back to this earth after having been a wandering ghost for a hundred years or so and see what has been going on in the flesh while we have been going on in spirit."

Even with the advent of the telephone, Hatty continued to write to Cornelia, little notes that began "My Precious," and were signed "Yr ever faithful Sis." She was a frequent visitor in Cornelia's busy household on Brattle Street. Thanking Cornelia for the recent Christmas celebration with the Carr family, Hatty told her friend that she had returned to Watertown just as quickly in a conveyance drawn by one horse as she had once done when carried by two. Thinking perhaps of the splendid brougham pulled by two fine black horses, which she had once owned, she added, "Of course I didn't carry my tail quite so high as when I had a pair but I ever preserve my equanimity—being neither inflated by splendor nor deflated by—t'other thing," her metaphor for her diminished means.

She dreamed of her own demise, she told Cornelia in the final months, insisting in the dream on a monument of yellow marble that she had seen in Liverpool, "because it harmonized with my complexion!" Before she could study the effect, she said, she awakened. For a minor

ailment, she went to Dr. Julian Mead, "who gave me something for my tummy," she told Cornelia. Then, on February 7, she spoke of a cold, the ailment that she had hoped to avoid that winter. Her condition worsened, and on February 21, "with mind undimmed," Cornelia later noted, "she passed into the Higher Life."

News of Hatty's death brought her name before the public again, for she had virtually dropped out of sight. Her long, illustrious career was reviewed, along with her friendships with the Brownings, Fanny Kemble, and European royalty. Although it was a private matter, the fact was that she had died insolvent. Everything she had, had been turned into cash, Dr. Julian Mead, who was also president of the local bank, wrote to Cornelia. What was unfortunate, Mead agreed, were the debts that had to be settled. There were three small local claims, including one for fifteen dollars for labor from Charles E. Gray. Two other debts were more substantial—one owed to a Mrs. Caroline Boldetti of London, for $1,457, and another to a Mrs. Carolyn S. Powers of Brookline, Massachusetts, for $1,139.04. Mrs. Powers had in her possession a trunk of memoirs that she intended to keep as satisfaction. Hatty herself had signed papers deeding the keepsakes to Mrs. Powers in case the debt was not paid. Various plans for settlement were discussed with Cornelia. Dr. Mead, albeit unwillingly, spoke of selling the original Hosmer lot in Mount Auburn, where the remains of Hatty's parents and siblings were interred. Her ashes had already been placed in a newer family plot by Alfred Hosmer's widow.

In the end, Cornelia took the assets held by the court for the sum of three hundred dollars, and the other debts were partially settled. The Hosmer lot, which Dr. Hosmer had bought when the cemetery association was formed, was not sold. With Hatty's papers, along with her own memorabilia of their long association, Cornelia Carr set about reconstructing the remarkable life and career of her famous friend. She spoke of the bond between her father and Harriet Hosmer, declaring that "to no one else did she write so freely and consecutively of her work and her life abroad." Of Hatty's sense of fun, her loving words, and her busy brain, Cornelia wrote, "The work dreamed of by her would easily have filled another lifetime." Whatever faults Hatty had, and Cornelia knew them well, the shining qualities of her character and personality far outweighed them.

Many called Hosmer a genius. Surely she was extremely gifted, intellectually as well as artistically. Her mind was quick and agile, her tongue articulate. She was facile with her hands and learned in a literary sense. In another time, she might have distinguished herself in a variety of other pursuits. Somehow, one concludes, that, given a gamut of

choices, she would still have been a sculptor. It may have been her joy in her work that draws us to such a conviction. Her happy heart and her certainty that she was favored with incredibly good fortune were in themselves gifts of the spirit.

When neoclassical sculpture, as it was applied by the expatriates in Rome, passed into oblivion, the names of its practitioners were nearly forgotten. It became fashionable, also, to belittle their works. Hosmer's star dimmed along with the rest, to be seen on the horizon again only in recent years with new interest in the history of American sculpture and in the pioneering spirit of women sculptors, of whom she is foremost.

In the Via Margutta, the sounds of chisel and hammer occasionally fall on the ear, while up and down the Spanish Steps, throngs of artists and peddlers still push their products. On the Pincian Hill, small boys on skateboards replace the starchily dressed children who came with their parents or nursemaids to hear the band play at sunset. The cleanliness and decorum of the Caffè Greco is a distinct change, but the old mailbox sitting in its place and the smell of good mocha recall the bygone era. The sights and sounds have changed since the years of the mid-nineteenth century. Yet, in many ways, subtle but pervasive, it is still the Rome of Harriet Hosmer.

Abbreviations

AAA • Archives of American Art, Smithsonian Institution.

ABL • Armstrong Browning Library, Baylor University, Waco, Tex.

AKS • Adelaide Kemble Sartoris.

Albrecht-Carrié • René Albrecht-Carrié, *Italy from Napoleon to Mussolini* (New York: Columbia University Press, 1949).

AnonBio • Anonymous biographical monograph of HH, copied in her handwriting and endorsed by her. The Harriet Goodhue Hosmer Collection, the Arthur and Elizabeth Schlesinger Library on the History of Women in America, Radcliffe College, Cambridge, Mass.

Ashburton • The letters of Harriet Hosmer to Louisa Lady Ashburton, in the private collection of the Marquess of Northampton, Compton Wynyates, England.

Berg • The Henry W. and Albert A. Berg Collection, the New York Public Library, Astor, Lenox and Tilden Foundations, New York City.

BL • British Library, London.

BM • British Museum, London.

Bosco • Ronald A. Bosco, "The Brownings and Mrs. Kinney: A Record of Their Friendship," *Browning Institute Studies* 4 (1976).

Bradford • Ruth A. Bradford, "The Life and Works of Harriet Hosmer, the American Sculptor," *New England Magazine* 45 (November 3, 1911).

CC • Cornelia Crow Carr.

Clark • Kenneth Clark, *The Nude: A Study in Ideal Form* (Garden City, N.Y.: Doubleday Anchor Books, 1956).

Clemens • Mark Twain [Samuel L. Clemens], *Life on*

333

the Mississippi, The Author's National Edition, vol. 9 (New York: Harper & Bros., 1903).

Cobbe • Frances Power Cobbe, *Life of Frances Power Cobbe by Herself,* vol. 2 (Boston: Houghton Mifflin, 1894).

Craven • Wayne Craven, *Sculpture in America* (New York: Thomas Y. Crowell, 1968).

Crawford • The Thomas Crawford Papers: Correspondence 1845–1857, microfilm, Archives of American Art, Smithsonian Institution.

Cushman/LC • Charlotte Saunders Cushman, The Papers of Charlotte Cushman, vol. 1 of 15, Library of Congress, 1931.

DI • Edward C. McAleer, ed., *Dearest Isa: Robert Browning's Letters to Isabella Blagden* (Austin: University of Texas Press, 1951).

EBB • Elizabeth Barrett Browning.

EBB-MRM • Meredith B. Raymond and Mary Rose Sullivan, eds., *The Letters of Elizabeth Barrett Browning to Mary Russell Mitford, 1836–1854,* 3 vols. (Winfield, Kans.: Armstrong Browning Library of Baylor University, the Browning Institute, Wedgestone Press, and Wellesley College, 1983).

EC • Emma Crow Cushman.

Ellet • Mrs. Ellet [Elizabeth Fries Lummis], *Women Artists in All Ages and Countries* (New York: Harper and Bros., 1859).

FAK • Frances (Fanny) Anne Kemble.

Fitzwilliam • Fitzwilliam Museum, Cambridge, England.

Freeman • James E. Freeman, *Gatherings from an Artist's Portfolio,* vol. 1 (New York: D. Appleton and Co., 1877); vol. 2 (Boston: n.p., 1883).

French • Michael Richman, *Daniel Chester French: An American Sculptor* (New York: Metropolitan Museum for the National Trust for Historic Preservation, 1974).

Gardner • Albert TenEyck Gardner, *Yankee Stonecutters: The First American School of Sculpture, 1800–1850* (New York: Columbia University Press for the Metropolitan Museum of Art, 1945).

Gaunt • William Gaunt, *Victorian Olympus* (New York: Oxford University Press, 1952).

Gerdts (1) • William H. Gerdts, *American Neo-Classic Sculpture: The Marble Resurrection* (New York: Viking, 1973).

Gerdts (2) • William H. Gerdts, *The Great American Nude: A History in Art* (New York: Praeger, 1974).

Gerdts (3) • William H. Gerdts, "Marble and Nudity," *Art in America* 59 (May, 1971).

Gerdts (4) • William H. Gerdts, "The *Medusa* of Harriet Hosmer," *Bulletin of the Detroit Institute of Arts* 56, no. 2 (1978).

Gerdts (5) • William H. Gerdts, Introduction to *The White Marmorean Flock: Nineteenth-Century American Women Neoclassical Sculptors,* exhibition catalog by Nicolai Cikovsky, Jr., Marie H. Morrison, and Carol Ockman (Poughkeepsie, N.Y.: Vassar Art Gallery, 1972).

Gillespie • W. M. Gillespie, *Rome as Seen by a New Yorker in 1843–44* (New York: Wiley and Putnam, 1845).

Greco • Diego Angeli, *Le Cronache del "Caffè Greco"* (Milan: Treves Editori, 1930).

Griffin • W. Hall Griffin, *The Life of Robert Browning with Notices of His Writings, His Family, and His Friends,* completed and edited by H. C. Minchin (1910; reprint Hamden, Conn.: Archon Books, 1966).

Hare • Augustus J. C. Hare, *Story of My Life,* vols. 3, 4 (New York: Dodd Mead and Co., 1901).

HH • Harriet Goodhue Hosmer.

HHLM • *Harriet Hosmer: Letters and Memories,* ed. Cornelia Carr (New York: Moffat, Yard and Co., 1912).

HHWL • Harriet Goodhue Hosmer Collection, Watertown Free Public Library, Watertown, Mass.

Hibbard • Howard Hibbard, *Bernini* (New York: Pelican Books, 1965).

Honour • Hugh Honour, "Canova's Studio Practice—I: The Early Years," *Burlington Magazine* 114 (March, 1972).

Hosmer (1) • Harriet Hosmer, "The Process of Sculpture," *Atlantic Monthly* 14, no. 86 (December, 1864).

Hosmer (2) • Harriet Hosmer, "Recollections of the Brownings," pts. 1, 2, *Youth's Companion* 74 (August 9 and November 15, 1900).

Houghton • Collection of Arthur A. Houghton, Jr., New York, 1974; since sold.

Huber • Christine Jones Huber, *The Pennsylvania Academy and Its Women, 1850 to 1920,* exhibition catalog (Philadelphia: Pennsylvania Academy of Fine Arts, 1974).

Hudson • *Browning to His American Friends,* ed. Gertrude Reese Hudson (London: Bowes and Bowes, 1965).

IB • Isabella Blagden.

James • Henry James, *William Wetmore Story and His Friends: From Letters, Diaries, and Recollections,* 2 vols. (Boston: Houghton, Mifflin and Co., 1903).

Jarves • James Jackson Jarves, *The Art-Idea,* 1st ed. (1864; reprint, ed. Benjamin Rowland, Jr., Cambridge: Harvard University Press, Belknap Press, 1960).

JC/AAA • Joseph Leo Curran, ed., "Harriet Goodhue Hosmer: Collected Sources," 1974, 7 vols. Watertown Free Public Library Collec-

tion, Watertown, Mass. Microfilm, Archives of American Art, Smithsonian Institution.

JHawthorne • Julian Hawthorne, *Nathaniel Hawthorne and His Wife: A Biography,* 2 vols. (Hamden, Conn.: Archon Books, 1968).

Kemble • Frances Ann Kemble, *Records of Later Life* (New York: Henry Holt and Co., 1884).

LA • Louisa Lady Ashburton, born Louisa Stewart-Mackenzie, second wife of William Bingham Baring, 2d Baron Ashburton.

Larkin • Oliver W. Larkin, *Art and Life in America* (New York: Holt, Rinehart and Winston, 1949).

Leach • Joseph Leach, *Bright Particular Star: The Life and Times of Charlotte Cushman* (New Haven: Yale University Press, 1963).

LEBB • *The Letters of Elizabeth Barrett Browning,* ed. Frederick G. Kenyon, vol. 2 (London: Macmillan Co., 1897).

Leighton • Mrs. Russell Barrington, *The Life, Letters and Work of Frederic Leighton,* 2 vols. (London: George Allen, Ruskin House, 1906).

Lincoln • F. Lauriston Bullard, *Lincoln in Marble and Bronze,* A Publication of the Abraham Lincoln Association, Springfield, Illinois (New Brunswick, N.J.: Rutgers University Press, 1952).

Lippincott • Sara Jane Clarke Lippincott [Grace Greenwood], *Haps and Mishaps of a Tour in Europe* (Boston: Ticknor, Reed, and Fields, 1854).

LMC • Lydia Maria Child.

LMC/*Corr* • Lydia Maria Child, *Collected Correspondence of Lydia Maria Child, 1817–1880,* ed. Patricia G. Holland and Milton Meltzer (Millwood, N.J.: Kraus Microform).

LMC (1) • Lydia Maria Child, "Harriet E. [*sic*] Hosmer: A Biographical Sketch," *Ladies Repository* 21 (January, 1861): 1–7.

LMC (2) • Lydia Maria Child, "Harriet Hosmer," *Littell's Living Age* 56, no. 720 (March 13, 1858): 697–98.

MassHis • Massachusetts Historical Society, Boston.

Maurois • André Maurois, *A History of France,* trans. Harry L. Binsse; additional chapters translated by Gerard Hopkins (1948; reprint, n.p.: Minerva Press, 1968).

McAleer • Edward C. McAleer, *The Brownings of Casa Guidi* (New York: Browning Institute, 1979).

MoHis • Missouri Historical Society Archives, St. Louis.

Negro • Silvio Negro, *Seconda Roma* (Vicenza: Neri Pozza Editore, 1966).

Notebooks • Nathaniel Hawthorne, "The French and Italian Notebooks," in *The Centenary Edition of the Works of Nathaniel Haw-*

thorne, ed. Thomas Woodson, vol. 14 (Columbus: Ohio State University Press, 1980).

NYPL • New York Public Library, New York City.

Ormond • Leonée Ormond and Richard Ormond, *Lord Leighton* (New Haven: Yale University Press for Paul Mellon Centre for Studies in British Art, 1975).

Ovid • *Ovid's "Metamorphoses": The Arthur Golding Translation 1567,* ed. John Frederick Nims (New York: Macmillan Co., 1965).

Palmer • R. R. Palmer, *A History of the Modern World,* 2d ed. rev. in collaboration with Joel Colton (New York: Alfred A. Knopf, 1959).

Powers • Hiram Powers Papers, microfilm, Archives of American Art, Smithsonian Institution.

Prezzolini • Giuseppe Prezzolini, *Come gli americani scoprirono l'Italia* (1933; reprint, Bologna: Treves Editori, 1972).

RB • Robert Browning.

Ritchie • Anne I. Thackeray, Lady Ritchie, *Records of Tennyson, Ruskin, and Browning* (London: n.p., 1892).

Robbins • Ellen Robbins, "Reminiscences of a Flower Painter," *New England Magazine* 14, no. 4 (June, 1896).

Roberson • Samuel Roberson, "A Note on the Technical Creation of *The Greek Slave,*" in *The Greek Slave* by Samuel Roberson and William Gerdts, Museum New Series, vol. 17, nos. 1, 2 (Newark: Newark Museum of Art, 1965).

Schiff • John M. Schiff, New York City.

Scripps • Browning Collection, Ella Strong Denison Library, Scripps College, Claremont, Calif.

SLRC • Harriet Goodhue Hosmer Collection, the Arthur and Elizabeth Schlesinger Library on the History of Women in America, Radcliffe College, Cambridge, Mass.

Smith-Rosenberg • Carroll Smith-Rosenberg, "The Female World of Love and Ritual: Relations between Women in Nineteenth-Century America," in *Disorderly Conduct: Visions of Gender in Victorian America* (New York: Alfred A. Knopf, 1985).

Stebbins • Emma Stebbins, *Charlotte Cushman: Her Letters and Memories of Her Life* (Boston: Houghton Osgood & Co., 1879).

Taft • Lorado Taft, *The History of American Sculpture,* rev. ed. (1903; reprint, New York: Macmillan Co., 1925).

Thorp • Margaret Farrand Thorp, *The Literary Sculptors* (Durham, N.C.: Duke University Press, 1965).

Thurston • Rev. R. B. Thurston et al., *Eminent Women of the Age* (Hartford, Conn.: S. M. Betts & Co., 1869).

Ticknor • George Ticknor, *Life, Letters and Journals of George Ticknor,*

ed. G. S. Hillard and Mrs. Ticknor, vol. 2 (Boston: James Osgood & Co., 1876).

Tuckerman • Henry T. Tuckerman, *Book of the Artists* (1867; reprint, New York: James F. Carr, 1966).

Ward • Maisie Ward, *Robert Browning and His World: The Private Face, 1812–1861* (New York: Holt, Rinehart and Winston, 1967).

Ware • William Ware, *Zenobia, Queen of Palmyra* (Boston: Dana Estes and Co., n.d.).

Waters • Clara Erskine Clement Waters and Samuel Hutton, *Artists of the Nineteenth Century and Their Works* (Boston: Houghton, Osgood, 1879).

WC • Wayman Crow.

Wheeler • Ruth Robinson Wheeler and George Frederick Robinson, *Great Little Watertown: A Tricentenary History* (Watertown, Mass.: Watertown Historical Society, 1930).

Whitla • William Whitla, "Browning and the Ashburton Affair," *Browning Society Notes* 2, no. 2 (July, 1972).

Wittkower • Rudolf Wittkower, *Sculpture: Processes and Principles* (New York: Harper and Row, Icon Editions, 1977).

WWS • William Wetmore Story.

WWS/*Roba* • William Wetmore Story, *Roba di Roma* (New York: D. Appleton & Co., 1877).

Wynne • George Wynne, *Early Americans in Rome* (Rome: Daily American, 1966).

Notes

Notes to Chapter 1: Beginnings

1. *Notebooks,* April 13, 1858, p. 158.
2. Lippincott, 249–50.
3. Descriptions of Beppo and of the Spanish Steps are found in Gillespie, Freeman, WWS/*Roba,* and *Notebooks.*
4. Gillespie, 88.
5. The proprietorship of Lepre's was explained to the author by Luciano Grimaldi, whose family has owned the Caffè Greco for generations, in an interview, May, 1981; Lepre's is described in detail in Gillespie.
6. The original painting is in the Kunsthalle, Hamburg, Germany; a copy hangs in the Caffè Greco. Writers who described the Caffè Greco include Gillespie and Freeman, who give the earliest accounts. Italian sources are Prezzolini and *Greco.* See also Thorp, 13–50. For information on the expatriate artists, see Gardner.
7. According to Luciano Grimaldi (see note 5), Giuseppe Prezzolini was the habitué who told Signora Gubinelli-Grimaldi, mother of the present proprietor, early in the twentieth century, that he preferred the medallion.
8. The *Apollo Belvedere* is discussed by Hibbard, 53, and Clark, 92–96.
9. Hare, 4:358.
10. HH to WC, September 14, [1859]; HH to WC, July 1, [1868], SLRC.
11. George Aldrich, *Walpole as It Was and Is* (Claremont, N.H.: n.p., 1880), 282–86. For Hosmer and Grant genealogies, see Martha McDanolds Frizzell, *A History of Walpole, New Hampshire,* vol. 2 (Walpole, N.H.: Walpole Historical Society, 1963); George Leonard Hosmer, *Hosmer Genealogy* (Cambridge, Mass.: Technical Composition Co., 1928); George David Read Hubbard, *Ancestors and Descendents of Josiah Hosmer, Jr.* (n.p., 1907); and William Thaddeus Harris, *Watertown Epitaphs* (Boston: 1869).
12. Sarah Grant Hosmer to Mary Kittredge, Watertown, November 30, 1834, SLRC.
13. HH to CC, [1849], SLRC.
14. AnonBio.
15. Mount Auburn Cemetery records indicate that Hiram Hosmer bought the Hosmer lot in 1835, when the cemetery

proprietors incorporated. The remains of those family members who had died previously were moved to Mount Auburn.

16. Maud deLeigh Hodges, *Crossroads on the Charles: A History of Watertown, Massachusetts,* ed. Sigrid R. Reddy, epilogue by Charles T. Burke (Canaan, Conn.: Phoenix Publishing, 1980), 105. According to information supplied by Charles T. Burke of the Watertown Historical Society, the Hosmer house was torn down some years ago to make way for an apartment building. The Francis house next to it still stands, in use as a mortuary.

17. Robbins, 447–48. For more on Convers Francis, see Wheeler, and see also Hodges, *Crossroads on the Charles.*

18. AnonBio.

19. F. M. Edselas, "A Golden Age and Its People," *Catholic World* 62 (February, 1896): 600–610, JC/AAA.

20. Didama [pseud.], *Three Holes in a Chimney; or, A Scattered Family* (Newton, Mass.: B. A. White, 1886), 34, JC/AAA.

21. LMC (2), 697–98.

22. LMC (1), 1–7.

23. JHawthorne, 1:60.

24. Robbins, 447–48.

25. Hodges, *Crossroads on the Charles,* 81, see also Didama [pseud.], *Three Holes in a Chimney,* 34.

26. LMC (1), 1–7. A more detailed but less plausible account of the Dr. Morse incident appears in Ellet, 356.

27. Handwritten notes for a speech made by HH at the Watertown Woman's Club, 1895, SLRC. Some writers have suggested that LMC advised Dr. Hosmer to send HH to Lenox. Since Mrs. Child did not meet Hosmer until 1852, just prior to her leaving for Italy, this seems unlikely. Mrs. Child and her husband, David Child, spent several years in the 1840s in New York, working on the *Anti-Slavery Standard,* published by William Lloyd Garrison.

Notes to Chapter 2: Mrs. Sedgwick's School

1. Bradford, 265–69.

2. Olive A. Colton, *Lenox* (n.p., n.d.), 16.

3. Kemble, 7ff.

4. Chard Powers Smith, *The Housatonic, Puritan River* (New York: Rinehart and Co., 1946), 284–87.

5. Katherine M. Abbot, *Old Paths and Legends of the New England Border* (New York: G. P. Putnam's Sons, 1907), 277; HHLM, 4–5.

6. HH to WC [1859–1860], SLRC.

7. Fanny Kemble Wister, *Fanny, the American Kemble: Her Journal and Unpublished Letters* (Tallahassee, Fla.: South Pass Press, 1972), 91. For more on Kemble and Pierce Butler, see Malcolm Bell, Jr., *Major Butler's Legacy* (Athens: University of Georgia Press, 1987).

8. Kemble, 7.

9. Seth Curtis Beach, *Daughters of the Puritans* (Boston: American Unitarian Association, 1905).

10. Colton, *Lenox,* 16.

11. Smith-Rosenberg, 74–76. "The Female World of Love and Ritual: Relations between Women in Nineteenth-Century America," a classic work that defines women's relationships in terms of social and cultural perspectives, is a fresh analysis to which the writer is deeply indebted.

12. Hiram Hosmer to HH, Watertown, February 27, 1849, HHLM, 7–8.

13. AnonBio.

Notes to Chapter 3: St. Louis Opens Its Doors

1. LMC (1), 3. Information from the archives of the Boston Athenaeum supports the fact that Peter Stephenson, listed in the Boston directory in 1847 and 1848, was Hosmer's instructor. Described as "a cameo cutter," Stephenson lived at 10½ Tremont Row. He exhibited his works at the Athenaeum from 1846 to 1866.

2. Rosemary Booth, "A Taste for Sculpture," in Pamela Hoyle, Jonathan P. Harding, and Rosemary Booth, *A Climate for Art: The History of the Boston Athenaeum Gallery, 1827–1873,* exhibition catalog (Boston: Boston Athenaeum, 1980), 24–30. On the beginnings of American sculpture, see Gardner.

3. LMC to Theodore Tilton, editor of the *Independent,* January 10, 1867, LMC/*Corr,* microfiche 66/1759.

4. Robert J. Terry, "Recalling a Famous Pupil of McDowell's Medical College: Harriet Goodhue Hosmer, Sculptor," *Washington University Medical Alumni Quarterly* 7, no. 2 (January, 1944): 59–65. See also Dorothy Brockhoff, "Harriet Hosmer: Nineteenth-Century Free Spirit," *Washington University Magazine* 47, no. 1 (Fall, 1976): 15. Brockhoff states that Hosmer was enrolled for several weeks before other students were aware of her presence.

5. Robert E. Schleuter, "Joseph Nash McDowell (1805–1868)," *Washington University Medical Alumni Quarterly* 7, no. 1 (October, 1937): 4–14; Estelle Brodman, "The Great Eccentric," *Washington University Magazine* 51, no. 1 (December, 1980): 6–11.

6. Ernest Kirschten, *Catfish and Crystal* (Garden City: Doubleday and Co., 1960), 168–71.

7. Two letters from HH to CC, Rome [1853], SLRC.

8. WC to CC, n.d., personal collection of Mrs. Delmar Leighton, granddaughter of CC.

9. HH to WC, St. Louis, January 9, 1851, SLRC.

10. "Grand Pic-Nic Programme," MS in SLRC.

11. HH to WC, St. Louis, January 9, 1851, SLRC. James Neal Primm, *Lion of the Valley: St. Louis, Missouri* (Boulder: Pruett Publishing Co., 1981), 240–42.

12. Clemens, 82–83.

13. HH to CC, on board the *Whirlwind,* February 8, 1851, SLRC.

14. Clemens, 202.

15. HH to CC, Fort Madison, Iowa, May 16, 1851, SLRC.

16. Clemens, 381.

17. HH to CC, Fort Madison, Iowa, May 16, 1851, SLRC.

18. HH expressed her intention to visit the lead mine in the letter to CC, ibid.; the incident is also recorded in Ellet, 58.

19. "The History of Lansing, Iowa," by William J. Burke, August, 1967, Iowa State Historical Society, Des Moines. See also the letter of the Reverend Mr. Houghton of Lansing, Iowa, 1888, *HHLM,* 12–13. HH to CC, [1867], SLRC.

20. HH to CC, Fort Madison, Iowa, May 16, 1851, SLRC.

21. Paula Blanchard, *Margaret Fuller: From Transcendentalism to Revolution,* Radcliffe Biography Series (New York: Delta/Seymour Lawrence, 1979), 196–212.

22. Hosmer's kind treatment of Edmonia Lewis, half Chippewa and half African-American, is cited in LMC to Theodore Tilton, April 5, 1866, LMC/*Corr.*

23. Joseph Nash McDowell to HH, October, 1852, *HHLM,* 19–20.

Notes to Chapter 4: On "the Eve of a New Life" in Italy

1. LMC (1), 7; HH to CC, Watertown, [1851], SLRC. Letters used in this chapter, largely undated, were written during the period between HH's return from St. Louis and her departure for Rome. In *HHLM,* CC took some liberties in editing

the correspondence of this period, probably in order to combine points of interest. She also substituted her father, Wayman Crow, for herself, as the recipient.

2. HH to CC, Watertown, two undated letters [1851], SLRC.

3. HH to WC, [1851], HH to CC, Watertown, July, [1852], both in SLRC.

4. HH to CC, Watertown, three undated letters [1851–1852], all in SLRC.

5. HH to CC, Watertown, [1851], SLRC.

6. Mary Louise Baker, Foreword, in *The American Frugal Housewife,* by Lydia Maria Child (Boston: Carter, Hendee, and Co., 1832; Publications Committee, Ohio State University Libraries, 1971).

7. James, 1:40.

8. HH to CC, July, [1851], SLRC; LMC to Francis George Shaw, September 5, 1852, LMC/*Corr,* microfiche 29/828.

9. LMC to HH, Wayland, September 16, 1860, SLRC.

10. LMC (2), 697–98; HH to CC, July, [1851], SLRC. See also *HHLM,* 13–14.

11. HH to WC, November, [1851], SLRC.

12. Ibid.; HH to CC, Watertown, [1852], SLRC.

13. HH to WC, November, [1851], SLRC.

14. For biographies of Charlotte Cushman, see both Leach and Stebbins, and also Barbara Marinucci, *Leading Ladies: A Gallery of Famous Actresses* (New York: Dodd, Mead & Co., 1961).

15. *Greco,* 64; Stebbins, 101; James, 1:256.

16. Ward, 221.

17. Griffin, 188; EBB to Arabel Moulton-Barrett, [October 22, 1852], Berg.

18. Smith-Rosenberg. See also Megan Marshall, "The Boston Marriage," *New England Monthly* (December, 1986): 71–73.

19. EBB to Arabel Moulton-Barrett, [October 22, 1852], Berg.

20. *HHLM,* 16–17. There is a discrepancy between the published letter and the original manuscript; the former appears to be a summation of recent events, probably to tell the story of HH's meeting with Charlotte Cushman.

21. Peter G. Davis, "Social Realism in the Met's New 'Ballo in Maschera,'" *New York Times,* February 3, 1980, sec. 1, p. 1. See also Harold Schonberg, review of *The Operas of Verdi,* by Julian Budden, *New York Times,* November 26, 1978, sec. 2, p. 17.

22. HH to WC, November, [1851], SLRC.

23. HH to CC, July, [1851], SLRC.

24. LMC to Francis George Shaw, September 5, 1852, LMC/*Corr,* microfiche 29/828.

25. [LMC], "A New Star in the Arts," *New York Tribune* [Summer, 1852]. *Hesper* can be seen in HHWL.

26. Didama, [pseud.], *Three Holes in a Chimney; or, A Scattered Family* (Newton, Mass.: B. A. White, 1886), 33–36, in JC/AAA. A collection of HH's tools can be seen in HHWL.

27. HH to CC, [1851–1852], SLRC.

28. *HHLM,* 19–20.

29. HH to CC, August 20, 1852, SLRC.

30. This information is contained in the last letter from HH to CC, September 27, 1852, SLRC, just two days before sailing. Much of it is incorporated in a letter purportedly to WC, August, 1852, *HHLM,* 17–19.

31. Ibid.

32. LMC (1), 4.

Notes to Chapter 5: The Gates of Rome

1. Lippincott, 158–215.
2. HH to CC, June, 1856, October 23, 1857, SLRC.
3. HH to WC, [1865], SLRC; James, 1:241.
4. Freeman, 1:28–32. The unidentified sculptor could have been HH; she used the expression "by the yard," in reference to the new arrangement of Roman streets after 1870.
5. Lippincott, 204.
6. WWS to James Russell Lowell, February 11, 1853, Hudson, 269–73.
7. HH to CC, December 1, [1852], SLRC. Shakspere Wood (1827–1886) was known as a sculptor and also as a lecturer on antiquities. He wrote for the *Times* (London) as a correspondent and had a good relationship with the Vatican.
8. HH to CC, [August, 1852]. Art historian William H. Gerdts states that Hosmer was counseled by Horatio Greenough to seek a place in John Gibson's studio. Gerdts (4), 98. While HH does not mention Greenough in her letter to CC, this does not eliminate the possibility that she spoke with him on his return from Boston to Italy in 1851.
9. WWS to James Russell Lowell, February 11, 1853, Hudson, 269–73.
10. Freeman, 1:15–18.
11. Mrs. Ellet, 349–69. LMC also describes Gibson's studio, using information that she probably got from HH or Dr. Hosmer. See LMC (1), 1–7. See also Lippincott, 158–215.
12. Freeman, 1:16–21.
13. "Life of John Gibson, the Sculptor," *Nation* 10 (April 28, 1870): 273–74; Cobbe, 356–57. Gibson's friend Lady Eastlake (Elizabeth Rigby) edited *Life of John Gibson, R.A., Sculptor* (London: Longmans, Green and Co., 1870). When it was published, Cobbe remarked that, had Lady Eastlake chosen to publish Gibson's own quaint autobiography, which she and Cobbe had read in manuscript, the result would have been "one of the gems of original literature" (357).
14. *HHLM,* 167–68.
15. RB to IB, Rome, May 19, 1860, *DI,* 65. A variation is found in Cobbe, chap. 14, 28–29.
16. Honour, 146–59.
17. Wittkower, 167–88.
18. Honour, 150. Honour quotes from Lady Eastlake, ed., *Life of John Gibson,* 48.
19. Hosmer (1), 734–37. On the process of sculpture as Hiram Powers practiced it, see Roberson. An eyewitness recollection of the armature in the studio of Daniel Chester French came from his niece Dorothy Van Slyke, in an interview with the author, September, 1980. The "butterflies" are described by Margaret French Cresson, *The Life of Daniel Chester French: Journey into Fame* (Cambridge: Harvard University Press, 1947), 45–49. French was instructed in the procedure by May Alcott, sister of Louisa May Alcott.
20. Both Wittkower and Honour discuss the process of mechanical transfer with the pointing apparatus. Each includes a plate showing the pointing apparatus from Francesco Carradori, *Istruzione elementare per gli studiosi della scultura* (Florence: n.p., 1802). The Villa Carlotta, at Tremezza on Lake Como, has a collection that includes Canova's *Love and Psyche* and a frieze by Thorwaldsen. A museum of Canova's works is located at his home and studio at Possagno. Many bear the marks of the pointing apparatus.
21. HH's first assignments are discussed in Ellet and LMC (1). See also *HHLM,*

23. In the AnonBio, the "Tasso of the British Museum," as CC and LMC wrote it, is merely "torso."

22. WWS to James Russell Lowell, February 11, 1853, Hudson, 269–73.

23. *HHLM,* 309–11.

24. "Life of Harriet Hosmer," anonymous review of *HHLM, Nation* 95, no. 2467 (October 10, 1912): 340–42.

25. HH to CC, December 1, [1852], SLRC. CC used much of this letter in *HHLM,* 22–23.

Notes to Chapter 6: A High-handed Yankee Girl

1. HH to CC, December 1, [1852], SLRC.

2. WWS to James Russell Lowell, Rome, February 11, 1853, Hudson, 269–73.

3. Ibid.

4. Lippincott, 239.

5. James, 1:9–21.

6. Ritchie, 192–94.

7. Gaunt, 39–43.

8. AKS to HH, [ca. 1867], SLRC.

9. Fanny Kemble Wister, *Fanny, the American Kemble: Her Journal and Unpublished Letters* (Tallahassee: South Pass Press, 1972). Hare, 4:376.

10. FAK to WC, October 8, 1853, *HHLM,* 27–28.

11. Thomas Crawford to his wife, Louisa, Rome, November 12, 1856, Crawford.

12. Gaunt, 24–29.

13. *HHLM,* 337–41.

14. *Leighton* 1:146.

15. Ibid., 2:166.

16. Ormond, 22–25.

17. *Leighton* 1:195, 2:289.

18. Gaunt, 46–50.

19. *HHLM,* 337–41. Subsequent recollections of HH are from the same source.

20. AKS to HH, Paris, [1855–1856], SLRC.

21. James, 2:47.

22. FAK to WC, October 8, 1853, *HHLM,* 27–28.

23. EBB to IB, May 8, [1854], Fitzwilliam.

24. RB to HH, Florence, November 16, 1854, *HHLM,* 44–47.

25. RB to the Story family, Florence, December 27, 1854, Hudson, 35–36.

26. HH to EBB and RB, Rome, January 19, [1855], Scripps.

27. RB to HH, Florence, February 21, 1858, *HHLM,* 120–21.

28. LMC to Sarah (Sturgis) Shaw, Wayland, October 25, 1857, LMC/*Corr,* microfiche 37/1026.

29. RB to IB, [January 7, 1859], *DI,* 24.

30. WWS to James Russell Lowell, February 11, 1853, Hudson, 269–73.

31. Lippincott, 216–18.

32. AKS to HH, Warsash on the Hamble, [1869 or after], SLRC.

33. HH to CC, April 22, 1853, *HHLM,* 26–27.

Notes to Chapter 7: *Daphne* and *Medusa*

1. HH to WC, June 11, [1853], SLRC. The date of this letter was altered to read April 10, 1853, in *HHLM,* probably to close the gap in correspondence. Subsequent references are to this letter.

2. *Ovid,* 1:623. For more on Daphne, see Edith Hamilton, *Mythology* (New York: New American Library with Little, Brown & Co., 1963), 114–15.

3. Hibbard, 48–54; Clark, 388–89. See also John Canaday, *What Is Art?* (New York: Alfred A. Knopf, 1980), 363–64.

4. *HHLM*, 334; Wittkower, 185–88.

5. The story of Medusa appears in *Ovid*, bk. 4, although *Ovid* is not an exclusive source, as it is with the story of Daphne. Quotations are from 4:971, 972, 975, 977.

6. Edward Tripp, ed., *Crowell's Handbook of Classical Mythology* (New York: Thomas Y. Crowell Co., 1970), asserts that Medusa's beauty is the product of later versions of the myth (463–64). See also Gerdts (4). The remarks of HH are contained in a manuscript in her handwriting, SLRC.

7. Bradford, 265–69.

8. Gerdts (4) cites the greater refinement of Hosmer's finishing of *Daphne* and *Medusa*, as compared with the earlier *Hesper*. Art historian Christine Jones Huber, in one of several conversations with the author, 1980–1981, emphasized the continuing problem for sculptors in terminating a bust.

9. Northrop Frye, *The Great Code: The Bible and Literature* (New York: Harcourt Brace Jovanovich, 1981–1982), xviii.

10. A fragment in the Hosmer folder of clippings and memorabilia, NYPL.

11. Letter written by an unidentified friend to the Reverend Robert Collyer, 1867, *HHLM*, 221–22.

12. HH to WC, June 11, [1853], SLRC.

Notes to Chapter 8: "The Perfection of All That Is Charming"

1. An excerpt from Hosmer (2), *HHLM*, 48–50.

2. James, 1:116. See also Ward, 206–26.

3. EBB to Mrs. David Ogilvy, Rome, January 24, [1854], in *Elizabeth Barrett Browning's Letters to Mrs. David Ogilvy, 1849–1861,* ed. Peter N. Heydon and Philip Kelley (New York: Quadrangle/New York Times Book Co. and Browning Institute, 1973), 110–11.

4. Freeman, 1:35–45; James, 1:367.

5. Ritchie, 190–93.

6. EBB to Henrietta Cook, December 30, [1853], Houghton.

7. EBB to IB, May 8, [1854], Fitzwilliam.

8. EBB to Henrietta Cook, March 4, [1854], Houghton.

9. EBB to Arabel Moulton-Barrett, April 3, [1854], Berg; *HHLM*, 46–47.

10. A typescript in SLRC duplicates HH's handwritten notes for an address in Chicago in which she gave an account of the modeling of the *Clasped Hands of the Brownings*. A note from CC on the typescript informs that Hosmer refused five thousand dollars for the *Clasped Hands* in England but that CC had to buy them from the court after HH's death. The cast that she purchased is the one given to the Schlesinger Library by Isabella Carr Thompson Leighton (Mrs. Delmar Leighton) as a part of the Hosmer Collection.

11. For measurements of the bronze casting, see item 20-R-1 BC, ABL.

12. *HHLM*, 48–50. See also Ward, 225–26.

13. Ritchie, 190–93.

14. *HHLM*, 99.

15. Ritchie, 190–93.

16. Descriptions of RB from *HHLM*, 48–50; James, 1:172, 269; Ritchie, 190–93.

17. EBB to Mary Russell Mitford, Rome, May 10, [1854], *EBB-MRM*, 3:409.

18. Dorothie Bobbe, *Fanny Kemble* (New York: Minton, Balch and Co., 1931), 256.

19. HH to CC, April 22, [1854], SLRC; EBB to Sarianna Browning, [June 8, 1854], *LEBB,* 167.

20. EBB to Mary Russell Mitford, May 10, [1854], *EBB-MRM* 3:409.

21. Ibid.

22. Ward, 199. In a MS in SLRC, Hosmer indicated that she, too, "enjoyed hospitality" at George Sand's villa at a later date. She commented on Sand's "noble face" and "magnificent eyes" but was otherwise noncommittal.

23. *HHLM,* 106–14.

24. Ibid.

25. Ward, 215. Ward states that C. Day Lewis called the poem "the most perfect of Browning's lyrics."

Notes to Chapter 9: Womanly Concerns and Girlish Escapades

1. HH to WC, January 9, [1854], SLRC.

2. Ibid. The *Daphne* on display in HH's studio was purchased by Mrs. Samuel Appleton of Boston, *HHLM,* 23–24. The second repetition was the "love-gift" to the Crow family, which is now located in Steinberg Gallery, Washington University, St. Louis, the institution that recognizes Wayman Crow as its founder. Another *Daphne* can be seen in the American Wing of the Metropolitan Museum of Art.

3. HH to CC, April 22, [1853], SLRC.

4. Ibid.; *HHLM,* 23–24. Subsequent renderings of *Medusa* were bought by Lady Marian Alford and the Duchess of St. Albans. The only known *Medusa* extant is in the collection of the Detroit Institute of Arts.

5. HH to WC, January 9, [1854], SLRC.

6. Jarves, 212.

7. HH to WC, October 12, 1855, SLRC.

8. HH to CC, June 12, [1853], SLRC.

9. Ibid. *John Gilpin's Ride* (1782), William Cowper's humorous poem, was a favorite of nineteenth-century readers.

10. A letter dated only "Sunday," apparently written just after the previous one, found in the Carr papers in recent years and now in the Hosmer Collection, SLRC.

11. Ibid.

12. HH to CC, October 30, [1854], SLRC. For CC's wedding date, I am indebted to Earl K. Holt III, minister of the First Unitarian Church, St. Louis.

13. HH to WC, June 17, [1854], SLRC.

14. HH to WC, March 2, [1854], SLRC.

15. HH to WC, August 7, 1855, SLRC.

16. HH to WC, October 12, 1855, SLRC.

17. HH to WC, August 7, 1855, SLRC.

18. Thomas Crawford to his wife, Louisa, July 5, 1854, Rome, Crawford, microfilm D-181, letter 0783.

19. Thorp, 116, 10.

20. Thomas Crawford to Louisa Crawford, July 5, 1854, Crawford, microfilm D-181, letter 0783.

21. McAleer, 89–99. The frontispiece in McAleer, reproduced from a painting by Florentine artist George Mignaty, shows the drawing room as it was at the time of EBB's death in 1861.

22. AKS to EBB, [August 1, 1854], Beinecke Rare Book and Manuscript Library, Yale University Library, New Haven, Conn.

23. EBB to Sarianna Browning, [September 18, 1854], Schiff.

24. EBB to Arabel Moulton-Barrett, with a note from Penini enclosed, September [12–]13, [1854], Berg.

25. EBB and RB to AKS, September 14, 1854, Scripps.

26. *HHLM*, 99-106, as reprinted from Hosmer (2). In this account from pt. 2, pp. 599-600, it is difficult to tell whether the incident occurred during the summer of 1854, which HH calls "the happy summer," or later. "Ba," the pet name given to EBB by her brother and retained by RB, meant "half a baby."

27. EBB and RB to HH, November 16, 1854, *HHLM*, 44-47.

28. Ibid.

29. FAK to HH, London, December 9, 1854, *HHLM*, 50-52.

30. HH to EBB and RB, January 19, [1855], Scripps.

31. Ibid.

32. HH to EBB and RB, April 6, [1855], Scripps.

33. EBB to Arabel Moulton-Barrett, August 22, [1854], Berg.

34. Bosco, 57-119. Bosco quotes from Elizabeth Kinney's journal and personal reminiscences, both MSS in Edmund Clarence Stedman Collection, Columbia University Library, New York City. In a letter from EBB to Elizabeth Kinney [ca. May, 1855], EBB says that "last night the costumes arrived—but in the matter of wigs we are in adversity" (ABL). A holograph by Elizabeth Kinney's daughter, Mary Kinney Easton, attests to her memory of the incident, which happened when she was "about eleven or twelve." Ronald Hudson supplied the information from the Kinney papers at Columbia University that Mary was born August 29, 1843.

35. Ibid.

Notes to Chapter 10: *Puck* and *Oenone*

1. *HHLM*, 24-25.

2. *Harper's Dictionary of Classical Literature and Antiquities,* ed. Harry Thurston Peck (New York: Harper and Bros., 1896), 1127.

3. George O. Marshall, Jr., *A Tennyson Handbook* (New York: Twayne Publishers, 1963), 63-65; Alfred Lord Tennyson, *Poems of Alfred Lord Tennyson,* selected, with a biographical introduction and notes, by Charles Tennyson (London: Collins, 1954), 38-40, 191-93.

4. HH to WC, August 7, 1855, and October 12, 1855, both in SLRC.

5. HH to WC, Albano, September 13, [1856]; HH to CC, June, [1856], SLRC.

6. In a conversation with the author, Phoebe Weil, senior conservator at Washington University Technology Associates, pointed out the differences in texture and polish of the marble of *Oenone* at the Steinberg Gallery, Washington University, St. Louis, November, 1981.

7. Ellet, 365-68.

8. HH to WC, August 7, 1855, SLRC; EBB to IB, [December 5-6, 1855], and December 24, [1855], Fitzwilliam. Sarah Freeman Clarke (1808-1896), not to be confused with Sara Jane Clarke Lippincott (Grace Greenwood), was a landscape painter who studied with Washington Allston and lived in Italy over a period of years. A sister of the Unitarian minister James Freeman Clarke, she was a friend of the late Margaret Fuller Ossoli and also a friend of HH, although not an intimate one.

9. RB to Edith Story, April 4, 1872, Hudson, 169-72.

10. HH to Anne Dundas, Albano, September 27, [1856], *HHLM*, 73-78.

11. AnonBio; HH first mentions "a little figure" in the letter to WC, August 7, 1855, SLRC. For comments on *Puck,* see *HHLM*, 79. Repetitions of *Puck* are in the collections of the National Museum of American Art, Smithsonian Institution; the Wadsworth Atheneum, Hartford, Conn.; and the Chrysler Museum, Norfolk, Va., as well as in private collections. A piece entitled *Puck and the Owl,* signed "Harriet Hosmer, Roma," is in the collection of the Boston Athenaeum.

12. Jarves, 220.

13. "The Prince of Wales at Miss Hosmer's Studio," *Harper's Weekly* 3 (May 7, 1859): 293.

14. *HHLM,* 53–54.

15. Hiram Hosmer to Lucien Carr, [1855], SLRC; interview by the author with Isabella Thompson Leighton, November, 1979. Mrs. Leighton supplied valuable details about the Carr and Crow families. She also recalled HH, "Aunt Hatty," from her earliest childhood. Lucien Carr served as assistant curator at the Peabody Museum, a fact corroborated by information from the Archives of the Peabody Museum.

16. *HHLM,* 54–55.

17. HH to WC, August 7, 1855, SLRC.

18. Ibid.

19. HH to CC, [1856], SLRC. HH refers to a new baby in the Crow family—Isabel: "Does she look anything like that sweet little Alice whom I always remember as the beauty of beauties?"

20. RB and EBB to HH, January 8, 1856, Paris, *HHLM,* 58–61; EBB to Julia Martin, December 19, [1855], "Unpublished Letters of Thomas de Quincey and Elizabeth Barrett Browning," ed. S. Musgrove, *Auckland University College Bulletin* 44 (1954): 23.

21. EBB to Julia Martin, December 19, [1855], "Unpublished Letters"; RB and EBB to HH, January 8, 1856, *HHLM,* 58–61. Subsequent quotations are from this letter.

22. HH to Anne Dundas, January 13, [1861], *HHLM,* 169–70.

23. HH to WC, October 12, 1855, SLRC.

Notes to Chapter 11: *Beatrice Cenci*

1. Earl K. Holt III, *William Greenleaf Eliot: Conservative Radical* (St. Louis: First Unitarian Church of St. Louis, 1984), 48–50; HH to WC, March 2, 1854, SLRC.

2. HH to WC, April 27, [1868], and HH to WC, [1869], SLRC. See also George McCue, *Sculpture City: St. Louis* (New York: Hudson Hills Press in association with Laumeier Sculpture Park, St. Louis), 42.

3. HH to WC, June 17, 1854, SLRC.

4. HH to WC, October 12, 1855, SLRC.

5. Albert Borowitz, "The Cenci Affair," *Opera News* 17 (March, 1973): 10–13.

6. Maria Luisa Ambrosini and Mary Willis, *The Secret Archives of the Vatican* (Boston: Little, Brown & Co., 1969), 207–12.

7. Borowitz, "The Cenci Affair," 13. The author saw the Guerrazzi book and other memorabilia at the Albergo Due Torri, a hotel in Verona, well over a century old.

8. Richard Holmes, *Shelley: The Pursuit* (New York: E. P. Dutton and Co., 1975), 512–17.

9. Mario Scotti, "Keats, Shelley, and Byron in Italian Literature," *I Poeti Romantici Inglesi E L'Italia,* catalogue for an exhibition at the Palazzo Braschi, Rome, from December 16, 1980, to January 31, 1981, sponsored by the Keats-Shelley Memorial Association in cooperation with the Assessorato alla Cultura del Comune di Roma, Sovrintendenza Archivistica per il Lazio, 72, 74.

10. Arline Thorn, "Shelley's *The Cenci* as Tragedy," *Costerus: Essays in English and American Language and Literature* 9 (1973): 219–28.

11. Holmes, *Shelley,* 517.

12. See Scotti, "Keats, Shelley, and Byron," 78, for more on attribution of the portrait of Beatrice Cenci.

13. *Notebooks,* February 20, 1858, pp. 92–93; May 15, 1859, pp. 520–21.

14. AnonBio; newspaper clipping describing HH's remarks to a women's club, *St. Louis Globe,* December 12, 1888, SLRC.

15. HH to Anne Dundas, Albano, September 27, [1856], *HHLM,* 73–78. This letter has not been located, so it is difficult to know whether CC edited it.

16. FAK, *Records of a Girlhood* (New York: Henry Holt and Co., 1879), 302. See also Thorp, 116. For further reading on the *nudo,* see Gerdts (1), (2), and (3).

17. Negro, 349. Negro quotes from Luigi Delatre, *Ricordi di Roma di Luigi Delatre* (Florence, n.p.: 1870), 90.

18. Matilda Hayes to CC, April, 1856, *HHLM,* 69–70.

19. Thomas Crawford to his wife, Louisa, November 12, 1856, Crawford, No. 0922.

20. HH to Anne Dundas, Albano, September 27, [1856], *HHLM,* 73–78.

21. "People Miss Hosmer Met," an unidentified newspaper clipping [ca. 1890], SLRC.

22. HH to Anne Dundas, Albano, September 27, [1856], *HHLM,* 73–78.

23. HH to CC, Albano, September, 1856, SLRC.

24. HH to CC, April, [1856], SLRC.

25. HH to CC, June, [1856], SLRC.

26. HH to WC, Albano, September 13, [1856], SLRC.

Notes to Chapter 12: The Homecoming

1. HH to WC, November 30, [1856], SLRC. CC dated this letter 1857, but HH received the Falconnet commission in 1856.

2. Negro, 214–15.

3. HH to WC, November 30, [1856], SLRC.

4. Freeman, 1:69–70; Francesco Alberto Salvagnini, *La Basilica di Sant' Andrea Delle Fratte,* 2d ed. (Rome: Basilica di S. Andrea delle Fratte, 1967), 19.

5. Ibid. Information about the miracle was given to the author by one of the *padri minimi* at the church.

6. Hibbard, 198–206. See also Mark Weil, *The History and Decoration of the Ponte S. Angelo* (University Park: Pennsylvania State University Press, 1974).

7. HH to Anne Dundas, December 13, [1856], *HHLM,* 117.

8. For more on the Falconnet monument, see Barbara S. Groseclose, "Harriet Hosmer's Tomb to Judith Falconnet: Death and the Maiden," *American Art Journal* 12, no. 2 (Spring, 1980): 78–89.

9. HH to WC, November 30, [1856], SLRC. The deed of trust was signed by WC in behalf of FAK (MoHis).

10. HH to WC, February 15, [1857], SLRC.

11. Ibid.

12. Ibid. The Talbot medallions are in HHWL.

13. HH to WC, November 30, [1856], SLRC.

14. HH to WC, February 15, [1857], SLRC.

15. HH to WC, London, July 25, 1857, SLRC.

16. CC incorporated the passage cited into letter cited in n. 15, above, *HHLM,* 82–83.

17. HH to WC, London, July 25, 1857, SLRC.

18. Ibid.

19. Ibid.

20. Ticknor, 371, 383–84; an extract in what appears to be HH's handwriting, SLRC. See also JC/AAA.

21. Ibid.

22. HH to WC, Watertown, September 27, [1857], SLRC.

23. Robbins, 440–51.

24. LMC (1).

25. LMC to Sarah Sturgis Shaw, Wayland, October 25, 1857, LMC/*Corr,* microfiche 37/1026.

26. Ibid.; LMC to Harriet Winslow Sewall, Wayland, July 10, 1868, LMC/*Corr,* microfiche 69/1841.

27. LMC to Convers Francis, Wayland, October 25, 1857, LMC/*Corr,* microfiche 37/1025.

28. A manuscript in Hosmer's handwriting (SLRC) is prefaced by the statement: "I recd the enclosed clipping from the octogenarian artist Peale of Phil—."

29. John Gibson to HH, [London], September 5, 1857, *HHLM,* 87–89.

30. John Gibson to HH, Rome, October 26, 1857, *HHLM,* 89.

31. Records of Bellefontaine Cemetery (St. Louis) give the cause of death for the child Wayman Crow Carr as an "inflammation of the brain." The grave was moved from a previous site to Bellefontaine in 1865; the burial certificate was signed by Wayman Crow. Quoted material is from HH to CC, Watertown, September and October, [1857], SLRC.

32. HH to CC, September, [1857], and HH to WC, Watertown, October, [1857], SLRC.

33. HH to WC, [October, 1857], SLRC.

34. Ibid.

35. LMC to Marianne Cabot Devereux Silsbee, October 25, 1857, LMC/*Corr,* microfiche 37/1027.

36. Ibid.

37. Ibid.

38. *HHLM,* 91.

Notes to Chapter 13: Interval in Florence

1. RB to HH, October 19, 1857, *HHLM,* 93–94. Transcript of deleted portion, SLRC.

2. James, 2:90–93.

3. *HHLM,* 49.

4. EBB to Fanny Haworth, [October 22, 1857], Fitzwilliam.

5. EBB to Arabel Moulton-Barrett, [1857], Berg.

6. McAleer. See also Philip Kelley and Betty Coley, comps., *The Browning Collections: A Reconstruction with Other Memorabilia* (Winfield, Kans.: Wedgestone Press, 1984).

7. Nathaniel Hawthorne, "An Evening at the Brownings," a selection from *The French and Italian Notebooks,* in *The Portable Hawthorne,* rev. ed., ed. Malcolm Cowley (1948; reprint, New York: Viking Press, Penguin Books, 1976), 667. See also *Notebooks,* June 9, 1858, pp. 302–3.

8. Cobbe, 14–15.

9. McAleer, 34.

10. Cobbe, 27.

11. Francis Steegmuller, *The Two Lives of James Jackson Jarves* (New Haven: Yale University Press, 1951), 118–20.

12. Ibid.

13. *Notebooks,* September 11, 1858, pp. 415–17.

14. HH to CC, November 12, [1858], SLRC; RB to IB, September 4, 1858, *DI,* 18.

15. HH to LMC, Watertown, [1857], MoHis. On Anna Ticknor's drawings, see LMC to HH, August 21, 1858, SLRC. See also *HHLM,* 126–7.

16. HH to Isabel Conn Crow, February, 1858, SLRC.

17. HH to FAK, Rome, December 10, [1857], p. 89; MSS W. b. 597, Folger Shakespeare Library, Washington, D.C. I am indebted to Sandra Donaldson for calling this letter to my attention.
18. HH to WC, December 9, 1857, SLRC.
19. HH to Anne Dundas, December 13, 1857, *HHLM,* 116–18; HH to WC, February 15, 1857, SLRC.
20. Item no. 17, pp. 69–71, from Maria Mitchell Memorabilia, Maria Mitchell Science Library, Nantucket, Mass.
21. Ibid.
22. HH to WC, December 9, 1857, SLRC.
23. HH to WC, a letter written to accompany the presentation of *Beatrice Cenci* to the Mercantile Library, St. Louis. The typescript is printed in "Forty Years of Long Ago," a chronological history of the Mercantile Library's first years, by Clarence Miller.
24. HH to WC, December 9, 1857, SLRC.

Notes to Chapter 14: Via Gregoriana
1. Cushman to EC, February 3, 1858, Cushman/LC.
2. Cobbe, 30; Cushman to EC, February 22, 1858, Cushman/LC.
3. Cushman to EC, [1858], Cushman/LC.
4. Cushman to EC, Staten Island, 1858, Cushman/LC.
5. Cushman to EC, n.d., Cushman/LC.
6. Cushman to EC, [1858], Cushman/LC.
7. Stebbins, 100.
8. Cushman to EC, Baltimore, April 27, 1858, Cushman/LC.
9. HH to CC, January 8, 1858, SLRC; Cushman to EC, Baltimore, May 3, 1858, Cushman/LC.
10. HH to WC, March 11 and July 17, [1858], SLRC.
11. HH to WC, July 17, [1858], SLRC.
12. Hiram Hosmer to WC, February, 1858, SLRC.
13. Hiram Hosmer to WC, November 26, 1858, SLRC.
14. HH to WC, January 14, 1859, SLRC.
15. Cushman to Sallie Mercer, July 18, 1855, Cushman/LC.
16. Cushman to EC, Rome, November, 1858, Cushman/LC.
17. Stebbins, 112–13.
18. HH to WC, December 2, 1858, SLRC.
19. Cushman to EC, March, 1859, Cushman/LC.
20. HH to WC, December 2, 1858, SLRC.
21. HH to WC, [1859], SLRC.
22. *Notebooks,* February 13, 1858, p. 71.
23. Ibid., April 22, 1858, p. 179.
24. Ibid., April 3, 1858, pp. 157–58; Nathaniel Hawthorne, *The Marble Faun,* chap. 12.
25. *Notebooks,* April 3, 1858, pp. 157–58.
26. Ibid., May 23, 1858, pp. 228–29.
27. The description of HH's fountain, Ellet, 368–69.
28. EBB to IB, December 12, [1858], Fitzwilliam.
29. Ibid.
30. HH to CC, November 12, [1858], and January 14, [1859], SLRC.
31. Cushman to EC, Rome, November, 1858, Cushman/LC.
32. HH to WC, December 2, 1858, SLRC.

Notes to Chapter 15: Gossip in the Caffè Greco

1. HH to WC, December 2, 1858, SLRC.
2. Jarves, 275; "The Beatrice Cenci," *Crayon* 4 (December, 1857): 379.
3. Taft, 204–5.
4. HH to CC, November 30, [1857], SLRC; HH to Isabel Conn Crow, March 11, 1858, *HHLM,* 122–24; Cushman to EC, November, 1858, Cushman/LC.
5. HH to WC, December 2, 1858, SLRC.
6. HH to WC, [1859], and HH to CC, February 26, [1859], SLRC.
7. HH to WC, [1859], SLRC.
8. Anna Jameson to HH, Brighton, October 10, [1858], *HHLM,* 149–51.
9. Ibid. See also Susan Waller, "The Artist, the Writer, and the Queen: Hosmer, Jameson and *Zenobia,*" *Woman's Art Journal* 4, no. 1 (Spring–Summer, 1983): 21–28. For HH's response to Jameson, Waller quotes from Mrs. Steuart Erskine, *Anna Jameson: Letters and Friendships, 1812–1860* (London: T. Fisher Unwin, 1915), 243–45.
10. RB to IB, Rome, [January 7, 1859], *DI,* 24, and February 15, [1859], *DI,* 36.
11. EBB to IB, ibid., 32–33.
12. *Notebooks,* October, 1858, p. 488, and March 15, 1859, pp. 508–10.
13. Ibid.
14. Taft, p. 208.
15. Nathaniel Hawthorne, Preface to *The Marble Faun,* dated December 15, 1859, Leamington, England, in *The Complete Novels and Selected Tales of Nathaniel Hawthorne,* ed. Norman Holmes Pearson (New York: Modern Library, 1937).
16. HH to WC, September 14, 1859, SLRC.
17. Palmer, 513–17; Maurois, 430–31; Albrecht-Carrié, 25–43.
18. HH to WC, September 14, 1859, SLRC.
19. HH to WC, [October, 1859], SLRC; Cushman to WC, August 17, 1859, Cushman/LC.
20. HH to WC, [October, 1859], SLRC.
21. HH to CC, November 12, 1859, SLRC.
22. Ibid.
23. HH to WC, December, [1859], SLRC.
24. Cushman to EC, [1859], Cushman/LC.
25. HH to WC, March 3, 1860, SLRC.
26. LMC to HH, Wayland, October, 1859, SLRC.
27. RB to IB, Rome, March 27, [1860], *DI,* 57.

Notes to Chapter 16: Tribulation and Triumph

1. HH to CC, HH to WC, both dated Watertown, April 18, [1860], SLRC.
2. HH to WC, Watertown, May 20, [1860], SLRC.
3. HH to WC, Watertown, June 20, [1860], SLRC.
4. HH to WC, Rome, May 5, [1858], SLRC.
5. HH to WC, July 17, [1859], SLRC.
6. HH to WC, December 29, [1859], SLRC.
7. Ibid.
8. HH to WC, Watertown, June 20, [1860], SLRC.
9. HH to WC, n.d., SLRC. This letter is difficult to place in the chronology of events relating to the Benton commission but clearly relates to it.
10. HH to WC, Watertown, June 21, [1860], and HH to CC, Watertown, October 19, [1860], SLRC.
11. HH to LMC, Watertown, August 24, [1860], LMC/*Corr,* microfiche 46/245.

12. HH to WC, Watertown, August 16, [1860], SLRC. *Crayon* 7, no. 9 (September, 1860), SLRC.

13. HH to CC, May 20, [1860], SLRC.

14. Ernest Kirschten, *Catfish and Crystal* (Garden City: Doubleday and Co., 1960), 135–49. For criticism of Benton, see Malcolm Keir, "The March of Commerce," *The Pageant of America* (New Haven: Yale University Press, 1927), 4:148.

15. LMC to HH, Wayland, July 7, 1860, SLRC.

16. HH to WC, Watertown, June 21, [1860], SLRC.

17. HH to CC, Watertown, July 8, [1860], SLRC.

18. HH to WC, August 28, [1860], SLRC.

19. *HHLM*, 362.

20. HH to WC, Watertown, August 20, [1860], MoHis.

21. George Steadman to William Torrey Harris, Brunswick, [Mo. or Ky.], October 17, 1860, Harris Papers, MoHis.

22. HH to CC, Watertown, May 20, [1860], SLRC.

23. Sir Henry Layard to HH, London, June 27, 1860, *HHLM*, 159–61.

24. HH to WC, Rome, March 4, [1861], SLRC; Ormond, 42.

25. Souvenir program from the ball, JC/AAA.

26. HH to CC, Watertown, October 19, [1860], SLRC.

27. RB to IB, Rome, December 3, 1860, *DI*, 67.

28. HH to Sophia Peabody Hawthorne, Rome, [1859 or 1860], SLRC.

29. Ibid.

30. HH to CC, Watertown, July 8, [1860], SLRC.

31. Undated postscripts and fragments, SLRC.

32. HH to WC, undated letter written in pencil, SLRC.

33. HH to Hiram Hosmer, Rome, November 16, 1860. This letter appears in *HHLM*, 165–66, addressed to Wayman Crow. Whether this was an error or an intentional change is not clear. In the letter, Hosmer asks her father to send the letter on to Mr. Crow.

Notes to Chapter 17: "Our Colonel" and the Loss of a Friend

1. HH to WC, November 23, [1860], SLRC.

2. HH to WC, February 23, [1860], SLRC. This was probably written before HH's forced trip to America. The recovery of HH's "sketch of the monument" is told in a letter from EBB to IB, [April 16–17, 1860], Fitzwilliam.

3. HH to WC, March 4, [1861], SLRC.

4. HH to WC, March 15, [1862], SLRC.

5. HH to WC, March 4, [1861], SLRC.

6. *HHLM*, 175–76.

7. HH to WC, May 10, 1861, SLRC. Also in *HHLM*, 175, with certain minor phrases deleted.

8. LMC to HH, Wayland, September 16, 1860, SLRC.

9. EBB to IB, March 20, [1860], Fitzwilliam.

10. Florence Compton (Lady Alwyne Compton) to CC, 1911, SLRC.

11. EBB to IB, [January(?) 28, 1860], *DI*, 54. See also EBB to IB, [February(?) 28, 1860], Fitzwilliam.

12. HH to WC, June, [1861], SLRC; EBB to IB, [May 18, 1861], Fitzwilliam; HH to CC, June 17, 1861, SLRC.

13. McAleer, 81; EBB's comments, [ca. October 10, 1859], *LEBB*, 344.

14. McAleer, 87. On Andersen and the tin soldiers, see Freeman, 1:45–46. Hosmer's recollections are in *HHLM*, 177–78. On the children's party, see James, 1:285.

15. James 2:65–67. See also Margaret Forster, *Elizabeth Barrett Browning* (New York: Doubleday & Co., 1988), 364–67.

16. James, 2:52.

17. HH to CC, Antigniano, August 27, 1861, SLRC. CC changed the term of address to her father's name in her editing.

18. James, 2:65–67.

19. RB to HH, September 24, 1861, *HHLM,* 180, and SLRC.

20. RB to IB, September 19, 1862, and December 19, 1862, *DI* 126, 143.

21. HH to CC, Antigniano, August 27, 1861, SLRC.

22. HH to Anne Dundas, January 13, [1861], *HHLM,* 169–70.

23. HH to Anne Dundas, December 28, [1861], *HHLM,* 182–83. Subsequent references are also from this letter.

Notes to Chapter 18: A Place in the Crystal Palace and Repercussions

1. Nikolaus Pevsner, *The Sources of Modern Architecture and Design* (New York: Oxford University Press, 1981), 10–11.

2. HH to WC, March 15, [1862], SLRC.

3. James, 1:27.

4. HH to CC, [Spring, 1862], SLRC.

5. HH to WC, March 15, [1862], SLRC.

6. *Notebooks,* "Explanatory Notes," 740–42. See also JHawthorne, 183.

7. John Rogers, Jr., to Henry Rogers, Rome, February 13, 1859, Miscellaneous MSS, Rogers, John, Jr., Manuscript Department, Library, New-York Historical Society. See also Charlotte Streifer Rubenstein, *American Women Sculptors* (Boston: G. K. Hall & Co., 1990), 56–63, and Joy S. Kasson, *Marble Queens and Captives* (New Haven: Yale University Press, 1990), 11–12.

8. HH to WC, [1861(?)], SLRC.

9. HH to WC, March 15, [1862], SLRC. On women in art, see Huber.

10. Margaret French Cresson, *The Life of Daniel Chester French: Journey into Fame* (Cambridge: Harvard University Press, 1947), 54–55.

11. HH to WC, March 15 [1862], SLRC.

12. Unsigned article in *Missouri Republican,* St. Louis, April 18, 1862; Thurston, 588.

13. RB to IB, July 19, 1862, *DI,* 110–11.

14. "Taste at South Kensington," *Temple Bar* 5 (July, 1862): 470–80, JC/AAA. Subsequently cited press notices and memorabilia relating to the International Exhibition, London, 1862, are in JC/AAA, unless otherwise cited.

15. J. Beavington Atkinson, "Modern Sculpture of All Nations in the International Exhibition," *Art Journal Illustrated Catalogue of the International Exhibition of 1862* (London: n.p., 1862), 313–24; and "Miss Hosmer's Statue of Zenobia," *New Path* 2 (April, 1865): 49–53.

16. "Taste at South Kensington," 478; J. Beavington Atkinson, "International Exhibition, 1862," *Art Journal* (December 1, 1862): 229–31.

17. Atkinson, "International Exhibition," 230; Atkinson, "Modern Sculpture," 323; "Miss Hosmer's Statue of Zenobia," 49–53.

18. "Obituary: Mr. Alfred Gatley," *Art Journal* 25 (September 1, 1863): 181.

19. J. Beavington Atkinson to Frances Power Cobbe, Bristol, February 28, 1864, and to WWS, Bristol, December 23, 1863, SLRC.

20. HH to WC, November 21, [1863], SLRC.

21. Ibid.

22. HH, "Correspondence: Miss Hosmer's *Zenobia,*" *Art Journal* 26 (January 1, 1864): 27.

23. A published statement by John Gibson, quoted in Cobbe, 28.

24. WWS, letter to "Our Weekly Gossip," *Athenaeum,* December 9, 1863, 840.

25. HH, "Correspondence: Miss Hosmer's *Zenobia,*" 27; RB to IB, London, December 19, 1863, *DI,* 182.

26. HH to Hiram Powers, January 19, 1864, Powers, no. 1145.

27. Ibid; Richard P. Wunder, "The Irascible Hiram Powers," *American Art Journal* 4 (November, 1972): 10–15.

28. *Notebooks,* Rome, April 3, [1858], pp. 153–56.

29. HH to Hiram Powers, January 19, 1864, Powers, no. 1145.

30. Hosmer (1).

Notes to Chapter 19: *Zenobia,* the Marble Queen

1. HH to WC, March 15, 1863, and November 7, 1863, SLRC.

2. HH to WC, [November, 1863], SLRC.

3. HH to WC, excerpts of undated letters [1862–1863], SLRC.

4. Ibid.

5. HH to WC, Edinburgh, July 27, [1864], SLRC.

6. HH to WC, Armistan, Scotland, August 11, 1864, and London, August 19, 1864, SLRC.

7. Elizabeth Sedgwick to HH, Lenox, October 27, 1864, SLRC.

8. HH to CC, New York, [October, 1864], SLRC.

9. Ibid.

10. HH to WC, Watertown, October 13, 1864, and New York, October 28, 1864, SLRC.

11. *HHLM,* 198–99. See also HH to CC, April 14, [1866], SLRC.

12. HH to WC, Watertown, October 13, 1864, SLRC.

13. "Harriet Hosmer and the English Journal 'Queen,'" *Boston Post,* undated clipping in scrapbook containing press notices and other memorabilia concerning HH and the exhibition of *Zenobia* in America. Subsequent newspaper and periodical references are from the scrapbook unless otherwise cited. JC/AAA.

14. *New York Times,* November 11, 1864, classified sec. For more on popular American culture, see Lawrence W. Levine, *Highbrow/Lowbrow* (Cambridge: Harvard University Press, 1988).

15. "Society News," *New York Home Journal,* November 19, 1864.

16. LMC to *Boston Evening Transcript,* February 2, 1865, p. 2, col. 2.

17. Anna E. Ticknor to HH, February 27, 1865, *HHLM,* 201–2; *Boston Commonwealth,* February 18, 1865.

18. John Greenleaf Whittier to Childs and Jenks Gallery.

19. "To Harriet Hosmer," G. S. Hillard, Boston, September, 1864, *HHLM,* 199; *HHLM,* 200–201.

20. John Greenleaf Whittier to Childs and Jenks Gallery. The connection to Ware's novel is also made in "Miss Hosmer's 'Zenobia,'" *Watson's Weekly Art Journal,* November 8, 1864.

21. A full account of the historical Zenobia, entitled "Zenobia," was written for the *Saturday Evening Gazette,* February 19, 1865, and addressed to "Gentle reader, art-lover, or critic."

22. Edward Gibbon, *The History of the Decline and Fall of the Roman Empire,* an abridgement by D. M. Low (New York: Harcourt, Brace and Co., 1960), 112–19.

23. Ibid., 116.

24. LMC to *Boston Evening Transcript,* February 2, 1865. Ware's Zenobia suffered a breakdown after the procession, withdrawing in silent grief (Ware, 430). *Boston Cultivator,* January 21, 1865.

25. *Boston Daily Transcript,* February 21, 1865; "A Friend in New York," *Boston Daily Transcript,* February 21, 1865.

26. *Portsmouth Chronicle,* February 13, 1865.

27. "Miss Hosmer's Statue of Zenobia," *New Path* 2 (April, 1865): 49–53.

28. Jarves, 211, 220.

29. CC selected the account of Zenobia in the *Atlantic Monthly* 14, no. 86 (December, 1864), as "the best" (appendix, *HHLM*).

30. "Miss Hosmer's Statue," *Boatswain's Whistle,* November 19, 1864.

31. HH to WC, December 10, [1864], SLRC.

32. Ibid.; HH to WC, London, November 28, [1864], SLRC.

33. Cushman to CC, London, [October, 1864], SLRC.

34. Ibid.

35. HH to WC, London, November 28, [1864], SLRC.

36. John Greenleaf Whittier to Childs and Jenks Gallery.

Notes to Chapter 20: Her Own Hearth in Rome and Success in Dublin

1. HH to WC, December 30, 1864, SLRC.

2. HH to WC, January 13, 1865, SLRC.

3. HH to WC, December 14, 1866, SLRC; Tuckerman, 574.

4. HH to WC, December 30, 1864, SLRC.

5. HH to WC, May 5, 1865, SLRC; Wynne, 5.

6. Wynne, 30–31. On Cushman's dislike of Stillman, see Leach, 318–19.

7. James, 2:127–28.

8. Gerdts (1), 57.

9. *The Marble Faun,* in *The Complete Novels and Selected Tales of Nathaniel Hawthorne,* ed. Norman Holmes Pearson (New York: Random House, 1965), 595. For more on *Hermes,* see Clark, 77.

10. Michael Richman, "The Early Public Sculpture of Daniel Chester French," *American Art Journal* 4, no. 2 (November, 1972): 97–115. Richman points out that both Thomas Ball and William Rinehart were working on statues of *Endymion,* which French saw. I am indebted to Michael Richman, editor of the French papers, for sending me French's letter to his stepmother, Pamela Prentiss French, April 12, 1875, in which he mentioned seeing the *Faun* statue in HH's studio. Barbara Roberts, conservator at Chesterwood in Stockbridge, Mass., substantiated the resemblance between French's *The Awakening of Endymion,* now at Chesterwood, and Hosmer's *Sleeping Faun.*

11. Busy Bee [pseud.], "Causerie on Harriet Hosmer," *Art Journal,* n.d., 19–21, SLRC. The author describes the subject of tinting statues as the source of a discussion during a dinner party at Hosmer's apartment.

12. HH to WC, May 20, 1865, SLRC.

13. HH to CC, July 3, 1865, and other correspondence concerning the Dublin Exhibition, SLRC.

14. HH to WC, June 30, 1865, SLRC. This letter, incompletely dated, was filled in by CC.

15. Ibid.

16. Homan Potterton, "Harriet Hosmer's Sleeping Faun," *Arts in Ireland* 2, no. 1 (1973): 22–25.

17. HH to WC, June 10, 1865, SLRC.

18. HH to WC, November 8 and November 15, 1865, SLRC.

Notes to Chapter 21: Monumental Matters

1. Wynne, 34.

2. *Lincoln,* 66–67.

3. Ibid., 53–54; HH to WC, November 15, [1865], SLRC.

4. *Lincoln,* 64–65.

5. Ibid., 67.

6. HH to WC, October 8, 1865, SLRC.

7. Copy of letter from HH to James E. Yeatman, Esq., Leghorn, September 15, 1866, SLRC.

8. *Lincoln,* 1.

9. William J. Hosking, "Lincoln's Tomb: Designs Submitted and Final Selection," *Journal of the Illinois State Historical Society* 50, no. 1 (Spring, 1957): 52-53; HH to WC, November 8, [1865], SLRC.

10. HH to WC, November 15, [1865], SLRC.

11. HH to CC, [November, 1865], SLRC; *HHLM,* 216. CC quotes from a letter written by HH to Lady Eastlake, Gibson's friend and biographer.

12. Freeman, 1:252 ff.

13. H. W., "John Gibson, R.A.," *Art Journal* 28 (1866): 113-15; RB to IB, London, December 19, 1864, and February 19, 1866, *DI,* 202, 231. See also "Life of Gibson, the Sculptor," *Nation* 10 (April 28, 1870): 273-74.

14. HH to WC, November, 1866, SLRC.

15. HH to CC, [1866], SLRC. At this date, CC was the mother of three children.

16. HH to WC, October 22, 1866, SLRC.

17. Ibid.

18. HH to WC, [December, 1866], SLRC. See also *HHLM,* 225-26.

19. The account of Rosa is in HH's handwriting, SLRC. It is also recorded in LMC/*Corr,* microfiche 71/1891, as LMC related it for an article called "Things Unaccountable," in the *Independent.*

20. Ibid.

21. HH to WC, December 31, 1866, SLRC.

22. HH to WC, August 5, 1866, SLRC.

23. HH to WC, October 22, 1866, SLRC. On the Rhode Island monument, see Thorp, 166.

24. HH to WC, November 16, [almost assuredly 1866], SLRC.

25. Ibid.

26. HH to WC, December 4, 1866, and [mention of "Carnival" indicates February, 1867], SLRC.

27. HH to WC, December 31, 1866, and January, 1867, SLRC. The Bowditch monument in Mount Auburn Cemetery was later recast in France.

28. HH to WC, December 31, 1866, and January 5, 1867, SLRC.

29. HH to WC, December 31, 1866, SLRC.

30. "The Freedmen's Monument to Abraham Lincoln," a letter from James E. Yeatman, on behalf of the commission, St. Louis, December 1, 1866, SLRC.

31. Ibid.

Notes to Chapter 22: A New and Intimate Friend

1. Lippincott, 226-32.

2. James, 2:125; HH to WC, [February, 1867], SLRC.

3. WWS to James Russell Lowell, Rome, April 28, 1848, Hudson, 237-38.

4. HH to WC, April 17, 1867, SLRC.

5. Wynne, 31-32.

6. HH to WC, November, 1866, SLRC. Information about Buchanan Read and the letters quoted were sent to the writer by Denison Burton (Mrs. Joseph A. Burton), a great-granddaughter of Mrs. Laing, Read's mother-in-law.

7. Busy Bee [pseud.], "Causerie on Harriet Hosmer," *Art Journal* [n.d. but presumably 1867 or 1868], SLRC.

8. Ibid.

9. Ibid.

10. *A Handbook of Rome and Its Environs,* 9th ed. (London: John Murray, 1869), xlii. I am indebted to the British Library for this source. Katherine Walker, "American Studios in Rome and Florence," *Harper's New Monthly Magazine* 33 (June, 1866): 101–5.

11. HH to WC, "At Lady Marian's," November 10, [1867], SLRC.

12. One of the fragments of memorabilia, SLRC.

13. LMC to Theodore Tilton, editor of the *Independent,* April 5, 1866, LMC/*Corr,* microfiche 64/1716. For more on Lewis and other women sculptors, see Charlotte Streifer Rubenstein, *American Women Artists from Early Indian Times to the Present* (New York: Avon Books, 1982); Rubenstein, *American Women Sculptors* (Boston: G. K. Hall & Co., 1990) 45–51; and David C. Driskell, *Two Centuries of Black American Art,* exhibition catalogue with notes by Leonard Simon (n.p.: Los Angeles Museum of Art with Alfred A. Knopf, 1976).

14. LMC to Theodore Tilton, April 5, 1866, LMC/*Corr,* microfiche 64/1716.

15. LMC to Harriet Winslow Sewall, Wayland, July 10, 1868, LMC/*Corr,* microfiche 69/1841. The manuscript is the property of MassHis.

16. Ibid.

17. Ibid.

18. HH to WC, n.d., SLRC. For more on Freeman, see Gerdts (5). For more on Margaret Foley, see Gerdts (5). See also *Watertown's Victorian Legacy: A Bicentennial Art Exhibition,* exhibition catalogue (Watertown, Mass.: Watertown Free Public Library, [1976]).

19. On Anne Whitney, see Elizabeth Payne Rogers, "Anne Whitney: Art and Social Justice," *Massachusetts Review* 12, no. 2 (Spring, 1971): 245–60. See also Rogers, "Anne Whitney, Sculptor," *Art Quarterly* 25 (Autumn 1962): 244–61. Gerdts (5) and Thorp, in their respective works, and *Watertown's Victorian Legacy* also provide information on Whitney.

20. A letter from an unidentified writer to the Reverend Robert Collyer, 1867, SRLC. See also *HHLM,* 221–24.

21. HH to WC, May 3, 1867, SLRC.

22. Ibid.

23. HH to WC, Paris, July 4, 1867, SLRC.

24. Thomas A. Bailey, *A Diplomatic History of the American People,* 7th ed. (New York: Appleton-Century-Crofts, 1964), 355–57; Wynne, 35–36.

25. Bailey, *A Diplomatic History,* 355–57.

26. AKS to HH, Warsash, n.d. but probably August or September, 1867, since she mentions the death of Pierce Butler (SLRC).

27. AKS to HH, September, [1867], and HH to CC, September, [1867], SLRC.

28. HH to CC, London, [1867], and October 13, [1870], SLRC.

29. *HHLM,* 355–56; MS in SLRC.

30. Hudson, 188–89. Hudson quotes from Lady (Walburga) Paget, *Embassies of Other Days* (London: n.p., 1923), 1:280–81. For a biography of Louisa Lady Ashburton, see Virginia Surtees, *The Ludovisi Goddess: The Life of Louisa Lady Ashburton* (Salisbury, England: Michael Russell, 1984).

31. Wynne, 90.

32. HH to WC, Ashridge, November 10, 1867, SLRC.

33. Wynne, 40–41, 5–6.

34. HH to LA, December 23, 1867, Ashburton; HH to CC, [1867], SLRC.

35. When the fountains were installed at Melchet Court is not clear, but they were in place in 1877. A repetition of *The Mermaid's Cradle* was placed in Fountain Square, Larchmont, N.Y., in 1893. For this information and photographs, I am

indebted to art historian Marlene Park. See also Judith Spikes, "Larchmont Fountain: A Feminist History," *New York Times* (October 12, 1980). HH to LA, two undated letters, Ashburton.

36. HH to LA, n.d., Ashburton.

37. HH to LA, n.d., but the greeting, "Dear Lady Ashburton," suggests an early letter, probably in the summer of 1867.

38. HH to CC, [February, 1867], and May 2, [1868], SLRC.

39. HH to WC, February, 1870, SLRC; *HHLM,* 280; HH to LA, n.d., Ashburton.

40. HH to LA, two undated letters, Ashburton.

41. HH to LA, two undated letters, Ashburton.

42. HH to WC, December 9, 1872, and an undated fragment to CC, almost surely December, 1872, SLRC.

43. HH to LA, [1875], Ashburton. A word that appears to be "all" is of uncertain transcription. If, in fact, the word is "all," it implies that the threesome, HH, LA, and Maysie, may earlier have acted out an informal tableau of Laocoön, in what became a private joke of double entendre.

Notes to Chapter 23: The Benton Bronze

1. "The Freedmen's Monument to Abraham Lincoln," *Art Journal* 1, no. 1 (January 1, 1868): 8.

2. HH to WC, January 20, 1868, SLRC.

3. Ibid.

4. RB to IB, March 19, 1868, *DI,* 295.

5. HH to WC, November 4, 1867, SLRC.

6. William J. Hosking, "Lincoln's Tomb: Designs Submitted and Final Selection," *Journal of the Illinois State Historical Society* 50, no. 1 (Spring, 1957): 51–61; HH to WC, February 21, [1868], SLRC.

7. HH to WC, February 21, [1868], SLRC.

8. The third letter from HH to WC written on February 21, [1868], SLRC.

9. Ibid.

10. HH to WC, March 26, 1868, SLRC.

11. Ibid.; HH to WC, Easter Sunday, [1868], SLRC.

12. HH to WC, Easter Sunday, [1868], SLRC.

13. HH to CC, [April, 1868], SLRC; HH to WC, May 7, [1868], SLRC.

14. HH to CC, [April, 1868], a fragment, and Cushman to CC, April 29, 1868, all in SLRC.

15. HH to WC, April 30, [1868], SLRC.

16. Ibid.; HH to WC, May 7, [1868], SLRC.

17. HH to WC, May 7, [1868], SLRC.

18. Ibid.

19. Ibid.

20. Ibid.

21. HH to WC, Easter Sunday, [1868], and April 30, [1868], SLRC.

22. HH to WC, July 1, [1868], SLRC; WC to HH, May 28, 1868, *HHLM,* 260–62.

23. WC to HH, May 28, 1868, *HHLM,* 260–62. See also Theodore Finkelston, "'Old Bullion' Bronzed," *Gateway Heritage* 11, no. 2 (Fall, 1990): 48–57.

24. WC to HH, St. Louis, May 28, 1868, *HHLM,* 260–62.

25. HH to WC, June 18, 1868, SLRC.

26. Ibid.; *HHLM,* 264–65. The title *chancellor* was not used until 1872, when Eliot received it.

27. James Yeatman to HH, St. Louis, June 19, 1868, *HHLM;* HH to WC, June 18, 1868, and July 1, [1868], SLRC.

28. Mark S. Weil, "The Serra Sculpture: How Public Is a Public Monument?" *St. Louis Literary Supplement* 1, no. 5 (September-October, 1977); Judge William B. Napton Diary, MoHis; HH to WC, [June, 1868], SLRC.

29. HH to WC, July 1, [1868], SLRC.

30. Ibid.

31. HH to WC, July 7, [1868], SLRC.

32. Ibid.

33. HH to WC, Paris, [July] 16, [1868], and Addiscombe, [July, 1868], SLRC.

34. HH to WC, July 29, [1869], SLRC; Karen J. Blair, *The Clubwoman as Feminist: True Womanhood Redefined, 1868–1914* (New York: Holmes & Meier Publishers, 1980), 15–38; Phebe A. Hanaford, *Women of the Century* (Boston: B. B. Russell, 1877), 268–71.

35. Hanaford, *Women of the Century,* 268–71; HH to WC, n.d. except "Just about off 10 P.M. on Tuesday," SLRC; Susan B. Anthony to HH, Rochester, N.Y., June 7, 1889, on stationery headed "National Woman Suffrage Association of the United States," SLRC.

36. HH to WC, Malvern, [England], [1871], SLRC.

37. HH's defense of Ream is referred to by Joan A. Lemp in "Vinnie Ream and Abraham Lincoln," *Woman's Art Journal* 6, no. 2 (Fall, 1985–Winter, 1986): 24–29. I am grateful to Ms. Lemp for supplying me with a copy of "Vinnie Vindicated," a letter signed by HH and dated Rome, April 3, 1871, which Ms. Lemp found in the Vinnie Ream Hoxie Papers in the Manuscript Division of the Library of Congress. Hosmer's statement was addressed to the editor of the *New York Tribune* and was reprinted in the *Daily Chronicle* (Portsmouth, N.H.), April 26, 1871.

38. Hosking, "Lincoln's Tomb," 51–61.

39. A description of HH's design for the Lincoln Monument at Springfield, Ill., is published in *HHLM,* appendix. A holograph in HH's handwriting (SLRC) is identical.

40. Hosking, "Lincoln's Tomb," 57.

41. HH to WC, December 2, [1868], SLRC.

42. Ibid.

43. HH to WC, Malvern, [England], [1871], SLRC.

44. A visit to the site of Lincoln Park, Washington, D.C., June 12, 1984, substantiated the account in *Lincoln,* 67–72. On the back of the monument, which is freestanding but has a frontal axis, is another plaque that names James Yeatman, George Partridge, and C. S. Greeley as the members of the Western Sanitary Commission, which was responsible for the erection of the work, entitled *Lincoln the Emancipator.*

Notes to Chapter 24: The Causes of a Quarrel

1. HH to WC, January 4, 1869, SLRC.

2. HH to WC, March 26, 1868, SLRC.

3. HH to WC, January 8, 1869, SLRC.

4. Wynne, 24–25.

5. HH to WC, January 4, 1869, SLRC.

6. For a description of Maria Sophia by the writer Clara Tschudi, see *HHLM,* 296–97. Negro, 460–64.

7. AnonBio. See also *HHLM,* 271–72.

8. Ibid.

9. HH to WC, January 13, 1865, SLRC; Stebbins, 132; HH to WC, January 13, 1865, SLRC.

10. HH to CC, August 16, 1869, SLRC.

11. HH to WC, Easter Sunday, 1868, SLRC. See also "Miss Hosmer and the

Master of the Roman Hounds," reprinted from the *New York Evening Post,* May 5, 1868, in the *Waltham Free Press,* May 22, 1868, SLRC.

12. HH to CC, August 16, 1869, SLRC.

13. Ibid.

14. Ibid.

15. HH to WC, June 8, 1869, SLRC.

16. HH to CC, August 16, 1869, and June 8, 1869, SLRC. Whether HH gave a second dinner party to honor the Longfellows is not clear. They are mentioned as guests in the letter to WC, January 4, 1868, when HH apparently entertained the Childs of Philadelphia as honored guests. Also, it seems unlikely that the story of her not inviting Charlotte Cushman to the event would have taken six months to come to light in her correspondence.

17. HH to WC, July 29, 1869, SLRC.

18. HH to CC, August 16, 1869, SLRC.

19. Ibid.

20. Ibid.

21. Cushman to CC, Edinburgh, October 15, 1869, SLRC.

22. Ibid.

23. Ibid.

24. HH to CC, July 1, 1875, and a fragment dated "Paris, 1871," in HH's handwriting, to CC, SLRC.

25. A letter signed by Stephen Weston Healy, Florence, Italy, January 28, 1874, under the headline "Alleged Art Frauds," *New York World,* Sunday, March 1, 1874, SLRC; HH to CC, April 8, [1874], SLRC.

26. HH to CC, June 18, [1874], SLRC.

27. HH to CC, April 26, 1876, SLRC.

28. HH to WC, July 29, 1869, SLRC. Franklin Simmons lived in Florence before settling in Rome. In spite of HH's ministrations, Mrs. Simmons died the following year.

29. Ibid.

30. Ibid.

31. *HHLM,* 275–76.

32. Ibid.

33. RB to IB, November 19, [1867], and February 19, 1866, *DI,* 285, 255.

34. Ibid. For analysis I am indebted to Whitla, 12–41.

35. Reprinted in Hudson, 189, from Lady (Walburga) Paget, *Embassies of Other Days* (London: n.p., 1923), 1:280–81; Whitla, 19; "Intimate Glimpses from Browning's Letter File," *Baylor Bulletin* 37 (September 1934): 3, 4.

36. "Intimate Glimpses," 3, 4.

37. RB to WWS, June 19, 1886, Hudson, 186; Whitla, 25; RB to Edith Story, April 4, 1872, Hudson, 170–71.

38. HH to LA, [June 1, 1873], and [May 31, 1873], Ashburton.

39. RB to Edith Story, Grantham, April 4, 1872, Hudson, 170–71.

40. A note quoting from WWS's letter to Emelyn Story, London, 1875, Hudson, 172; Whitla, 32–33; HH to CC, November 28, [1875], SLRC.

41. HH's note of introduction was enclosed in a letter signed RB to the Storys, April 4, 1887, Hudson, 190–91.

42. *HHLM,* 49; Lilian Whiting, *Women Who Have Ennobled Life* (Philadelphia: Union Press, n.d.), 322.

Notes to Chapter 25: Farewell to Pio Nono

1. Taft, 256–57, 131. See also Larkin.

2. *HHLM,* 331–34.

3. HH to CC, April 26, [1876], SLRC.

4. Thurston, 588. Designs for the Golden Gates are described in AnonBio.

5. HH to WC, April 22, [1874 or 1875], and HH to CC, May 9, 1876, SLRC.

6. Waters, 366–67. See also "Miss Hosmer's Discoveries," correspondence of the *Evening Post,* October 26, 1878, SLRC.

7. "Miss Hosmer's Discoveries." The imitation-marble process is described by HH in a letter to WC, [early 1870s], SLRC.

8. On the perpetual motion machine, see Waters, 367, quoted from an article in the *Boston Daily Advertiser,* November 11, 1878. See also Matilda Joslyn Gage, "Woman as an Inventor," *North American Review* 136 (May, 1883): 478–89.

9. HH to WC, June 8, [1869], SLRC.

10. HH to CC, April 14, 1875, SLRC.

11. HH to CC, July 1, 1875, and November 28, 1875, SLRC; Craven, 226, 230.

12. HH to WC, April 22, [1874 or 1875], SLRC. For more on the Crerar competition, see Louise Hall Tharp, *Saint-Gaudens and the Gilded Era* (Boston: Little, Brown & Co., 1969).

13. HH to WC, March 30, 1870, SLRC.

14. HH to CC, June 18, [1873], and HH to WC, April 22, [1874 or 1875], both in SLRC.

15. The Letchworth monument is mentioned in AnonBio.

16. HH to CC, December 21, 1869, October 2, 1867, May 2 [1868–1869], and [September 2, 1869], all in SLRC.

17. HH to WC, March 30, [1870], SLRC; Hare 4:346; HH to CC, July, [1875], and St. Peter's Day, June 29, 1876, SLRC. Isabel Crow married Dr. Richard Kealhofer. She died at the age of thirty of peritonitis in Germany and is buried in Bellefontaine Cemetery, St. Louis.

18. HH to CC, December 21, 1869, SLRC; Dorothie Bobbe, *Fanny Kemble* (New York: Minton, Balch and Co., 1931), 281.

19. HH to WC, August 20, [1873], SLRC.

20. HH to LA [1869], Ashburton; HH to WC, January 10, [1873], SLRC.

21. HH to WC, December 2, 1869, SLRC.

22. HH to WC, July 19, 1870, SLRC; HH to LA, [1869], Ashburton.

23. Palmer, 525–27.

24. Ibid.

25. HH to WC, July 19, 1870, SLRC.

26. From a journal written by Caroline Hyde Butler Laing, 76–77. This information was sent to me by Mrs. Laing's great-granddaughter, Denison Burton.

27. Hare 4:358–60.

28. HH to WC, London, October 13, [1870], SLRC.

29. HH to WC, December 31, 1870, SLRC.

30. Ibid.

31. Ibid.; HH to WC, January 10, [1872], SLRC.

32. HH to WC, Malvern, "Tuesday, I believe the 11th but dates are beyond me," [1872–1873], SLRC.

33. Hare 4:346, 358–60.

34. HH to WC, Malvern, "Tuesday, I believe the 11th but dates are beyond me," [1872–1873], SLRC.

Notes to Epilogue

1. All quoted material, unless otherwise cited, can be found in SLRC. Henry James to Alice James, February 10, 1873, Henry James, *Letters,* ed. Leon Edel, vol. 1, 1843–1875 (Cambridge: Harvard University Press, Belknap Press, 1974), 339.

2. Henry James to William James, January 8, 1873, and Henry James to Alice James, February 10, 1873, ibid., 320–35, 339; James, 1:257. See also Jane Mayo Roos, "Another Look at Henry James and the 'White, Marmorean Flock,'" *Woman's Art Journal* 4, no. 1 (Spring–Summer, 1983): 29–34.

3. Louise Hall Tharp, *Saint-Gaudens and the Gilded Era* (Boston: Little, Brown & Co., 1969), 119.

4. "Art Museum Centennial," *Washington University Magazine* 51, no. 3 (Fall, 1981): 2–3.

5. HH to LA (no salutation), [late 1870s], Ashburton.

6. On HH's inventions, see Matilda Joslyn Gage, "Woman as an Inventor," *North American Review* 136 (May, 1883): 478–89. See also Cobbe, 27–28.

7. Susan B. Anthony to HH, Rochester, N.Y., June 7, 1889, and January 2, 1898, both in SLRC.

8. HH's participation in the World's Columbian Exposition is drawn from her letters to CC and from clippings in SLRC and HHWL. See also Jeanne Madeline Weimann, *The Fair Women* (Chicago: Academy Chicago Publishers, 1981).

9. *HHLM*, 332.

10. Eliza Allen Starr, "Written for *The New World*," February 24, 1894. I am grateful to Richard Shouse, San Francisco Public Library, for this clipping. The account of the workmen substantiates the operation of Hosmer's Roman studio at this late date. Apparently, reproductions of her works were still being produced there in the 1890s, although she seems to have given up her apartment many years before. In an undated letter to WC, written in the 1870s, she spoke of subletting the apartment if she could find a proper tenant. In the 1880s, she stayed at the Hotel l'Italie, situated in the Via delle Quattro Fontane, so that she could be near the Story family in the Palazzo Barberini.

11. Frederic Leighton to HH, Morlaix, Finisterre, 1895, and Frederic Leighton to HH, Algiers, 1895, SLRC.

12. Anne Dundas to HH, Cannes, February, 1896, *HHLM*, 131–32.

13. Lilian Whiting, *Women Who Have Ennobled Life* (Philadelphia: Union Press, n.d.), 231.

14. *HHLM*, 355. See also Virginia Surtees, *The Ludovisi Goddess: The Life of Louisa Lady Ashburton* (Salisbury, England: Michael Russell, 1984).

15. Information on the Compton family comes from William Bingham Compton, *History of Compton Wynyates* (London: John Lane, Bodley Head, 1930).

16. "The Little Woman Who Wouldn't Give Up," *Boston Sunday Herald*, April 5, 1908, SLRC.

Index

Note: Numbers in italics refer to illustrations

Women: physical exercise for, 10, 17, 66;
Victorian standards for and views of,
12–13, 23, 36, 66, 78, 91, 103, 113–14,
174, 192, 205, 215, 236; as writers, 13,
20, 36, 44, 78, 86, 94, 95, 109, 156–57,
255; education of, 15–21, 23–24, 215,
258; romantic friendships with women,
20, 41–42, 164–65, 185, 169, 270–71,
272–73; male views of, 23, 135, 215,
232; and marriage, 35, 104–5, 124,
169–71, 211, 241–42, 248–49, 314; in
the theater, 39; masculine clothing
worn by, 41, 90; as sculptors, 54, 63,
136, 161, 188, 191–92, 193–94, 205,
213–15, 220, 222, 258–60, 288–89,
321, 324; images in literature, 86; sin-
gle, 103, 123, 169–70, 314; childbirth
experiences of, 108, 235; as political
figures, 123; suffrage for, 324–25. *See
also* Feminism

Women of the Century (Hanaford), 287
Wood, Shakspere, 53–55, 117–18, 124,
190, 194, 217, 343n7
World's Columbian Exposition, 324, 325,
327
Wounded Amazon, The (Gibson), 55, 107

Yeatman, James E., 245, 251, 274, 253,
276–78, 281, 283, 285, 286, 290, 315
Young, Brigham, 29

Zenobia, 160, 231–32
Zenobia: Queen of Palmyra (Ware), 160,
231
Zenobia in Chains (Hosmer), 161, 166,
173–74, 177–80, *181,* 182, 185–86,
190, 212, 216–19, 225, 227–34, 236,
237, 239, 240, 294, 303, 325